My Land Is the Southwest

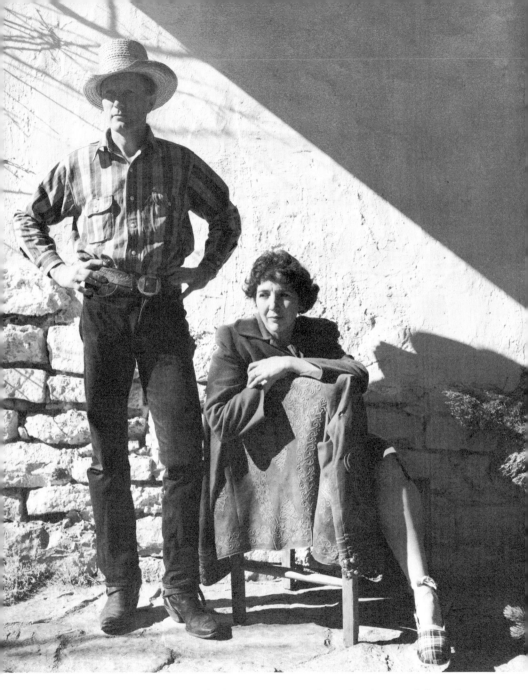

Henriette and Peter Hurd, about 1946, Sentinel Ranch. *Photograph by Walt Wiggins, courtesy Walt Wiggins, private collection.*

My Land Is the Southwest

Peter Hurd Letters and Journals

Edited by

ROBERT METZGER

Introduction by
PAUL HORGAN

TEXAS A&M UNIVERSITY PRESS

COLLEGE STATION

EC

Library of Congress Cataloging in Publication Data

Hurd, Peter, 1904–
 My Land Is the Southwest.

 Includes index.
 1. Hurd, Peter, 1904– . 2. Artists—United
States—Correspondence. 3. Artists—United States—
Biography. I. Metzger, Robert, 1950–
II. Title.
N6537.H85A3 1983 759.13 [B] 83-45101
ISBN 0-89096-156-5

Manufactured in the United States of America

FIRST EDITION

1276-85

Contents

List of Illustrations

Editor's Preface

Final selection for the present volume was made from approximately one thousand of Peter Hurd's letters. Most were written in a strong and graceful hand, with a black calligraphic pen. In later years, Hurd often had his letters typed for him.

While maintaining lasting relationships with persons to whom for one reason or another he did not have the habit of writing, Hurd did correspond regularly with many close friends and relations. The reader is asked to bear in mind that although when writing to his parents Hurd addressed most letters to his mother, he usually felt at odds with her and was much closer to his father, as well as to his father's sister, Mrs. Edward Hutchins. Hurd regarded Mrs. Hutchins (his beloved Aunt Susan) as a "second mother," yet only two letters to her are extant. The scale of the remainder of the correspondence, however, tends to reflect Hurd's genuine feelings for the recipients of his letters; those he wrote most often were on the whole those to whom he felt closest.

From an early age Hurd sought in his letters to meet prevailing literary standards. At nineteen he wrote his mother from West Point, "In re-reading this I have become aware that probably my command of the King's English is too limited to give you a proper picture of the sunset." Writing accurately and clearly was important to Hurd throughout his life, and he devoted much time, thought, and care to his correspondence. "I dread to think of the heavy, ill-phrased, graceless screeds that too often go forth from my hand," he wrote to Eric Knight, modestly misjudging his later letters. " — It seems to me that they lack utterly the gracious felicity of expression — that stream of consciousness veracity that letters like yours always have. I'm really

a little sad about this for it seems to me I think in terms of definite words and enjoy the language *per se* enough to do better about it."

Hurd's self-conscious desire to write precisely and felicitously sometimes resulted in archness or in stiffness, particularly in some of the West Point letters. "I believe I have outlined herein briefly but clearly my views along these lines." But the formal cast to some of Hurd's early letters probably stems less from his true sensibility than from youthful impulses to meet an exemplary code of propriety and to satisfy an image of himself as being coolly independent. (Perhaps too, though to a lesser degree, cadet Hurd was influenced in his expression by the severely formal atmosphere of the military academy.)

In the main, though, the style of Hurd's letters is fresh and relaxed, and at times even pleasantly colloquial. He had a knack for vividly recounting events, and for easy description. "The cottonwoods that border the *acéquia* are teeming with birds — Every breeze — be it ever so gentle makes their shiny leaves dance and sparkle in the brilliant sunlight."

The tone of Hurd's letters varies somewhat according to his correspondent. In writing to N. C. Wyeth, for example, he was inclined to be direct, earnest, and deferential; while to Paul Horgan and Eric Knight, his two best friends, he was more spontaneous, off-color, ironic, and exuberantly witty; and to his wife, Henriette Wyeth, Hurd composed a number of letters in the same key of lyrical intensity in which he liked to paint.

At various times in the course of his life Peter Hurd kept a journal. In October, 1932, at the age of twenty-eight, he began his first extant diary and made entries in it fairly regularly until May, 1933. He resumed it in October, 1934, but only for a brief period. After November, 1934, he discontinued the diary until March, 1935, and shortly after that he concluded it.

In total pages the diary amounts to more than two hundred, handwritten in black India ink. In it Hurd frankly discusses both his work and his life, as well as his inmost feelings. When he does this, he is apt to be plain and emphatic. "I have a deep set & completely pervading love for the Mexican people," he wrote on February 21, 1933, while traveling in Mexico, adding signifi-

cantly in Spanish, "I know them and love them more than my own people."

From May to November, 1942, Hurd kept an almost daily record of his wartime experiences on a United States air base in England as an artist-correspondent for *Life* magazine. Unlike the diary, which was private, the war journal was written with an audience in mind—specifically, the editors at *Life*, who had asked Hurd to collect material for them to use in stories on his paintings. Hurd also recorded in the journal his impressions of settings and incidents that he later intended to paint, as well as his reflections on the war. He wrote the war journal in longhand, then revised it and had it typed on his return to New Mexico.[1] Although exigencies of security prevented Hurd from discussing certain occurrences, he did manage to fill more than one hundred pages with detailed accounts of his adventures.

When Hurd traveled around the world with the Air Transport Command on a second wartime assignment for *Life* from January to July, 1944, he again kept a journal, but it is far less extensive than the previous one. As Hurd noted with frustration one day, "The scene changes so fast and so completely it is at best only a smattering that I can record!" He made entries infrequently and hastily on small pieces of lined paper.[2] Evidently a large number have been lost, and the rest were never revised.

On his return to New Mexico in July, 1944, Hurd wrote several essays on his experiences overseas, and years later incorporated them into a draft of his autobiography, which many persons had asked for, and which he began writing in 1970. Having previously published numerous magazine articles, not only on art but on other subjects ranging from polo to soil and land conservation—an issue to which he was passionately committed— Hurd appreciated the demands of formal writing. He knew that the autobiography would take away from the time and concentration he needed for painting; nevertheless, he applied himself to it with wholehearted, though intermittent, effort.

[1] In selecting entries from the war journal, I have mostly used Hurd's first and freshest efforts, rather than typed or revised versions.

[2] The entries from Ascension Island were taken from photocopies of typescripts provided by the Time & Life Archives.

But failing health caused him to cease working entirely, and the manuscript was never completed. Excerpts from its several hundred pages, as well as from Hurd's other writings, appear throughout this volume in annotations.

Certain limits have been placed upon the selection of material for this book. First of all, as a principle over and above that of objective presentation I have tried to respect the privacy of living persons. Consequently, remarks of Hurd's considered hurtful to the feelings of others have been deleted—their significance or truthfulness notwithstanding.

Secondly, as a painter, Peter Hurd when writing letters was not at work in his own medium. If many of his letters have inherent literary worth, that is not their supreme virtue; and not every line he wrote calls for the attention it would if Hurd were a writer. Therefore, redundant and unimportant material has been omitted.

Naturally, what is "unimportant" or "hurtful" is subjective. But in making selections I tried to be disinterested within the bounds of decency and include whatever seemed to illuminate Hurd's character and personality, as well as his painting methods and philosophy of art.

From the above considerations came not only the need to discard a number of entire letters and journal entries, but also the decision to use excerpts where appropriate, rather than including only whole letters. All deleted portions of letters and journal entries, indicated by three dots, have been removed in such a way as to prevent distortion of Hurd's meaning.[3]

The aim of this book is to give the reader in narrative form an epistolary autobiography of Hurd. For each of the book's ten chapters except the first, I have written an introduction or headnote, followed by the text of material. At the top of each letter is the name of the recipient. If the letter is an unsent draft for which no other version was found, the word *Draft* appears in brackets beneath the heading. Journal entries are indicated by

[3]The proportion of letters selected for this volume to the total number of letters available is approximately one of three. The same ratio holds for letters to each of the principal recipients, and for journal entries it is slightly lower.

the word *Journal* enclosed in brackets at the top. To improve the narrative, letters written to Hurd have been occasionally incorporated into the text, introduced by a pertinent heading.

Beneath each heading, generally at the right, appear the date and place of writing, as Hurd wrote them. Dates or places that Hurd neglected to include are supplied within brackets; if guessed at, they are followed by a question mark.

Each letter or journal entry leads directly into the next. Where necessary I have written brief joining passages, not to offer interpretation of events or analysis of paintings but to fill in significant factual gaps in the story. Though the letters and journal entries unfold mainly in chronological order, on occasion it seemed effective to skip forward or pull backward in time, in order to trace or complete an important theme or idea. Excerpts drawn from the same letter sometimes appear in different parts of the book, and a few are used twice. All departures from strict chronology are indicated by enclosing the date and place of writing in angled, as distinguished from square, brackets.

In reproducing Hurd's letters, I have largely been faithful to the peculiarities of his style, though various silent corrections have been made, especially where it seemed that exactly rendering Hurd's idiosyncratic use of punctuation might mislead the reader. For instance, Hurd seldom placed a punctuation mark after a sentence that ended at the right-hand margin, and in certain cases it was necessary to add a period or a dash in order to avoid a confusing run-on sentence.

Other silent editorial changes include the following:

Where Hurd has evidently rewritten part of a sentence without carrying out all implicit grammatical corrections in it required by his revision, I have done so.

Words that Hurd crossed out have been eliminated, unless they seemed to throw light on his sense or meaning, in which case they remain crossed out.

Hurd's infrequent misspellings have, where found, been corrected.

Where Hurd dated a letter both at the beginning and at the end, the latter has been dropped.

Hurd rarely put apostrophes in contractions; thus the word

I'd is written in his letters as *Id*. For the sake of clarity, I have freely added apostrophes.

Where Hurd used three dots to show a pause, a dash or period has been substituted. Though his dashes vary in length, only one size has been reproduced throughout.

Superior numbers have been lowered: hence $5.00 is now $5.00.

The bracketed *sic* has been used sparingly and follows only textual ambiguities.

From time to time in his letters and journals Peter Hurd wrote in Spanish. What prompted his shifting from one language to another is often revealing. For longer segments written in Spanish, a translation has been substituted in context, set off by the word *Spanish* enclosed in brackets. When Hurd reverts to English, the word *English* within brackets precedes his return. Spanish words and phrases whose meaning the reader can determine from the context remain untranslated in the letters, but an English translation is provided in a footnote for the Spanish that seemed to require it.

Footnotes are numbered within each letter and listed at the end of the letter. The abbreviation *PH* is used for easy reference to Hurd. Names and places that are not footnoted are either unidentified or not important. The source of a quoted passage in a footnote is given at the end. Unless otherwise stated all quoted magazine articles were written by Hurd.

Finally, bracketed inserts have been added to supply words or phrases that Hurd apparently left out through inadvertence; to clarify parts of excerpts made vague by deletions; to complete certain names and abbreviations; and to point out illegible, torn, or missing portions of letters, as well as drawings and sketches made by Hurd.

Through the course of six years many people have contributed to the completion of this book.

My first debt of gratitude is to Paul Horgan. His support, encouragement, and counsel greatly heartened me in my efforts. Without him this book could not have been done.

To Peter Hurd, Henriette Wyeth, and Michael Hurd I am deeply grateful for much generosity and kindness in making

available to me for purposes of research and for use in this book their original letters and private files.

I wish to thank the following persons and libraries for photocopies of letters and for permission to use them in this volume: Diana Alten, Haverford College Library; the late Judge John Biggs, Jr.; John Biggs III; John Hersey; Jere Knight; Kenneth A. Lohf, Columbia University Libraries; Mary Longwell; Mr. and Mrs. John McCoy; Warren Roberts, formerly of Humanities Research Center, University of Texas at Austin; and Mr. and Mrs. Andrew Wyeth.

To Gretchen Mueller I am indebted for extensive preliminary research.

For additional research assistance I am grateful to the following individuals and libraries: Marie Capps and Herbert Leventhal, West Point Libraries; Rosemary Frank and Lillian Owens, Time & Life Archives; Donald Gallup, Beinecke Rare Book and Manuscript Library, Yale University; and Loren Metzger-Marcus.

I wish to thank Alezandro J. Alvarez for his translations from the Spanish.

For help of various kinds I am grateful to the following persons: Phelps Anderson, Robert O. Anderson, Roman Anshin, Carl Brandt, Leon Edel, B. C. Fowlkes, Jr., Ann Granger, Major General Robert Lee Howze, Jr., Patrick Kelly, Harry Koss, Colonel M. Krisman, Donald Metzger, Colonel Russell P. Reeder, Walter Robinson, and Louise T. Trigg.

Letters to J. Frank Dobie and Oliver La Farge are the property of the Humanities Research Center, University of Texas at Austin. Letters to Daniel and Mary Longwell marked with the letter C within brackets are owned by Columbia University. The letter to William Wistar Comfort is owned by the Charles Roberts Autograph Letters Collection at Haverford College.

In closing, I would especially like to thank my parents for their constant friendship and encouragement. My work on this book is dedicated to them.

Santa Monica, California Robert Metzger
March, 1983

Introduction

Approaches to Painting

Since the early decades of the twentieth century the visual arts have been flowing in a divided course, where in all earlier times they flowed through history in a single coherent expression, whose aim, however varied the styles and temperaments of individual artists, was to represent and celebrate the visible world in all its aspects. Human experience perceived in common was the inexhaustible domain of any artist. If he was a good artist, he added penetration to recognition, and a personal manner to the representation of commonly accessible pictorial information. If he was very great he created marvels of discovery in the familiar which he dominated by his own vision, yet without dismissing the known world or its facts. His tradition rose in earliest times and has never lost its vitality.

But it ceased to be unique as an approach to painting when the increasing currency of systematic psychology, particularly that of the analysis of the self, gained generalized interest in the early twentieth century. Not the outer world, but the inner self, became more and more the medium for a wholly new tradition of painting, and of the allied arts, including sculpture, with which we are not here concerned. The temper of the times was favorable to the onrush of this new aesthetic tradition, which looked inward to the abstraction of the intellect rather than outward to the concrete realities and the observable conditions of life.

Science increasingly penetrated the invisible and made the habit of abstraction plausibly idiomatic; and technology, the runaway offspring of science, continuously made the mechanical aspects of life the very material of wildly accelerated change in

human circumstance. Adjustment to this by society at large was full of vast confusions, ominous discoveries, and rapid alterations of values, including those related to the preciousness of human life. Subject to systems and machines, the collective life seemed to force man into extremes in order to secure his individuality. What he saw when he looked beyond himself seemed less demanding of expression than what he searched out within himself: material related more to fantasy than to external reality, and as with all such, it could relate more to private concern than to the common vision. So-called modern art resorted to pictorial ideas often so simplistic in their images that they seemed to celebrate merely the materials of painting—pigment itself—or schemes of color in themeless decoration.

Two traditions of painting, then, came to coexist—that of the outer reality, and that of the inner. Both traditions continued to find their followers and collectors throughout the century. As in all periods, painters of any sort were eventually evaluated less by their chosen systems than by the often indefinable but recognizable qualities of superior taste, technical aptitude, freshness of style, and emotional relation to their subjects or their design imperatives. As always, fashion favored novelty in approach; and the "modernists" created a decorative abstract slang through no fault of the most serious among them, just as the traditional "actualists" always had their vulgar imitators in attempts at realism.

It was inevitable that the abstract, or "modern," mode of visual art should have its arbiters of reputations and careers, and that they should deride as dismissable that other vision in art derived from the long history of wresting secrets from the commonly visible aspects of life.

And yet in the work of such twentieth-century American painters as Edward Hopper, Charles Burchfield, Andrew Wyeth, Fairfield Porter, Charles Demuth, Georgia O'Keeffe, Marsden Hartley, George Bellows, Henriette Wyeth, Randall Davey, and Zoltan Sepeshy—to cite only a few of those artists who fully loved the visible world even as the new tradition became dominant—the great older tradition continued to find expression,

and, more appositely in the drift of our synopsis, recognition as perdurable.

It is with such allies and achievers of the objective vision that Peter Hurd belongs.

This Painter

Though he has painted many portraits and several murals, Hurd is primarily a painter of landscape. The single most expressive element of his likenesses of the world is the great clarity of his captured vision. This is so strong and direct that—as many observers have remarked—his paintings seem to be a source of light as well as a depiction of it; and even in a room dimly lit, his surfaces give out light from their own shapes and colors. Both near detail and summarized distance have the same power of illumination, and the source of this is the dynamic sky of the vast Southwest, where so much of the drama between sky and earth is visible in the sweeping dimensions that he knew without comprehension in his boyhood, but which later received his passionate study.

For Hurd was born to the landscape that became his life subject.

The light: it is what draws most response from those who know New Mexico. Many have said it is like the light in Spain, and the light in Greece. Earth forms assume a sharper contour, shadows are denser, sunward surfaces are fixed in dazzle. In the distance color remains clear. The great available sky in its fully seen horizon-circle may show several weathers at the same time. At night the immanent stars pulsate through the pure clarity.

The continent rises westward along a slow lift of plains toward New Mexico, and then lifts again, immensely, in the great chain of the Rocky Mountains. All the way from the Canadian north to upper New Mexico the mountains reach, until in southerly plains they break and scatter, standing separate more than in coherent line. But plains and mountains abide in every direction, and down into Mexico, in an immensity of distance perceived in the universal light, in any weather.

This is the land of Peter Hurd's life vision. The summer heat by day in open sun has a wilting pressure. Heat waves take the distance-summoned roads to shimmer out of sight into the horizon sky. In spring the desert plains rise under the wind and for weeks the heavy dust of dry lands blows grittily across empires and changes the sun from diamond white to hazy gold or metallic blue. In the autumn a pure aura seems to outline all objects and the air is so flavorsome that it answers an appetite of the spirit for color and form at their most crisp and delectable— the eloquent blue of far mountains, the lion-pelt gold of the plains, the silvery sparkle of cottonwood leaves before they turn to pale golden brittleness, the cool of cloud shadows as they waft across the land altering the rise and fall of coutours. Snow in winter, over mountain, plain, or dry valley, will often vanish in a matter of hours under the sun after a continental blizzard.

To translate what he saw of all that, Hurd eventually came to a technical medium of painting which in its very materials had the appropriate character to hold atmospheric brilliance. He had started his career painting with oils on canvas; but discovery of the technique of painting on gesso, first with oil paints, and then with egg tempera, was a determining breakthrough into an old medium new to him, which resolved his style for the rest of his life.

As a youngster he delighted in scientific aspects of even ordinary matters, and in an improvised laboratory conducted "experiments" whose processes had a seed of discipline in them. These took a maturing turn when the study of tempera and gesso methods brought problems strictly to be solved in preparation of the materials. He fashioned his own panels of gesso with pots of hot sizing and marble dust, applied to board paneling sandpapered many times. He ground his own mineral colors, and plumbed the mysteries of the egg yolk, all according to what he found in the writings of Cennino Cennini and other medieval and renaissance masters of the technique. The tempera on gesso method was used almost not at all by his contemporaries. For him it was the ultimate instrument with which to translate the light, the definite edge, the luminous shadow, the sky-source of all vision whose variations and combinations be-

came his subject matter. (It is interesting to note that his tempera technique eventually influenced his teacher and father-in-law N. C. Wyeth and Wyeth's son Andrew to adopt it as their frequent means of expression.)

A kind of simplicity, even of austerity, seemed to accompany the vision released by painting in tempera. In his development of style, Hurd first painted after the manner of the thin oil texture of his teacher Wyeth; then broke into an energetically individual expression of lush, heavy impasto in oil; and finally found the releasing precision through which to paint the pour and drift of light in his ample skies, and the grand arrested tumble of earth forms, the schemes of intimate color in his detail and the rasp of dust and the cut of rock, and the airy edifices of the atmosphere. Too, tempera suited the sometimes stark severity of his portraits and, in all his work, his habit of design—that spare, severe handling of spaces and objects which lacking an easy grace would be bleak if it were not so strong. In his mature work there is no sensuous exploitation of the medium for its own sake, but always a subordination of the means to what it must disclose.

To manage in the field the heavy apparatus of tempera painting on gesso'd panels, Hurd worked into wreckage a succession of wide-windowed camper trucks that he drove over roadless plains and up flood-carved arroyos in search of subjects from which to paint directly. But tempera painting is not a rapid means, light changes constantly, and successive visits to the same place cannot be counted on to sustain a single effect. In the end, the answer was to make rapid, brilliant, suggestive field notes in watercolor on small blocks of paper, and later, through days of orderly progress, to realize in the studio on the large heavy panel what the dashed-off field sketch held.

The process has constituted almost another genre of work by Peter Hurd. By the hundred, those field sketches—in size rarely larger than six by nine inches, and often smaller—done while driving anywhere, or riding a horse over his own acres of ranchland (his most constant source of subjects, the true raw material of his work as of his daily life), fueled the work in his studio. (We note that it was his brother-in-law Andrew Wyeth, al-

ready a master of the medium before he was twenty, who led
Hurd into watercolor painting in the early 1940s.)

When Hurd was called into service as a pictorial war corre-
spondent in the Hitler War, he was faced with the need to re-
cord episodes of training and battle swiftly and directly. During
his assignments, which ranged from the Caribbean and South
Atlantic islands to Great Britain, North Africa, Italy, and India,
he rapidly developed his control of watercolor, combined with a
wiry, strong line in India ink, to catch the immediate. It was
a technique that when he returned home to New Mexico to
stay gave him his new means of seeing and saving the instant of
light in its modeling of form upon the land he has loved so
productively.

There are critics and connoisseurs who are not hesitant to
place Hurd's field watercolor drawings in the same order of in-
terest as those of Constable and Turner—two masters to whom
Hurd was devoted since his youth. His sketches are not imita-
tive of theirs, but in actual dimension, and in swift perception,
truth of atmosphere, fresh appositeness of color, and virtuosity
in handling the medium, the comparison is just, and once again
illustrates the truism that a great tradition in art is never inter-
rupted, but only added to as the generations of artists advance
through time.

In the matter of field notes in general, it is interesting to see
that paintings later developed from them sometimes do not fully
capture their flash of truth, the very instant of vision, which
brought them to be. However carefully enlarged and elaborated
in detail, the consequent paintings, while they may be successful
in themselves, could often be said to be of a different order than
that of the little papers from which they took their beginnings.

In Hurd's case what does not change between sketch and
picture is the urgent sense of truth to the natural facts of his
land. He has not merely lived upon it, he has incessantly studied
its every aspect; and implicit in his records of it is humanity's
sense of the fugitive moment. It is as if he were saying to the
phenomena of sun-pour and crystalline heat, the hang of dust in
the air, the marvel of clarity in twilight, and the mysteries of
change wrought by moonlight, or by snow, "Hold! Hold!" in that

awareness of time passing which all men know now and then, but which the artist feels without cease.

If by his truth Hurd has taken the particular and the local to the general and the universal in his art, he has not escaped the witless penalties of being known mainly as a painter of a defined region—the Southwest, or, as most people see it, the West in general, which art criticism *à la mode* has, until recently, disdained as serious subject matter. The fact that he depicts without sentimentality the world he inherited and chose to keep has not saved him from being regarded by the undiscriminating as a "cowboy artist," or as a regionalist only. Well, in the life around him, people go through their days pretty much unaware that they are living and using the raw materials of art; for as they raise a windmill, or break a pony, or irrigate a field, or cultivate apples or cotton, they do not reflect that all life, any life, everywhere and anywhere, is worthy of record in works of art. It is only when someone lives their life with them and sees it with a fresh vision every day and puts down the vision itself as though it were entirely new that those people are struck by the recognitions and values, the beauties, of their own common dignity.

Hurd does this for them. The great demand in the Southwest for his paintings, lithographs, drawings, and watercolors has absorbed most of his entire production, to the almost complete exclusion of eastern dealers and galleries. It has been only in retrospective exhibitions, such for example as those in Columbus, Ohio; the Brandywine Museum; the Philadelphia Museum of Fine Arts (in a huge show combining his work with that of his brilliant wife, Henriette Wyeth); and the Palace of Fine Arts in San Francisco, that the public far removed from his landscape has had opportunities to see his work in broad representation. His work is included in such permanent collections as those of the Metropolitan Museum, the Art Institute of Chicago, the Nelson-Atkins Museum of Kansas City, the art museums at Rochester, New York; Honolulu; Minneapolis; Roswell, New Mexico (which has the largest collection of his work in all media); and the National Gallery of Edinburgh. His most important mural paintings are to be seen in Lubbock, Dallas, and Big Spring, Texas, and in Albuquerque, New Mexico. In subject matter, the

murals arrest the likeness of historical and contemporary life in the Southwest, against the grand spaces of its backgrounds.

The localism of the subject matter, then, has been one factor in identifying Hurd with the popular image of the cowboy—that historic American figure so tediously parodied in written and filmed romance. Further, it must be admitted that by being a superb rider, and by wearing the sensible dress, including the high-heeled boots and the work clothes of the ranch horseman, and by respecting the life of the countrymen all about him, Hurd himself has in working hours superficially resembled the cowboy character.

No matter what the limitations of those who, whether in admiration or dispraise, persist in the "cowboy" or "western" artist caricature, Hurd disposed of the matter in an interview he gave to the *Houston Chronicle*. "They call me a western artist, but it's true only in the sense that I live in this area. I don't think of myself in the tradition of Remington or Russell. I'm simply a painter of what occurs around me."

Among American painters of today, Peter Hurd is significant not because of the fashion but in spite of it. Fashion exists by the very fact of change. The tradition from which Hurd sprang and to which he has added his own vision continues, beyond fashion, to hold elements common to the experience of both artist and layman.

If genuinely gifted painters of today's individual abstract vision of spiritual chaos tell us something we should know about our time, then so does this painter who blesses the face of the land with certainties which abide.

A Start in Life

In the early years of the century Roswell, New Mexico, was a small city with earth streets, under a great canopy of cottonwood trees, set twelve miles west of the red middle Pecos River. In a grand plain all about, ranches ranged their cattle, and artesian wells fed fields and orchards in the midst of the prevailing dry. Commerce consisted of supply for the ranching and farming country, the usual general stores for the town, and the servicing

of the town's largest institution and industry, the New Mexico Military Institute, on the crest of the hill of north Main Street.

The community had its few well-to-do citizens, its genteel society consisting of settlers from the East and the South who maintained polite standards; its Southern Baptist and Methodist constituencies; and its small servant and laboring populations of Mexican Americans and a few Negroes who lived in two districts apart. The Mexican—the larger—occupied a dusty southwest section of town referred to as "Chihuahua," probably because most of its original settlers and many later ones came from the north-central Mexican state of that name. It was, like the rest of town, unpaved, and its roads and alleys were lined with shacks and hovels whose only dignity depended upon the rude adobe and cement Roman Catholic church of Saint John. The district was what in modern parlance would be called a ghetto.

To feed commerce, there were banks and a spur of the Santa Fe Railroad; and to feed the western Saturday night tradition, a few saloons. A red brick hospital maintained by German-American nuns bounded the town at the south end of Main Street, in the midst of open country which sustained a few small, scattered farms.

One of these belonged to the young attorney-at-law Harold Hurd. An immigrant from a distinguished Boston family, he had come west after the Spanish-American War, in which he served as a navy volunteer aboard the armed transport *Yankee*. He saw action in Cuban waters, and during a typhoid epidemic on board the *Yankee*, he fell ill with the disease, which made him susceptible to a later attack of pneumonia. This was serious enough to threaten him with pulmonary tuberculosis. He was advised to move to the West in search of health—a commonly practiced treatment in those days. A graduate of the Columbia University Law School who had previously practiced law in New York City, he opened an office at Albuquerque, but soon afterward moved to Roswell, where he established his legal practice and acquired his small farm of twenty acres or so south of town near Saint Mary's Hospital. There he brought his bride in 1902. She was Lucy C. Knight, whom he had met in 1901 on a visit to his sister and brother-in-law, Edward and Susan Hutchins, who owned a

large farm at Castine, Maine, as a place for vacations from their
Beacon Street house in Boston—Edward Hutchins was a co-
founder of the Boston law firm of Hutchins and Wheeler. Susan
Hutchins and her brother Harold Hurd were very close, and she
figured large in the life of Peter Hurd, who said of her, "Closest
to me of all my relatives was my Aunt Susan." She was a woman
of grace, rather formal gaiety, and charming mind, with a fine
patrician profile like her brother's, the main feature of which,
an arching Roman nose, found its dynastic repetition in Peter
Hurd. The Roswell and Boston families maintained lively rela-
tions, and in later years Mrs. Hutchins came west to visit at her
brother's place, and as he grew up young Peter often spent vaca-
tion times on the Maine farm of his aunt and uncle.

Harold Hurd's twenty acres had a windmill, an earth tank
for irrigation water, lofty groves of cottonwoods, and—Peter
Hurd's birthplace[1]—a rambling one-story house with a wide
porch for shade in the white-skied light, a turret for ornament
above a bay window, all given proper approach by a long, winding
driveway. Eventually there was a plantation of dozens of spruce
trees set out in formal rows for no purpose but the owner's plea-
sure, possibly as a reminder of the evergreen forests of the North-
east: a grove locally known in a genial way as "Hurd's Folly."

Within the house, under Lucy Hurd's informed style, a
measure of luxury fitted into a tone of civilized comfort, signaled
by handsome possessions, immaculate housekeeping, superior
food prepared by a generic cook and served by a white-jacketed
Negro butler (a succession of individual servants seemed to hold
brief tenure under Mrs. Hurd's inflexible standards). Books in
profusion, both classics and modern, were ranked along the
walls, where good pictures, either original or in reproduction,
were hung.

It was a household to which the town's eminent families
naturally drifted. In a sense it was an oasis of a style alien to the
local, for it reflected manners and tastes rooted in "Eastern"
and, in a few cases of constant callers, European tradition: there

[1] Now obliterated by a huge shopping plaza centered around a Sears Roebuck
store.

was an Italian count who came and went, there was a Swiss colonel who settled in the Pecos Valley where Roswell was situated, and there were other immigrants in the professions—law and medicine—and in capital investment and development. The mixed pattern was familiar in the West of that time—the early twentieth century—when recently arrived gentlemen sent their linen to Chicago for laundering, and when wines, oysters, and other table luxuries, along with new books, clothes, and gifts for occasions, were imported by rail. The senior Hurds' modestly elegant style was derived not only from the Boston heritage of Harold Hurd, a direct descendant of Nathaniel Hurd (the Revolutionary War silversmith always paired with Paul Revere), but from the background of Lucy C. K. Hurd, with its casual references to Georgia estates, railroad presidencies, private railroad cars, and a privileged society in the image of Charles Dana Gibson's dashing drawings in pen and ink.

The Hurds had two sons. The older, Harold Hurd, Jr., was born on February 22, 1904; the second, William Knight Hurd, a few years later. (William Hurd developed a free and easy nature, briefly served as a merchant seaman as a youth, and later entered the oil business. He died in a car accident in the late 1930s. The brothers were never close.)

For both sons, the father projected much of his own nature in military ambitions—the army for the elder, the navy for the younger. Mr. Hurd's military stance was supported by a powerful tradition in his own New England family, which sent a soldier to every American war, beginning with the French and Indian War and reaching down to his own service aboard the *Yankee* in 1898. He bore himself in a soldierly way, so erect as to seem to lean slightly backward. He was a tall man, with a shaggy, handsome head, a high sense of probity, a rigid patriotism, and an assumed gruffness of speech in which he often barked affectionate and comic words. During his brief residence in Albuquerque, he had been appointed a deputy United States marshal by President Theodore Roosevelt (his Cuban hero), and when he moved to Roswell, he joined Battery "A" of the New Mexico National Guard. The unit consisted of Roswell's elite, commanded by Colonel E. N. de Bremond, the aristocratic native of Swit-

zerland who maintained extensive vineyards such as then flourished in the broad Pecos Valley. The battery saw service on the Mexican border during the bandit raids of Pancho Villa. Harold Hurd served as first lieutenant and battalion adjutant until relieved for physical disability. When the battery was sent overseas in World War I, Hurd was not enrolled.

But the martial spirit, and its external style, survived in the Hurd household. Young Harold, or "Pete," as his parents called him from infancy onward, was surrounded in his childhood by souvenirs and events that gave him a romantically colored sense of soldiering. He saw General Pershing riding at the head of mounted troopers on a visit of inspection to Battery "A," and there with an officer's saber was First Lieutenant Hurd riding in the column—a stirring sight for any small son, who at the age of eleven studied the United States Cavalry Drill Manual. He grew up in a household whose walls were hung with guns, and his father taught him their use in target practice. When troop trains left Roswell carrying young soldiers off to World War I, as the band played and crowds waved and cried and cheered, he was there; and long later he recorded in a private note how he dreamed one night of enlisting in the army in that war, while the same band played, and pretty girls threw flowers as the train moved out

Colonel de Bremond, his delicate wife, and cultivated daughters were close friends of the Hurd household. Others were the members of the family of the Minneapolis capitalist James J. Hagerman, who built the railroad line from Clovis, New Mexico, to Pecos, Texas, giving Roswell access to the great world, and offering a lifeline to a vision of rich agricultural and industrial development which was only partially fulfilled. The Hagermans built the region's largest mansion in the country south of town, where the owner's private railroad car had its own track siding. Mrs. Hagerman was the godmother of Harold Hurd, Jr., and when years afterward he changed his name legally to Peter Hurd, she sent for him to chide him for abandoning what had sacramentally been bestowed upon him under her sponsorship. His Boston relatives shared her view—Aunt Susan Hutchins never used his new given name, and had occasion to

address him with amused reproof as "Harold, you rogue!" But in changing his name, Peter declared his personal style. More, he was used to being called "Pete" by everyone, and in a sense he was simply legitimizing the nickname. Again, there was more swagger to it than to his original name, and it proclaimed a sense of himself which grew through a colorful lifetime. Peter Hurd once said, "My father, a proper Bostonian, believed it unbecoming to be in any way conspicuous. I have lived by the opposite principle."

Child, boy, youth, Peter was the obvious presence to lead the companions of his early days. While his mother conducted her fastidious drawing room and dinner party life, calling the farm at the end of Main Street "South Highlands" on her blue stationery, her son Peter, forecasting his young future and acting out the gallant nature of his father's example, became at an early age the commanding general of a ragamuffin army drawn from the male children of the Mexican-American *barrio* of Chihuahua, Roswell. As a leader of boys who spoke Mexican Spanish, he soon became as fluent as they both in their own language and in perfect mimicry of the accent with which they spoke English. On the dusty flats of Chihuahua and South Main he led many a neighborhood campaign with his troops. Except for his blondness and blue eyes he was as Mexican as the rest. He rode to battle at first on a bicycle; later, on a succession of ponies given him by his father. Ragged, profane, and reckless, he was becoming the peerless horseman of his later life. It was a time when boys were expected to be compact of mischief—though of a finally harmless kind, and in any case a mischief which when detected was accompanied by an air of aggrieved innocence. Peter was a master of the style.

He grew into a youth of startling good looks, with a trim figure far stronger than it looked; bright blond hair; a finely carved narrow face from which his intensely blue eyes gave out a piercing interest in what he looked at. His imagination danced through innumerable fads and briefly arresting skills. He read everything. He roved his country with alert curiosity in its flora and fauna and what might be called arrow-head archaeology. He had something to compare his land to, for in addition to sum-

mers in Maine with the Hutchinses, and visits to their town of Boston, he had been taken as a small child to visit his grandmother Knight in Buffalo, New York, and saw that big city, and great parkways, and a vast lake, and he sailed his toy boat in the fountain basin at Gates Circle, amongst other children. He never saw anything in all his life that made him prefer any place to his own New Mexico; and whenever he was far from there, his longing to return, and to remain, determined the course of his life—and his art.

In due time, Peter outgrew the dusty street wars of Chihuahua, and in September, 1918, at the age of fourteen, he was enrolled as a cadet in the freshman high school year at the New Mexico Military Institute on North Hill—his first move into the world of his father's hope for him. Academically, Hurd was a brilliant cadet, and in military subjects superior. The bravado that conquered Chihuahua served him equally well as a cadet. His active imagination and its offspring, originality, led him to ingenious subversions of school authority, while he continued to show the world a face of misjudged virtue. This echoed a national tradition given literary character through Huck Finn, Tom Sawyer, and Peck's Bad Boy, with whose exploits he was familiar.[2]

In his three years as a New Mexico cadet, Hurd began to show newly developing talents. He was a successful gallant with the town girls, and he formed an ideal of "The Pretty Girl" based on popular magazine covers by such illustrators as Howard Chandler Christy, Penrhyn Stanlaws, Coles Phillips, and, from the Sunday supplements, Nell Brinkley. He took to drawing Pretty Girls after these models, and making other sketches at about the same level of taste for the school magazine. Though without losing his interest in The Pretty Girl in the flesh and his pursuit of her, Hurd presently began to lift his esthetic ideal to a higher plane. His inherent romanticism was attracted to the decorative illustrations and paintings of Maxfield Parrish, which were appearing in books for the young and in magazines. Copy-

[2] For a fuller account of his early youth, see Paul Horgan, *Peter Hurd: A Portrait Sketch from Life* (Austin: University of Texas Press, 1965).

ing these, at which he spent much time in school, took greater effort and perception than the Pretty Girl covers, and he went at them with serious attention.

It was a tendency regarded at home with a mixture of indulgence and dismissive shrugs; for the father was working to have his older son appointed to the United States Military Academy at West Point, and the son, drawn to military panache, was compliant and even eager. Senator Albert Bacon Fall of New Mexico nominated Harold Hurd, Jr., for entrance to West Point. In January, 1921, Hurd was accepted, and because of a certificate of proficiency from NMMI he was excused from any entrance examination as a United States cadet. He was seventeen years old when his three years at NMMI ended and his career at West Point began in July, 1921.

He had reached his full height. His wiry figure was tense with vitality. He was quick and precise in movement, and his temperament was as high-spirited as his mind was dartingly active. He looked with gaiety and confident curiosity upon life. From hearing excellent English at home, he was exceptionally well-spoken. Thanks to the civility of his family, and to his early training by nuns in the parochial school of Saint Peter's, Roswell, where he had received his primary schooling, his social usages and manners were correct and charming. In his New Mexico cadethood he had acquired a disciplined demeanor and neatness of appearance, and he had a right to a degree of vanity for his good looks, which approached a pre-Raphaelite ideal. This was relieved of softness by the intensity of his nature and his quick physical coordination. "Going for a soldier," he was optimistic, healthy, idealistic, and confident. At seventeen, he believed in the future he thought he saw, for it promised to fulfill the martial romance of his boyhood's imagination.

The Powerful Vision

He was not yet aware of the powerful vision of his native corner of the earth which he carried within him, and which in time would sharply turn his life toward different paths and goals than those he aimed for while wearing the cadet grey and polished

buttons of West Point, the white cross belts and the plumed shako, the shield with its motto of "Duty, Honor, Country," details of which he set down in little drawings sent home in his early letters.

It is with those letters that this book of the life of Peter Hurd now takes up the story that unfolds in his own words through six decades.

PAUL HORGAN

My Land Is the Southwest

A Soldier Disillusioned

To Mrs. Harold Hurd

July 1st '21
[West Point]

Dear Mother,

A "Plebe" at last! I arrived in W.P. yesterday and after a night at the West Point hotel I [reported to the Post] with about 300 others all members of the plebeian caste. I cannot begin to tell of all I have done since this A M but suffice it to say that we have worked —

I have been issued with all that I was supposed to bring and as I brought only the minimum number of each I will be O.K. By all I mean nearly all that is towels, stationery, sox, laundry bags, stamps, raincoats etc.

The reason that I wrote you none of my plans was that I had none. Who wants to be worried with plans when he is on a pleasure trip?[1] Now that I am here of course it is different.

I have met several ex-cadets of N.M.M.I. whom I didn't know were coming here. I have not met Robert Howze[2] yet tho I have seen his name. He is not in my Company —

What did you say about Mabel Cahoon, I couldn't read it.

All of my expectations have been fulfilled about the beauty of the Post — It surely is a beautiful place.

We are dressed in Grey — gray flannel shirt gray trousers with a black stripe and a black necktie. Our caps look like this:
[drawing of cap]
this of course is not full dress. —

Lots of love to you all
"Pete"

[1] After leaving Roswell PH had stopped to visit relatives in several cities.

[2] Robert Lee Howze, Jr., later a major general, was PH's fellow cadet at NMMI and one of his roommates and good friends at West Point.

To Mrs. Harold Hurd

July 16, 1921
[West Point]

. . . First you speak of the Howitzer staff.[1] Major Potts one of our "tacs"[2] and an instructor in French stopped me and asked me to keep all of the sketches etc I make around here as the Staff will be anxious to get them. So I will get you to send on the picture,[3] board and all. The protecting shield of Celluloid laps over on the upper side. This can be cut off, even with the top, with a pair of scissors so as to allow it to fit the paper when you wrap it up.

There is no hurry for this.

The Staff found out about it thru Maj Kalloch[4] who saw a pastel portrait (of my roommate in a Full dress uniform) on my desk when he was inspecting quarters . . .

[1] *The Howitzer* was the West Point yearbook.

[2] Faculty "tacs," short for tactical officers, supervised each company of cadets.

[3] One of PH's first paintings, called *The Unmasking*.

[4] Major Parker Cromwell Kalloch, Jr., was the tactical officer for cadet Hurd's company ("D"). He continually encouraged PH in his artistic pursuits.

To Mrs. Harold Hurd

[July 27, 1921
West Point]

. . . At your request I am enclosing a hasty sketch of an extremely slouchy gentleman in the West Point uniform. This is our Full Dress. The hat (it is officially called a hat altho technically a cap) is "slangly" called a "tar bucket." It is over a foot high and weighs a ton! The full dress coat is a beautifully tailored affair with huge round (spherical) brass buttons. There are forty four of these. It is trimmed in black braid. The tail is of the "swallow" type and needless to say the coat itself fits like a pair of gloves.

The cross & waist belts are of course worn only at parade — these are of white canvas. They are held in place by a "B" plate. It is here that the plebe spends many a long weary hour, for just *one* little nick or bit of tarnish means a "skin."[1] They are made of

brass but must be polished white; not a bit of yellow is to show. The cross belts hold a leather cartridge box which like everything else must be shined.

The waist belt is secured by a brass belt similar to the "B" plate. The trousers are either white or grey, if white they must of course be immaculate. We have to hoist ourselves into them for they are as stiff as a board . . .

[1] Delinquency report.

To Harold Hurd

July 28 & 29, 1921
[West Point]

Dear Dad: —

Parade this P.M. was witnessed by some two thousand people who formed an excursion from New York.

It may be hard for you to realize, but the lines were all as nearly *perfect* as any *I* have ever seen anywhere! The sixth parade held by the class of '25! This may be due to the large percentage of Ex-service men in our class or it may be due to the excellent training given us by the officers;[1] or possibly it is due to the excellent morale and Esprit-de-Corps displayed here. Probably it is a combination of all these causes. Every parade is preceded by a rigid Company inspection; this takes about twenty minutes so you see parade *here* is quite an affair.

. . . Did I tell you that we have gotten *four* first lines at parade? The fourth Company has "placed" in every line awarded!

Did you know that the present superintendent of the Academy is the youngest general officer in the service? He looks to be about thirty years old.[2]

Well so long — I must get back to the old rifle.

Your Loving son
"Pete"

[1] While most of the corps of upperclassmen were at Camp Dix, New Jersey, for summer training, a detail of first classmen remained in barracks to help train and orient the plebes.

[2] Brigadier General Douglas MacArthur (1880–1964) served as superintendent of the academy from June 12, 1919, to June 30, 1922.

To Harold Hurd

[August 27, 1921
West Point]

Dear Dad:

Well the hike is over! We are back to garrison duties at the Point again after a rather hard hike thru the mountains around the vicinity of West Point.

The first day we camped at Peekskill after a ten mile (up-hill) hike. — I say Peekskill altho we really camped at the N[ew] Y[ork] N[ational] G[uard] camp near there. Next day we moved on to Lake Mohanset where we had a series of field manoeuvres. The next day found us at Lake Mahopac a distance of about 15 miles from Mohanset. There is a large "exclusive" summer resort there and we had a fine time (after camp was pitched) swimming and boating on the lake. That night a dance was given in honor of the West Point Cadets by the Mahopac Country Club. The following day we arrived at Lake Oscawana which is also a large resort. There we were given rides on the various motor boats small yachts etc. owned by the summer people. From Oscawana back to West Point we had our first down-hill hiking. The head of the long column gave a loud cheer when they saw the gray walls of West Point across the river and it was echoed by the whole column for we were "sure" glad to get back to old West Point altho of course the change of routine was enjoyed by all. The weather was fine, tho quite hot, and on the whole I had an enjoyable time. My feet held out well; I was [spared] the discomfort of blisters, corns etc. which many in our company had.

The upperclassmen returned about an hour ago. The Fourth class (provisional) companies were formed in a long line on one side of the parade ground during the twenty minutes required for the column to pass. First came two troops of cavalry then two batteries of field artillery several batteries of heavier guns and the long line of supply wagons, rolling kitchens, ambulances etc . . .

To Mrs. Harold Hurd

September 17, 1921
[West Point]

. . . We had a big time Thursday; President Harding steamed up the Hudson in the "Mayflower" accompanied by Secy. Weeks [1] & Mrs. Harding and others. We attended classes as usual Thur. Morning; our first news of the President's expected arrival was received about 11:50; at twelve ten we were formed & ready for review, white trousers, cross belts, full dress coats and hats. The President preceded by a troop of the "Nigger" cavalry drove down the long avenue in front of barracks while the corps stood at "Present arms." A saluting battery of four French 75 mms fired the customary 21 guns after which we formed for review. After the review came dinner. The Presidential party came over to the mess hall and after walking around a bit proceeded to the Parade ground, which is also the golf links, where the President crossed clubs with some of the officers of the post.

So now you know all the excitement we have had in the past week. Nothing else of interest has occurred. The corps went out of white [2] yesterday which was a very welcome occurrence for White trousers are a nuisance.

My warrant, engraved on parchment, was given me yesterday.

It reads like this:

To all whom it May Concern:

Know ye that the President of the United States has been pleased to appoint Harold Hurd Jr. a cadet of the U.S.M.A. to rank as such from the 1st day of July 1921.

Given under my hand and the seal of the War Dept. this — day of — etc.

Seal	P.C. Harris [3]	John W. Weeks
of		
War Dept	Signed	(Signed in Person)

These are rather interesting in that they bear the pen signatures of P.C. Harris and Secy. Weeks . . .

[1] John Wingate Weeks served as secretary of war until 1925.

[2] Ceased to wear white trousers. In PH's day at the academy there were nearly a dozen different combinations of authorized military dress.

[3] The adjutant general of the army.

To Harold Hurd

October 3, 1921
[West Point]

. . . I have just come back from Artillery school and my head is buzzing with angles of site panoramic sights mils deflection range etc. I rather like it however. We are studying the *British* .75 mm and its mechanism (of recoil) is most interesting since it typifies science's most far advanced step in Gunnery. It is a wonderful gun and approaches perfection in its precision . . .

To Mrs. Harold Hurd

October 27, 1921
[West Point]

. . . Our work on French & British .75s continues. To qualify as expert gunners we have to lay (directly) for range with either panoramic or open sights & set off deflection in ten seconds or less. We have ten seconds in which to set the angle of site on the gunner's quadrant and five seconds to set the range on the range drum. We completed the drill of the gun squad last week.[1] This probably won't interest you much but Dad will no doubt be interested . . .

[1] PH received Not Qualified on his Gunner's Instruction Exam in December, but a year later made Expert. In all other weapons courses he scored either Average Mark or Qualified.

To Mrs. Harold Hurd

4:30 P M December 9, 1921
[West Point]

. . . I received a letter from Bill[1] today asking for my wireless etc. You will recall my parting wish concerning the disposal of my Radio outfit and Laboratory apparatus.[2] I asked that the chest of wireless stuff be left alone in the maid's room. This I hope that you will do for I really desire to keep it, especially the *wireless*. As for anything other than what is in the chest, why let him have it but I wish that the chest of receiving apparatus be left alone. I do not wish to disappoint Bill but I made it plain

before I left that I desired that all my old laboratory equipment and especially the wireless be unmolested. I hope you will see to it that this is done. As for the aerial and such other Radio equipment as he may find *outside of the chest*, let him have it.

I shall write him at my earliest opportunity which will probably be Saturday. I continue to remember with pleasure the days when I used to listen in to Arlington from my little station. I used sometimes to talk "Radio" with some of my classmates whom I found were interested in it.

. . . Lots of love to all at home and please see that the chest remains where it is. Bill will ruin the wireless and I do not wish this to be done. He can't expect to start wireless with a large set; if he is in earnest, which I very much *doubt*, let him build one up as I did . . .

[1] William Knight Hurd (1908–39), PH's younger brother.

[2] PH had converted the farmhands' quarters on his parents' ranch into his own chemical laboratory, where he liked to study light-emitting substances and tinker with explosives.

To Mrs. Harold Hurd

⟨May 10, '22
[West Point]⟩

. . . I wrote Bill last week asking him to look some stuff up for me that I had cached before I left home last summer. I was prompted to do this by a recent lecture delivered by the Chief of Chemical Warfare U.S.A. He mentioned the chemical and told of some very unusual Properties possessed by it. It chanced that I had some of the stuff, dichlorethylphenylide. I got it at Camp Kearney Cal when I was there with the R.O.T.C.[1] If by any chance I happen to still have it I am desirous that it be kept until some future date when I mean to use it. It is not important however and if Bill decides to ignore my letter why I shall let the matter drop . . .

[1] The summer following his second year at NMMI PH spent ten weeks at Camp Kearney. Part of his training as an ROTC cadet exposed him to chemical explosives. On one occasion he "borrowed" some mustard gas and concealed his find in the right pocket of his breeches. He ended up with a six-inch water blister on his hip and had to spend three weeks in the base hospital. PH explained to his doctor that he had accidentally scalded himself in the shower.

To Harold Hurd

12/24/'21
[West Point]

Dear Dad:

Well, the writs[1] are over at last and I am not turned out! I missed the examination list by 8 *tenths*! so you see I am no "engineer" in math. In French I am way pro.[2] as in English.

The last week, things went pretty hard with me. I was deficient in Math up to the last writ (which was yesterday) but by studying until after midnight Thursday night I succeeded in "Maxing" the last writ that is, getting a 3.0 out of 3.0

It has been a very hard ordeal and I am *"sure"* glad it is over with. Bob Howze took my turn of guard duty the last study night. I am also greatly indebted to him for his coaching in Math during the last week.

I sent [Christmas] cards and posters to those of whom I chanced to think — no doubt I missed a few for which I am sorry.

The upper classes have gone on their Xmas furlough having left yesterday. The Plebes (who of course have to remain at West Point) are acting Company officers. I am, through no fault of my own, acting corp. Bill[3] is 1st Sergt! I am now N.C.O. in charge of Qtrs . . .[4]

[1] Written examinations.

[2] Proficient; a score of 2.0 (the passing mark) or higher out of a possible 3.0. At the end of the first semester, PH's standing in the general order of merit, from a class of 303 cadets, was 190 in English, 72 in French, and 301 in Math.

[3] William O'Connor Heacock, later a colonel, was PH's second roommate and another fellow cadet from NMMI. Heacock's father and Harold Hurd were friends from Albuquerque.

[4] While the upperclassmen were on leave, plebes were fairly free to do as they pleased around the Post. Some were detailed as temporary cadet and noncommissioned officers.

To Harold Hurd

Jan 4, 1922
[West Point]

My Dear Dad:

I am very glad of your recent letter telling of your appreciation for the envelope embellished with the brownies and those

with the various other odds and ends which may have been at my fingers' ends when I wrote.[1] — The accompanying sketch, while somewhat past season, I hope will interest you. — More of the brownies will follow later. They are queer little things, but drawing them gives practice in figure drawing . . .

[1] PH had the habit of decorating envelopes, frequently in the style of Maxfield Parrish. The Brownies, however, are imitative of Palmer Cox, author of thirteen Brownie books for children.

To Mrs. Harold Hurd

West Point,

January 23, 1922

. . . I did a cover for the Hundredth Night Program. It is a simple poster-impression in Grey wash, Black ink and red paint. The cost kept me from putting it in full colors.[1] The show is a Musical Comedy written by the cadets. The scene is laid in Cuba so the cover is Spanish in its gist.[2] I'll send you a program if they print well — Hundredth Night comes on the 20th of February this year; it is the annual celebration of "one hundred days till June."

Nothing further to tell of except it's cold and everything is covered with ice. I'm going to start walking on my hands and knees, or wearing sandpaper-soled overshoes if this keeps up.

The Howitzer has given me some stuff to do. I think it is all line work. I wish it were colours but this year's Howitzer seems opposed to the printing of anything but cartoons and photos. In the former I am but very little interested but I'll have to see what they want. — The Drawing Academy is very good about donating all sorts of supplies[3]. . .

[1] "This [made] it harder to do since more color would do much to camouflage my 'amateurishness'" (PH to Harold Hurd, January 19, 1922).

[2] PH's design shows a masked serenader and his sweetheart, who is wearing a lavish, low-cut gown. "They were both purely imaginative but the girl's dress was modelled after one I had seen in a theatrical magazine. I don't know how 'Spanish' it was but I used it anyway" (PH to Mrs. Harold Hurd, March 12, 1922).

[3] "My first box of paints was bought through a civilian employee of the Drawing Department, who with me, bemoaned the dropping of free hand drawing and sketching from the curriculum" (autobiography).

To Mrs. Harold Hurd

[March 5, 1922
West Point]

. . . I guess any further drawing this year is out of the question. The March writs are not conducive to the use of the palette and brush. —

I have been working on a pair of life size pictures of baseball batters. These were painted in white on a large piece of black tarpaulin with rectangular targets outlined for the Varsity pitchers to throw at for practice. This was the coach's idea and it has proven so valuable that he had it patented. I have just finished the patent-office sketches . . .

To Mrs. Harold Hurd

March 21, 1922
[West Point]

. . . Last night the (Art) editor of the Howitzer was up here. He took some, three I think, of my drawings; these were some I had done during the summer — done with no intention for publication in the Howitzer. Two were pencil and one was pen and ink. No color was taken. They are very costly to produce so I guess that is the reason oils are not popular with them.[1]

Your letter (about Mrs. Weist) amused me greatly! What I said to give her the impression that I was "unhappy" I don't know. — West Point isn't a place to be very much in love with especially for a plebe but as for my voicing any such sentiments — I guess she got her wires crossed. I haven't any kick to give. I didn't come here expecting to enter a theological seminary nor to tread the path of violets so I got just about what I expected. I wonder what made her say all that . . .

[1] When the yearbooks were issued in May, PH wrote his father: "My three meagre contributions came out O.K. I only wish I had had time for more — I have had many ideas but very little time to develop them" (PH to Harold Hurd, May 26, 1922).

To Mrs. Harold Hurd

May 10, '22
[West Point]

. . . I only wish I *were* able to cut down on my demerits but it is impossible I am afraid. With 2000 miles between us it is useless to try to explain the many trivialities of this life. Such rather caustic comments as, "It *does* seem footless to break confinement deliberately etc — etc.," quoted from a recent letter from Dad, in no way tend to "elevate the morale." Perhaps were he better acquainted with the subject of his discourse he would be less inclined towards censure.

I have quite a number of demerits and am well aware of it.[1] Moreover if it were within my power to cut down on them I would do so.

It is far more important however that I do better in math. They will not discharge a man on account of an excess of demerits, who has the number I have, while my progress in mathematics is such that I have little or no assurance of getting through in it.[2] As for the graduation standing (military) I care very little about that at present.[3] I have long since abandoned the idea of the army as a profession and am more desirous of getting an education than anything else . . .

[1] A cadet was allowed 100 demerits that year before he had to face disciplinary charges. From August through May, PH received 79. Some of his offenses were: "Improper expressions at table"; "Wearing underwear to physical drill"; "Left mathematics section room by permission 8:35 A.M., did not return"; "Off limits in drawing academy 11:20 A.M." (PH's West Point [201] file).

[2] "It seems very queer to me that I should have been so great a devotee of chemistry, physics etc during my spare time at home and now be so at a loss when it comes to the theoretical side of Math" (PH to Mrs. Harold Hurd, April 12, 1922).

[3] Of the twenty-eight cadets in his company, PH was ranked fifteenth in industry, sixth in attitude, and sixth in officer material. "Has plenty of ability and is good officer material," Major Kalloch wrote in his report. "Inclined to be careless but will improve."

To Mrs. Harold Hurd

June 27, 1922
[West Point]

My Dear Mother:

You have long since been in receipt of my telegram telling of the results of the examinations [1]—

The news came to me last night when the list of unfortunates came back from Washington.

It would be very difficult for me to try to tell you of how I feel — a whole year's work lost was my first thought. The truth was a long time in dawning on me but when it did I began to realize that the year's work was not lost but that its benefits would remain with me thru life. I don't know if my telegram explained it — but I am really more fortunate than some of my class-mates who were discharged without being granted the privilege of a re-examination.

Whether or not I take the re-exam of course rests with you and Dad and Uncle Ned.[2] There is a great deal of argument on the matter — both pro and con. — I often wonder if I would see math any plainer if I went over it a thousand times — I sometimes doubt it. By talking it over with Uncle Ned — which I considered the most logical thing to do, I can get oriented and should he deem it advisable to go back will select a prep school. — This is of course a necessity.

The news came to me not, perhaps, as a complete surprise but it was none the less unexpected. I believed that I had gone a trifle deficient on algebra but thought that I had made it up on the trigonometry examination and since the sum of the two were taken believed I had a good chance of having passed it. There is no use holding a post-mortem however for it is evident that my surmises were wrong. —

There were thirty-some men found deficient and discharged six of which were out of my company.

I am all packed up and will leave tomorrow for New York from whence, after seeing Henry,[3] I will proceed to Boston.

The worst of leaving is of course the good-byes — I rather dread that. The class of '25 is a fine class and has a good reputation with the "powers that be."

Anyway the year has been a success for me Mother, even if its culmination was a deficiency discharge. — I have grown both physically and mentally. My set-up like those of all others who have passed a year here shows a marked change for the better — I have profited immensely by the course [of instruction] and beyond all possibility of a doubt I have not lost a year in any respect except that I have lost my class.[4]

That my knowledge of math has increased is evident from the fact that I now often wonder how in the world I ever got through until Christmas. I probably wouldn't have gotten by then had it not been for Bob.

Bob had troubles of his own this time though, so I had to do without his coaching. Bill's help was good but he had two of us to coach and only a short time.

I have not yet recovered from the long séances after taps — often extending into the small hours of the morning in which I tried by sheer force to understand math. Many of my classmates who were found[5] at Christmas are now in some of the largest colleges of the east ranking high in technical courses. They who were plainly the goatiest of goats[6] when here — There certainly must be a great difference in West Point Math and College math.

I am truly sorry for you and Dad whose optimism has been manifest all along in spite of my dubious tone —

It is for you and not for my self that I am disappointed in losing my class —

Tell Frank[7] that about 15 men were found out of his class — French, the foot-ball star, was *not* one of them.

Well Mother I guess this is about enough. I have outlined the situation to you just as I see it with no attempt to either better or make worse my condition — I was a yearling[8] for fifteen days anyway — Should I re-enter in September after passing the re-examination I would have the social status of an upperclassman although I would of course be taking the fourth class work over and would really be a fourth classman.

I got your letter of the twenty third and was delighted that you had seen Frank —

I do not think my visit to Uncle Ned is an imposition for he once told me if I ever was in trouble or needed advice to come to

him — an invitation very characteristic of Aunt Susan and Uncle Ned. —

Love to you and Dad,
"Pete"

Please don't worry — I will write you often and inform you of my actions. I am well financed — I do not know yet just how much I have coming to me but it is plenty — also the Xmas check from Uncle Ned for fifty dollars to be used as a reserve fund. —

[1] PH did not pass mathematics.
[2] Edward Hutchins.
[3] Henry Hutchins, PH's first cousin.
[4] A cadet with a deficiency discharge was required to repeat his studies with the succeeding class.
[5] Short for "found deficient and discharged."
[6] A cadet whose standing in a subject was near the bottom was referred to as a "goat."
[7] Frank Thompson, another friend from NMMI, was two years ahead of PH at West Point and was back in Roswell for the summer.
[8] Third classman.

To Mrs. Harold Hurd

June 30, 1922
166 Beacon St. Boston

Dear Mother:

I pulled into Boston night before last at 10:00 o'clock. Uncle Ned and I talked the matter over thoroughly and came to the conclusion that I had better make another try at it. Looking at it from a very optimistic standpoint one might consider the past year as equivalent to a year at a prep school — a darned stiff prep school however, but one that preps in how to receive hard knocks. Uncle Ned and I are going out to Westwood this A.M. to consult Gen'l Edwards[1] as per Dad's suggestion.

Later: — Went out to Westwood with Uncle Ned as planned and there found Cousin Clarence who was very helpful; — he said beyond a doubt that he would find some officer to coach me —

Possibly someone at Devons or on some island fort in the harbor. Lieut Nichols, the General's aide was found in Math in

his plebe year — he returned as a turnback[2] and completed the course. —

Cousin Clarence drove me back to Corps Area headquarters where he called in all of his staff — seven colonels and a Major — They offered various suggestions — Finally Lt. N[ichols] was sent to Camp Devons by airplane to make a canvass of the camp. I wonder when I think of the great steps Gen'l Edwards has taken in the matter. He is sure a fine man and exceptionally popular with *everyone*! Traffic cops salute him as he passes them. [Illegible] men call greetings to Daddy Edwards from everywhere —

I am to know tonight the result of the Arrangements made by Lt Nichols . . .

[1] Major General Clarence R. Edwards was Harold Hurd's first cousin and the head of First Corps Area Army Base, Boston.

[2] A cadet who has been "turned back" to join the next class because of a deficiency in his academic record.

To Harold Hurd
C/o R.O.T.C. Hdqtrs Camp Devons Mass
July 9, '22

. . . As to your queries.

I have bought no civilian clothes and do not intend to —

The cost of tutoring has not yet been decided; it will be very nominal. I put in from two to three hours per day (Sundays excepted) and from three to four hours' preparation by myself Sundays included.

We expect to finish both algebra and trig by the 18th of August allowing us two or three days' review of everything before Capt Willard[1] goes to West Point. If I don't get it this time I guess I never will —

Capt Willard has just completed a course in Tech and has a very good understanding of mathematics.

The news from West Point will come in due time.

My standing in the re-entrance exam means nothing to my class standing in case I pass and re-enter.

You will *not* have to deposit any money so don't by all means think of sending the Academy a check or draft. Many cadets, in particular those appointed from the U.S. Army did not deposit any money at all — I will have all my equipment etc (it is now Stored at the Academy) and the only thing that will draw on my salary will be the mess fund, which is very little —

You ask where all the money came from (that which was given me when I left.) No doubt you have forgotten that the salary of a cadet is approximately $90 per month fourteen dollars of which is set aside (each month) to serve as a fund with which to buy equipment after graduation. It is known officially as the "equipment fund."

About the time spent in painting drawing etc. mentioned in a recent letter. Any time which I may have put in on such was taken every bit from the brief time allotted for Authorized Amusements and Recreation — brief enough I can assure you — during these times the remainder of the Corps such as were not serving punishments were engaged in athletics, boating on the river, in the library etc. This came once a week and was the one and only break in a most monotonous existence through the long months.

I put out more studying last year than I ever dreamed of before — *and incidentally there will be a long time before I essay to put forth more* effort than I did during the past year! —

<div style="text-align:center">Love</div>
<div style="text-align:center">"Pete"</div>

Your letter to W.P. said "My son — *is attending* the R.O.T.C. Camp etc." This I am not doing as my letter probably explained; I am in no way affiliated with the R.O.T.C. but am merely quartered with the Regular Army officers detailed here to instruct the R.O.T.C. contingent.

<div style="text-align:center">HH Jr.</div>

[1] Captain Robert A. Willard of the Signal Corps, an instructor at West Point, was PH's tutor.

On July 25, Major Edwards wrote Peter's father, "Everybody likes him — he is studying hard and he is just bound to get in, and

I have asked Major Cunningham to give him additional attention." Late in August Peter took his exam and then spent a week with the Hutchinses at their summer home in Castine, Maine, before returning to the academy.

To Harold Hurd

September 12, 1922
[West Point]

Dear Dad: —

I am Back in the old rut as my last letter indicated I would be —

No doubt you want to know something of my sentiments concerning the future so I will unfold to you some of my opinions: I can talk freely now since I have passed my examination and am once more here at West Point.

Firstly you must know that I have no intentions whatever of making the army my career and that only as a last resort would I consider accepting a commission. A year ago I had a certain amount of "martial ardor" which was, no doubt, the cause of my being so enthusiastic about entering the Military Academy. Only one other thing was the cause of my choosing such an obviously narrow field. — I refer to economy, or the expenses entailed in getting an education anywhere else — This was of course a very strong element in the choosing of a school — I felt, and still feel, that securing an education from your pocketbook would be an imposition — due of course to the low ebb of business in Roswell.

Since my entrance into the service a year ago my views on many things have, as I intimated above, changed. The army has no attraction whatever for me and my only object in remaining in the service is to secure an education. — But as my future is not to be spent in the army I see no reason why I should spend four years at a technical school whose sole aim is to prepare a man for the army unless, as I said, economy demands that I "grab at" any education which does not require the expenditure of a large sum of money to obtain.

I spoke of the academy as "a Technical school whose sole aim is to prepare a man for the army." This is entirely true but the definition holds better for the last three, or possibly two years than for the first year.

The *first year* at West Point is equivalent to that in any of the large colleges or Universities and even covers in the subject of mathematics, two or three years at a civilian college — Also credit is always given to anyone who has successfully completed any part of the course at West Point. —

All this has been leading up to a statement of my plans for the future which are briefly this: To Complete one (or possibly two) years at the military Academy, obtain my credentials for such, resign and enter a University here in the East specializing in English and History or something similar.

My work at West Point in mathematics would be a great sufficiency to allow me to say good-bye forever to that subject, — for which I hold a great abhorrence! — Again the question of cost is brought up and it is this question that will, I believe, be the deciding factor in the realization of my plans. Most of the colleges have a system whereby students are enabled to work their way through the college — tuition, board, lodging et al. — This I know to be true — and even know a very distant cousin, Oliver Edwards, who is doing this at Yale this year. I met him at Camp Devons this summer where he was awaiting the returns of his examination for entrance.

This Plan is a mere skeleton now but I mean to fill in the particulars and details during the winter.

I think that I acted wisely in returning to the academy[1] for if I hadn't I would probably have lost two years instead of one due to my inability to get a place at a college. Also the one year at West Point will serve to put all necessary math behind me forever — which is just what I wish to do, and as expediently as is possible!

Should I decide to adopt this plan it will in no way endanger my class standing here but will on the other hand give me a real goal to strive for, and I will dig in hard on the subject that has once proven to be my Nemesis.

As you read this I hope you will be in no way disappointed

but will be in sympathy with my feelings. On the other hand
I hope that you do not consider this as the natural period of
depression following my re-entrance under unfortunate circum-
stances (losing my class) to the Academy. I am not at all de-
pressed and the opinions I hold are the products and culmina-
tion of over eleven months at the Academy as a cadet and two
months of mingling with officers at camp Devons. I hope you
will realize the sagacity of this reasoning and the folly of continu-
ing to the end of the course here to prepare for a profession
which I do not wish to make mine. —

I believe that I have outlined herein briefly but clearly my
views along these lines — My reason for not acquainting you
earlier with this was that all depended upon the outcome of the
examination at Fort Banks, as you know.

My love to Mother —

Your Son
"Pete"

[1] "To have entered and *failed* at West Point would be a blot on my escutcheon
which would remain with me through life. So I am going to do my best this year for that
reason as well as for the reason that I owe it to those who helped me during the Summer"
(PH to Mrs. Harold Hurd, September 19, 1922).

To Mrs. Harold Hurd

Sept 30, 1922
[West Point]

. . . The Arabian Nights plus several very welcome vol-
umes of "Life" [magazine] arrived, for which I am very much
obliged. As usual they have circulated thru the company until
they are well nigh tattered already. My reason for wanting the
Arabian Nights was as follows:

While in Maine I read an old volume of these tales which
was exceedingly poorly illustrated in the droll style of engraving
which was in vogue a hundred years ago. Struck by the latitude
of imagination allowed an illustrator of these stories and lacking
any better amusement I drew a set of five sketches illustrating

events and incidents described in some of the various tales. Four of these I later developed into paintings — the fifth being an incident in Aladdin which had already been depicted by Parrish[1] and which I later remembered. So I sent for the book to see if perhaps some other one of mine was also one of the incidents already used. —

Dad has asked that I send some of these out home for you to see; if you are sure you really want this done I can do so but will tell you now that they are rather bulky and would need quite a sizeable crate, or rather box — say about 30″ by 24″ by 8″ . . .

[1] PH avidly collected prints of paintings by Maxfield Parrish (and by Howard Pyle, as well as by Pyle's most distinguished pupil, N. C. Wyeth). In a letter to his father, he described his own early paintings as "ranging in themes from portraits of ladies to landscapes of a highly imaginary almost 'Parrishesque' style" (PH to Harold Hurd, September 21, 1922).

To Mrs. Harold Hurd

Oct. 12, 1922
[West Point]

. . . Major Kalloch and the Assistant Commandant together with another officer came in this morning and had me show them some of my paintings. They, especially Maj Kalloch (who is our Company Tactical officer) seemed to like them very much particularly some of my illustrations of The Arabian Nights.

Major Kalloch wanted to buy some of these but as they are original and may sometime be of use, I declined his offer. — The Post photographer Mr. Gordon, also wanted to buy but for a similar reason I declined his proposal — which was an offer of $40 for a picture which I call "Dawn."

. . . Maj Kalloch brought his Wife in while the Corps was at supper tonight, to see the pictures — My reason for stating that a crate would be necessary to ship them is that all of the best ones are framed and under glass with the exception of the oils which are only framed —

Love To You and Dad. —
"Pete"

To Harold Hurd

Oct. 15, 1922
[West Point]

. . . I am sending a package containing two of the unframed and hence inferior pictures. —

I weeded out all but the best when I had them framed — I hope you receive them O.K. and that they help to cheer you up. — The one, (the larger) is a painting in Tempera which illustrates a quotation from Shelley's "Ode to a Lark."

The other is an oil painting which was done from a photograph of a fashion Model. — Both are original altho as I said the smaller is from a photographic model. The water-color needs a lot of apology as it has a great number of out-standing crudities many of which I have done away with in my later water-colors of "The Arabian Nights" and Omar Khayyam. I am enclosing the verse (and titles) with them so that you may see what caused me to paint the larger . . .

To Mrs. Harold Hurd

December 2, 1922
[West Point]

. . . The prints came, and as before I am delighted with them — They are just as interesting a collection as were the first group. — Of those you sent the second time I am most fond of those by Leon Guipon — Do you recall them? He and my old "friend" Howard Pyle are the two best I think altho there are a score of close seconds.

. . . Major Kalloch bought a picture[1] of the North Guard-House which I did last Xmas. I would have liked to have given it to him but that of course would not be proper since he is our Company Tactical Officer. — The ten dollars which he offered will come in handy however. — The picture referred to is an oil depicting the Guard House at ten P.M., the hour of taps with a "furlough moon" rising above the hills in rear. — A bugler is in

the foreground, blowing a call which may be induced is taps
since the tower clock points to ten . . .

[1] PH's first sold painting.

To Mrs. Harold Hurd

Jan 2, 1923
[West Point]

. . . In your last letter you mention a possible communica-
tion with you by radio-phone. — Alas! this would be as impossi-
ble for me to achieve under Sladen's rule as would a flight to the
moon![1] You have no idea of the changes that this place has un-
dergone since last July! What was quite feasible and proper un-
der MacArthur and his immediate predecessors is now chimeri-
cal. I have come to realize the great difference between the
"military" and the "militaristic"; as a result I detest both . . .

[1] Major General Fred W. Sladen served as superintendent of the academy from
July 1, 1922, to March 23, 1926.

To Mrs. Harold Hurd

[January 12, 1923
West Point]

My Dear Mother:

The Christmas leave is fast ebbing away and we will soon be
back to normalcy, or to as near normalcy as the Sladen regime
will allow. I have accomplished quite a good deal, however as
most of my time has been spent either in my room or in the li-
brary.[1] The northern winter is anything but conducive to ventur-
ing out; I have read several of Shakespeare's dramas. A Midsum-
mer Night's Dream, Measure for Measure, Twelfth Night, and
Much Ado About Nothing. In the library, which is a very large
one I have found a great fund of information on Old English
Costumes etc. which I have been seeking for some time. Did
you know that there are three of Thomas Sully's originals in this
library? The original portrait of Washington, painted by Gilbert
Stuart also hangs there. Sometime I will send you a sketch of the

Memorial Tablet executed by Mr. Augustus St. Gaudens to the memory of J. McN. Whistler who was once a cadet at West Point. It is a simple piece of work but nevertheless possesses the unmistakable characteristic of St. Gaudens' work. The Inscription as I remember it is as follows:

To James McNeill Whistler

The Story of the Beautiful is emblazoned in letters of gold on the Parthenon and embroidered with the birds on the fan of Hokusai. —

During the holidays I have been working on a "miniature mural frieze" (or rather panel) if you know what I mean. It is done in oil on canvas about 50" x 20". The theme is an original one so far as I know. — It depicts a forest at twilight, bits of yellow sky peeping through great oaks etc. — In the centre is a huge greenwood tree beneath which on a rather rustic throne is Robin Hood. — He is standing on the dais and is in the act of blowing his bugle (as per ~~the~~ Ye Ballades of Robin Hode). To the right and left of him are distributed the various characters which go to make up the ballads; Little John, Will Scarlet, Allan-a-Dale, Sir Richard of the Lea, Queen Eleanor, The Curtal Friar, The Miller, etc.

This is still in a very undeveloped stage but by the use of patience and the week-ends during the coming year I hope to finish it. —

I wrote to Miss Helen Baldwin before Xmas and today received a very nice Reply in which she sent you-all her regards. —

Love to you and Dad,

"Pete"

P.S. I am rather Sorry that Horgan[2] has persisted in painting in The Futurist or ultra-Cubist style which he started two years ago. Like you, I am "uneducated in that school" — In Modern art and "vers libre" I must confess I see naught. —

H.H. Jr.

[1] PH had already begun to pursue his much-desired liberal arts education by steeping himself in books. "I am profiting strongly by what I am reading," he wrote his father on May 17, "— picking my subjects to give as wide a scope as possible in my knowledge. —"

[2] Paul Horgan (b. 1903), later a novelist and historian, was PH's classmate and close friend at NMMI and was exercising an early knack for painting.

To Harold Hurd

Jan 17, 1923
[West Point]

. . . Yes, I am privileged to attend the hops here but do not care to do so. I am anything but a "social butterfly" and West Point hops, which are little more than military ceremonies are not conducive to making a debut. — My Saturday evenings are always spent in my room where I find plenty to do. It has been 16 months since I have been to a movie! I am scarcely a "fan." — H.H. Jr. —

To Harold Hurd

Feb 28, '23
[West Point]

. . . About Boston Tech. — there is but one branch of technology for which I ever had any desire viz chemical engineering but two years of "militarism" has completely purged my system of all inclinations in a technical way. — I thank you for your suggestion of M.I.T. but am confident that I have no desire whatever of going there.

What profession I intend to follow I have not yet decided — this will come when the test of time has been applied to several alternatives; meanwhile I shall continue in my endeavor to obtain a college education. Several professions have been "eliminated" and one is the Army, which I detest in every form . . .

To Harold Hurd

March 17, 1923
[West Point]

. . . Every letter expresses a hope that I would stay here another year.[1] — Dad, I wouldn't stand a show in Yearling math! I have to "put out" as much energy studying this year as last, in the subject of Math. I simply lack that which goes to make up a mathematical brain; nor is this lack due to a failure to study it is simply an inherent inability to conceive the intricacies of that subject. Whether this lack has been made up for in other lines

remains to be seen. You would not have me duplicate the procedure of last June for the real reason that I am back here is to make up for that failure. To continue would be a gamble — we are both opposed to gambling, sharing the belief that Life holds sufficient gambles without the addition of any artificial ones.

So for this reason I look for a change.[2] —

The parting with friends made while at the Academy is not a pleasant thing to look forward to nor is the act of establishing myself elsewhere — yet both are over-balanced by the causes for my desiring to change. —

With love to you and Mother,
"Pete"

[1] Harold Hurd was upset by his son's determination to resign from the academy. On April 30 he wrote Major Kalloch, urging him to try to persuade PH to reconsider. "It will be a very keen disappointment to me if he does not graduate from West Point, yet I want to do what is best for him. It has occurred to me if someone could and would take hold of him and have a friendly talk the atmosphere might be cleared."

[2] PH has by now cited three different reasons for desiring to leave the academy: his disillusionment with military life, his eagerness to obtain a broader education, and his ineptitude in mathematics.

To Mrs. Harold Hurd

Sun. March 25, 1923
[West Point]

. . . I received Dad's letter of the 21st — I enjoyed this very much especially the first paragraph telling of his seeing the Jack and the Giant envelope —

Some time I hope to show him a series of panels done of this kind of theme. They are all of the same size and will be suitable for the decoration of a Nursery or some other place where reality has not banished every vestige of fairy lore. Do you remember my making mention of the Robin Hood muralette? I have kept this in the back of my head and have collected a number of ideas for it so that I now have a clear mental picture of what it will be like. I cannot work in oil at all now for it takes too long to dry and when once I have a palette of oils I like to continue uninterrupted, which I would not be able to do here at West Point except at Xmas time. So Robin Hood must wait. —

Meanwhile the panels mentioned above progress, or will pro-
gress from week-end to week-end after the writs are over. —
The following is a list of titles for these panels. — "Storyland,"
"The Elfin wood" "The Wizard of Wonderland," "Nocturne"
"Dreamland," "The Fairy City," "The Enchanted Pool" and
"Pierrot." From these captions you may be able to get an idea of
what the panels are to look like. The two last mentioned, "Pier-
rot" and "The Enchanted Pool" are completed now. — The re-
mainder are all planned but have not yet been done. — The size
of each panel is 14½″ x 17″. They are done in Tempera — In ad-
dition to these there are two larger panels for the same series. —
One of these I have finished; this is entitled "The Kingdom of
Fancy." It is sized about 36″ x 10″. Its companion piece, of a
similar size is "The Dream Garden" which is yet to be done. So
you see my remaining week-ends will not be dull. In addition
to, or perhaps in connection with these I have the ones for Maj
Kalloch to do. — I don't know why I should like these childish
subjects in which enchantment and kindred things play an im-
portant part but for some strange reason they hold a great fas-
cination for me. — The enjoyment derived from their execution
does not lend itself to analysis but it seems that while I am work-
ing on these I am living and taking an active part in the scenes
portrayed. In planning them I also derive a keen enjoyment.
The other reason why, after trying other themes and styles, I
have stopped on this one is that it adapts itself easily to the free
use of imagination; its conventionalities are not barriers, but are
necessary land-marks which seem entirely in consonance with
their fanciful realm . . .

To Mrs. Harold Hurd

April 20, 1923
[West Point]
 . . . Where I once delighted in the conspicuous, I now de-
sire only the opposite. For this reason probably as much as for
any other I thought of Haverford [College]. The absence of
glamour and the inherent quietude which seem associated with
the place have a strong appeal to me.[1] This is a quality which I

like about West Point although the rigidity of discipline almost entirely eclipses [the appeal of] its seclusion etc.

. . . Yesterday I received the following letter from Dr. Comfort:[2]

"My Dear Sir:

I have your application blank, properly made out for membership in the Sophomore Class of Haverford College and shall expect, after the conclusion of the Military Academy year a full statement of your work at West Point together with an honorable dismissal. If these are satisfactory I shall be glad to admit you to the Sophomore class under the conditions mentioned in my last letter regarding such balancing of courses as may be required to conform with our curriculum."

Signed —

This is fine, and as you see leaves but one matter open. I quote the letter rather than send it as I may have occasion to use it in connection with getting my certificate from the Academic Board: Love to you and Dad

"Pete"

[1] On one of his frequent trips to the library PH came across a magazine article about Haverford that apparently gave him this impression, for he had never visited the college. The article was written by Dr. Christian Brinton, an art historian and critic.

[2] William Wistar Comfort, scholar, elder, minister, professor, and author, was president of Haverford College from 1917 to 1940.

To Mrs. Harold Hurd

April 29, 1923
[West Point]

Dearest Mother: —

This Sunday has passed away in good style, in spite of a tour of guard which I have just completed. I spent the morning in my room, working on the eighth of the series of panels. One or two of these have been slightly changed but for the most part they are the same whose captions I sent you not long ago. The name "Nocturne" sounded too "Whistleresque" so I changed this panel for one entitled "Robin Goodfellow" a title which is, I think, much more applicable to the purpose of the panels.

This afternoon I spent an hour in the Chapel at the 58th organ Recital — I enclose the program. — My acquaintance with Gounod had heretofore been very slight, altho I well remember two selections from the opera Faust on the Victrola, "Scenes that are Brightest" and "Waltz from Faust." I sat alone in one of the transepts and made a drawing of one of the columns which I want to use on the interior of a medieval castle soon.

Tonight there was the most brilliant sunset which I have seen in many days. I have more or less grown used to the dull saffron skies which we have been having of late, altho I never tire of watching the maze of twig patterns outlined against such a sky. The sun also often sets leaving a dull brassy glow over the ridge of "Crow's Nest,"[1] not unlike the reflected glow of the inside of a brass bowl; Tonight however was something quite unusual for this country. The entire western sky became, shortly after eight o'clock, diffused with a beautiful pink colour. This colour was reflected from numerous low hanging clouds so that the earth beneath seemed to be momentarily changed from its usual grey monochrome to a wonderful harmony in pink and purple, the purple being the shadows. Not the least of this effect was the remaining portion of the sky which was of a brilliant robin's egg — cobalt blue.

So striking was this effect (even upon the Philistines*) that the officer in charge dispatched the Officer of the Day to summon me to the plain, the better to observe the colors. This was a most surprising and irregular procedure but you may be sure that I was not slow to take advantage of the O.C.'s kindness. When I reached the plain the eosinic pink was rapidly becoming mottled with violet and the brief space of three or four minutes saw the brilliant colour scheme replaced by the gray-purple of dusk.—

I am very much indebted to Maj Boldy for letting me watch that sun set and am sure that memories of the wonderful pink will linger for a long time.

x x x x x x

I use the little Japanese mixing pan a lot and am very thankful to you for sending it to me. — Also the prints especially those

by E.A. Abbey interest me greatly. I found his biography very interesting, as I believe I told you in another letter.—

Well mother I have rambled on for several pages, of mostly sunset I guess, so I will say good night with Lots of love to you and Dad —

<div align="right">"Pete"</div>

P.S. In re-reading this I have become aware that probably my command of the King's English is too limited to give you a proper picture of the sunset. However there was little else to tell of.

About the Art magazines — There doesn't seem to be any other magazines along this line and I hardly know what to say. — How about my getting the Life and Work of Edwin Austin Abbey — Chas Scribners? This work contains over 200 illustrations, mostly rotogravure (no color) from Abbey's work. I would like very much to own this book and, since there are no other magazines, I guess it would be a worthy substitute — What do you think?

<div align="right">"Pete"</div>

I had intended drawing a May Day envelope but have been "uncommon busy" on the panels. Spring was never before hailed with greater avidity than after the last long cold winter —

<div align="right">"P"</div>

[1] A large peak overlooking the academy on the West Point side of the Hudson River.

<div align="center">*(unwarranted satire perhaps)</div>

To Mrs. Harold Hurd

<div align="right">May 28, 1923
[West Point]</div>

Dearest Mother: —

The first of the Pirate series, which I notice by your last letter you are expecting, is going herewith.

Did I tell you how I happened to be thinking lately of pirates, and seafaring men of all descriptions? In one of my frequent visits to the library I happened to stray into a very rarely

frequented part of the building, 'way up in the tower. There I found a number of most interesting volumes, most of which were almost hidden by dust. Among these was a musty old volume printed in 1684. It was a chronicle of the exploits of a certain of the most notorious pirates off the coast of the Americas, written by Esquemeling a Spaniard, and translated into English in 1683. This book as you can well imagine, with its delightful quaintness of style and diction afforded me much pleasure. — The author not only gives a very graphic description of the isle of Hispaniola, now Haiti, but tells of the many nefarious acts of L'Olonnais, Bassalino, Morgan etc. — It is very interesting, and as a further search revealed additional volumes of a like nature, I am interested in pirates and shall return to the subject later when I have time to pursue it, possibly with a brush.[1]

I will send your Howitzer,[2] (this time I will preclude delay by going directly to the Post Office), in a day or two.

As we move into the Academic building Sunday next, I shall close my "work-shop" and postpone the two pictures for L'Allegro for a later date.

I am awaiting advice from you and Dad as to how I shall answer Aunt Susan's offer.[3]— I got a mighty nice letter from her today which I am enclosing. — It is too bad about Mr. Beal's death; I have often heard Uncle Ned and Aunt Susan speak of him.

I am of course looking forward with no little avidity to coming home, and to seeing you and Dad but am quite willing to respect your wishes should you wish me to remain here for the summer. West Point would have the sole advantage of being a place in the East where I could hang my hat for the summer. I speak of this plan as it was mentioned in Dad's last letter. My personal dislike does not enter into the matter so suit yourselves — Three months more could be endured without too much difficulty —

Should you decide to abide by your present plan, you will find me a "peaceable sort of fellow" well content to live without the pale of society etc. The trip to Santa Fe sounds great to me — Santa Fe, as you remember was the source of much interest to me in a trip once before. —

This letter has been rather long for the reason that with the present chaotic state of things I must write only when I find time.

Will close now as I have two writs tomorrow, one in Engineering and one in English. I am now 36 tenths pro in English, a wide margin but I must keep at it.

<div align="center">

With lots of love to you

"Pete"

</div>

I got a fine letter from Maj Thomas[4] today telling, as did your last letter of his being at the house the preceding evening.—

[1] PH would later illustrate "Captain Henry Morgan and His Buccaneers," from John Esquemeling's *The Buccaneers of America*, for a book of pirate stories entitled *Marauders of the Sea*, edited by N. C. Wyeth (see PH to Paul Horgan, April 10, 1935).

[2] PH drew the title pages for all four classes. The drawings are medieval in subject matter and are highly romanticized.

[3] Mrs. Hutchins had offered to pay PH's way back to Roswell.

[4] Major J. Ross Thomas was an instructor in math at NMMI and a close family friend.

<div align="center">

To the Adjutant General of the Army

June 25, 1923

[West Point]

</div>

1. I hereby tender my resignation as a cadet, United States Military Academy and request that same be accepted to take effect immediately.

2. My reasons for resigning are as follows:
I wish to follow a profession other than the military one, and in order to prepare myself, desire to seek an education better adapted to my selected profession.[1]

3. I am nineteen years of age: my father's written consent to my resignation is attached hereto.[2]

4. I am over two hundred dollars out of debt.

<div align="center">

Harold Hurd Jr.

Cadet Pvt. Co. D 3rd Class.

</div>

[1] In a letter to Dr. Comfort dated June 28, 1923, Robert S. Donaldson, assistant to the commandant, wrote of PH: "He is resigning of his own volition and has not been in trouble of any kind. In other words, his separation from the Academy is entirely honorable and his record here has been that of an honorable and upright young man. We are

sorry to see him leave our institution, but he hopes later to take up the study of art and has shown unusual ability in this line."

[2] On June 16 Harold Hurd wrote the commandant of cadets, "I approve the application for resignation of Cadet Harold Hurd, Jr."

[Journal]
⟨Sun Sept 27. [1942]⟩

. . . I remember so well the tremendous psychological effect of the decision to leave West Point. How the complete security and haven quality weighed heavily against my decision to resign. That it was only the deep conviction that I could never find myself as a painter while in West Point — that invaluable time was slipping away. How great a decision this was — or rather how deeply impressing it was on me is attested to by the fact that I have so repeatedly dreamed I was back there again — always in some peculiar circumstance — such as appearing at a formation in improper uniform or forgetting the proper execution of an evolution of close order drill. I have occasional long, vivid and disturbing dreams in which I am back in Cadet gray again to finish those two remaining years!

In late June, 1923, Peter left West Point for Roswell. When fall arrived, he traveled back across the country to Pennsylvania and enrolled as a sophomore at Haverford College.

To Harold Hurd
Haverford College Haverford, Pa
Mon. Oct 1, 1923

My Dear Dad:

In my last letter I told you something of my becoming established at Haverford omitting entirely all mention of my summer in Roswell.

In this letter I want to express to you and to Mother my appreciation for the summer in New Mexico and to say that I believe I received many benefits from it. I lost my New York pallor and gained in its place a coat of tan of the New Mexico variety. The mountain trip and the re-witnessing of the Indian dance will be remembered for a long time . . .

To Mrs. Harold Hurd

Nov 19, 1923
[Haverford]

. . . Thursday brought me an offer from the editor of a trade magazine, "The Plan" (run by the Penna. Lumbermen's association) to do the cover design. (The editor is an alumnus of Haverford.) This is to net me $25.00 but it must be out this week — so I have been busy working on it and have just now finished it. —

In addition to this my schedule runs as follows: Mondays Wednesdays & Fridays French and English in the morning and raking leaves in the P.M. and athletics [from] 4 to 6. Other week days classes from 8 to 4:00 except Sat. when I have athletics in the P.M. From 8 to 9 every night I wash dishes for one of the professors. — In between times (if there is any) I peddle stationery for Hammermill Bond Co. Does the above show you that time does not hang heavily on my hands? I hope so. I go to bed between twelve and one and rise at seven fifteen in the morning. — Oh yes I am also a substitute waiter in the dining hall.[1]—

I am very contented however and there is not a day that goes by that I am not glad of having come to Haverford. —

I have sold three of my pictures around college here. —

. . . "Chuck" Nash a Senior and very good friend of mine, is going to take me home over Thanksgiving. He lives in Philadelphia and his father runs a large engraving plant. I shall look forward to those four days for a rest . . .

[1] PH was determined to be self-supporting and provide for his own education. On May 17, he wrote his father, "Remember, tho', that this [going to Haverford] is an entirely independent venture and that I mean to see myself through it" (see PH to Harold Hurd, September 12, 1922).

To Mrs. Edward Hutchins

Dec 2, '23
[Haverford]

Dearest Aunt Susan:

I got back to College this evening at about 6:00 o'clock after a very pleasant visit with the Nash family . . .

. . . many things have transpired in the past four days not

the least of which was the arrival of the Thanksgiving packages from you! The doughnuts kept in fine shape and are quite up to Mary's standard. The cake I am saving for tonight when I will call in some friends around the dormitory and I will re-live certain very memorable West Point nights — nights following the arrival of some of your boxes. The only difference now being that we don't have to throw a blanket around the light at the sound of a foot step in the corridor or scamper for safety at the rattle of a sabre!

I feel very much rested up as a result of the last few days. — Mr. Beck (owner of the largest Roto-gravure & color engraving plants in the country and grandfather of Nash the boy with whom I was visiting) took us all through his Philadelphia plant on Friday and on Saturday morning we motored up to Beach Haven New Jersey where we spent the night at their summer home on the shores of the Atlantic.

. . . I have an engagement with Mr. Chas. Beck Jr. on Friday in Philadelphia to meet Mr. N. C. Wyeth . . .

Apprenticeship and Marriage

The Beck Engraving Company made reproductions of art-work, including many illustrations by N. C. Wyeth. It was this artist who was now Peter Hurd's most admired master. When Peter said as much to Charles Beck, Jr., on his tour of the Philadelphia plant, Beck offered to arrange a meeting between Hurd and Wyeth in early December, 1923. Wyeth was best known as an illustrator of classic writings for children; he was a first-rate artist and a superb teacher. On the day of the appointed meeting, Peter boarded a commuter train at the Thirtieth Street station in Philadelphia with a thirty-by-forty-inch canvas rolled under his arm, determined to persuade Wyeth to take him on as a pupil.

It was an ambitious objective. Had Peter truly weighed the quality of the work he planned to put forward as evidence of his artistic ability, he perhaps might not have been so bold. Yet the young man (he was not quite twenty) had confidence in himself and in his promise as a painter; and while he knew that Wyeth had ceased to accept new students, Peter believed that in his case he could convince him to make an exception.

Peter intended to get off the train at Ardmore, only a short distance away, and then take a taxi to the Wyeths' house in nearby Chadds Ford. But when he stepped onto the station platform after the fifteen-minute ride, he saw N. C. Wyeth standing there to greet him. Peter, of course, was astonished—and awed. Here he was suddenly face-to-face with the great man, the outstanding former apprentice of Howard Pyle and the famous illustrator of such classics as *Robin Hood, The Mysterious Island,* and *King Arthur*—books that Peter had read and loved in his boyhood. Wyeth's physical presence was no less impressive than his reputation. He was a large, robust-looking man in his middle years, a little overweight but built strongly, with a husky voice and dark, serious eyes that glowed with animation behind round wire spectacles.

He led Peter to his station wagon, then drove him through the little village and up a hill, past his large brick house to his barn-sized studio, which overlooked the Brandywine Valley, then

covered with snow. "So elated was my state of mind," Hurd later recalled, "that neither then nor when he drove me back to catch the return train did I pay the slightest attention to direction—which way or how far the Wyeths' house lay from the station."[1]

Wyeth's studio was alive with the smells and tools of the artist's craft: turpentine, oil paints, and natural resin varnish; objects for still lifes, including apples stored from hillside trees; a rack for storing finished pictures; and a high, custom-built easel holding a work in progress, half-concealed by a large cloth. The walls were covered with books and weapons from various periods. A large desk was strewn with Wyeth's correspondence. As Peter looked about him, he imagined his own future as a painter, working in a studio like this one, and the vision that came to him seemed even more romantic and compelling than the dream he had relinquished—but never fully surrendered—of going for a soldier.

The two men exchanged some friendly words about New Mexico; Wyeth, it turned out, had spent some time there in his youth. Then Peter unrolled his canvas on the floor of the studio and asked the master's opinion. The picture showed a medieval scene of ladies in long gowns reclining beside an azure lake on a marble-floored veranda. In content if not in technique, it clearly suggested the fantasy worlds of Maxfield Parrish.

N. C. Wyeth was known for his candor in assessing works of art. In examining a picture, he would generally point out flaw and virtue alike, and the overall effect of his criticism, which was rooted in solid standards and powerfully delivered with apt, articulate, and wide-ranging references to painting and to the other fine arts, was invariably uplifting for the listener.

Peter's picture was commonplace and derivative, but as Hurd later explained, Wyeth's reaction to it was "a masterly act of restraint."[2] Wyeth was lenient with the neophyte for several reasons. First of all, he was drawn to Peter, who carried himself well, was handsome, vital, and extremely winning. Also, Wyeth felt that Peter had demonstrated a certain amount of conviction in coming to him, and he thought he sensed in the former cadet a capacity for hard work and for discipline—a capacity that he actually underestimated. Moreover, Wyeth's nostalgia for the land Hurd loved so deeply had been the source of an immediate bond between them. "This was for me a fortunate coincidence," Hurd later remembered, "for without it as a prelude—the natural enthusiasm for the Southwest—the sight of my dismal attempt at painting might well have forever discouraged him."[3] In short, Wyeth had a kindly nature and did not wish to discourage Peter; he urged him to enroll in drawing classes at the Pennsylvania Academy of the Fine Arts, explaining that he did not now take on students.

This was not what Peter had come to be told. But when he left Wyeth's studio that day, stirred by the artist's paintings, his eloquence, his very presence, he was resolved more than ever to attach himself to Wyeth in an apprenticeship. All through the winter he worked hard at painting. Then, in the spring, he made another trip to Chadds Ford—but this one was unarranged, and no one met him at the railroad station.

Having failed to note the way to Wyeth's house the previous December, Peter now had to ask directions from a commuter. As he spoke, he noticed that an attractive young woman with "luminous dark eyes" was staring at him; her gaze, he also noted, "fell short of admiration."[4] It was the eldest of the Wyeths' five children, Henriette (b. 1907), who at sixteen was already a serious artist, having studied with her father since childhood. She had seen a lot of young apprentices come and go, and with evident disdain had hastily concluded that the blond young man in cowboy boots who was waving a rolled-up canvas and asking directions to her father's house must be another one.

Peter managed to persuade Henriette to let him accompany her home in the family's chauffeured car. Then once more he pleaded his case with Wyeth. The canvas he had selected this time for his viewing did not show much improvement. But Wyeth was moved by Peter's dedication and accepted him as a pupil during the summer. He was quick to point out, however, that Peter would need invincible discipline to serve an apprenticeship in painting, and expressed doubt that Peter's military background had prepared him sufficiently for what lay ahead. But Peter knew differently.

Before the school year was out, he left Haverford College and moved into a farmhouse less than a mile from Wyeth's studio. For his own studio he used the loft of an adjacent wheelwright shop. "Work began early in the day," Peter later recalled. "The custom was for Mr. Wyeth to stop in each morning about 8:30 as he went to the village to get the mail. He would review my progress and criticize my work, sometimes staying to give what he called a 'working criticism,' which consisted of his actually working on my canvas."[5]

Beyond the formal instruction in painting that Peter received from Wyeth, he benefited immeasurably from his contact with the entire Wyeth family. It was a family in which the members all loved being together and nourished each other in their pursuits. Carolyn (b. 1909) was also a painter; so was Andrew (b. 1917), the youngest child, who at six was already drawing furiously and with skill; Nathaniel Wyeth (b. 1911) was planning to be a scientist; and Ann (b. 1915), a pianist and composer. The mother of the clan, Caroline Backius Wyeth (1886–1973), known

intimately as "Ma," while N. C. Wyeth (1882–1945) was known as "Pa," ran the household with warmth, ease, and generosity, preparing wonderful meals and lovingly overseeing every dimension of home life.

The Wyeths soon took Peter Hurd into their daily life as one of their own. When they were not at work or engaged in discussions on literature or music, history, or philosophy, they often held gatherings at which a spirit of revelry would reign. Friends and neighbors from the surrounding countryside would add to the gaiety and humor, which was always robust and frequently bawdy. Peter fitted in well. In the presence of so much learning and stimulation, in a home environment far different from his own, his sensibility began to flower.

Toward the end of his first summer in Chadds Ford, Peter was invited to join the Wyeths at their summer home in Port Clyde, Maine. He later described Port Clyde as "a primitive fishing village, somber & with that strange northern loneliness that reflects even in human faces—sometimes even very youthful ones. It is in no sense a resort. Thank Heaven!"[6] When fall arrived, Peter enrolled as a student at the Pennsylvania Academy of the Fine Arts. There he attended classes each day with Henriette, who had overcome her initial suspicions and found herself attracted to him. "Give my regards to Texas Pete," she wrote her father on June 24 from Boston, where she was visiting relatives. "I mean to say I cra-a-ve Peter when I have Kamp[7] with me. Whew!!"

Peter was now living in a large Victorian house in Ardmore, paying for room and board with his pictures. He worked long hours at landscape, still life, and portrait paintings. He obtained a number of small commissions on his own, but relied for his livelihood chiefly on the overflow of illustration assignments that Wyeth received and passed on to him. Under this arrangement, Wyeth promised the client that he would supervise the job for acceptable quality.

[1] Autobiography.
[2] Autobiography.
[3] Autobiography.
[4] Autobiography.
[5] "A Southwestern Heritage," Arizona Highways, November, 1953.
[6] PH to Paul Horgan, August 17, 1933.
[7] One of Henriette's many suitors.

To Harold Hurd

Tuesday

Oct 21, '24 [Ardmore]

. . . I sold a picture the first of the month for sixty dollars (of which I may have written you) and a couple since then payments for which were due at the end of this month.

Also I have another overmantel decoration job — I have done two as you may know. This one is for a man in Atlantic City for his summer home there. I go down for over the weekend to get measurements etc. and to see the setting it is to have.

. . . I go into Phila. on the 8:32 Express (Penna. R.R.) from Ardmore arriving there at 8:46. The academy is only three blocks away from the station. There are no classes — Elementary students go there and draw first from antique busts in charcoal every day for as long as they want to. Daniel Garber has charge of this and criticizes once a week. — From here the students go to the next antique room of casts of figures — more difficult to draw than busts (when their work in 1st antique is sufficiently good, usually at the end of two or three months). From second antique they go to life class and illustration or portrait depending on their individual wishes. As you can see work is more or less optional a certain amount being necessary to go from one course to another. — There is no regular number of years attendance. They work a scholarship system which many stay the requisite (3?) years to compete for . . .

To Mrs. Harold Hurd

Thurs Oct 30, 1924

[Ardmore]

. . . I sold a couple of pictures to John Wanamaker's[1] in Phila. last week. — I went in to get them framed and on learning I intended to sell them the framer introduced me to the buyer who took them both, much to my surprise. One was a Spanish Galleon. The other the Ships of Columbus . . .

[1] A large department store.

To Harold Hurd

Nov. 5, '24

[Ardmore]

. . . Have just finished an ad for a book store that I have promised for some time and which will soon be done.[1] It is advertising sea stories and was ordered by the owner of the book store who is a graduate of Annapolis and a young retired Naval officer. His shop is full of seafaring things and he specializes in ship models and maritime books. — I picked my own subject and chose for the idea a Seaman of the 18th Century sitting on a quay telling yarns to a boy who is watching him very attentively. The Seaman is dressed in the blue jacket with brass buttons worn by sailors of that time and has on the broad short duck trousers and low square-toed shoes with silver buckles. He wears a large cocked hat (tricorn) on his head. — The boy is dressed in brown breeches with light trimmings and hose to match and has a brown beaver three cornered hat on his head. Behind them beyond the quay lies the sea and the top-hamper of several frigates and sloops of war are silhouetted against a sunset sky. The lettering across the top is in vermillion and is done in a decorative (16–17th Century) style. It reads "Tales of Ye Sea" . . .

[1] In return PH received a special discount on a twenty-five-dollar book of ship models.

To Mrs. Harold Hurd

Sat. Dec 9, 1924

[Chadds Ford]

. . . I am out at Chadds Ford now and we had the Composition class,[1] which was a very good one tho I was the only one there. Mr. Wyeth is certainly a wonderful person! After one of these classes I seem to teem with ideas for and about pictures, induced by his talk. Mr. Wyeth has the most powerful and versatile imagination I have ever encountered in or out of books[2] . . .

[1] "Mr. Wyeth's teaching included landscape, still life and the weekly production of an imaginative composition — a charcoal on paper of some subject which appealed to us

and which might be considered as a prelude to a finished work in oil. These were reviewed and criticized each Saturday night when we gathered at eight o'clock to meet Mr. Wyeth in his great studio" (autobiography).

[2]"With a surge of concentrated imagination he seemed able to transmute himself, like a changeling in a fairy tale, into whatever he was depicting. 'Identify yourself,' he would tell us, 'become for a time whatever you paint — that creature, this object, whatever it may be. Thus and only thus can you in painting arrive at the truth beyond the fact'" (autobiography).

To N. C. Wyeth

December 29, '24
[Boston]

Dear Mr. Wyeth:

We've just returned, my Aunt Susan and I, from a pilgrimage to the First National Bank. My Aunt was quite as interested in going as I was and, like myself, was delighted with what we saw.[1]—

The panels certainly *do* look wonderfully in place. How well you judged the distance from which they were to be viewed! Aunt Susan was particularly attracted by the City of Tyre — for my part I have no favorite — Each one seems to embody in itself and to epitomize what I long to do! — tho I fully realize I am miles from its achievement. Seeing the panels again, also awoke a flood of memories of the summer. The composition classes on those never-to-be-forgotten summer evenings.

My stay in Boston has been a pleasant one as they always have been in the past. I have seen a great many exhibitions some of which stirred me and others of which left me somewhat disgusted. — Of the former category was one by a Russian named Boris Anisfeld which I liked immensely. I think he is one of Dr. Brinton's[2] friends. Anyway his work seems very powerful and full of imaginative quality.

Some of my relatives are conducting a campaign against my uncouthness[3]— which amuses me greatly — not that I am blind to the uncouth properties rightfully attributed to me, but to wonder how it would feel to be as some would have me. — Needless to say I am anything but an apt pupil! — Confidentially, I must confess that much more than two weeks running of Beacon Street ways would "get" me. This, you know is no allu-

sion to my relatives here whom I love and respect. Seeing their way of living and entering into it, (tho always an alien) is very interesting for a while but somehow it always convinces me more and more of the greatness of simplicity.

Please remember me to your family and accept my heartiest good wishes.

<div align="center">

Sincerely

Pete

</div>

I take the Quaker Express on the night of the 3rd arriving in Philadelphia Sunday A.M. — School on Monday.

[1] N. C. Wyeth's mural, *The Galleons*.

[2] Dr. Christian Brinton was a friend of the Wyeth family. He especially admired Russian artists (see PH to Mrs. Harold Hurd, April 20, 1923, note 1).

[3] Probably a reference to PH's style of dress. "He wore cowboy boots because he had always worn them except when in uniform, and chafed blue jeans, and canary yellow or watermelon pink shirts, and when he dressed up for evening, he put on bright silk neckcloths and a special pair of boots polished to a military lustre" (Paul Horgan, *Peter Hurd: A Portrait Sketch From Life* [Austin: University of Texas Press, 1965], p. 39).

Peter attended classes at the academy in Ardmore through the spring term of 1926. During this time, his relationship with Henriette Wyeth deepened.

In the society of Wilmington and the Brandywine, a sort of country-squire society presided over by the well-known Du Pont family, Henriette Wyeth was perhaps the most appealing and desirable young woman. She had dark hair and dark eyes; in an elegant yet simple way, she was beautiful. The noted English photographer E. O. Hoppé had chosen her for a volume of his pictures as one of the "ten most beautiful girls in the United States."

Peter saw more than beauty in Henriette. He saw an exceptional painter and a brilliant, compassionate young woman. For her part, Henriette believed in Peter as an artist. She admired his discipline and his dedication, and the help she gave him in his apprenticeship was invaluable to him. Beyond this, she took deep delight simply from being in his company.

The young couple soon fell passionately in love. Their romance was so intense that it disturbed Mr. Wyeth, who feared it might undermine his daughter's painting. There was talk of marriage. But at the end of the summer of 1926, possibly as a tactic to assuage Wyeth, or to sound the depths of Henriette's as well as his own emotions, Peter decided to pull back a little.

To Henriette Wyeth

October 2, 1926
[Boston]

Henriette, dearest I'm thinking continually of you and wishing more than it's possible to tell you that we were together now!

Aunt Susan was delighted with your photograph, which I am having framed up here, and many very sweet comments with which I thoroughly agreed and of which I shall tell you more next week.

Last night I underwent a rigorous treatment of what Nancy[1] was wont to call "hot lemon with whuskey" tho her libations would be better described as "hot whiskey with lemon." The result has been most effective and I feel fine again with only traces of the cold left.

Since leaving you Darling, I have thot much of the things we've talked of together on so many occasions recently and I have reached a number of conclusions which quite set at naught my former opinions. Briefly they are, that in so far as I and my feelings for you are concerned I not only recommend but strongly desire that you be entirely free to speak and act at all times with complete lack of restraint toward others. Moreover that I am now opposed to reference being made at this time to any intended relationship between us. In writing these lines I realize that I have swung to the opposite extreme of feeling. That my change is for your good I am well convinced. At best your youth and freedom regardless of future developments or of your intentions is an ephemeral thing; too short certainly for me or for anyone else to in any way curtail or lessen its sweetness. This is what I had in mind and hinted at in so awkward and oafish a fashion one evening not long ago. — The evening of the moving pictures in West Chester, you remember.

That you are at the heart of my present existence and that about you as a nucleus I build every plan and dream of the future I have often told you. Now as before, with increasing fervour do I feel this dearest Henriette.

Write, dear, won't you?

Peter

I have reservations for Tue. night on the Quaker express.

P.

[1] A black cook of great girth and spirit, engaged by the Wyeths.

The "conclusions" that Peter had reached concerning his relationship with Henriette were short-lived. The following winter the couple announced their engagement. No date was set for the marriage. "It is all so wonderful!!" Mrs. Hurd wrote Mrs. Wyeth on February 11, 1927. "I want you to know that I am looking most eagerly forward to having Henriette in the family—and to having a daughter."

Mr. Wyeth did not look upon the proposed event with equal enthusiasm. He had misgivings about Peter's prospects both as artist and provider. That his oldest child, with whom he long had treasured a mutually nourishing relationship, should ever permanently leave the Wyeth family embrace was unthinkable to him, yet Henriette and Peter were speaking about marrying and living in New Mexico. Wyeth's regard for the Southwest was shallow next to Peter's. To him New Mexico was culturally barren. He felt sure—and Henriette herself had begun to fear—that away from Chadds Ford, some two thousand miles from her family and her world, she would neither live nor paint so well.

But for the present, Wyeth kept his concerns quiet, and Henriette ignored her doubts. Nothing, after all, was definite. All the same, Henriette was in love with Peter. In the spring of 1927, the young couple traveled to the Boston area to celebrate with friends and relatives.

To Mrs. N. C. Wyeth

Concord, Mass
[April 24, 1927]

Dear Mrs. Wyeth:

Henriette has doubtless told you of most of what's been happening here — We are whisked about from place to place keeping elaborately planned engagements, meeting hosts of venerable Uncles & Aunties (pr. Awnties) and Cousins-German in untold numbers. — In all we are having a rare time: Can any flight of Fancy however far reaching allow you to picture *me* having breakfast in Bed. — I felt this morning when that astonishing thing took place as if I were Louis of France at a petite levée

— or better like the beggar in the Arabian Nights who was transported in his sleep to the Caliph's palace where he awoke to find himself in the Caliph's bed surrounded by all the viziers and attendants. For a day you remember the Beggar was Caliph but by the time the true ruler was ready to take his throne the Beggar was firmly convinced he was the Caliph and the other a rank impostor. His former life as he remembered it he decided was all a nightmare. — Here the analogy of the beggar ceases for when I awake from this I really look forward to the return to normal and the pleasure of remembering. Don't you think half of 'most all really joyous occasions lies in their being conjured up later by Memory? — . . .

To Mr. and Mrs. N. C. Wyeth
Concord — [April 26, 1927]
Tuesday Morning

Dear Mr. and Mrs. Wyeth:

The Beggar still moves in state in the Caliph's palaces and this Northern Bagdad proves to be as full of Adventures, Surprises and Colorful Excursions as was ever the Valley of the Tigris. And certainly thus far one of the good Genii has presided over our fortunes.

To Henriette I leave the task of a detailed chronicling of our experiences but I must tell you something of our trip to Boston yesterday when we went to the Vose Galleries. We met Mr. Vose (Senior) just coming back and were conducted by him into the Sanctum Sanctorum of his galleries — The sales room where he keeps stored some seven hundred paintings; there we saw some fine things, notably a Forain (à la Daumier) an Abbott Thayer (Jeanne d'Arc) and a magnificent Inness landscape. — Ample payment for looking at & weakly praising a number of things which I thot were pretty bad by Mancini, Monticelli and the other gentry of their ilk. But the whole effect was one of genuine stimulus and inspiration. Mr. Vose was very much interested in hearing accounts of your work Mr. Wyeth and seemed anxious to have an exhibition of your things. He swore you threw all his letters in the waste-basket unread and that *writing* you of such

things was one of this world's most futile occupations; but he really was very much in earnest about wanting the show.

Henriette (who is this moment writing at a desk just across the room from me) is doubtless telling you all this and more — the real purpose of this is to let you know above this hubbub and tumult I think often of you in Chadds Ford.

With love to all the family —

Peter

When Peter's engagement to Henriette had been announced, word reached Paul Horgan in Roswell. Horgan, working toward a career in literature, wrote Peter congratulations, and with Peter's response their friendship was resumed (see PH to Mrs. Harold Hurd, January 12, 1923, note 2).

To Paul Horgan

⟨Feb 20, 1927
Chadds Ford⟩

Dear Paul:

Your letter came as a pleasant surprise some days ago. I had thot often of you, had heard indirectly of you on certain occasions, and had made a dozen resolves to write you but these resolves like so many others of their ilk refused to crystallize into actuality.

Your letter recalled most vividly our friendship in those days at the Institute which is, to me at least, the outstanding event of those years. The many adventures, nefarious rallies against "the peace," tributes to the gods of Folly and Excitement have merged all, into a sort of nightmarish recollection.

The news that you are writing was very gratifying to me. I say gratifying without qualifying it for do you remember your one-time ambition to be a surgeon? — In those days of darkness when I was enveloped in a Napoleonic complex[1] neither of us had a serious thot for our now respective fields. — But the days in Schaeffer's class *were* delightful, weren't they? We scaled a miniature Parnassus and fancied ourselves two singularly enlightened mortals enjoying all the indulgences of Mount Helicon. "The Silver Lamp"[2] is unfortunately irretrievably lost —

unless Mother has the black-bound copy book in which we kept it. By the vaguest chance she might know something about this. I would certainly like to see it after these years. —

. . . The successes you generously attribute to me are I fear largely fabled reports engendered perhaps (and of course pardonably) by a devoted Mother. I am, it is true, working like the devil and am extremely interested in what I'm doing. — But the things which have thus far been published under my name are I truly think *execrable*! They show a Wyethian trend which, paradoxically, makes them right in every detail but the signatures! This is not the way I want to paint and I weary of the present which seems to hold little else — Not certainly in the field of illustration which for financial reasons I must follow for a time. But in the field of imaginative composition which I carry on together with study and occasional illustration work, I certainly show no such marked influences. I am at any rate myself and myself only. — It is this which gives me encouragement to go on; this together with the knowledge that others numbering scores have in the course of years lifted themselves by their own bootstraps out of just such a dilemma as I am in, in the illustration [work].

"The Grey Swans"[3] interests me very much and I'm certain you will make a good thing out of it. That you think of me as one who might embellish it is a great compliment. I think it would be great to "collaborate" again — even if in different media.

I wish I had something to send The Library[4] but I almost never do anything in black and white and have never attempted wood or linoleum printing.

Henriette (to whom I had often spoken of you) was much pleased to hear your opinion of the charcoal head and of the reproductions in the Penna. Academy Catalog. I hope the time is not *too* far distant when you meet her . . .

[1] A reference to PH's genuine martial impulse.

[2] A romantic novel PH and Paul Horgan wrote and illustrated together at NMMI as their exclusive assignment in English class for one entire school year.

[3] One of Paul Horgan's early unpublished novels.

[4] A periodical started and published by Paul Horgan while he was librarian at NMMI.

By summer's end 1927, having decided that his daughter's romance with Peter Hurd had reached the limit, Mr. Wyeth spoke out sternly against it. He told Henriette that she had lost her discipline, that her painting was suffering, and that whatever health problems she was complaining of were traceable to the wildness of her involvement with Peter. Then he sat the young apprentice down and told him plainly that he had serious reservations about the strength of his dedication and the caliber of his work. Peter answered him promptly.

To N. C. Wyeth

Sunday Evening
[September, 1927?
Chadds Ford]

Dear Mr. Wyeth:

For the first time in the four years of our knowing each other I feel you are mistaken in certain of the views you hold toward Henriette and me. The fact that I feel this way very strongly, coupled with your invitation this afternoon to reply to your talk makes me seek this means of answering — My Writing being more deliberate & I feel more lucid than my word of mouth.

During the past months since our return from Boston Last Spring there has come between Henriette and me a mutual adjustment of our Natures — A slow but definite change in our attitude toward one another. Poignantly aware of the necessity of perhaps years of waiting we have adapted ourselves to this condition and to each other. The first flush of our Love has been replaced by a tranquil Understanding of one another and the first blind madness of our attachment by a more sober realization of our immediate prospects — or lack thereof! Where once in our meetings a great degree of nervous Force passed between us there is now the delight that comes in the companionship & mutual sympathy of two people who are genuinely devoted to each other. The seeds of that first hectic Love (when we were truly [madly in love] as you evidently believe us still to be) have been sown and the fruit of a completer understanding is now ours.

It comes as quite a shock to both of us to know that you have

not noted this very real change in our Relationship. When Henriette & I are together there is now contrary to what you suppose a nervous relaxation on her part and on mine. It was Henriette herself who first spoke of this and I immediately recognized it as true. There is now a certain serenity which we have grown to look for and to need. If you fail to understand this I can only attribute such to the differences in our personal organizations for it is *very real* to us two.

I wonder if you will understand me when I say that a great deal of what I now seek & find in Henriette is a Maternal love. A very vital element of whose benefits during my earlier life I had very little.[1] This I feel was due almost entirely to my own shortcomings. But in these later years since meeting Henriette and more particularly in the past few months I have come to realize its importance and to seek it. Henriette radiates this to me to a great extent but it is very different from the intense, passionate & all-consuming Love you believe it to be.

The Kernel of the above is really this, that whatever may be the cause of the decline you note in Henriette's Health you are mistaken in believing it lies in our relationship. What you said concerning her decrease in Vitality has alarmed me. However I am convinced and H. agreed in our discussion that followed the talk in the Studio that the twofold cause lies in Diet and a Lack of Exercise. She has promised to fasten strict attention to these two very important factors immediately.

This embodies my only point of contention to what you said this afternoon. For all the remainder which dealt with me — for my lack of intensity, my vacillation, my technical shortcomings in Painting, my apparent lack of Scope & of inward Growth I can only "mumble in silence" my resolves. One other thing — I have not been oblivious to the possibility that my continual & unceasing visits might disturb you.[2] After all I have no real right to intrude into the circle of your family during the hours when you might all be alone. There may be times when only forebearance on your part keeps me from knowing this. I have certainly never felt intuitively that I haven't been wanted there and I can I think always know by some intuition things like this. But do tell me if you would on this account have me come less often.

I am moved to wonder this by realizing how tiny an amount I give for what I take. Nor is it only in material things that this terribly uneven exchange takes place. I know this — know too how you would welcome in anyone particularly in one near you in age and in advancement a stronger bond of Sympathy — how you thot for a while you had found such a person in Harl,[3] and the subsequent realization of his Limitations.

My hope is that one day when the differences in our Years and Experience have lessened I will fill this niche. Meanwhile I regard you with a Reverence and Affection such as I feel for no other Man. Transcending the tepid admiration of friends my feeling toward you makes me say that I can brook no thought of rift or misunderstanding between us two.

Pete

[1]"From a very early stage in my childhood I was at odds with my mother" (autobiography).

[2]PH was then living in a farmhouse close to the Wyeths' residence.

[3]Harl MacDonald was a composer and the general manager of the Philadelphia Orchestra.

A year went by. Peter grew impatient with Wyeth's opposition to his romance and with Henriette's misgivings about marrying him and living in New Mexico. He felt himself an outsider, an exile, in Chadds Ford. He was weary of the "Wyethian trend" in his work and of painting the Brandywine Valley, which, though its beauties surely appealed to him, did not elicit his deepest passions and seemed incompatible with the expression of his own vision, which he had long been carrying inside him.

To develop this vision, and to seek his independence, Peter decided to return to New Mexico in the fall of 1928. He asked Henriette to go with him—independence for Peter meant a life with Henriette in New Mexico—but she refused. He then set out by himself in a small convertible, with the understanding that Henriette would meet him in Roswell the following spring and that eventually they would marry—somewhere.

The return home was propitious for Peter's work. Removed from Wyeth's influence, he now employed a bolder, freer technique. Unlike Wyeth's restrained style, Peter's new approach to oil painting was characterized by a rich, lush impasto. He went on daily expeditions into the plains and mountains to the west and into the valleys of the Capitan and Sierra Blanca ranges, renewing

his intimate connection with the landscape and painting with a fervor he had not known in Chadds Ford.

Peter lived with his parents on their South Highlands farm and worked in a one-room adobe studio, which his father had built for him a comfortable distance from the Hurds' house. He rekindled his boyhood friendships with the Mexicans in Chihuahua and with Paul Horgan, whom he now saw frequently. Initiating a lifelong habit of helping Peter in his career, Horgan arranged an exhibition of his friend's ten best paintings in the library at NMMI from December 11 to December 21.

The whole time Peter was away, he missed Henriette and wrote her daily love letters.

To Henriette Wyeth
[Draft]

[November? 1928
Roswell]

A man in love I do think cuts the sorriest figure in the world.

My mind keeps searching the panorama of memory for every sort of incident and scene in which you figured and focusing on them as with powerful binoculars it suddenly throws them into magnified relief in my vision with a vividness that later startles me. I remember how we used to sit together in the dining room — or playing Parcheesi and the very dress you wore and the things you said and your dear smile will all suddenly appear. Or your voice as you used to say to me each night goodbye till tomorrow Peter be very careful and don't run in a ditch. The pain of those moments has now grown light with this month long separation. Then the wan northern sunshine will appear and we are reveling in the beauty and excitement of a noonday picnic at Sugar Loaf — and I remember how sweet you looked sitting beside me urging me to take more of the lunch you had prepared and how delicious was your mouth to kiss.

I am afraid I cannot tell you if you have not already read it, how incompatible with my feelings is any thot of faithlessness to you. I adore you completely and wholly with every atom of what is me.

Always your
Peter

To Henriette Wyeth
[Draft]

[December? 1928
Roswell]

Dearest,

Selfishly, I am writing you again for when I write you, then am I nearest to being happy. With the heavy file of your letters before me containing everything you ever sent me written by your hand I long to answer some of these dear bygone letters. A sort of ecstatic joy fills me as I reread them and imagine them as being of the present. The richness of their feeling relieves the strange chill (an actual and physical sensation) that holds me now as that time last July. — I shall rent a safety box in the bank where I may keep these letters for should anything happen to them now Henriette I don't know what I should do. I half believe they hold within themselves my mortal life, like the amulet of the wicked sorcerer in the Legends of Arthur.

I am poor company for friends and family tho I try to be otherwise. There is no one whom I want to talk to except you.[1] Does this all reek of self-pity? I hope not for I am wasting very little time in self-pity. I do seek relief in remembrance of things past and in letters as one who takes an opiate for a paining wound.

My letters are perfunctory, how doubly so they seem to me after rereading your own. I want them to be otherwise, as far from commonplace as possible. They are the only testimonial I can give of my devotion and faithfulness to you ¡Ójala que pudieran estar fuertes![2]

. . . My existence in Chadds Ford, so delicious to remember was too parasitic a one [for me] ever to consider repeating. Sometimes I think that a degree of happiness could be found in living over the line in Delaware somewhere where I could be near but not dependent on your family's ready generosity. Then I reflect that ever to realize my dream of becoming one of the American Painters I must know this my home land in its every mood and prismatic variation. Only thru this can I attain to this ambition which haunts me every moment. And these days even

in this period of abjectness I am having an increasing belief that I shall some day attain to this [letter ends here].

[1] "I sometimes think I am to all but you a bleak soul and uncommunicative. Certainly I find little real solace or benefit accrues from pouring forth one's own troubles and problems to a friend or relative however near" (PH to Henriette Wyeth, draft, written during this period).

[2] And oh how I hope that they are strong enough!

To Henriette Wyeth
[Draft]

[January, 1929?
Roswell]

My Dearest Henriette

Please write me my Sweet — write me that as before you are still my true Love. When after taking my last letter to you a few hours ago I went to get the northern mail and found no letter there from you nor any awaiting me on my return from Santa Fé today I was deeply disappointed. But in your telegram — those last three words — Much Love, Henriette — thrill me and buoy my spirits. O, love I long to hear you *say* you love me and to feel your dear warming embrace!

With me now everything centers about one burning Truth: *I love you*. And I long to possess you and care for you: To do for you my utmost and to start building with you a home for ourselves, to share with you all the sorrows and pleasures of this Destiny. Do you not think that only in this longed for union can we be happy? I'm not talking impractical nonsense. I know I can support you if we live moderately. My work is selling and *I am progressing* too.

I will go East in a moment if when you receive this you have decided not to come to me. — I only dread the old life of the ungiving parasite — you know that I truly love your family and to lose by continuation of this, their love and respect is awful to think of. We have often spoken of this. It is for this reason coupled with my unshaken dream of having you here and seeing with you this country that I am not now on my way East.

You have asked me not to ask you to set any date for our marriage — and so far I haven't done so but now in this crisis, with our feelings pitched as they are and all the judgment and reasoning of my own that I can command counselling me to it, I do — where and how you will, please marry me soon.

You know I love this country here and that I am organically a part of it; that thru its beauty, sometimes a hard and cruel one, sometimes very tender, I have been attuned to the infinite and felt stir me, a great compelling poetry which must come forth on Canvas. But much more than this I love you and [letter ends here]

To Henriette Wyeth
[Draft]

[February, 1929?
Roswell]

. . . If your father's cruel plan of separating us is succeeding as he had intended then my appraisal of the depth of your love and loyalty has been proven false; better say aye that it be known now. Yet I marvel at how such disillusionment stuns one in the days of youthful confidence.

Curiously I find in my own unshaken love for you a certain strength which gives me confidence in my self. So don't really feel badly about wrecking anyone's life. I know now that I have an unwavering strength and also that I have no heart of pith. This has been an acid test if ever there was one.

Your mutability reminds me of our mountain weather which may suddenly in the midst of a fair bright day startle one with a peremptory cloudburst. But invariably the sun shines afterward.

If I am cast aside as it appears, by you whom I worship and adore I don't feel at all in the conventional way — I haven't one slightest hankering to absorb any cyanide nor to blast out my tired brain with a very convenient Colt .45! Nor yet am I suddenly become a lovelorn cynic who finds the race of women all fickle. Rather I feel surer of myself than ever — knowing that I have the powers of Love and Fidelity which are the foundations of the home I long to build.

Do I bore you by telling you also that like the Phoenix in Greek Mythology who you will remember sprang from his own ashes, I feel that from this searing ordeal you have put me thru I have been tempered and have emerged believing more than ever in my Destiny? . . .

I should be growing gradually accustomed to my dreams changing suddenly to nightmares, as did West Point and the romance of military life. But this last has been more stunning, really deeply agonizing you know.

You write today in a letter received after the rather unedifying conversation we had by phone this morning — "I haven't the courage to marry you now. At least when I think of marrying you I am afraid." How ridiculous and whimpering you sound — whom have you been talking to? You sound like one of those queer unnatural panting females. —

I'm a little tempted to go on in a continuation of this last paragraph which isn't a very gallant vein for a Romeo to be wooing his mistress in.

But I've already written too much — I smile to think of the pages I have poured out to you — and now wish the time I used thus were ahead of me instead of in the undeniable past . . .

Late in the winter, Henriette finally made up her mind to marry Peter. He returned at once to Chadds Ford.

To Paul Horgan

[March?, 1929
Chadds Ford]

Dear Paul:

After a journey of five days and five hours I arrived here last Tuesday to a great welcoming from the Wyeths. The trip itself was the means of a continual and intimate revealment of the country that I traveled thru — and a dozen times I wished you could have been along to enjoy the little adventures which kept befalling me. The differences of the various sections of the country were never as clearly exhibited to me, everything seemed significant on this trip thru widely differing localities. Names on

mail boxes, — inflection of speech, roads, faces all had their stamp of locality. I enjoyed particularly the South with its dim, funereal swamps and grey weathered cabins, tall pines whose slim, bare trunks surmounted by tufts of foliage are very beautiful in their design against the sky.

[drawing of pine trees on bank along shore]

Influenced by the prevailing north winds they lean their heads wistfully toward the warm south.

Further on in the very different terrain of the Cumberland mountains a different and to me entirely new country appeared. — and such strange people! some with idiot faces that would haunt me after I had seen them. The mountains of course are different — They seem so near at hand and so lacking in that elusive mirage-like beauty of our mountains. And lacking too in the mystery which seems to envelop a distant range of Mountains in New Mexico. — A mystery I'm not sure doesn't exist to an even greater degree on arriving at them and knowing them better physically.

Henriette has just come into the room and on hearing I'm writing to you asked that I say that she was delighted with the scroll. It is to me a beautiful little verse Paul, and of course the gesture is perfect. Henriette and her father liked your Catalogue[1] too which made me very happy.

Mr. Wyeth has done some superb new things — Those we saw in the black and white were quite fine in colour and there are others more recent ones. He is now launched on the Odyssey of Homer and two perfectly stunning canvasses have resulted one of the old Man of the Sea and the other of the Cyclops, Polyphemus his one eye gouged out lifting a mountain peak and ready to hurl it at the tiny ship of Ulysses. Done in brilliant prismatic colours and with a wonderful epic, imaginative quality quite interpretive in its handling it is to me the finest illustration of his career so far.

My own plans are still somewhat vague but I'm hoping to be in New Mexico in a month's time — Returning I shan't drive so fast, and plan a stop with Mr. Danciger. Old men are grand institutions! Henriette and I plan to be married early in the Summer probably in New Mexico — or if not to return there shortly afterwards. And then the search for a place to live. Santa

Fe seems attractive — particularly when I think of Henriette I don't want her to feel the distance from cultured people and interesting ones. For my part I would probably be just as happy or more so, away from them all down in the Tularosa valley.[2]

. . . Adiós for now I will write again and I hope better — The excitement of arriving isn't out of me yet. —

<div align="right">Ever your friend —</div>

<div align="right">Pete</div>

The flashlight was great — and was used many times —

[1] Paul Horgan had written the catalogue note for PH's 1928 exhibit at NMMI.

[2] Although PH and Henriette at first planned to marry and settle in New Mexico, in the end they decided to hold the wedding in the East and to honeymoon in the Southwest. They also decided that when their honeymoon was over they would live in the Chadds Ford area.

To Mrs. N. C. Wyeth

<div align="right">Sunday March 24, 1929</div>

<div align="right">Roswell — N. Mexico</div>

Dear Mrs. Wyeth:

The stay at Chadds Ford was one of the most pleasurable times of my life. Easily! Stepping from an existence so distant both geographically and mentally of course enhanced the effect. — Since tearing myself away I have been continually "on the go" — MacMurphy's[1] commission looked like it might develop into an important one in the assignment to me of an entire series. — So when it would have been a great boon to simply return home and rest for a few days before beginning work here it was really essential for me to cruise all over the State of Texas. I've certainly had some practical lessons in the physical Geography of Texas!

Now with this all thankfully behind me I am back at home where the need of quiet and time to think and remember — ruminate I suppose it could be called — about the visit with you in Chadds Ford is possible. Never, as on this Texas sortie have I before so poignantly experienced a desire for the delicious calm of congenial surroundings. One reason for this was that for all this time I was completely out of touch with Henriette — and imagination was ever-busy inventing things which might be hap-

pening. Can you from your removed position of perspective see all this as it happened to me in my state of mind? I rather think you can.

Henriette has written me about the set of table linen — Spanish — It sounds perfectly splendid and I add my thanks to hers for this gift. My mother and father have offered to give us some furniture — thoughtfully suggesting that we pick it out where and when we will, for here in Roswell the furniture is not very good —Tho I haven't any hopes of immediately getting any very fine things I should like them to be as pleasant looking as possible. This home building urge has become a most compelling one with the possibility of realization now here. — I yearn so to have a place which will be our own — having so long lived on other peoples' kindness! I feel handicapped in doing anything very definite by Henriette's not being here.

This has been a letter entirely composed of "I-s" so far — which I hope you won't mind. You are all of you very often in my thoughts. The memory of vast piles of doughnuts and Sand tarts — and of Sunday dinners with you is a memory which occurs with almost too much vividness for comfort. Your love for your home — I mean not abstractly altogether but materially and physically is a stirring thing to me. How strongly you have this quality I've been made to understand during the last part of my trip back when I was a guest in half a dozen homes — Few approached and none equalled yours. If one can willfully model one's home — I of course refer to the spirit — I certainly mean to shape ours to something very near yours!

Please don't let the answer to this letter trouble you — If you find opportunity I should like much to hear from you. — But I shall understand if you don't — and besides — we will be talking vis-à-vis before many weeks have passed.

Much love to you Mrs. Wyeth and to all the family. You remember, you used to say you were my "Eastern Mother"? And this is how I think of you —

 Peter

[1] Dempster MacMurphy, an alumnus of NMMI, was legendary for his brilliance and for his humorous exploits. He was later secretary to Samuel Insull of Chicago, a famous utilities executive.

Peter married Henriette Wyeth on June 28, 1929, in the First Unitarian Church of Wilmington. He was 25; she was 21. A reception was held for them afterwards at the Wyeths' house in Chadds Ford. Before it was over, the Hurds had left on their honeymoon.

They set sail on a coastal steamer, the S.S. Dixie, stopping briefly in New Orleans and finally disembarking in Galveston, Texas. From the Gulf they took the Santa Fe train to El Paso. "You've no idea how beaming Peter is," Henriette wrote her parents on July 4; "the farther South we get, the happier he looks." The Hurds spent a short time in Juárez, Mexico, just over the border from El Paso. "Lots of Mexicanos, of course," Henriette wrote her mother on July 9, "some of whom Peter knew. He'd stop every few yards to have the most long winded chats with them. They like him enormously, I should say; they feel at once that he likes them — and he *sounds* exactly like them, too."

The Hurds had now reached Roswell. They lived in the house with Peter's parents and worked each day in Peter's studio.

To Mr. and Mrs. N. C. Wyeth

July 10, 1929
[Roswell]

Dear Mr. and Mrs. Wyeth.

On our return here we found the Rimmer drawings had safely arrived. I am completely delighted with them. So many times I have wanted to have access to your book while I was down here. These drawings should be of value in the coming Whitman picture[1] I think.

We wired you this morning about the house and are of course much pleased with the whole arrangement as it now stands. To live over in that old house and use the school for our work seems as ideal an arrangement as we could wish for.[2]

You have heard by now from Henriette of her impressions of the voyage — New Orleans, El Paso — Juárez — and finally Roswell. She seemed to enjoy the entire trip greatly. She has a hearty appetite and looks very well. (This, Sir and Madame is no mere lover's illusion!) Arriving here we found a great sheaf of mail — two letters from you, Mrs. Wyeth (the first I have ever seen, you know!) were so warm and seemed so easily written

that I was immediately sorry I had always believed you when you said you couldn't write letters.

Henriette is beside me as I write this, deep in a weighty tome, "But Gentlemen Marry Brunettes"[3] and at frequent intervals bursts into laughter, and then reads me the passage.

The reception we both thought was perfect; we only wish now we could have been able to stay on to watch the revelry from behind some convenient arras. We were certainly fêted and feasted during that month that preceded the wedding. So that now, back to a quiet and more static existence we are enjoying it all in retrospect and at the same time looking forward to work. Henriette likes my studio and is looking forward to working there . . .

[1] An advertisement in which pirates are shown opening plundered treasure chests filled with Whitman's chocolates.

[2] Their honeymoon over, the Hurds moved into a small, white, three-storied farmhouse overlooking twenty-five acres of meadowland in Chester County. It was several miles from an old clapboard schoolhouse that Mr. Wyeth owned, and which the Hurds refashioned into two separate studios, one for each, connected by double doors (see PH to Paul Horgan, December 20, 1929).

[3] By Anita Luce—the sequel to *Gentlemen Prefer Blondes*.

The Hurds remained in Roswell through August. Peter, of course, was delighted to be living and painting in New Mexico, but Henriette was lonely for Chadds Ford. Toward the end of July, she wrote her family: "Each day here, spent in this uninteresting country (Roswell and the surroundings *are* dull) and in this mediocre house, makes me treasure my own lovely home — and my family . . . I am not unhappy here, for Peter invests every thing with his own particular glow and enthusiasm." A week or so later, on August 4, she wrote her father, "Lord, I wish I was coming home!"

In spite of her distaste for Roswell and her difficulties with Peter's mother—"Heavens, but I do dislike Mrs. Hurd!"[1]— Henriette soon settled into her work.

[1] Henriette Wyeth Hurd to N. C. Wyeth, August 4, 1929.

To Mr. and Mrs. N. C. Wyeth

Roswell —

August 23, 1929

Dear Mr. and Mrs. Wyeth:

Henriette is beginning a still life[1] this morning in the studio which is a good testimonial of how she is feeling. Her large canvas needs only a few more things to finish it. It is really a most stunning thing — Different from any of the others and therefore difficult of comparison in quality. But I personally have become greatly attached to it — As with "Adolescence" it speaks to one thru a poignant nostalgia and retrospective Meditation.

I am sitting at the West side of the house on the lawn. Sixty miles away El Capitán's[2] azure cone supports a billowing mass of cumuli; sixty feet away an irrigation *acéquia*[3] ripples and swirls on its way down to the corn fields. The cottonwoods that border the *acéquia* are teeming with birds — Every breeze — be it ever so gentle makes their shiny leaves dance and sparkle in the brilliant sunlight. I am sometimes reminded of the French Pointellists by these trees. They seem designed by nature to fit Seurat's or Monet's technique.

I think never since I was a child have I enjoyed this farm more than since Henriette and I have been here together. I recognize a reappearance of the same attachment I had then (which I know you can understand) an attachment I never was able to feel in the short visits of the past ten years. Having Henriette here is of course a contributing cause for this rebirth of my early feelings . . .

[1] A painting of a blue glass decanter and a spray of hollyhock against a background of white linen, with PH's pink silk kerchief falling against it.

[2] El Capitan was a spectacular mountain with a ten-thousand-foot summit, standing apart from the Sierra Blanca Range. It symbolized to PH his enduring love of New Mexico.

[3] Canal.

To Ann Wyeth

[August 30, 1929
Roswell]

. . . Henriette and I are going to the Mountains tomorrow — we plan to leave around six o'clock in the morning and arrive at the cabin¹ about nine o'clock. Up there where we are going it is as different as anything can be from the country around here. There we are eight thousand feet above sea level while here we are thirty six hundred. Everything is different there — there are tall woods of pine and spruce and occasional groves of aspen trees trembling in the Sunlight — and then too — what I forgot to tell about — a trout stream that tumbles down among rocks, glides past heavy ferns along mossy banks and seems to be forever rejoicing at being there. And there above everything else is the peak — El Blanco, sometimes gray & frowning under a bank of clouds sometimes smiling and radiantly blue with cloud shadows racing across its broad back. On the far side is a deep cavern where icy winds blow even on a midsummer noon and where few persons ever venture.

The forest that covers the north slope is a wild country overgrown with primeval trees so tall that one can scarcely see the sky above so that a person chancing to wander among those mighty trunks may remain there for some time never knowing whether the sky be fair or cloudy, whether the sun be at meridian or low in the sky. But this forest is never silent: always there is the gentle sighing of the south wind which sweeping over the peaks catches the tops of the trees in the upper reaches of the forest — near the timber line — (above which no tree can survive long,) and by some sympathetic attunement seems to set the whole wood to singing a long sustained note of exquisite sweetness so that it seems that there must be a mighty organ somewhere near whose swelling diapason creates that sound. And at times there is the wild, eerie moaning of the north wind whose chilly blast races up the cañons and across the snowy summit.

. . . where we go there are cabins — a whole colony of them — stores a post office barber shop — and woe-to-tell! even a golf links! — all a full day's journey over winding mountain

trails on horseback from that remote and almost inaccessible place I have been telling you of . . .

[1] Located in an isolated, rustic spot in the Capitan Mountains, at the head of Ruidoso Canyon, the cabin was a loan to the Hurds from a friend.

To Mr. and Mrs. N. C. Wyeth

Ruidoso, N.M.

Sept. 4, 1929

Dear Mr. and Mrs. Wyeth:

Your telegram reached us just before starting for this place last Saturday. It seemed to us both, particularly nice of you to respond so quickly to Henriette's letter — albeit it *did* contain some certainly important news![1] —

This development is hardly in keeping with our plans — and when I remember our decision to wait, I am, I confess abashed. But Henriette is delighted — and — of course I too am. She is now very well and to my delight, happy in her surroundings here in this mountain cabin.[2] We are living as simply as possible and she has no hard work of any sort to tire her.

I wish you could have seen her today when she sallied forth after lunch for an afternoon of trout-fishing. Clad in a long brown slicker, brown boots and topped by a very broad, brown, hat of mine with a low crown she set out, carrying a creel and a pole about four times her length. She returned at five, sans trout but with a vivid description of *two bites*! She has become this day a confirmed angler! I recognize the same elation that old sportsmen have in telling of their catches (and *near* catches).

This cabin has a long well lighted room and there Henriette plans to commence some new canvases. (We have brought along enough paints & canvas for a year's "hermifyin'" I think.) Another Ginn illustration is occupying me now and there is the prospect of two more to do when this is finished.[3] What a splendid feeling to begin to have a demand for my things — I haven't yet heard what they thought of my "Columbus" which I sent a few days ago. These subjects are all fine ones that Ginn's gives

me. The one I am now at work on Henriette has described to you — the next two are of Cortés — and the trade with the Orient respectively. It seems an ironic turn that I should now be painting the coming of the first white man to America here within a stone's throw of the boundary of a reservation where one of the last remnants lives of that once proud race of American Indians.

Henriette is sitting across from me as I write this, reading Mr. Hergesheimer's latest in the current Sunday Evening Post[4]— "Whew! Gosh this is a good story!" says she at frequent intervals so I see where I am next at it. The gentle patter of rain on the roof is a soporific sound and my eyes are already heavy-lidded. The rainy season here (as all over the state) has been abundant and the mountains are a fairy-land of wild flowers. Henriette has big bowls of them — the same sort as she used to gather — and shall gather — in Chadds Ford . . .

[1] Henriette was pregnant with Peter Wyeth Hurd.

[2] "I can't tell you how I love that place!" Henriette wrote her parents from Ruidoso, "the first of New Mexico I've even *liked*, personally, too —"

[3] Ginn and Company of Boston published historical textbooks and had given PH his first illustration commission, a painting of Marquette on the Mississippi.

[4] Joseph Hergesheimer was one of the most popular and successful novelists of the period and a good friend of the Wyeth family. He lived across the countryside in West Chester. Henriette painted his portrait and in 1932 it won first prize at the annual exhibition of the Wilmington Society of the Fine Arts. Hergesheimer's latest work was *Swords and Roses*.

To Paul Horgan[1]

Sunday Night
[September, 1929
Ruidoso]

. . . We both enjoyed the short stories immensely — for my part and I think H. agrees they leave a decided tang and seem to me darn good things in every way. You will certainly find a publisher for them. We still laugh at the mention of your imitation of the epicurean Jewess or the YMCA man's "Folks-s-s-s!" And the mortified dismay of My lady the president of the Woman's Club of Roswell.

. . . Autumn approaches perceptibly each day — The sumac is a profusion of clarion scarlets and booming crimsons. From a hilltop where I climbed this morning I could see the north slope of El Blanco with newly wrought patterns of yellow and bronze where the aspens and oaks are turning. I have completed a 25 x 30 of an aspen glade — my best thing so far I think and which I'm anxious to have you see — I call it — *Pastorela* . . .

[1] Paul Horgan had visited the Hurds for three days at their mountain retreat.

To Mr. and Mrs. N. C. Wyeth
Ruidoso, N. Mex
September 28, 1929

. . . Henriette's health seems good to me — her appetite is normal and steady and her face shows color and a general look of health — This all in spite of the fact that she is a day or so out of each week made uncomfortable by recurring spells of nausea — the usual accompaniment of early pregnancy. She sleeps from eleven to twelve hours each night and her duties are, as you know doubtless from her letters, not heavy or tiring ones. She is a true daughter of *yours* Mrs. Wyeth. Already I pronounce her a splendid cook! She makes delicious muffins, hot cakes, salads and for me a certain most savory combination which she has invented of *chile*, tomato, meat, *orégano* etc. etc. and which I call in the style of cook-books: "Mrs. Hurd's Mexican Plate." 'Ay *qué* pretty fine stoff, you betcha *que* yes M'am!' But of course this is only an assertion in taste, due to my long line of swarthy Spanish ancestors!

Heigho! this *has* been a delightful month that we have spent here. It is such pleasure to see Henriette enjoying her surroundings so heartily.[1] Our days here unless subjected to the closest scrutiny are as alike as anything could be. Yet each is subtly shaded and nuanced into a definitely new and different adventure. So that Monotony of any sort is unknown to us.

Henriette has done a new and brilliant canvas during the past ten days: It hangs on the wall before me as I write this and I smother a temptation to tell you about it. Better that you should

see it without what might be a misleading or unworthy description. Beside it, on each side of the door of the cabin are your two Nat'l Geographic Society Maps,[2] which I had among the books we brought from Roswell. Beyond them your Homer — (the Book-lining) which I think is a stunning thing. Your best black & white drawing, without doubt!

A complete angler-ess has H. become and scarce a day goes by that she [doesn't] bring in one or two trout, together with vivid tales of some mighty leviathan that she hooked, had ready to land — when away he swam! O, these fishermen — and women!

Accounts of the progress of our house are fine to hear. I cannot say with what great anticipation I look forward to a permanent home — permanent at least, as earthly things are. This cabin incomplete as it is and tentative as is our stay here none the less has shown me how fully may be realized one's hopes and dreams of the joy of having a home. To be sure it has been milk and honey thus far, with no calamities. But we have founded a bond between us which is greater and deeper than I knew it could be. New and fine qualities in Henriette seem to appear each day; and that sterling fibre of which she is made shows clearly in this period which cannot but be one of stress for her.

x x x x

Ginn & Co. have again sent me commissions of which doubtless Henriette has told you. Interesting and sympathetic subjects all of them. About the Cortés one which they wanted a sketch for I became very enthusiastic and evolved a splendid conception albeit one out of the run of usual illustration. I sent them a sketch accompanied by several pages of, I hope, persuasive description. I have not yet heard of their reception of it or of their choice of the two sketches I made for them representing different conceptions. The Whitman Canvas has been finished six weeks and is now en route to them. I hope to get more Advertising work — for in the Commercial field I feel that for it I am best fitted. The modern magazine story seems to require many talents for its illustration which I'm afraid I lack. Ginn's is too unsteady a market to do much more than help things along from time to time and Mr. Wheelock uses but one Pleasure Is-

land picture[3] per year. So I'm looking out for more work of the sort I can do. It would be fine if Mr. Stone[4] would commission me to do his dining room decorations as he proposed. The only thing to keep him from it would be price, I think — of course I can't do it at a sacrifice appealing as is the opportunity. Margaretta & Crawford[5] still want a decorative panel. I have a fine idea for it — You remember the goatherd drinking at the falls and the flock gathered at the pool below — I have made studies of the stream and of Aspen trees etc. etc. here this month which will be very valuable.

No word as yet from Chapin[6] altho a month ago I wrote him a letter, sent a copy of The Mohicans and a sheaf of proofs. Things may come out yet tho.[7]

My mother & Father are coming up for overnight and are soon due here so I close for now. Please give my love to the children Andy, Ann, Nat, Carolyn and with much love to yourselves —

<div align="center">

I am affectionately

Peter

</div>

H. feels fine again today

[1] Henriette, as has been mentioned, liked Ruidoso Canyon, but when she and PH returned to the South Highlands farm in early October she again felt estranged. "God damn it, you've no idea how heckling Peter's mother is," she wrote her parents, "— & this time I suddenly got awfully tired of being a kind of buffer between these two. (The combination of an utterly unsympathetic nature and a fussy one too, on Mrs H's part — with Peter's young disdain and personal carelessness is *unpleasant*.)"

[2] N. C. Wyeth's Map of Discovery—Eastern Hemisphere and Map of Discovery—Western Hemisphere were two murals from a series of five that he painted in 1927 for the National Geographic Society in Washington, D.C.

[3] The name the Whitman Company gave to its chocolates advertisement.

[4] A neighbor from the Wilmington area (see PH to Paul Horgan, July 21, 1932, note 2).

[5] Margaretta Du Pont was married to Crawford Greenewalt. He later became president and then chairman of the board of the Du Pont Corporation.

[6] Joseph Chapin was a member of the editorial staff at Scribner's.

[7] PH's first illustrated book was James Fenimore Cooper's novel *The Last of The Mohicans*, consisting of eight color plates made from oil paintings. It was published by the David McKay Company of Philadelphia. Mr. Wyeth had himself illustrated Cooper's novel in 1919 for Charles Scribner's Sons.

East and West

The Hurds returned to Chadds Ford in mid-November, after four and a half months in the Southwest. Their Chester County farmhouse was not ready to be lived in, so until Christmas they stayed in the Big House, as the Wyeths' residence was called. The Depression was on, the Hurds were expecting their first child in March, and they were not well off. To pay bills, Peter had to take commercial jobs, in the way of book jackets, advertisements, and illustrations for juvenile classics. These commissions limited the time he was able to devote to his main passion—painting the landscape. Peter was constantly and poignantly aware of the passing of time, of "the value of this moment in which we live bordered by the two eternities," and his sense of the dearness and evanescence of things, a recurring theme in the letters and journals, served as the mainspring of his landscape painting.

Peter and Henriette began their day early. They would rise before seven, have breakfast and see to various chores, and then drive the short distance to their schoolhouse studios for the morning's work. There was a barn outside the farmhouse with stables attached for horses, and toward the end of the day, while Henriette visited her family, Peter usually rode, alone or with friends. Peter had inherited a love of horses and of horse lore from his mother, who grew up riding on her family's plantation near Augusta, Georgia. He took equitation at West Point, played polo at Haverford, and by this time was an accomplished horseman. He rode with style and daring, participating in horse shows and in fox hunts with various local clubs. In the evenings, Peter liked to read—novels and poetry and art books—or else spend time with friends.

Life in Chadds Ford was far from unpleasant for him, though he did complain of the winter weather. He liked "the feeling of security and safety," and for a while enjoyed painting the Brandywine Valley again, at least for its contrast to the sterner features of New Mexico. But within a month, having found himself absorbed once more into the Wyeth world, he longed to re-

turn to New Mexico. "I could never stay here year in and year out," he wrote Paul Horgan. In this straightforward confession he sounded the keynote of his Chadds Ford existence.

To Paul Horgan

Nov 13, 1929
[Chadds Ford]

. . . The Wyeths met us on the Pier and we all went to a show of French Moderns — marvelous! You Don't know Van Gogh till you see his work in colour — No man is hurt more by black & white! — superb still-lifes by Cezanne! — decorations by Gauguin. Then we went to the opening of the [John] Carroll Show which was sensational if nothing else — Carroll has changed a great deal since the last show of his I saw — I don't know really how big he is. — I have mixed feelings. Henriette was much interested in his show.

The country here is very beautiful — That rich, damp luxuriance is particularly appealing in coming from New Mexico . . .

To Paul Horgan

Nov 13, 1929
[Chadds Ford]

. . . Do try to make a trip here at Christmas time Paul. I feel more and more as the flow of stimulation from Mr. Wyeth and his family pervades me that a visit to him would much more than repay you in what it would contribute to your work — His galvanic, radiant enthusiasm always re-amazes me. His understanding and interest is so spherical and comprehensive that tho your medium be literature you will find that his penetration and judgment is acute. He has a vitality — a restless germinating quality and a constant yearning toward expansion through delving deeper into himself — which he alone of all the people I am acquainted with possesses — and to what degree! All of this is contagious or is made so by the sheer force of his character. So I

say — If you can possibly swing it do come. Of course H. and I would be delighted if you would come and spend some time with us in our new house. We know an increasing number of brilliant people near our own age and interested in the Arts. This you know but I am trying to lay out all the enticements I can. — However the main one of these is the one I first mentioned to meet Mr. Wyeth — I mean to know him for I realize you have met — and hear his views and get that unquestionable and inevitable stimulus . . .

To Paul Horgan

Chadds Ford
December 1929

Dear Paul:

Your letter was fine and H. and I enjoyed it much. What you wrote about the Odyssey was particularly well said. Mr. Wyeth was delighted that you had in each painting singled out the very qualities which he had himself desired most of all to express therein. He has gotten some splendid reviews and H[oughton] M[ifflin] are printing the second edition already.

H's picture has created a great stir — The one she painted in Roswell[1] — and Joe H[ergesheimer] wants to Buy it. Tho I don't think she will sell it to him there is a chance that he will write a monograph on her for Vanity Fair. He has promised to at least. We have seen him several times since returning here. His new Post story "The Limestone Tree" is starting off wonderfully well — read the one in the Post 2 weeks ago and the 2nd installment in the current issue if you have not already done so — I think he's getting a new hold on things.

I'm beginning work on Scribner's next year's Holiday juvenile — "The Story of Roland" a tale of the Legendary Charlemagne. I've got a fine chance to do some brilliant things for this book.[2] I hope I can get into the thing and really do something good. I also have a sketch made for another Whitman Ad.— this time a medieval motif for their "Prestige" package. Also I have a grand Space to decorate in Margaretta Greenewalt's new home

— The Greenewalts (you will know them when you come here) are young people — near our own age and very attractive. She is daughter to Irénée Du Pont. With two or three other tentative commissions in the air I'll have a busy year ahead. This in some-way explains together with a damnable sloth with which I was seized on returning here — why The School[3] hasn't heard from me on the Christmas Card yet. I'll do one for them for next year.

I have had some great fox-hunting. The Country looks gorgeous — I'm not apostate to N. Mexico but here I enjoy the country for its lush opulence— The feeling of security and safety a feeling that here the struggle for existence is reduced. Here one may yet attain to that continental perfection in the art of living. The Southwest still has the element of the frontier — Should the race of man become extinct in Roswell for a few years the desert Salt Grass would encroach rapidly and soon all would disappear — every vestige of man and the substances necessary to sustain him — But just as this opulence and abundance stimu-lates me now so too can it revolt me: I could never stay here year in and year out — there comes with it sometimes a feeling of being over-crowded— too many neighbours! I think I have ex-pressed this very badly but I think you know what I am trying to say.

Sat. Morning:

How about "A Farewell to Arms"? Don't you think it is a pow-erful work? I was completely swept over by it — his Mannerisms — clipped sentences, preponderance of dialogue etc. all were, for the first reading at least — subjugated by the drama of the thing — Whether it would hold up under several readings I don't know — nor can I say how it would be to open the book to any part as one can in Hardy and Tolstoi and enjoy it as a jewelled part of the design — as one can enjoy the passages in a fine canvas — This is a real test — do you not think so [letter ends here]?

[1] See PH to Mr. and Mrs. N. C. Wyeth, August 23, 1929, note 1.

[2] For *The Story of Roland* PH made twelve color plates as well as drawings for the title page and endpapers after oil paintings.

[3] NMMI.

To Paul Horgan

Chadds Ford December 20 [1929]

. . . We have finally moved in — our house is really quite perfect, with its white walls — inside and out, and the beautiful views it commands in every direction. The farm that goes with it — a twenty-five acre tract is a great place to keep horses which of course delights me. There is an indeterminate number of milk sheds — corncribs wood houses and a carriage house all dominated by a fine old Chester County barn, with stone work like a feudal castle. On its gable-end in a [drawing of niche] brick-framed niche is the builders initials and the date something like this sketch.

. . . Roswell does seem a parlous long way off — both now and in terms of the future. But I must return there (at least to some place in New Mexico) as soon as I am able to swing it — A year I may have to wait — I hope not more. We still have a "date" for Mexico City some winter — *qué no*? Egad! I hate cold dreary sunless weather. So far this year we've had but little of it but I daresay our share will be none diminished for being slow to arrive.

There's an old Maryland Negro who lives in a cabin near where we often fox hunt; he takes 'possum fat for his "misery" and sings some of I think the world's saddest songs. This phrase of a spiritual floated out of his cabin window the other morning as we rode by:

"One of these mornin's — still an' clear
Well I'll leave this earth — so sad an' drear"

It all belonged to an era long gone by. The setting — the old negro and his melancholy song and for the duration of his song I felt myself one with it. — We shall go and see him when you come here. His face has in it that look of infinite wisdom and melancholy that belongs only to negroes and hound dogs.

You must write me about the great tea party. You should have gleaned material enough for a Roswell story that day alone. How is Vernon?[1]

Henriette is having her first one man show in Washington early in January — we are just beginning to collect the various canvases — mostly loaned ones — for the show.

Do write soon we all enjoy hearing from you — Merry Christmas to you from all of us here!

<div align="right">Pete</div>

[1] Captain Vernon Knapp, an instructor at NMMI.

To Paul Horgan

<div align="right">Chadds Ford
Jan 17, 1930</div>

Dear Paul:

Don't think your first letter (two have come from you) was disregarded nor that I was insensible to the argument you advance on the topic of one's living in the East. I agree entirely with what you say — agree with [torn page] longing poignantly for the Southwest, particularly when the long [torn page] winter is on and the short sunless days are separated by long, icy nights — But aside from this — culturally — from the standpoint of my advancement I feel I could nowhere be better off than here in Chadds Ford — Sometimes though I feel much like a tadpole swimming dangerously near the open maw of a whale. Particularly where illustration is concerned — I have not yet struck any individual note in this work and it is depressing to think of going on aping the Wyeth manner with none of the distinguishing verve of the original. I'm due for a revolution! Knight Roland progresses fairly well however I have three canvases of the twelve done and am well on my way on the fourth . . . I have plenty of work ahead. The Advertising Manager of Whitman's liked my charcoal sketch and I am going to do it for them in color. He was out here to dinner last week and after approving the sketch bought the New Mexico Moonlight canvas from me. Were it not that I know him very well I would believe Delaware apple-Jack was responsible.

Henriette's Washington Exhibit is hung and looks extremely

well. She has twenty-one canvases in the show and they seemed to be very well received.

News that you have already completed one of your scenarios sounds fine! Luck to you on them all. We all are anxious to hear all of *gli brilletini d'al Messer Horgano.* — if you know what I mean.

As the wind howls and I gaze out on a wintery landscape I bethink me let us not delay too long that winter we are going to spend in Mexico City. *¿Como dices?*

I'm glad you liked your sword.[1] When I was in New York I went around to an antique place I had seen listed in the Studio and found some perfect beauties at twenty-five —, thirty and thirty-five dollars. I didn't weaken but 'twas a great temptation.

. . . By the way — I have found the Horgan drawings for The Ballad of The Cat The Bitch and The old Man so I hereby revoke my request that they be re-done and ask instead if the facile Mr. Horgan does not find something inspiring in the second stanza which has recently been brought to light by a group of learned scholars. It runneth something in this wise:

> "O, the cow kicked Nellie in the belly in
> the Barn
> But the old man said it never done her
> any harm."

Has this not achieved through the simple means of the native poet that plaintive bucolic quality so sought after by a certain school of English lyricists. Poor Nellie — one is quite crushed at her predicament in the first line only to be relieved greatly by the old man's optimistic pronouncement in the second. *Later*

Since beginning this letter two days ago your poem to H. and me has come and we are both of the opinion that it is one of your best things. *Le felicitamos* — and the fact it is inscribed to us — pleases us greatly too.

I wish it were here — (I am writing from the Studio —) for I should like to quote to you my favorite stanza[2]— However I

shall write you again soon and do so. H. wrote you I think — we now both send our love — as ever — Pete

[1]PH, while on his honeymoon, had shipped a rapier to Paul Horgan from New Orleans.

[2]"I think I am able to react to poetry (at first at least) in accordance with its mnemonic stimulation," PH wrote Paul Horgan in March. "I mean according to the way that it stirs my memory or something which seems akin to memory yet which unlike memory is alienated from experience."

To Paul Horgan

Jan 29, 1930
[Chadds Ford]

Dear Paul:

You know, the book on fox hunting, (the only one I own!) is grand! I am having a great time reading random passages in it and of course have picked up a great many things of interest which I never knew before.

I of course love the chase and all to do with it — Its fine tradition, its bravura! The joy of being atop a good Horse on the bracing air of a good hunting morning is incommensurable. This winter as well as last I have gone a-hunting two days of each week. This until ten days ago when my horses fell ill with a Distemper. They are not badly sick but to ride them would be admitting the danger of pneumonia. I now have a stunning thoroughbred named Lady Fox, in addition to the Black mare Topey. Do you remember when Doris Du Pont died last summer? This horse was hers — poor girl! — and her mother knowing how much I admired the horse let me have her in return for a painting of their home. Lady Fox is a splendid hunter and can jump like a cat[1]— Of course I could never afford to buy her outright.

You touched my heart with the Levis; they are *suave*! They are standard and prescribed wear in Chadds Ford (for me) you know at all the functions and ceremonies save the chase. Then I must needs conform to the dictates of a fine and ancient tradition.

Mother and Dad gave me a beautiful serape woven in Oaxaca Mex., perhaps you saw it. I am delighted with it.

Say — great news came the other day — returning from a hunt Miss Schaffer[2] informed me that a Mrs Gunterman of Longmans, New York City had called by 'phone and requested that I call her back immediately, — result: 5 pen and ink drawings a book lining and jacket for a new juvenile they are bringing out: "The Long Defence." Wasn't that good — all the result of the visit there on your recommendation. They are now finished and Mrs. Gunterman was well pleased with them. I'm not much of a pen & inkster you know and I had quite a fight with them, but enjoyed it nevertheless — I am now beginning a series of pictures for "The Adventures of Tom Sawyer" (John C. Winston, Phila). A new type of book for me to be illustrating and probably the closest approach to a classic I have yet been given. Baldwin's[3] prose is abominable I think. Have you ever tried to read any of it? It stinks of 1880 to me — I mean in the awfulest sense. Despite this opinion I have of my own free will chosen his Story of Siegfried as my next book for Scribners and have already made three pictures for it to use as bait in getting them to give me the contract. They seem interested but they may not let me have it after all. In them I think I have made my best illustrations thus far. They are done in Spagne watercolor — and are quite unlike anything I have ever done before. Perhaps you would like to retell this Legend of Siegfried weaving into it the skeins of Norse mythology which are its natural background. You could certainly do it — I think we would make a good team — the two P.H.s of Roswell, New, by God Mexico and Points east. If Scribners do take it they will doubtless use Baldwin's text to which they hold the copyright. In the event they don't take to the idea I'd hate to have my pictures go a-begging. I think you would like them. By the way I have learned to lay gold-leaf and in two of these pictures have made use of it.

Tom Sawyer — maladroit in many ways and not up to Mark Twain at his best, has a fine thread of humanity through it — The kids in it are certainly real, — aren't they? — however overdrawn some of the dramatic incidents may be.

. . . Mr. Wyeth and Henriette were delighted with your letters to them. — They were swell — Paul. — You have (among many other things I admire) a vast nimbleness.

Well — Adiós — & think about that trip East to Chadds and
return to the Southwest later together.

With Henriette's love — and mine —

Pete

[1] "I never rode a horse that gave such a feeling of springing steel as she" (auto-biography). See PH to Paul Horgan, January 2, 1933, note 2.

[2] A stolid and kindly Pennsylvania Dutch nurse employed by the Hurds.

[3] James Baldwin, not to be confused with the contemporary black novelist, was the author of the children's classic *The Story of Siegfried*. PH illustrated the book in color after paintings in gouache on illustration board.

To Paul Horgan

[March, 1930
Chadds Ford]

Dear Paul:

Long before this I had hoped to have launched a heavy en-velope in your direction but what with being behind the sched-ule with Scribners (due to another Whitman ad I have just com-pleted) and driving the sixty miles to Philadelphia and back each evening my schedule is well nigh complete! H. and I were greatly delighted by the telegram from you and its festive mood fitted right into our own. — What an ordeal a birth is I suppose no man can ever really know — but even being intimately con-nected with one as I have just been is a terrific experience. Henriette, praise heaven, had an entirely normal time — and is now resting in the hospital very happy and looking splendidly. Her self control was heroic and moving to see.

Peter Wyeth Hurd entered the world at 6:42 PM Sat. [March 22] wailing lustily and clenching his fists. His weight was 7 lb 13 oz.

. . . Four more Scribners paintings to be done then for a breathing spell of some landscapes. I have really enjoyed Roland but now that I'm on the last lap I'm longing for a period of out-of-doors painting — *C'est le printemps*.

. . . Andy[1] is in fine health again. Roland has gotten him off on knight-errantry and every knight in Christendom must have

become reincarnate in the Andy workshop during the past three or four weeks. British grenadiers and Pirates are quite out of fashion! He and the other children are listening, spellbound, to the last chapters of "Dracula" read to them by their father.

. . . Herewith are my engraver's proofs from Scribners of the 1st 3 pictures. Cover, Title Page & 1st Illust. By an oversight they neglected to send me the book lining . . .

[1] Andrew Wyeth was then twelve years old.

To Paul Horgan

[May, 1930
Chadds Ford]

. . . I have been making some landscapes which I'm anxious to have you see. They are my best yet I think.[1] When you come be sure to fetch Corona scrip paper pens brushes etc — or rather no need to fetch any but the first as I will supply all drawing materials. We should have a grand time — more of the old Horgan-Hurd guild meetings.[2]

The interlude of landscape together with a new job for a N.Y. advertising Co. has delayed work on the last two Scribners pictures.

I am sitting on a hillside near the house as I write this — it is a marvelous May afternoon. The air charged with the old-wine fragrance of blossoming fruit trees. Myriads of petals drift past me borne by a gentle south wind, on the broad fields across the valley men are plowing. As evening approaches, the breeze dies and "Drowsy Tinklings lull the distant herds"[3] —

Truly a land of milk and Honey! I have the inevitable feeling that each hour brings these beauties of new-green meadows, brown hills and flowering trees nearer to their end. No consolation I make myself of future springtimes affects me. — It seems that this must be the last one that no such beauty could be ever repeated. I suppose it is this almost painful contemplation that drives me to paint in frenzied attempts to record my feelings of it . . .

[1] PH won first prize that year in landscape painting at the annual exhibition of the Wilmington Society of the Fine Arts.

[2]Paul Horgan stayed with the Hurds during the summer of 1930.
[3]"And drowsy tinklings lull the distant folds"—Thomas Gray's *Elegy Written in a Country Churchyard*.

Peter soon made a discovery in his work that dramatically changed its course and eventually led to his return to New Mexico. By painting on panels covered with several coats of gesso, first with oils and later in tempera, he found that he could capture light more vividly. If the haze and mists of the Brandywine came alive for him in paint more readily through the use of this new technique, Peter knew how satisfying it would be to try to arrest what for him were far more exciting effects of atmosphere in New Mexico. He felt impelled to go back there and paint. But he needed an economic purpose for leaving Chadds Ford. As Peter himself realized, "Such a cause as a real commission would make my departure from here much easier."

An opportunity came toward the end of 1932. But until then, Peter had to contend with the Depression—smaller commissions for less money—and with the old life in Chadds Ford.

To Paul Horgan

March 8, 1932
[Chadds Ford]
. . . I have one new book, limited to 4 illustrations & a lining, (to sell at $1.00, *hell!*) for which I am paid just ½ what I would have been a year ago. But actually I'm lucky to have any work at all.

But in the interim between illustration jobs I have done half a dozen landscapes which are without a doubt I think — a big improvement and my best work so far. Three in particular I am keen to have you see. I am really very sanguine over this and am hoping for time and opportunity to do another series of landscapes in the spring

. . . Marion[1] and I are talking of driving out to New Mexico in the late Spring or early Summer — Henriette to join us at the end of five or six weeks and return with us. I am most anxious to go. Two years away from there is much too long! So unless financial reasons prevent that is what we will do. —

There are so many things to talk about to you. I certainly look forward eagerly to our next meeting. In a traveling exhibition of Mexican Art at the gallery of the Wilmington Soc. of Fine

Arts opening Monday night I have been invited to exhibit some of my Mexican portraits. As I am on the hanging committee for this show the task fell to me of hanging Hurds beside Orozcos and Riveras. I shan't know how they really look until Monday night. Perhaps, thru a beneficently blinding Providence, not then! I met Diego Rivera in New York last month — (no it was the month before, January). I introduced myself to his wife who answered the phone at the Barbizon Plaza and after questioning me and learning that I hablo Castellano she immediately invited me up to see Diego altho he was abed with la gripa. There he lay, his great frame looking like a section of the Sierra Madre and his broadly smiling countenance for all the world like his photo-portraits. He was delightful and during the twenty minutes that ensued seemed (on such casual acquaintance) to be so naif and ingenuous that it was hard to think of him as going hob and nob in the cafés of Montmartre with Matisse, Degas, Renoir, Picasso, Derain etc.

My page ends — and perforce my letter — we all love you here and speak often of those fine times you were here —

reciba un abrazo de — Pete[2]

[1] Marion Parsonnet, a frequent visitor, later became a Hollywood film producer.
[2] Here's an embrace from Pete.

To Paul Horgan

Chadds Ford July 21, 1932

. . . The damned financial situation has kept me here much longer than I had planned, but we have some work ahead of us now and the ménage chez Hurd is much reduced — no nurse for Peter and a reduced cuisine. But we are content with things as they are and only hope work will continue.

. . . During the winter Mr Wyeth and I collaborated on a new edition of Hans Brinker which should be on sale very soon. He did the cover inlay & I the remaining six pictures, five of them in Black & white. I am now at work on a book of Sea Stories[1] — a juvenile edition comprised of short stories and excerpts from famous authors — from Homer to Masefield. Mr. Wyeth will make the final selection of titles to be included and his name will appear as editor. I am doing 16 black & white line

drawings for the book which is to be done by January. McKay is the publisher. I have already done five of the drawings and the full-colour frontispiece. In addition to this work I have commenced work on a mural frieze for a private home in Wilmington.[2] The subject is the pastoral landscape of the valley of the Brandywine. The room is roughly 14′ by 18′ and the frieze occupies a band 26″ wide (i.e. in height) from the ceiling down to a wainscoting. The first wall represents a Spring Dawn with the subordinate figures of the ploughman etc very small to scale up the landscape — the other walls are respectively Midsummer Noon with resting workmen in the wheat fields. Autumn evening with the return of the hunters and the herdsmen driving the cattle home to the barn. Winter moonlight with a sledding party or perhaps coon hunters abroad with hound and farm lantern. This is the sketchiest kind of a description but you can see what a fine chance I have. I am doing them in thin oils on panel board I have carefully prepared according to the formula of the old Italians with many coats of gesso which build up a splendid time-defying surface — not that time concerns me much but the principal thing is that it is a most agreeable surface to work on. I wish you were here to watch it progress. — I am only in the early stages of the Cartoon (in charcoal) for the first panel of Midsummer Noon —

[diagram of panel area]

. . . The Wyeths are all going to Maine soon. Perhaps H and Peter will go for a week or ten days — For my part I have no desire to move anywhere but Southwest[3] . . .

[1] *Great Stories of the Sea and Ships.*

[2] The Stone dining room decoration (see PH to Mr. and Mrs. N. C. Wyeth, September 28, 1929, note 4).

[3] PH later changed his mind, and in early September he spent ten days in Port Clyde with Henriette, little Peter, and the Wyeths.

To Paul Horgan

September 22, 1932
Chadds Ford

. . . I can only hint at how anxious I am to return. I have been practically static here for three years and I am certainly

primed for a change. The entire summer I have been hard at landscape and have completed one panel of the frieze I wrote you of. There is no question that it is my best decorative work thus far. I have discovered a wonderful new medium (I mean new for me) — the gesso-coated panel of the renaissance painters. El Greco, da Vinci, Botticelli all used it at times. It is a marvelous surface to work on — I am anxious to have you see and try it. This last [mural] decoration is done on it and I have been able to get a *colour quality* and *flatness* hitherto unknown to me. This method with tempera colour was called il fresco secco — And it is a dry fresco — dry in that the surface is not wet when the colour is applied. It allows of a marvelous flowing of colours as in watercolour, as well of course as passages of opaque painting — of course what it — this last work has done is to make me keen as hell to get a hold of some more spaces to decorate — Isn't there something you can find in the way of an architectural space at the Institute and persuade — or let me persuade the Colonel[1] to have me do? My Prices are the lowest possible — paints and materials and enough to live on is all I would demand — write me about this. God it would be grand to spend several months out there with you and do a really fine job of decoration. I have taken a big jump ahead in my understanding of decoration.

Speaking of El Greco — I have been reading that splendid work of Willumsen's "La Jeunesse du Grec"[2] which Henriette gave me one Christmas. Playing our old game of listing the gods of Painting I make Greco, Bruegel, Botticelli still top the list — with — for me El Greco in the ascendancy. Do you remember that marvelous canvas of his we saw in Chicago? And the one — the landscape of Toledo which was in the Havemeyer collection[3]— you sent me a print of this which is one of my prize possessions — it is an unfailing source of stimulation and has gone a-landscaping with me many a time! . . .

[1] Colonel Daniel Cecil Pearson was superintendent at NMMI. Paul Horgan, a captain in the school's military hierarchy, was still librarian there.

[2] *La Jeunesse du peintre El Greco, essai sur la transformation de l'artiste byzantin en peintre européen,* by Jens Ferdinand Willumsen.

[3] *View of Toledo,* now in the Metropolitan Museum of Art, was one of PH's favorite paintings.

[Journal]

Chadds Ford

Oct 24, 1932

. . . This afternoon I read Bird of God, romantic Biography of El Greco . . . in many spots it rises in a great surge and creates in me a great yearning to paint new and better things — In the way Fame does more often . . . So few books on painting are at all *directly* stimulating but when one is how valuable an aid it can be! . . .

[Journal]

Chadds Ford

Oct 24, 1932

. . . This morning's mail brought me the exciting news that the Corcoran Gallery in Wash D.C. has invited my Mexican Ranchero [Spanish] (Tómas, with the farm's landscape in the background), [English] to their annual exhibit . . . I am of course greatly pleased at this stroke of luck — and feel much encouraged . . .

[Journal]

⟨December 8, 1932

[Chadds Ford]⟩

. . . The opening at the Corcoran — throngs of people (who really looked at the paintings) mostly elderly — hundreds of faces — none familiar — except [Franklin] Speight's. — With him I had a pleasant chat. His picture had many fine things about it but was not thoroughly sustained. The Show in general excellent had universally good hanging. Wyeth's picture always had a knot of people in front of it — My own very well hung did not look so well to me — too blue and cold — without the carrying finality it should have had. A general criticism of the show was that so few of the things exhibited were sufficiently motivated. They were nearly all fragmentary — a direct result of French influence. Coming away I felt definitely stimulated — none of that usual feeling of abject and vacuous futility.

. . . In New York I saw the American show at the Modern Museum — (America 1862 — 1932) — a generally fine show with some mouldy old works that had no message for me — notably two Wyants — and a Dewing. The Whistler Mother was disappointing, being much yellower and having far less of the pearly grays of Velasquez that I had always associated with it through prints. Time and Whistler's faulty technique are playing the devil with it.[1] Also a show of Renoir since 1900 at Durand-Ruel — Not so good — none of the stunning bourgeoisie paintings of the earlier period. I have never been able to understand or enjoy those vast red and brown nudes painted with blurred edges. Notable at the Museum of Modern Art was Bellows' "Stag at Sharkey's"[2] — also his two old ladies and the little girl — Many other fine things.

[1] For a contrasting view of Whistler's work, see PH to Henriette Wyeth Hurd, July 1, [1942].
[2] Now in the Cleveland Museum of Art.

[Journal]
Chadds Ford Oct 25, [1932]
. . . The ms. of Basso's "Beauregard The Great Creole"[1] has come from Scribners. I am to make a 2-colour jacket . . .

[1] Hamilton Basso's *Beauregard* was published the following year.

[Journal]
⟨Nov 11, 1932
[Chadds Ford]⟩
My Beauregard sketch, an adaptation of my original idea is now ready to mail to Scribners. This one shows the close up figure of the general ¾ length left hand on sword head slightly averted — and gazing into the distance. His right hand is tucked into the breast [of] his long military coat in the best Napoleonic (and civil-war) manner. Behind him a battery of field artillery

with pieces still smoking. It should be very effective. I think the design is good . . .

[Journal]

October 29, [1932
Chadds Ford]

No entry yesterday for the reason that we (Beulah Emmet Bob E. Marion Parsonnet, H. & I) arrived home from the Wyeth Brawl *a las cuatro de la mañana!*[1] and after a four hour sleep I was up at the studio with H. who had her second sitting with Emily Seaman. — The party was a thorough success. Ann H. Mary Sargent all the various functionaries and assistants looked perfectly great! With the genius the Wyeth family has for entertaining the party was a complete success. Thirty of the debutante party had supper here before the *baile.*[2]

. . . next A.M.

Later to Rusts for Dinner where while the urge to *scintillate* lasted — (thruout the meal —) things were fairly amusing — at least for Marion and me — we it was who did practically the entire enlivening work but when as usual 11 P.M. came my emotional graph curve took a nose-dive and not another drop of char-r-rm could I exude. My impression this morning is of an evening of great dullness despite plenty of splendid Jamaica Rum and later, Port . . . I shall be very glad to return to the routine of studio work again . . .

[1] At four in the morning.
[2] Dance.

[Journal]

October 31, [1932]
Chadds Ford

. . . I am into "Green Doors" (jacket for Little Brown) and am finding it an ingratiating subject — (the one *they* chose for me) and much more nearly on the lines of personal expression

than any other such commission has ever been — I hope it turns out as well as it bids fair to . . .

[Journal]
⟨Monday, Dec. 12, [1932
Chadds Ford]⟩

. . . This morning came a note from Little Brown saying that they and the author of Green Doors were tremendously enthusiastic over my painting. Great news! I had of course resigned myself to the idea that they didn't reply because they thought it was thoroughly lousy. Altho I personally had no feeling (as I have had at times) that it really was! . . .

[Journal]
November 3rd, [1932
Chadds Ford]

My often-exhibited and several times almost sold canvas Autumn Brook — (a wood-interior painted as I had heard Segantini sometimes painted over a gilded canvas) has now finally really been sold — so I am told by the Greenwood bookshop in Wilmington where I have a group of landscapes on display. [Spanish] The price, sixty-five dollars, is very good because of the depression.

[English] Sent in yesterday one landscape (the Walker Farm) and one illustration (Charlemagne Crossing the Alps). I am not particularly proud of either of these entries as they are both over a year old — but with four in New York — one in Phila & one in Washington, together with what the bookshop has that is the best I could do. —

[Journal]
⟨December 23, 1932
[Chadds Ford]⟩

The third picture has been sold at the Greenwood Bookshop. Mrs. Rupert has bought for her daughter Amy the small

sketch I did one afternoon early last month (with a line of fox hunters in the distance) and a man named Magonigle — the summer sketch of the Walker Farm looking partly toward the light . . .

[Journal]
November 9, [1932
Chadds Ford]
. . . Yesterday was election day and I cast my vote for Hoover as did H. A few hours later word came that Roosevelt was sweeping the country — So that's that. — I felt no dismay at this news — a little surprise perhaps for I had more than I would admit believed a silent vote would put Hoover back in. I am not proud of being pretty ignorant of party differences — Candidate speeches etc. Patriotism — until recently at least has always been a vital thing with me — In late years this feeling has waned so that I can no longer imagine myself as once having the fiery fervor I *know* I did possess when at West Point. I have no pride in this country or in this state *as political entities*. In fact the only place I can be enthusiastic about is New Mexico . . .

[Journal]
November 12th, [1932
Chadds Ford]
. . . Back in my mind for the past few days has been the slowly growing idea of doing a [mural] decoration for the New-Mex. Military Institute, (where it seems I am pointed to with some pride as the home boy who made good). If I can write my plans — or my proposition to Colonel Pearson in such a way that he will see the value to the school of this being done — and make him realize that now as probably (I hope!) never again will I be able to do it at a very low price for the reason that it will simply be giving me the necessary employment while in N.M. So far I have made no draft of the letter to the Colonel. It must be forceful and free from the fault of wordiness which I often show.

To Colonel D. C. Pearson
[Draft]

[November, 1932
Chadds Ford]

Dear Colonel Pearson

Reading recently of contract being let for a new [post-exchange] building [at the Institute] commemorating Major Thomas[1] has led me to write you of a matter I have had in mind some time. Without any circling around I'll come to the point which is that I want very much to be given the opportunity to do a mural painting [on the walls of the lounge room of the new building].

You will understand my reason for wanting to do this which, aside from the selfish reason of my yearning to do again something in and of New Mexico is that the Institute (with West Point) gave me by far the most significant part of my education and I want to have there a painting embodying the best I am able to do.

Subjects for the painting are innumerable. My only stipulation in this would be that I be given something which I know well [letter ends here].

[1] See PH to Mrs. Harold Hurd, May 28, 1923, note 4.

[Journal]

⟨Sun. December 18, [1932
Chadds Ford]⟩

. . . Day before yesterday I mailed the letter to Col. Pearson. I really — down in my belly have no belief that they will ever seriously consider having me do the Fresco decoration I proposed. But nevertheless I am truly excited about the idea. It would be a marvelous opportunity. And how great to return to N Mex knowing I really had work to do there! But I have only a little hope — It is simply a shot in the dark — which once made will prevent me from in the future saying "why didn't you?!"

[Journal]

Nov 13, [1932
Chadds Ford]

Today after a routine morning in the studio was a very gay
one — To the Biggs'[1] for luncheon where the chattering clamour
of twenty-five people mounted steadily in pitch until it reached a
shrieking din. The punch was very smooth but very strong. One
impression I retain was of the two Sargents — father and son,
both nearly loop-legged standing close together & face to face in
the midst of the crowd and talking in their nasal way eyeing each
other with the utmost gravity. Ralph Jr. who indiscreetly tried
ale on top of apple jack last night at our house passed out cold at
Wyeth's later.

. . . To the Hoopes for supper — after riding (dressed of
course as usual in blue jeans and turtle neck jersey) I carefully
changed into riding clothes, hunting boots and tailored breeches
and coat. The latter the splendid tweed one H. gave me. Mrs.
Hoopes looks like Margaret Oakes (Hoffman) Mr. Hoopes was
out of town. Clem has a grand set (2 Vols.) of a first edition of
Johnson's life of Boswell.

[1]John Biggs, Jr., and his wife, Anna. John Biggs had been F. Scott Fitzgerald's
roommate at Princeton. Biggs wrote two fine novels, both published by Scribner's, be-
fore entering his father's Wilmington law practice. He later became chief judge of the
Third Circuit Court of Appeals in Philadelphia.

[Journal]

November 16, [1932
Chadds Ford]

[Spanish] Today the shearing machine arrived and it is mag-
nificent — During the afternoon, alone with no help what-
soever, I sheared two of the mares (except for their heads which
Charlie[1] is going to help me with tomorrow).

[English] These duties make a most agreeable relief from
studio work[2] — the stable and the farm — (grass pastures) give
me a reason to be out of doors and physically occupied. I am in a
sort of routine or perhaps a better expression for what I mean

would be I am living now according to a certain scheme which I
have always heretofore striven for — till now without success. —
It is a most satisfying sort of thing. I am absolutely never bored
while here or at the studio and when bed time comes I am com-
pletely tired altho I keep wishing for more daylight . . .

[1] A stable hand and occasional butler for the Hurds (see PH to Paul Horgan, May
22, 1934, note 1).
[2] To augment their income the Hurds stabled and looked after the horses of various
neighbors.

[Journal]
November 18, [1932
Chadds Ford]
. . . The new clipper works wonderfully well and Clavelito
and Ermintrude have bright shining golden coats. They are of
course kept in the stable now and have to be exercised every
afternoon after I return from work — It is sport — sometimes I
ride them separately over a course that includes three fences
(and a gate to be opened tho I think I have found a way around
this). At other times when time presses I ride one and lead the
other which is when galloping cross country great fun . . .

[Journal]
November 22nd, [1932
Chadds Ford]
The last of the glowing autumn foliage has disappeared —
Instead there are the moss greens and warm earth colours of
early winter. The fox-grass so particularly beautiful after a rain
and the tawny hills under a sky of great shifting masses of grey
and white cloud. Inwardly I get a stabbing sort of sensation at
beholding this. A sudden realization acute and terrible of the
value of this moment in which we live bordered by the two eter-
nities; and at the same time a longing to paint it to allow my
hand to be dictated by these swift and compelling emotions. I
know that in the past most of the best work I have done has been

when I have felt this. — Of late I have again and again wilfully put off painting telling myself, fatuously, Oh, another time will do and giving myself some trivial excuse for postponement. Realizing this folly I have definitely set out to curb it and I think that while Mr. [Daniel] Garber was most certainly right when he used to tell the class at the P A F A that there is no "I will" in art — here is an occasion where one can exercise a strong will — the will to deny for the time necessary to paint the existence of any exigency or of any thing except the dictating emotions. I think in my case the greatest curb on over production and perhaps a harmful check on experimentation is the terrible sunk feeling I get after having turned out a completely lousy canvas. —

[Journal]

November 29, [1932
Chadds Ford]
. . . Yesterday dressed fantastically but quite warmly in a full half dozen sweaters and jerseys and with an auto robe girded about my legs I stood on the hill above the house and made a sketch. It was late afternoon and looking eastward the landscape was woven with warm greens and browns. I think the sketch came out quite well — anyway it is a start and I mean to make two or three a week from now on for a time.[1] One thing I have learned: that I can keep fairly warm on a very cold day by standing in the engine backdraft of my motor car (standing to leeward of it) and frequently warming my hands with the warm air from the running motor.

The Polo mallets have come from New Mexico — and Charlie and I had a grand time knocking balls about last evening up on the hilltop. Charlie whose dream this has been began with valiant optimism to try to hit the ball with the *end* of his mallet head —

[1] "I hope this program doesn't sink our already leaky ship of finances. Canvas or even board and paint cost like hell" (journal, December 1, 1932).

[Journal]

Sun Dec 11, [1932
Chadds Ford]

. . . Yesterday dawned chill and grey — I arose (with Charlie who spent the night) at six fifteen got my boots polished helped Charlie with the horses and after having breakfast and taking H. to the studio set out on Clavelito for the Mather's kennels. The hounds were scheduled to leave from there at ten and I arrived there at about ten minutes before the hour.

Mr. Gilbert Mather rode down to the kennels from the large white-pillared house where he lives and I introduced myself to him. He is the most candid sort of a person and seemed honestly pleased that I had come to hunt with his hounds. Mr. Mather the Master and the several hunt-servants looked very dashing in their neat uniforms of autumn brown with black velvet caps. The huntsman, Jack Smith looks like a character out of Whyte-Melville[1] and I keep thinking I have seen his portrait by George Stubbs.

We found fox immediately — in the first cover we drew and he gave us a lively chase in two or three wide circles with diameters of a mile or so. The field was about 15 people including the Master's wife and Sister, Miss Josephine. The snow was falling fast on the frozen ground and before long I began to be sorry I had not had Beck put Neverslips on Clavel — Fortunately for me we went south (towards Chadds Ford) into a wild country where there are no fences to jump. Clavel was performing beautifully never once striking a fence rail in all the ride but the powdery snow on frozen ground made a treacherous combination and I was damned glad we came to no more fences after twelve o'clock — At one we were on the hills overlooking Chadds Ford which, in the whirl of snow flakes was barely distinguishable. I decided as we had then found no fox to take my leave — which I did and Clavel and I walked slowly homeward — I lost in a sort of reverie brought on by the acute silence of the snow storm.

We all had lunch at Wyeth's — a very merry one in which many a lusty tale was told . . .

[1] George John Whyte-Melville, nineteenth-century British author of poems and novels on the sporting life, was considered an authority on fox hunting.

[Journal]

Dec 14th, [1932
Chadds Ford]
. . . In the afternoon as I was finishing up for the day Deborah Rood[1] came in the studio and we had an hour or so of talk — It was twilight when I returned and as Charlie had had two of the horses out I bridled Ermintrude and jumped on her for a ride on the upper pasture. The snow had not melted at all on the hilltop and its luminous surface gave to all things a strange cool light. I enjoyed the experience of that swift gallop into the twilit landscape. It was one of the *moments*.

[1] A country neighbor who raised thoroughbreds.

[Journal]

Dec 26, 1932
[Chadds Ford]
New Mexico really seems imminent again. The day before yesterday came Col Pearson's reply to my inquiry in which he seems very warm toward the idea of my making a fresco for the new J. Ross Thomas memorial at the Institute, to be completed (the building) around May 1st. I am tremendously excited; such a cause as a real commission would make my departure from here much easier. I am asking the lowest figure possible in hopes that price won't stand in the way of my getting the commission . . .

To Paul Horgan

Jan 2, 1933
Chadds Ford
Mon Très Cher Paul:
There is no one *anywhere* anything like you — first the grand box of Mexican glasses — eight perfect beauties which charmed both of us. Then your swell letter which arrived last night just as we were departing for the Greenewalts on a New Year's Eve party. Otherwise it could have been then that this

answer would have been written — I can't tell you how com-
pletely delighted tickled bowled over and C. I am concerning
the [NMMI] job. What a swell room to decorate: I of course de-
tected your influence as soon as I read the specifications. — well
— nothing could be better and if the [Board of] reegents [sic]
don't go completely philistine on us, I am all set.

However the whole nucleus of my scheme is doing them in
fresco — regardless ir-regardless as Uncle John[1] says of when I
have to go down there to do it. You see — I have made the dis-
covery of a splendid thing (a rediscovery) in the dry fresco which
has amazing decorative quality — remarkable brilliance and
complete flatness — with absolutely no shine in any light! I can't
tell you what a boost it has given my work — this new technique
— which combines all the brilliance of watercolour with the
great advantage of being readily wiped out — or if dry sand-
papered out and passages redone. You will be crazy about it as a
medium. All sorts of effects are possible — washes, stippled
effects, smeared colour — thin palette knife impastos & glazes.
All the worries canvas has had for me as a ground are removed
by using the gesso surface. Bothering about flatness is prac-
tically obviated by virtue of the fact that it comes willy-nilly.

In a second letter to the Colonel I stated prices — $850 for a
panel involving 60 sq ft or under — from 60 sq feet to 150 sq ft
$10.50 per sq. foot which is so damned "reasonable" that I won-
der if when I've hired an assistant to help with the plastering
and pouncing the design as well as paid for materials and a scaf-
fold I won't find I have contrived a beautiful bag for myself to
hold! But the thot of adventuring onto a big wall space no longer
terrorizes me and the joy of doing a brilliant work in sympa-
thetic surroundings in and of New Mexico is almost reward
enough by itself, — would be — if it weren't for a family to sup-
port here!

In this second letter to Col. P. I suggest my going out early
in April (after Lady Fox's blessed event[2]) sizing up the job space
surroundings etc — making sketches and a cartoon then when-
ever the workmen are out of the way putting up my scaffold and
having at it! One of the greatest advantages of this scheme is that
during the planning and probably the execution I would have

you there to help and to advise me. Boy! am I hoping this doesn't fall thru!

. . . I am glad you tell me to make the themes comprehensive. I of course had no idea before your letter how large an area would be decoratable. I will be turning the matter over in my mind altho the final decision as to theme need not be made till I get to Nouveau Mexique. — The big panel in the south end (of which you enclose a drawing) seems certainly the place to begin. The actual *painting* (i.e. final operation) of a panel say 10 x 11 feet shouldn't take more than three or four weeks at most, provided it isn't very complicated and full of difficult drawing. Of this type of thing I want to steer clear and make my things as direct and simple as possible — which treatment should certainly go well with the room, from your description.

The series for Annapolis — (which I deceitfully didn't expatiate on to the Col. allowing him to think it might be a mural job —) consists of 9 or more full colour paintings showing significant events in the evolution and growth of the midshipmen in the U.S.N. to be used as the sole (thank heaven!) decorative work in the 1934 Lucky Bag.[3] [A] good enough job and I'll try to do my damndest to make them an attractive book — but of course all such historical painting so called is tripe unless you have lived and dreamed it until you *have* to kill the fever of it by doing it in colour, or words — in your case. Isn't it ironical — an old desert rat like I am, being elected to do maritime things.

Beside the winter panel for Mr. Stone which I am soon to begin I have still got the McKay Sea Stories to finish. I am only ½ finished — also I have a horse portrait to do for one of the Doo-Ponts which I am glad of. — I have done several of these in the past year and a half — but this is the first commission of this sort with gold in it.

. . . I am of course deeply grateful to you for being my impresario at the Institute. The sketch was just what I needed and has given me a fine idea, with your description, of the room . . .

[1] John McVey, a native of Chadds Ford, was affectionately known as Uncle John. PH painted his portrait, called "The Old Homesteader" or "Uncle John McVey."

[2] PH rode Lady Fox in a Wilmington horse show in June. ". . . no ribbons which

does not disturb me in the least for I don't take horse shows at all seriously" (journal, June 9, 1933). In 1940 Lady Fox broke a foreleg and had to be destroyed.
[3] The yearbook of the United States Naval Academy.

To Paul Horgan

Chadds Ford —
January [1933]

. . . I suppose the reason I have heard nothing further is that the matter of price hasn't yet been discussed with the Regents. One reason I am anxious to know soon what they are going to do is to discuss with the builders the kind of plaster surface and lath they use — I think it should be fairly rough in texture and the lath would be better [on] steel or some material (tile?) other than wood, which would be slow to dry out thoroughly.

I am trying to dope out a way to have Henriette and Peter taken care of here while I go to Calif. with Aunt Susan in the middle of Feb. from thence to Mexico City to see the frescoes there and return to meet her in Roswell and talk over the mural with you and Col. Pearson deciding subject getting an idea of surrounding colour dimensions & c. I would then return East (with Aunt Susan who is giving me the trip out and back) and make my research (if any is needed) draw sketches and cartoon here where I would have H.'s and Wyeth's criticism then return to N.M. anytime thereafter to execute the decoration on the wall . . .

[Journal]
Chadds Ford February 2. [1933]

It seems to be set — we're leaving on the 16th and I am as busy as anyone could be these days — finishing the winter panel[1] in the remaining time — as well as making all the arrangements for the household[2] here and my trip.

I am above all anxious to whet my sensitivity to the greatest degree attainable — To make every single moment a vital and receptive one. This is always easy at first but becomes increasingly difficult as one continues seeing new things . . .

[1] For the Stone dining room mural decoration.
[2] Henriette and little Peter planned to move into the Big House while PH was away.

[Journal]

⟨Chadds Ford
October 20, [1932]⟩
. . . [Spanish] And now my land how I long to see you!

To Henriette Wyeth Hurd

[February 18, 1933
Chicago]

My Dearest Minx —

Do I miss you! Busy and Greatly excited over the trip I am but darling I miss you like the devil. That is the principal purpose of this scrawl to tell you I hate like hell being separated from you and Pamoo![1] I keep wondering what you are doing at given moments; if you had any trouble moving — or rather will have had as this is only Friday. I hope you didn't get a cold and that Pamoo's is all gone. Does he sometimes say —"whea' *is* Papa?" You know the inflection.

I will now in the few minutes remaining before I board the Golden State Limited give you a resumé of the events up to now: I landed in N.Y. shortly after noon went right up to Rehns Gallery where I found Tucker's work — It is honestly most uninspiring stuff. Leaning heavily on Van Gogh and the impressionists his things are absolutely wanting in any *passion* or real *guts*. I know I am right! They are lousy canvases — I hope your Father sees them tho just to see if he doesn't agree.

. . . I went to several other shows none worth a G.D. except the Maillol which was fine. Saw Chapin Miss DeVoy and George S.;[2] the last promises to try to get me some horse portraits to do among the Essex crowd. *Está bien!*

Met Aunt Susan's[3] train and together we boarded the Manhattan Ltd. attended by a platoon of eager redcaps.

Today between trains in Chicago while Aunt Susan rested

here I went to the Chicago Art Institute.[4] Saw some Marvelous
things. More than ever I know Tucker and those others are weak
as lamb's piss. The tremendous El Greco[5] was not on view. I was
sorry but I saw many other things I hadn't seen before. The In-
nesses were badly hurt by a wholesale and indiscriminate redo-
ing of their frames — à la Modern French. Of course these
darkish glazed things couldn't stand this. I saw some grand Van
Goghs — Bellows — Renoirs Cézannes (several new ones)
Degas — Poussin — Rembrandt — and far from least a tremen-
dous Constable — a canvas 5″ x 6½ done in the same manner as
his sketches — A Marvelous thing honestly — which holds its
place with any modern there is —

 I must run now — Aunt Susan sends her love — You know
you have all mine — You and Pamoo — I adore you sweet. How
I wish you were here now. You know what we'd do —

<div align="center">

Adios

Peter

</div>

Love to all the Family — Ma, Pa, Carolyn, Annie, Andy, Nat —
Pamoo and You

<div align="center">

P.

</div>

[1] A nickname for Peter Wyeth Hurd. Others included "Chuki" and "Flea."

[2] Editorial and managerial staff at Scribner's.

[3] "Being with her is always a most easeful thing — so much so that I have grown to
regard her quiet sympathy not based on anything other than love as a most stimulating
thing — in an indirect but potent way" (journal, October 20, 1932).

[4] "I was much moved and greatly stimulated by this — without feeling I have
really done anything yet still I had the feeling I am not really far off — that — with
continued progress — and every effort I can bend — I will really be someday — among
the American Painters" (journal, February 21, 1933). See PH to Henriette Wyeth, draft
[December? 1928].

[5] The Assumption, an altarpiece.

<div align="center">

[Journal]

</div>

<div align="right">

Estado de Durango

E U de Mexico

Feb 21 1933

</div>

. . . At Alamogordo I awoke on Sunday Morning to see the
sun rising over the sierras — I was half asleep for several mo-
ments and it seemed a marvelous improbable dream my seeing

those sierras with El Blanco in the distance to the northeast with
the early sun touching with rose its snowy heights. What a Mo-
ment — It was one of ecstatic happiness as I realized suddenly
that it was real and actual. I hastily dressed and ran out on the
platform my lungs expanding with that delicious and exhilarat-
ing air . . .

To Henriette Wyeth Hurd
El Paso —
Monday Feb 21, [1933]

My Darling Henriette:

But for a hitch with the Mexican Immigration service[1] yes-
terday I would be arriving now in Mexico City — As it is I am
just about to board the train. The day was not entirely lost — I
met (as *you* can well believe) an old friend — a Mexican boy in
Juárez who insisted on giving me a letter to a particular friend of
his in Mexico. In return I made a pencil drawing of him which
he gravely terms a maravilla tho there is little marvelous about it
— I went with him to the plaza de toros and we went into the
ring wandered around looking at the *Toril* where the Bulls are
kept at the rather flimsy *burladeros* — the protective ramparts
you remember.[2] It was a strange experience being alone in the
ring seeing the seats now empty where once we two sat on a
scorching July afternoon. The great Cagaucho is going to *torear*
here next Sunday — I shall miss this — He is highly praised by
Hemingway.[3]

. . . I am a real credit to you — not one single day missed
yet in shaving! I refrain with difficulty from underscoring that! I
miss you *like Hell.* Honestly like the Devil — when I called
home I kept calling Mother, "Henriette." Darling minx — Be
very careful of yourself — I keep this in mind all the time — and
have no desire at all to take any unnecessary risks — I adore you
Darling, always — O I wish you were here

Always your
Peter

The Porter has come to put me on the train.
P.

[1] [Spanish] "I was told that I could not enter the Republic of Mexico — the reason being my immigration card that says that I am going to study the frescoes of Rivera. Of course it was an error of the consulate in Philadelphia but a fellow named Luna, a wise-guy, stopped me hoping to receive a tip. I gave him some dough and he submissively fixed all my papers the son of a bitch!" (journal, February 21, 1933).

[2] The Hurds had visited the plaza de toros in Juárez on their honeymoon.

[3] PH had recently read Hemingway's *Death In The Afternoon*. "I find it tremendously stirring and stimulating. He is a man who seems to partake entirely of the cynicism and the crassness of the post-war period yet to be equipped with such sensitiveness that I wonder that such dissimilar qualities can be sustained in combination. Not that Hemingway is himself — as a writer crass — but a crassness of milieu sometimes so pervades his work that it seems he cannot but be of it himself — It is certainly the most incisive writing of today that I know anything about — Faulkner is often fine but having read only "Sanctuary" by him I don't feel at all competent to say how great I feel he is. It seems to me that the average novelist is to Hemingway a good deal as Murillo is to Goya — In fact the association of Goya and Hemingway appeals to me and has I think validity" (journal, November 9, 1932).

To Henriette Wyeth Hurd

[February 21, 1933
Mexico]

. . . My Mexican friends in Juárez turned out in fine style to speed me on my way. I am promised all sorts of things when I return — the not least bizarre being a pleasure ride on a Mexican Cavalry horse — with Enuardo and Luis, both doughty horsemen. After the hour in Juárez Station amid yells and cheers from the mob on the platform and all sorts of exchange of pleasantries with the armed military escort[1] which occupy the leading car, the engine gave a terrific shriek spun the drivers on the track — and we were off.

. . . We are now in the State of Coahuila: Sierras on all sides great ranches with scores of peon laborers plowing with tiny mules, smaller than those in Carolina.[2] Spring has been here six weeks and the flowers are blooming everywhere. Eucalyptus Date palms acacias & cottonwoods the last in full foliage here — altho last night in Chihuahua they were white sere skeletons. We still have a day to travel before reaching the Capital.

. . . I have made a *tremendous* hit with Death In The Afternoon. I am the storm center of a voluble, gesticulating group — mostly the train crew & all aficionados — of the Bull Fight.

What a train this is! The military escort is singing a sad song in the coach ahead . . .

[1] Necessary on trains at that time as protection against possible bandit raids.

[2] PH and Henriette often vacationed in Charleston, South Carolina, and at Cat Island Plantation, where they had spent two weeks in January.

[Journal]

Estado de Durango
E U de Mexico
Feb 21 1933

. . . Now, speeding across the plains of Durango in a mixed company of passengers who speedily came to know one another — I am having a grand time, tho we haven't yet reached the heart of Mexico it has all been marvelous — The to me delicious smell of dust the glare of sunlight — the sound of Spanish every-where — and — perhaps what is most important — the *Simpatico Mexicanes* — always their point of view is like my own — I can't analyze it — it is no longer anything like a mere romantic interest — I have a deep set & completely pervading love for the Mexican people — [Spanish] I know them and love them more than my own people . . .

To Henriette Wyeth Hurd

Feb 1933
[Mexico City
Hotel Regis]

Darling Henriette

Your wire was a grand surprise: It is a fine comfort to take it out of my pocket and read it when (as often) I think of you with acute longing. The merest sight of a hat or a dress only *something* like some one you wear — or seeing a little child near Peter's age always sets me going no matter how occupied I am. I am completely devoted to you — Henriette Darling, and you are the only person I could love entirely and passionately. The times we have spent together since that winter when we met nearly ten years ago seem to me the only part of my life when I

really lived. I adore you Sweet — you and only you I long for now and always. This can only be a note and if it succeeds in bearing you some of the comforting warmth of your telegram to me its mission will be fulfilled. I will tell you in my next about Mexico . . .

To Henriette Wyeth Hurd

Mexico 25 Feb, '33

. . . I have gone nowhere outside of the city so whatever I tell you in this will be of the City of Mexico.

Picture just the *alameda* a sort of park covering about 25 acres — or the better to give you an idea of its size 5 blocks long and 2 wide. Here all thru the day people come to lounge to sell their wares to take advantage — in the heat of the day — of its hundreds of shade trees — They are all in foliage and of those I can recognize there are black poplars, ash trees — (tremendous ones) palms of many kinds and acacias. Between the paved walks and around the trees grows a rich, thick green grass — watered each morning early by a band of barefoot peons. It is a most beautiful park and unlike most others I know of is kept absolutely free from litter of any kind!

Along one side of this runs the Avenida Juárez the city's 5th Avenue. Beyond this on all sides, picture an endless series of typical Utrillo scenes under an ever-cloudless sky with occasional glimpses of distant sierras over the house tops.

. . . There are many huge markets — Mexico City has a million inhabitants and such running around such stir I haven't seen in ages — crowds, hurrying motors (myriads of them) their horns braying, small rickety brilliantly colored Ford *camións* heavily loaded with people and charging at a terrific pace . . . One's impression is of tremendous activity a constant buying and selling the gabble of hundreds of voices (mostly haggling). There are honestly more people with things to sell in Mexico than I have seen in years.

. . . Coming into Mexico at this time I have profited greatly by the exchange. Just think, three pesos and 54 centavos for one American Dollar! I am now living at the University club — And

my room here costs me eleven pesos a week about three dollars and fifteen cents! The entire pullman — 2 nights to Mexico City from Ciu. Juárez was only seven dollars and a lower berth too!

You would be entranced by the flowers: Roses, sweet peas, Geraniums, the rare brand Duke Jasmine and *many* whose names I haven't learned.

. . . In all parts of the city I am struck by the number of soldiers military uniforms everywhere — The officers all carrying large automatics at their sides even when not on duty — a bit of latin-ism.[1]

. . . It is of course futile to try to draw any conclusions about Mexico so soon and I shan't try — Only this I will say: These people here have no idea of the financial crisis as we know it. There is food a-plenty and money is circulating. I have been to see the Rivera Frescoes (and Orozco's) here in the city. I still have those to see in Cuernavaca. I have mixed feelings about them which I shall try to express in a letter to your Father — as soon as I have seen those at Cuernavaca . . .

[1] "There is a sort of indefinable cruelty and starkness which to the casual observer is hidden by palm-lined *prados*, pied with flowers — by songs and dancing everywhere; by a carefully studied politeness among strangers and among friends. But this is the mask. On the wall of a house just around the corner & half hidden by the perfumed wares of a pretty Indian flower girl are the scars of machine-gun and rifle bullets" (PH to Henriette Wyeth Hurd, March 11, 1933).

To N. C. Wyeth

[March 4, 1933
Hotel *Los Arcos*
Taxco, Guerrero, Mexico]

Dear Mr. Wyeth:

I will have to admit the decorations in Mexico were some of them a disappointment to me. Rivera seems so hopelessly bound up with an endless lot of idealistic social theory which — my feeling at least was — could better be expressed in writing. In fact he does write a great deal on many of them to expatiate better on his ideas. They were largely disappointing altho it was interesting to trace the sequence of his development from the first fresco to the last one finished some four years later.

But yesterday at the Cortés Palace in Cuernavaca I was really swept off my feet — Here was Rivera untrammeled — no half-formed political theories clouding his mind — Here he was in the true field of the mural painter — his job was to show the conquest of Cuernavaca by the Spaniards, the subsequent erection of Cortés' palace and the period of the suppression of the Indian until the coming of Emiliano Zapata the great Indian leader of the State of Morelos who brought them freedom. He has done a grand job! His frescoes here as elsewhere face the open air protected only by a roof, supported by arches & columns. The strong sunlight is reflected everywhere upon them and as you can imagine it was no time to stint in Colour — He didn't! His palette is much more forceful than the things in N.Y. indicated. Like the best of them there — gone much farther.

Here as always I am struck by his simplicity of form and now suddenly I see what a marvelous ability he has to turn practically everything into a symbol which fits his vocabulary of hieroglyphics. I recognize trees plants utensils etc etc which I have seen in life, but all have been given a timeless quality by the subtle way he has adapted them into the cosmography he has created. This is one of the most significant things I have learned about his work down here. You felt it in the New York things — of course — but not nearly so completely as here.

Of the other men here Orozco is of course the most interesting. But his things have an oppressive quality about them that I have found hard to analyze. The most important ones are in the preparatory school in Mexico and they are within reach of people's hands who pass them. It is hard to get into the spirit of a great decoration expressing the Revolution or something of the sort when the kneeling figure in the foreground representing the poverty stricken peon has a great pecker standing forth from it a foot and a half — the artistry of some Mexican brat with a sharp instrument on the plaster. This and other similar things as well as a generally oppressive atmosphere made the Orozcos in the school have little real significance for me.

But the Riveras at Cuernavaca are tremendous things! I wished often you could have been there with me . . .

To Henriette Wyeth Hurd

Tuesday March 7, 1933
[The University Club
Mexico City]

. . . I have just come back from Chapingo to see the only remaining Riveras which I had not yet visited. They are really stunning! I am not over balanced either because he is a Mexican — There has been plenty of his things that I have been entirely unable to react to. But in the Chapel at Chapingo where I spent about an hour all alone (the authorities kindly turned over the keys to me,) I truly felt I was in the presence of a tremendous work. Many of these I had never seen before and such as I did know were ever so much better in the original. At Taxco last week I got all of Rivera's Fresco formulae — type of brushes paints — much advice — in short everything I came here for. It was very curious how I found it. We[1] got to Taxco late in the evening went to an inn and had a bath and supper — Next morning — knowing no one there at all I began wandering around looking for the post office where I wanted to post a card to you. An old lady directed her grandson — a little boy about ten years old to guide me thru Taxco's steep cobbled streets to the P.O. There after my card was mailed he asked with the air of a professional guide what more I would see — adding that whatever there was to be found in Taxco he could find it. So I decided to put my problem in his hands. I wanted to find a painter of frescoes and talk with him. The kid frowned thoughtfully a minute then motioning me to follow struck out up one and down another of Taxco's narrow winding streets. We climbed and clambered thru yards and gardens & literally over house tops, Taxco is so mountainous, and finally came to a stop at the Hotel *Real* — which I should say was royal in no thing but name. Out on a tile roofed balcony overlooking the town of Taxco we went and into one of the rooms — I followed the kid. There sitting at a table drawing was a young Mexican who introduced himself as Ramón Montes. It took but a minute to find out that he did know something about fresco that he was even then working on a cartoon for one at the *Tasqueña* hotel. Moreover right there on the

table was six typewritten sheets written by Alba Rivera's assistant describing accurately and closely the procedure in fresco painting — So how about that for a coincidence — perhaps it happened at the moment some of yours were happening to you! I copied carefully the entire thing and have it now . . .

[1] PH had met up for a brief period with two friends from Chadds Ford.

[Journal]
Estado de Aguas Calientes
Mexico 13 de Marzo.

This trip has certainly been everything I had hoped — and more — of the good gotten — the principal part is the information relative to the painting of frescoes the formula used by Rivera and the actual seeing of the decorations. — Secondly the intimate contact with the people of Mexico[1] and the realization that for me the place to paint still is New Mexico — But the Mexican people there now take on a new meaning after I have glimpsed Mexican civilization — at its best — and also probably worst, for it is the quality of Mexico to deal in extremes. Grand as the country is and colourful as the people are I yet somehow never once got anything like the *wrench* the moment of overwhelming emotion as when that dawn last month I saw the Sierra Blanca from the pullman window . . .

[1] "I have met and grown to know very well — store-keepers and bull fighters, club servants and American colonists, peons and young Mexican 'men about town' the last a strange and humorous travesty of the New York article" (PH to Henriette Wyeth Hurd, March 13, 1933).

To Henriette Wyeth Hurd

March 17, 1933
[Roswell]

Darling Minx:

It is very strange to be sitting in the Studio here again writing to you. I have trouble putting aside that same old oppressive feeling of doubt and yearning.[1] But rereading your letters — which I do often breaks the spell.

This country all seems so curiously high-keyed in colour after the tropics — particularly now when trees have (due to a sudden cold spell last month) been greatly delayed. In Mexico colour and values were in a richer lower octave. As always the emotion caused by suddenly after a long absence being near things which I have always known grips me. The funny old Chinese bell in the dining room, the serene blue peak of Capitán & certain weeds that seem to grow only here. Do you know how this is? It is particularly true after traveling a month in a land where everything was entirely new.

I was jubilant at the news of your fine press. I can't wait to get from you the clippings. Paul was here last night and is the same charming person, alert witty and extremely stimulating. We both await eagerly the clippings!

Last night we worked out together a magnificent scheme for the decoration of the Lounge room of the new building. It is a monumental and inclusive theme[2] which can stand in parts or as a whole and yet is perfectly fluent. I can't tell you about it here as I have to meet the Colonel in a few minutes to show him the model and Description Paul and I made here at the house last night. God knows if I'll ever have it to do but it is great to think about and hope for! . . .

[1] PH is referring to the fall and winter of 1928–29, when he was living in Roswell and his future with Henriette was uncertain.

[2] "The theme I used deals with the three dominant racial stocks of New Mexico — the aboriginal, Spanish and Anglo-Saxon — the pageant of their conflicts and changing relationships through the centuries" ("Painter of New Mexico," *Magazine of Art*, July, 1939).

To N. C. Wyeth
[Draft]

[March, 1933?
Roswell]

Dear Mr. Wyeth,

Your letter with the prints has stirred me almost constantly since its receipt last month; I have read and reread it and if my answer seems slow in coming, count it that I realize what a standard you have set me in this letter. The reproductions were

complete revealments of your established place in Contemporary Art. And I look forward to their public exhibition with interest. Not that their contemporary reception really *means* anything. It seems to me that a painter stands less chance of making a great sensation today with his work than does any other artist. And this very quality is I think probably a good one — He has less chance of being thrown off his balance by adulation — And if he is a sincere artist it seems he can work on without the temporary exhilaration of this and without fear of having to paint to the pleasure and taste of a certain public.

Together with your letter and reproductions the fine books Henriette gave me for Christmas on Van Gogh Cézanne and Vlaminck are proving a great stimulation (These you must see when we meet again. They are grand!) So my oasis out here is I think a well-nourished and fertile one in spite of the fact that there is no one — with perhaps one exception in Paul Horgan who knows the first thing about the arts. But the harshness of their ignorance is softened by a genuine and widespread interest. People here do seem moved by the beauty of the country. Perhaps it is because the tempo is a bit slower here and there is time for observation & meditation. I know you think western people in general are lacking in an inner reflective power — but I disagree with you in this. Of course one finds arid natures in many people — but there is also a deep resonant richness among the mountain folk [and] a simple mysticism if one can combine the two words. I mean by this there is a continual naive and child-like speculation on the phenomena of the world physical & metaphysical and on the universe.

My own work, I'm sure progresses, and in spite of the Stone Decoration[1] which I know now was no advance — Nevertheless I have some canvases which I know would interest you in their direction. I am paying scant heed to the plaudits of the well meaning but little comprehending people here, if my work were much worse or much better it would receive the same praise! The first still life — of which I wrote you sold for three hundred dollars and brought me a commission for a companion piece from the same man.

The uncertainty of my immediate future bothers me some.

I wish constantly for a more stable location.[2] Of course my new Studio is a splendid pro-tem place to work and a fine gift. But I suppose I don't have to tell you my devotion to Henriette continues unabated — rather it goes on with increasing intensity. I know she is doing some real painting and thru it making an enviable name for herself but love makes small account of such things — and I am never happy without her. I guess this point of view you won't like to hear but selfish tho it may be it is the truth.

I am reading Proust's Swann's Way (the first Vol of his long novel) and find its slow moving & re-created incidents of the narrator's early life very interesting and provocative of similar excursions on my part into my own memory. Frost's Running Brook I didn't think came up to his former books of verse tho I enjoyed some few of the component poems. What did you think of this? I haven't yet seen Hardy's posthumous book of verse but expect to soon. I wonder what Fergusson's[3] forthcoming (or is it out) book will be. Someone has lent me Blood of the Conquerors but I haven't started it yet.

I think often sometimes in minute detail of the past in Chadds Ford — and I fancy derive stimulation from these now bygone times. How poignant was your own picture of your Mother in the kitchen at New England and looking at it one feels echoed the crash of emotions which must have played in your heart as you painted it. The storehouse of the past seems to me to be constantly growing richer and I find myself more regularly delving into it, often with the paining realization of past times' irretrievable remoteness . . .

I am sending you soon a new copy of the Life of Inness to replace the older one of yours which I found among the possessions I shipped down here. — Unless you want the older and soiled copy (many stains of them I'm afraid mine) I shall keep it. Also with this goes a belated copy of the Last of the Mohicans[4]. . .

[1] See PH to Paul Horgan, July 21, 1932, note 2.
[2] PH probably means a place of his own in New Mexico.
[3] Harvey Fergusson, the novelist (see PH to Paul Horgan, April 19, 1949, note 6).
[4] See PH to Mr. and Mrs. N. C. Wyeth, September 28, 1929, note 7.

To Henriette Wyeth Hurd

Sunday — March 26
1933 [Roswell]

Darling Bean:

Here is I hope my last letter to you — at least for a long, long time. This separation has been cruel — I realize more than ever how different are experiences when one is alone after having become used to a companion who shares everything. I have missed you terribly — and a graph curve of this quantity would show an incline with each day that passes. Do you know how essential you are to me? Happiness as I knew it in the last months before my leaving I haven't really known since seeing you disappear thru the station door. You complement me in such a complete way — It is really as if part of me were not along. Actually so far as I can analyze myself I am growing steadily more needful of you as time goes on (I don't mean just since I've been away). You wrote me recently (in a letter I can never forget) that I am a good companion to you — It is this very quality which *you* have to such a degree that it makes me think what I have learned has come from you. There is no one I so like to be with as you.

Sitting here in the shade of the studio I keep remembering those dismal days in the fall of '28 when I used to sit here wondering if you continued to love me; wondering and conjecturing on when we could marry. Now that those times are bygone I know they were valuable — That time of duress taught me to evaluate you — I knew then how utterly wretched I would be without you; how frightful would be my yearning. Sometimes you have said we are changing — you (momentarily at least) lament the passing of that first love — I'm sure as I read and re-read your letters that you can't really feel this is so. To me it seems that that first rush of our love has been replaced by a steady comfort in one another — a devotion that I then knew nothing of but which I now find tremendously more satisfying than anything else. Isn't this so?

Today is a marvel of clear blue distances, of radiant, quivering mirages and gleaming snow peaks. The trees are leafing now; a storm of bees is looting the pussy-willows in front of where I

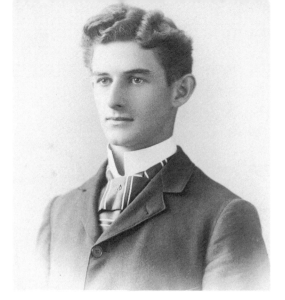

Left: Harold Hurd, Peter's father, June, 1892. *Courtesy Henriette Wyeth Hurd. Right:* Lucy C. Knight, Peter's mother, about 1895. *Courtesy Henriette Wyeth Hurd.*

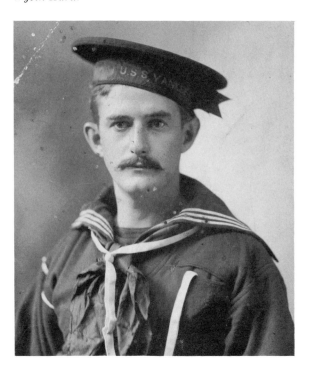

Left: Harold Hurd as a navy volunteer aboard the armed transport *Yankee*, 1898. *Courtesy Henriette Wyeth Hurd. Right:* Lucy Knight as a bride, 1902. *Courtesy Henriette Wyeth Hurd.*

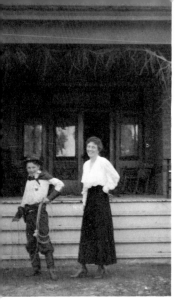

Left: Peter and his mother in front of the Hurds' Roswell house. *Courtesy Henriette Wyeth Hurd. Right:* Aunt Susan Hutchins, Peter's "second mother." *Courtesy Henriette Wyeth Hurd.*

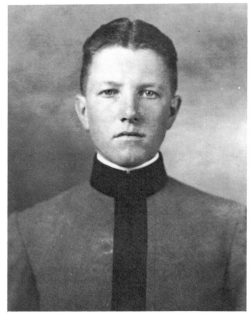

Left: Peter in Chadds Ford, Pennsylvania, about 1928. *Courtesy Henriette Wyeth Hurd. Right:* Peter Hurd as a plebe at the United States Military Academy at West Point, 1921. *Courtesy U.S. Military Academy Archives.*

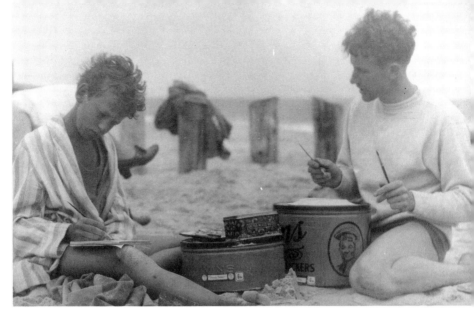

Andrew Wyeth (left) and Peter Hurd at Rehoboth Beach, Delaware, 1928.
Courtesy Henriette Wyeth Hurd.

N. C. Wyeth near his studio in Chadds Ford, 1944. *Photograph by William E.
Phelps, courtesy Henriette Wyeth Hurd.*

Hurd (right, first row) building his own ranch in the mid-1930s in San Patricio, New Mexico, helped by local hands. *Courtesy Henriette Wyeth Hurd.*

Sentinel Ranch, about 1965. *Courtesy Henriette Wyeth Hurd.*

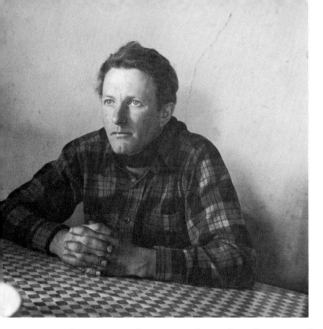
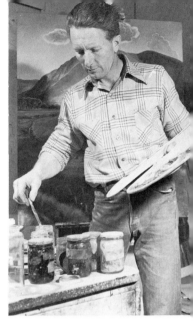

Left: Peter Hurd at Sentinel Ranch, July, 1939. *Photograph by Peter Stack-pole,* Life *magazine, Time, Inc. Right:* Peter Hurd in his studio at Sentinel Ranch, using raw pigments taken from minerals on his own land. *Courtesy Henriette Wyeth Hurd.*

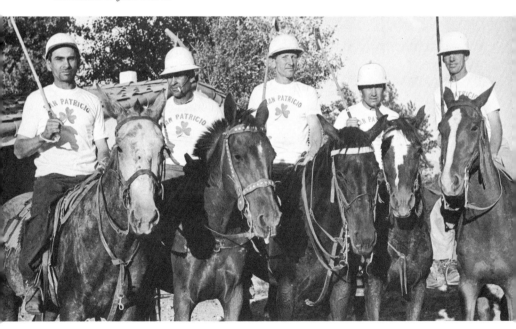

Peter (center), a dauntless polo player, and his New Mexico polo companions. *Courtesy Henriette Wyeth Hurd.*

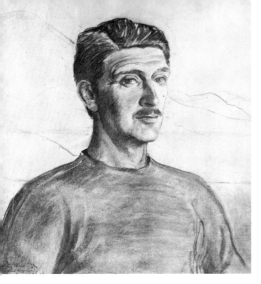

Left: Portrait of Eric Knight, about 1939, by Peter Hurd. Charcoal. *Courtesy Collection of American Literature, the Beinecke Rare Book and Manuscript Library, Yale University. Right:* Portrait of Jere Knight, 1941, by Henriette Wyeth. Oil on canvas. *Courtesy Jere Knight.*

Left: Paul Horgan, 1950. *Photograph by Rodden of Roswell, courtesy Henriette Wyeth Hurd. Right:* Portrait of Chookie (Peter Wyeth Hurd), about 1959, by Henriette Wyeth. Oil on canvas. *Courtesy Collection of the Brandywine River Museum.*

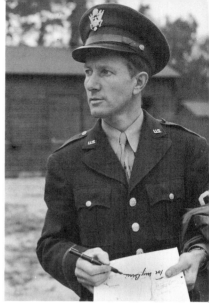

Left: Michael Hurd, 1981. *Courtesy Henriette Wyeth Hurd.* *Right:* Hurd as a war correspondent for *Life* magazine, 1942. *Courtesy Henriette Wyeth Hurd.*

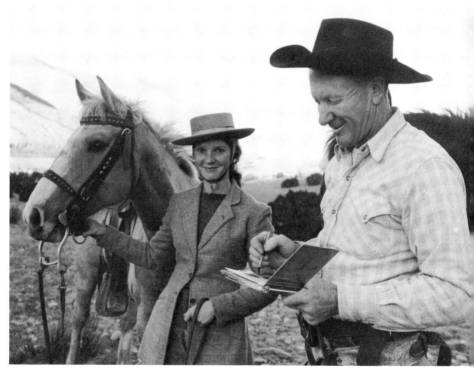

Carol Hurd and Peter, about 1955. *Courtesy Henriette Wyeth Hurd.*

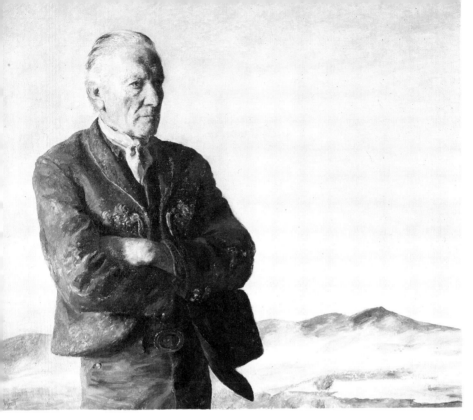

Peter Hurd in Landscape, 1972, by Henriette Wyeth. Oil on canvas. *Courtesy Richard Reilly.*

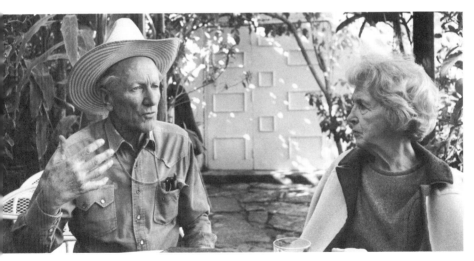

The Hurds in the Orangery at Sentinel Ranch, 1978. *Photograph by John Young, courtesy Henriette Wyeth Hurd.*

sit. A mocking bird in the Carolina Poplar down near José's[1] house is praising the day so loudly that I can hear her from here.

Interlude: Mr. & Mrs. Ames[2] just arrived and spent a few minutes with me in the Studio. Mr. Ames is strong for my plan of decorating the School, plans to see the Colonel this week to stress to him the Advertising possibilities of the project.

. . . *Next day* —

This is just a few hours before we[3] set out for Vaughn by automobile to catch the Rock Island train for the East. It has been a most satisfying visit here — Some great change has come over us — somewhere. I don't know where it is and am not anxious to analyze it. It is probably a change on all of our parts — One thing is most apparent to me: that there is much less nervousness & worry — My Mother and Father are both extremely well and good health seems for the first time to be taken for granted — No more headache cloths at the breakfast table! A fine spirit of content prevails. The farm is prosperous & much of the food comes from it. Don't think I'm dreaming all this, it was apparent from the start but a skepticism born of the remembered past kept me from speaking much of it. The entire stay here has been absolutely fine not even a hint of any friction.

. . . I am bringing back with me a packet of your Father's letters to me. Several I reread. They were as fresh and warm and as strongly stimulating as ever. I felt suddenly very close to him. I really owe him everything. We must never grow apart as we began to (due *to me!*) a couple of years ago. This phase has passed and I feel he knows it. I love him and believe completely in his greatness both as a person and as an artist.

You my Darling wife — I adore — I am mad to see you again . . .

[1] José was the gardener on the South Highlands farm.

[2] Ben and Isabel Ames, an older Roswell couple, were close friends of the Hurds. Henriette painted Mr. Ames's portrait.

[3] Mrs. Hutchins, having visited relatives in California and her brother Harold in Roswell, made the return trip with PH to Pennsylvania.

When Peter left for Chadds Ford in April, Colonel Pearson, though interested in the mural project, had made no commitment to it.

To Paul Horgan

May 16, '33
[Chadds Ford]

. . . The visit with you — in spite of its briefness and its unfortunate termination was great — As always you imbued me with a sort of burning impatience to get started — to lose myself entirely in some work. I champed at the bit all the way home — (in consideration of Aunt Susan not too visibly) and no sooner was I arrived here the welcome celebrated (*some welcome* too!) than I launched into my book of Sea Stories for McKay. The black & whites for this are without doubt my best illustrative work yet. I hit a good stride and the series seemed to grow out of those I did for you and with you when I had la gripa or flu or whatever I did have in New Mexico five years ago. These new ones are simpler less involved in pattern and yet with design I think very carefully considered. There are eighteen of them in all — with also a lining and title page as well as sundry headings & decorations. I of course wish continually you were here to help me plan the format. McKay is dumb as hell but has the saving grace of being amenable and not at all arrogant. My title page is one of my best things so far I think. The title by the way is — Great Stories of the Sea and Ships Edited and with an introduction by N. C. Wyeth. I am anxious to make it as distinguished a book in format as yours.[1] The gesso board helped enormously in this series which is done with a sort of engraving method revealing white under black in places. A splendid aid in this has been the little jars of Johnston's ink which you gave me. It is superb stuff and tho I have only used a little of it it has always pulled me neatly out of any difficulty.

. . . But chiefmost of your lavish gifts to me Sir is the hat which is my pride and joy. It fits nicely into a slender category: it answers and satisfies the demand of my vanity for a hat with dash and bravado to it and yet does not draw the comments of the roving bands of urchins in Wilmington. Charming hat! Henriette is as attached to it as I and brushes it regularly.

Can you come East this summer — if I have the murals to do we could all drive back together to N. Mex, wouldn't that be great? I really rely on your being there when I work on them.

Perhaps you don't know how much a collaboration I mean to make this. It certainly has begun as one. No sketches or cartoons as yet tho I have been incessantly turning the matter over in my mind and am soon going to begin.

. . . How about the Rivera "scandal"! We had just been planning a trip up to N.Y. (H & I) to watch him at work on the fresco there when the news broke out that he was fired.[2]

. . . Andy continues with Pen & Ink in a sort of etcher's technique with which he renders all kinds of subjects — nowadays much of it is local landscapes with only an occasional trip into the past from which he emerges with a company of archers in white surcoats — or the twelve paladins of Charlemagne . . .

[1] *Men of Arms*, a book about soldiers from ancient times to World War I, consisted of text and drawings by Paul Horgan.
[2] Rivera refused to remove Communist propaganda from a mural commissioned by the Rockefeller family. The mural was taken down by the owners.

At the end of May, the board of regents of NMMI, backed by the school's alumni association, agreed to commission Peter to begin painting the mural on the south wall of the lounge room in the new post-exchange building, with a view to having the remaining walls decorated at a later date. The extension of the mural scheme was contingent upon several factors: Peter's satisfactory completion of the first series of panels, the financial capabilities of the institute, and the politics of its officials. Peter's strongest supporter among them, next to Paul Horgan, was Lieutenant Commander Donald W. Hamilton, a retired naval officer and the head of the alumni association. Lieutenant Commander Hamilton, who knew Peter and whose parents had been friends of the senior Hurds, was soon made chairman of the Mural Committee.

To Donald W. Hamilton
[Draft]

[June? 1933
Chadds Ford]

Dear Don:

I have been living since your letter in a state of tremendous excitement — Nothing could have been better [news] than your note bringing word that the murals are actually to be begun.

It seems to me that even in this era of the increasing popularity of mural decoration few painters could hope for so fine a place and motif as those we have.

In making a study of fresco technique I find that one of the things to be most careful of is to have the plaster walls thoroughly dry before beginning the fresco coating. Six months is the time suggested as the [illegible] with a margin of safety. This would mean October or November as the date for beginning work. As an additional measure of safety I should suggest that you have the building — at least the lounge room — kept as open to the drying sun and air as possible.

In the months that elapse before the preparation of the walls I shall make all the preliminary sketches studies etc here in Chadds Ford, as you know.

It is hard to express to you my feelings about this — I am a little awed at times by the tremendous responsibility I have been given and at other times as the designs begin to resolve themselves (in my mind's eye) into coherence I know a stimulating elation and feeling of confidence in myself.

As I tried to tell you in Roswell I count it a glorious stroke of fortune to have in you and Paul such a strong pair of allies. I am reluctant to speak more now — on the eve of the battle — beyond saying I long to justify completely the trust you and the other alumni have placed in me.

With my warmest wishes to you and Harriet — I am —

Sincerely

Peter Hurd

To Donald W. Hamilton
[Draft]

[August? 1933
Chadds Ford]

. . . I can easily see how anxious you are to have the visiting alumni see some actual signs of activity, something definitely already accomplished which would spur their interest and urge them to give their whole-hearted support. This I certainly agree must be done but not in just the way you suggest. This decora-

tion as you know is the most important thing I have ever attempted. I have no established rule of procedure based on previous ones. Its size and magnitude of motif make it unique in my experience. By what I do on this south end stands or falls our prospects for doing the remainder of the room. *I must have* ample time to work this all out! I don't refer merely to the time spent in front of my easel — that is relatively short: But to a sort of period of gestation — I know no better word for it — to allow my conception to mature — This is no imaginary need! The ideas and feelings I want to express must simmer in my mind for weeks before I set charcoal to paper. Wyeth took a year and a half on one of his decorations recently, a painting the *execution* of which took him only a couple of months.

Don't think I am stalling — I'm not in any sense. I have no other important work scheduled for this time. The thing is that this decoration must be miles ahead of anything I have ever done before. Not merely an enlarged colour illustration for a Scribner Juvenile. Into it I want to weave as many of my feelings of New Mexico and her splendid past as space will allow. I must go to every physical means I know to make it a brilliant thing!

This then is my plan: to have in your hands by the middle of October a good clear preliminary sketch in colour of what I mean to do first — viz. the three end panels; this together with a select group of eight or ten of my recent canvases would be nearly as good as a start on the actual wall. Probably in so far as expressing to the layman what I intend to do a graphic sketch would be much more eloquent than the beginning of the decoration which is likely at first to look something like Chaos. This modification of your plan is I admit an expedient but I'm sure you will agree — a necessary one.

The amount of $1300.00 is only $100.00 short of the amount needed to do the so. end. This small deficit will of course in no way deter me. If it can be raised before the completion — or thereafter — it will probably come in very handy for I am working on the closest margins possible.

I would rather not begin the side walls until a cartoon — viz. preliminary sketch can be made of each entire side. This for the technical reasons of colour & design.

I have just realized the possible import of your paragraph telling [that] the walls are to be *painted*. It has suddenly occurred to me that it might be planned to paint them with oil paint which would be a mistake as it is very doubtful if the fresco plaster (gesso) would adhere to that — so I have wired you not to paint them. I shall next week see Mr. Weber the colour manufacturer and chemist to consult with him [as to] the best sort of paint to use. I feel sure he will suggest kalsomine (i.e. watercolour) of some sort in lieu of oil. I hope I'm not too late to prevent the painting. I think it would be best to leave the South end [a] plain plaster colour with no painting at all.

If my sketches are in your hands by October there is no reason why the next month shouldn't find me in N. Mexico to begin the preparation of the walls and the actual painting.

I'm glad the [top] moulding has been eliminated. As to furniture, Paul's and your opinions are as good as mine — simplicity seems to me the most important thing with dignity of style and, of course, comfort.

I'm glad Mr. Atkinson has come over to our side. Your letter should certainly have convinced him.

I am waiting to hear about the painting of the walls & whether my telegram arrived in time to prevent it . . .

To Peter Hurd
From Donald W. Hamilton

Roswell,
August 7, 1933

Dear Pete:

This is a letter to advise you of a regrettable action here in regard to the finish of the walls in the Thomas Memorial Post Exchange. In brief, at the orders of the Superintendent [Col. Pearson], the walls—all four walls—of the lounge room you are to decorate have been painted with a cream coloured mixture of paint containing oil.

. . . Everything possible was done to get these walls into

the condition you asked for; but it was not enough. The Superintendent and Mr. Vorhees[1] proceeded with their plans, unmindful of the very important warnings you made. It is now too late to correct the misunderstanding, if that's what it was.

. . . We are a very avid committee, bent heart and soul on the completion of your mural project, and, completely unable to understand how the point could so utterly have been missed regarding your written and wired communications, we nevertheless beg of you and urge you to help us overcome the troubles that we have herein set down.

The building is finished.

Your proposal of an exhibition of your latest work for the opening of the building and its dedication ceremonies is an extraordinarily happy one, and we'll take the greatest delight in seeing that your work is hung well.[2] Pictures will look well against the walls, which are of a new, but neutral, color. Send as many canvases as you can. They'll give the alumni a good look at your work, and help stimulate interest for the future of the mural project. When you're ready to ship, go ahead, and send the pictures collect.

. . . Our warmest regards, and urgent request for a victorious rebound from the disappointment we are really expecting this letter to bring you—for which we are sorrier than we can say . . .

[1] Roy Vorhees was the superintending architect.
[2] PH's designs for the mural decorations and fifteen of his paintings were exhibited in October in the lounge room of the new building.

To Paul Horgan

Port Clyde Me.

August 17, 1933

. . . I echo all your vituperation [at Colonel Pearson] . . . — I can't help feeling some petty grudge has motivated him somewhere. Don's letter was abjectly apologetic but seemed to buoy me up to the skies by virtue of its extreme eagerness and

sympathy with my project. Just how serious a coat of *varnish size* and 3 coats of oil paint are I won't know until I see Mr. Weber and some Jews (brothers to the late Fonis Wolheim) in N.Y.C. who specialize in mounting mural decorations. It sounds awful but with their help and a chemist's I hope to obviate the need to replaster. My first sketches are here now and Wyeth was much pleased with them — I have since coming here had an enormously productive period and have completed three canvases which stand among my best — One of "Doo doo" the Wyeths' nigger boy seated on a rock (profile, long nigger legs straight out, dark african face and cap) [drawing of cap] reading the funny papers with a look of great and serious intensity and behind him the Atlantic breaking in surf about the rock below him. It is about my most powerful painting so far and has a serio-comic duality which I feel sure will delight you.

. . . This is a most fertile atmosphere here — It couldn't be better — unless perhaps you had been able to be here too. I feel a great rapport with Wyeth who is doing some stunning new things of the Maine scene. Andy is illustrating Conan Doyle's "Sir Nigel" beautifully in Pen and Ink with grand initial letters and chapter headings which would delight your topographical eye. Ann is working hard at the piano . . .

. . . We return home on Monday — 3 weeks after our arrival. H. and Peter are fine — she is rested and eager to return to several new portraits. I hope you will urge her to return with me to N. Mexico. We would have a gorgeous time all together again. There is no reason why she shouldn't work in my studio there. I'm afraid I haven't stressed to her enough the great change in Mother & Dad. How much more mellowed they are and tolerant. It would be a splendid 2 months for all of us.

. . . Back I go [to Chadds Ford] very soon as I have said to continue work on the decoration. I keep thinking of new things to incorporate into the future panels if I am to go on. It will be a question of discarding all but the most vivid.

. . . By the way one of the purposes of this letter was to ask you to say to the Colonel that in my opinion the best colour for the velvet curtains would be an old gold — you know what I mean and you might show him with a splash of watercolour . . .

Anyhow *the committee* is swell and no man ever had a better confidential agent than you —
> With much love from us all here
> Siempre Peter

To Donald W. Hamilton
[Draft]

Chadds Ford

Sept 20, 1933

. . . The cartoons are finished and I think they look fine! They only await Wyeth's return in ten days before being shipped to you. I am of course anxious for him to see them and hear any suggestions he has to make. They will be rolled in heavy cardboard mailing tubes and expressed to you. The charcoal will have been "fixed," i.e. sprayed with shellac — so you need not use unusual precautions in unrolling them — I don't know where you intend to show them; the actual spaces in the Lounge room will be O.K. if you trim the margins which I have left. Otherwise perhaps some space in Cahoon Armory would be good. In showing them it would be well to place them 4 feet above the floor and to separate them by five feet just as they will be when *in situ*.

I have made brief colour notes in pastel on a small scale for 2 of the panels — these are simply to give a rough idea of the colour possibilities of the large uncoloured cartoons. They will be shipped separately and as they are not fixed you had best be a bit careful of them. (Fixing pastel darkens it so much that in this case I chose not to do it.)

Yesterday 15 of my pictures went to the framers to be packed and shipped to Paul Horgan. I do not yet know if freight will give them time to be there by the 14th — The framer will let me know as soon as he finds out.

A few more queries about the plaster: would you find out from Mr. Vorhees what material the plaster is laid on, (tile brick etc) and whether this original surface is plane or irregular. Also are the two coats of Lowes paint flat or gloss paint. Could you send me a sample of this paint and the size, or if not this an accu-

rate description of it so I could get some here. I would also like to know how thick the plaster is.

All this is of course a great nuisance — but it seems to me of greatest importance to go about the beating of this material obstacle in the most methodical and scientific way possible. I feel certain that unless your own affairs prevent you will help me at the New Mexico end.

I am making a list now of a dozen or so items which if ready and waiting for my arrival would expedite things no end. With this new problem of paint removing I will probably be busy every minute of daylight. Can I count on your help?

With my warmest regards to you and your family — I am,

<div style="text-align: right">Sincerely,
Peter.</div>

P.S.

The framer has just called to say he is shipping the 15 pictures tomorrow, Sept 21st by Freight collect, that the freight office tells him to allow 9 days for them to reach Roswell — This gives us 13 days of grace — in case of delay — plenty I should think.

<div style="text-align: center">P.H.</div>

<div style="text-align: center">**To Paul Horgan**</div>

<div style="text-align: right">*Thursday*
[October, 1933
Chadds Ford]</div>

. . . I kept wondering how they [the paintings] would look to you — but your telegram was a great surprise coming when it did as I didn't think the shipment had had time to get there. I'm delighted you feel so unqualifiedly my advance — I do, and believe my whole attitude has grown and hardened since you were last here. My credo is developing and I begrudge all those hours I spent uselessly before I felt as I do now.

I was deeply touched to know that you want to *buy* one of the paintings you to whom I am much more indebted than the value of this picture or any other I have made, — for your steadfast loyalty and stimulation. This is all true, yet I believe I

should accept your offer — tho with what mixed feelings I shall wait for our meeting to tell you.

. . . *Later Thurs Morn:*

Wyeth is crazy about the Cartoons and color sketches — Am I riding high! what with this enthusiasm from the three who count most, Henriette,[1] Wyeth and you — I'm feeling tremendously elated —

But wait, I'd better, — you haven't yet seen the Cartoons! Perhaps you won't be as enthusiastic as they. I feel that this opening movement of the symphony that is to follow should be formal and remote — particularly the central panel — primeval and mysterious, a slow-tempo prelude for the gamut of orchestration that is to follow . . .

[1] "Peter's drawings for the mural are the best yet" (Henriette Wyeth Hurd to Mrs. N.C. Wyeth, September 7, 1933).

To Donald W. Hamilton
[Draft]

Sunday —
[October, 1933
Chadds Ford]

. . . The cartoons left by express yesterday addressed to Paul Horgan. They are enclosed in a special cardboard tube 10 feet long by 10″ in diameter. Also by express yesterday went the two colour sketches in a separate box with — to fill up an excess of space — my palette — The colour sketches are done in Pastel — as I believe I wrote you before and are only sent to give a rough idea of the colour possibilities of the theme I we have chosen. I did not make these elaborate or complete because I want the colour and light of the room to dictate to me regarding the colour I use. I did not make any colour note of the right hand panel which admits of a more subtle treatment than the left hand panel.

In preparing these cartoons and sketches the outlay in time and materials (with what of the latter I am ordering sent to Roswell by my dealers) has been considerable so I am going to

ask that $500.00 of the money I am to receive be sent to me upon receipt and Approval of the cartoons.

I am enclosing herewith a copy of a contract used by Mr. Wyeth. This agreement I have paraphrased in longhand into one which I believe covers all the points of our transaction. I send Wyeth's contract only to show the committee that advance payments in mural commissions are customary. I send my own version so that you will have in your hands an agreement outlining what I shall do in carrying out the work in Roswell as well as outlining the payments I am to receive. So the purpose of this agreement of mine isn't to dictate terms to you but only to place in your hands something which should protect you in advancing me the sum of money I request.

x x x x x x

I feel I have in this triptych composed a good prelude for the symphony that is to follow — that — like a prelude it is yet able to stand alone as a unit. I know that I have poured into it the best that I have in me now. I think one feels in the central panel even as it stands now, — The Pueblos' mystic remoteness and the legendary quality of aboriginal New Mexico; and a hint of that marvelous burning-cool of the land. And the left panel I think expresses the Spaniard as they saw him — fanatical and with all the quixotic bravura of a moribund chivalry. His golden armour reflecting an aureate nimbus about him and his brain clouded with visions of golden cities. I have tried to draw him and his horse as the Pueblo people must have seen them. —

And in contrast to him is the mountain man — the blond, cold-eyed frontiersman slouching indifferently in the saddle with only a flintlock in the crook of his arm pointing to his deadliness.

As our plans stand now we leave by motor for New Mexico on the 21st — or a week later if Henriette is delayed in a portrait she is working on . . .

To N. C. Wyeth

February 1st *1934*
[Roswell]

Dear Mr. Wyeth:

The past two months here has been a field course in Rural Politics. What a time it has been with all kinds of cross currents and eddies playing their part in tossing me around like a chip in the maelstrom. Part of the battle has been very humorous — some of it exciting. But at last we have won a victory in having the State, going against the School Superintendent's recommendation, commission me to do another area, larger by 20 sq feet than the first, making use of federal funds under the Public Works of Art program.[1] With certain materials and all assisting labor supplied I am being paid $42.50 per week.

Officially my pay stops under my present contract on February 15th but "confidential information" (I hear this phrase plenty!) from Santa Fé predicts the program will extend thru May anyway and possibly more. So the State Board of Regents in charge of the school here have agreed to the continuation of the frieze. This after more arguments, secret meetings, wire pullings cozening & bulldozing than I can ever write you [of] — Some time over the dinner table at Chadds Ford I promise you a big laugh while I describe the machinations of New Mexico Políticos.

Of course I am tremendously interested in this work at this time and am glad to accept the Federal help in its continuation. I have the entire room planned now in some detail and the conception has become really a monumental thing!

The thing I am to tackle next is the period of the Commerce of the prairies, a long panel joining the mountain man at the south west corner of the room and shaped like this:

[diagram of panel]

I am going to spend several days reading the seventeen books I have borrowed from the NMMI Library before beginning the sketches or cartoon — But I have my motifs pretty well mapped out and I think they entirely escape the commonplace — This is particularly necessary we both know in an era so exploited in movies and painting as the covered wagon one.[2]

So this brings a change in our plans & instead of returning East with H. and Peter this month, as I had planned, it seems much more important to stay here and lose no time with the frescoes; and as Henriette is most anxious to return and begin really working again[3] we have decided the best thing is to avail herself of your offer and return with little Peter[4] immediately. By doing this — and thru your generosity in keeping Henriette at the house we hope to crawl out of debt by the time I return. I am sure anxious to pay everybody up — after being under over 2 years — We are both grateful to you for allowing this. I am against giving up our house in Chadds Ford — at least until we can find a similar place at lower rent. The income from Gen'l Motors just covers the rent and by a process of just forgetting we can count on this money for any other purpose, we can pay the rent and keep Mr. Haskell in pocket handkerchiefs. My expenses out here will be almost nothing and I can save nearly all of the Government salary.

I guess I told you how beautifully the plaster took the egg-tempera[5] (— I used egg and stand oil with distilled water). It is just as solid as oil in colour and in its adhesion and has the advantage of greater clarity. I used almost no white — none at all with the tempera and only a little with the oil colour I used to retouch with. The surface quality is thus very much like the wet plaster fresco.

I feel tremendously excited and the days are never long enough in which to do things I want to. For the first time I'm getting at the heart of this country in landscape painting. This part of New Mexico, so different from the Taos section is utterly untouched by painting. One can't be influenced in one's interpretation. It has become suddenly imperative that I come here part of each year to paint. So I am going to establish a tangible and independent base down here . . .

[1] In spite of Colonel Pearson's opposition, the mural scheme was extended under the New Deal's enlightened visual arts and architecture program, which made government funds available to the state-owned institute (see PH to Paul Horgan [Winter? 1936], note 3).

[2] "Peter's plans & composition for the next 'covered wagon' panel seem to me fine & rich, & in that direction I haven't a suggestion," Henriette wrote her parents. "But I have, as solemnly as possible, tried to warn him about the inevitable *bad drawing*. That

he must get models of *different* types; make the most accurate & painstaking drawings, and to check them thoroughly when transferred to the final wall. He may not do this, and if he doesn't, it'll be one hell of a lesson later; I have not so gently hinted this, too . . . You see, I fought Peter from the beginning about the *figures* in the finished decorations. And I still feel embarrassed about the cowboy. If you remember, the drawing for the Indian holding the spear wasn't so hot. Well, I had to get up on the scaffolding, finally, and draw the figure over; it will pass now — and before, the poor man was invested with the most distorted physique you ever saw. Perhaps if I'm not around Peter will be more strict with himself. His drawing of other things is progressing steadily. Funny, isn't it?" (Henriette Wyeth Hurd to Mr. and Mr. N. C. Wyeth, November 20, 1933).

[3] Henriette had brought along a supply of paints and canvas to last the three months she was in Roswell, but had found it hard to work there. It was her first visit to New Mexico since the honeymoon nearly four and a half years earlier, and her response to it this time was mixed. "I, myself, feel quite happy and really almost *charmed* with this country —," she wrote her parents on November 20. "Of course, Paul is the person who fills the greatest gap between myself & Chadds Ford." But two weeks later, she wrote her sister Ann: "I still hate the town & people, though I'm growing to appreciate the country itself. It is strange & desolate and beautiful, and *compels* one's regard & love" (Henriette Wyeth Hurd to Ann Wyeth, December 5, 1933).

[4] "Little Peter has developed a really intense interest & fondness for the following things —" Henriette wrote her mother on December 5. "The Fugue, (Bach's in G Minor) and all of the Pastoral Symphony of Beethoven's — he becomes completely lost in it, and fascinated as never before by music!" Peter Wyeth Hurd grew up to become a pianist, composer, and professor of music.

[5] The chipping off of the paint on the walls had left a very rough surface, and the mural spaces had to be plastered over as thinly as possible.

Migrations

In May of 1934, having completed the first series of mural panels at NMMI and hoping that the scheme would be extended further, Peter found forty acres of land for sale in the small village of San Patricio, fifty miles west of Roswell, in an irrigated valley near the Rio Ruidoso, a mountain stream. "A long distance telephone call across the state brought the owner to meet me next day down the valley on a friend's ranch," Peter later wrote. "There, after interminable heel-squatting conferences and a fair amount of stick-whittling, we agreed on a price."[1]

For $2,600, Peter bought the property. It consisted of an old, L-shaped adobe house of four rooms, one of which was filled with apples stored from surrounding orchards, and a small barn. Peter named the ranch *El Centinela* (Sentinel Ranch) after a mountain near the hacienda on which Mexican settlers stood watch for attacks by Texas outlaws and Apache Indians in the 1860s and 1870s.

His "tangible and independent base" in New Mexico secured, Peter now had to start back for Pennsylvania, not knowing when he would return to the Southwest. He stopped briefly at his new ranch, and with a quill pen and washes of diluted India ink he made several drawings of it, which he showed to Henriette on his arrival in Chadds Ford.

[1] "A Change In The Weather Of Opinion," *The Land*, Spring, 1950.

To Paul Horgan

Chadds Ford May 22, 1934

Dear Paul:

As I had so hoped — Henriette's great understanding and justness triumphed easily — She is not only reconciled to the Rancho but really pretty nearly as enthusiastic as we who have seen the place are. Isn't that great? The drawings I made of the place proved more eloquent than I had hoped they could be.

The homecoming of this Odysseus was as perfect a one as it is possible to have. Everyone was well and seemed so happy to see me. The farm was in grand shape, the horses fat and sleek with their new and resplendent spring coats. Our old cook and butler have returned to us — Mary is really the most amazing Africana, a noble cook who with her ebony consort, Charlie[1] makes a splendid domestic combination — So we are all ready for you — Also be advised that no longer need you repose in the garret room — The bedroom on the second floor awaits your occupation.

The trip back was made with no outstanding adventure befalling me; tho the experience of reviewing the phantasmagoria of America from a motor car in five concentrated days is always intense and vivid . . . The trailer-pullman worked superbly even during a pouring rain in the Ozarks. The drawings have made a great impression on the Wyeth family which is gratifying. Also the colour sketch of the Santa Fé trail which Wyeth says is one of the best contemporary decorations he has seen!

. . . You will be amused to hear I am riding a horse race in Atlantic City next week. I am to ride six horses for some bird named Hertz. He has been to Roswell and with Will Rogers had a falling out with Pearson. Have you heard of him? It is a race for "gentleman jockeys" over a track one furlong to the lap — in other words 8 laps to the mile. I have never laid eyes on the bang-tails I am to ride.[2]

I have not yet made any definite plans about making the rounds of the galleries. It seems fantastic simply to load up the trailer, haul fast the wagon sheet and head for New York with my wares aboard — but what else is there to do? I have no photographs; they are at best incomplete in their explanation. The next best thing to the impossible one of having various dealers visit my studio is this plan of parking car and trailer in front of each gallery and unloading what I have for them to see . . .

[1]"He to my complete delight is an accomplished guittarista with a knack for picking up Mexican songs. — I can scarcely wait for you to join us with *flauta* [flute] zither and *sonajas* [small cymbals]. The *Sonajas* will be marvelous with two guitars" (PH to Paul Horgan, June 17, 1934).

[2]PH finished the race "a close second" and was one of two jockeys "lucky enough to come through without a spill" (PH to Paul Horgan, June 17, 1934).

To Paul Horgan

Chadds Ford
June 17, 1934

. . . Two weeks ago in New York the Rheinhardt galleries represented by Fred Lake agreed to hold a show for me next October. Lake saw the N.M. drawings and was really voluble in his praise — so was John Cunningham of Knoedlers. I just happened to meet Lake there when he dropped in to see John whom I have known a long time. I suppose it isn't official yet — Lake is to come here in the next few weeks to look at my work — aside from the drawings. It sounds great and Rheinhardt is certainly a damned good gallery to traffic with. I hope it comes off but if it doesn't I shan't be greatly surprised — the whole affair has been so casual thus far . . .

To Paul Horgan

⟨Chadds Ford
October 8, 1934⟩

. . . The Rheinhardt-Hurd Entente has come to grief — a nice note from Mr Lake in reply to a query from me relates that he is no longer in the art business but is representing his "uncle's firm in this country selling Pol Roger Champagne etc" further stating that he is genuinely interested in me and hopes to represent me some time in the future. A note to Rheinhardt about the show elicited a brief answer telling me that no plans for winter shows have yet been formulated but that when they are I will be notified. An equivocal reply certainly! . . .

To Paul Horgan

Chadds Ford
August 13, 1934

. . . The New York Jaunt was perfect Paul[1] — nothing could have been more fun — unless perhaps to have had you return with us here again afterwards. The whole rapport was as you say in one of your letters the best yet.

Dad is having the hell of a time with the legal administra-

tion of the ranch due to fences water rights and land titles but the latest news is that he is making fair headway[2] — I have my first dividend cheque — ten dollars on the sale of some apples and vegetables. The old man (Lehn)[3] pressed it on my Dad in dirty bills when he was there saying he "didn't like to have so much money around the house." I hope you will go up there on a party or a picnic when you get back — It should be very lovely in the fall.

. . . I have proofs of my first lithograph from the drawing of the Ranch at San P. drawn directly on the stone. It is really a good one, Paul, wait till you see it — As soon as the edition of 30 is printed I will send it to you — when you get it you better tear up the dreadful one of the Fuller Ranch[4] I gave you, made from a paper transfer. You will note a difference! . . .

[1] "It's hard for me to tell you how much seeing you meant to me in buoying me up in that awful period of reaction after N. Mexico" (PH to Paul Horgan, August 28, 1934).

[2] In his Roswell legal practice Harold Hurd often dealt with cases concerning real estate and water rights.

[3] Chester Lehn managed the farming on the ranch in PH's absence.

[4] The P. R. Fullers owned a large ranch south of Picacho, New Mexico, and later became friends of the Hurds.

To Paul Horgan
Chadds Ford August 28, '34

Dear Pablito:

How fine to have your letter in the morning's mail — and your good sympathy about the leg.[1] But I hardly merit any at all. I get around like a cricket and have developed a sort of manual of crutches — "prepare to mount stairs!" — "mount stairs!" — "Secure crutches!" — "ground crutches!" etc. I drive myself around in the car with no trouble and have had installed thru the kindness of Margaretta [Greenewalt] the official du Pont wheelchair, a most elaborate affair full of amazing gadgetry. With this I can paint and move to and from the easel with great facility. It is a grand chariot and you can propel it like the devil across the studio floor and suddenly (when you wish) whirl it into a series of pirouettes.

. . . Henriette and Peter are in Maine — as are the entire Wyeth family — I am here alone but have four big lithograph stones to keep me occupied and I am much interested in this. I wish you were here to see the two so-far unprinted stones — I think they are going to be the best of any. — I am drawing from the figure a lot you will be pleased to hear and while I can't hope to do it so much here as in N. Mex. it is a good prelude for an intensive course down there. Henriette was un-well for a couple of weeks before leaving last Friday and as the symptoms are identical to those she showed when Peter was in the early stages of creation it is to be supposed that we can expect another child, which is fine! altho I could wish for much better times, because it is a very expensive thing — I'm so glad for Peter for I believe an only child has a great handicap to fight against.

. . . My guitarism progresses[2] — Tell Harriet I am now able to render and quite adequately accompany that charming Tango, "A la Orilla de Un Palmar."[3]

. . . I'm out of the doldrums now altho I can't yet get the least bit excited over this country. I mean, to paint it again . . .

[1]"Carolyn's horse Taboo slipped on wet grass in front of the Studio (I had been drawing him) then decided to take a short canter around the yard and caught my leg under him" (PH to Paul Horgan, August 13, 1934).

[2]"I took the strolling minstrel trip Eric [Knight] and I always wanted to take — and believe it or not we made money — three other boys — down the coast of Delaware and Maryland, 2 guitars, Sonajas a banjo and a fiddle, all dressed like cow persons. We made $7.07 the first night!" (PH to Mrs. Eric Knight, September 19, 1934). See PH to Eric Knight, November 28, 1935, note 1.

[3]"Sitting Under A Palm Grove."

[Journal]

October 17, 1934

[Chadds Ford]

Today I began actual work on Mrs Sellers' overmantel [decoration] — a view from her old house of the Delaware river — I have hopes of making a brilliant painting of it — I am relying on a fine handling of light — pale opalescent early morning light rather than any brilliance of colour. This I think is a fortunate solution of the problem — one that will obviate the use of forced

unnatural colour which in such a subject couldn't I think escape the sentimental & sweet — or even the just plain cheap!

Henriette has just completed a large flower still life of an autumn bouquet — the best so far of any she has done.

The *caballos*[1] are fine — my leg troubles me hardly at all tho as Flinn predicted swelling of my ankle joint continues. Peter is well and developing mentally and physically each day. In fact everything is splendid except the bank account and that is in pretty poor shape almost nothing definite ahead! This troubles me principally because it stands in the way of my return to N. Mexico in January. I have got to do something some way!

[1] Horses.

[Journal]

November 2, 1934
[Chadds Ford]

. . . Sold the Wilmington Gallery — my *"First Snow"* a painting in oil on gesso — tho at a reduction in price, I'm delighted to have them have it —

The Sheepherders' Christmas, a lithograph is finished and today was printed. I have no idea how it will take as a Christmas card — its subject matter[1] is probably too bizarre to allow for popularity around here — anyhow as a litho it isn't bad tho if it had been four times as large it would have been much better — more textures more careful — subtle handling.

The Whitney Museum in N.Y. have invited 2 lithographs of mine for their current show — "The Old Homesteader" and "The Windmill Crew."[2] So that's good news — Also I have sold 2 more prints — total to date — four — Dr. & Mrs Reese Mrs. Rupert and Lydia Du Pont. Cuno[3] the printer swears I will make many sales — "shust vait — undt prizes too" — prizes, quotha!

[1] Five sheepherders singing around a campfire before a starlit tepee in the prairie.

[2] "Among the first things I remember as a child in New Mexico was the sound of the old Eclipse windmill on my father's farm" ("A Southwestern Heritage," *Arizona Highways*, November, 1953).

[3] Theodore Cuno printed PH's lithographs.

To Paul Horgan

Chadds Ford *November 10, 1934*

. . . The news about the lithographs is of course amazing to me (I mean the sales[1] — I felt sure *you* would like them) and beyond measure encouraging.

I shall get off a new supply of prints to you immediately. I really had no idea they would actually sell in New Mexico and was astonished at your report . . .

[1] PH's lithographs helped supply the greater part of the Hurds' income during this period.

To Paul Horgan

[December, 1934

Chadds Ford]

. . . perhaps you have already seen a rather cheap (but in its essentials, true) account of how I got a one-man show at Macbeth's.[1] It was very Horatio Alger and *not without* a lot of excitement. We sold six prints and 2 drawings when at the end of the first week I left town. I was given a royal time by friends including (*particularly*) Howard and Myra.[2]

The latest plan is that along about January 10th young Howard[3] and I are setting sail in the chevrolet and prairie-schooner trailer *con rumbo de Nuevo Mexico*[4], for a 6-week's stay there. There is work to be done at the Ranch, also some legal matters I must attend to — but above all (I needn't tell *you*) I am most anxious to do some canvases. By the way the drawings done in Roswell (and the lithos) have been invited to the Kansas City Museum.

. . . I'm enclosing my catalogue from the very impromptu Macbeth show — At my next show you must do the foreword, as heretofore.[5] It was damned nice of John [Cunningham] to do this one tho wasn't it, and very valuable to me as Knoedlers are looked upon by all the dealers as the very crest of Mount Olympus and John no less than Mercury himself — Messenger of the gods . . .

[1] PH had his own show of twenty-one drawings and eight lithographs at the William Macbeth Gallery in New York from November 20 to December 3.

[2] Howard Taylor had recently married Myra Kingsley.

[3] Howard Taylor's son (Myra Kingsley's stepson), later referred to as Chico, was going to San Patricio as a "paying guest."

[4] In the direction of New Mexico.

[5] Paul Horgan had written the catalogue notes for PH's exhibits at NMMI both in 1928 and 1933.

To Paul Horgan

Chadds Ford

January 1935

. . . Christmas at Chadds had no end of *gemütlichkeit* as you can of course imagine — It is a wonderful combination of Dickens, Irving and Alcott all plentifully spiced with Père Rabelais. I thoroughly enjoyed it this year.

Of course your letter delighted me the one with the neat and telling little painting of El Capitán (I mean La Capitán).[1] It was particularly meaningful then since it arrived on the day that I made my decision to postpone my trip to N. Mexico until after the birth of our child in April. Henriette is much happier at this prospect of my being here in the intervening months and of course that is most important. Actually two things make the later trip more desirable. I shall be able to stay longer and of equal importance, you will be there then — at least I suppose you will — I hope to leave before the middle of May — taking with me young Howard Taylor — unless this change in plans makes him give up the idea of going with me. I hope not because I like him a lot and would enjoy having him with me. Besides the financial end of it is much more feasible with someone to help support me there — I feel like a sort of shameless painting gigolo — not really because with Howard it will really be enjoyable as he definitely appeals to me as a person.

The reason I have been so slow with No Quarter Given[2] aside from having the galley stolen once — is that since beginning it I have done three book jackets[3] which meant reading these Mss. and in addition to this I have read and annotated two other stories which it may fall to my lot to make pictures for . . .

[1] PH frequently mocked "tourist" Spanish in its inaccuracy.

[2] A new novel by Paul Horgan. PH was reading the galley proofs.

[3] One was for a reprint of Booth Tarkington's novel *The Conquest of Canaan*.

[Journal]

March 12, 1935

[Chadds Ford]

Today came an invitation to the opening and varnishing day rites at the Nat'l Academy of design where Miss Sullivan[1] sent my lithograph "Texas Nomads." Curious my being on display there — an institution as the New Yorker says more notable for the fact of its continued existence than the type of Art it purveys!

This month my show in Kansas City. — No news of it yet — The Wm Rockhill Nelson Gallery of Art has no notice in the Art digest. The Print Club [in Philadelphia] seemed pleased with my show there — about a hundred and twenty dollars worth of prints (& 1 drawing) were sold.

. . . Am busy these days collecting material for the Pirate book for Putnam's[2] which I'm most anxious to make my best — a really distinguished job — *mi obra bien distinguida.*[3] Mr. Wyeth has with his customary generosity offered us the 200.00 given him as editor & author of the introduction. Also there's the possibility of doing the book for Paul — The Return of the Weed.[4]

. . . Foxhunting with the Brandywine day before yesterday — a grand day — Clavelito performing beautifully a little over-anxious sometimes tho less so than before — Put a heavy vixen to earth — found again over near Downingtown but checked soon. Grand day and plenty of fun.

. . . Am on some tenterhooks about the Corcoran show. I find myself really concerned this time — I am really hoping they take one of the three things I sent. The painting "West of The Pecos" is I think my best thing to date and if it is turned down then I must conclude I'm simply not yet ready to show in national shows — I should conclude thusly I suppose but one look at the tripe that is often accepted will put this notion out I know well![5]

[Spanish] Right now I feel great — I'm not as dejected as before. The feeling of being landless goes away when I think of my return to New Mexico in May.

[1] Pegeen Sullivan worked for the Macbeth Gallery, which now represented PH as his agent.

[2] *Marauders of the Sea.*

[3] My most distinguished work.

[4] A book of seven short stories. PH made a lithograph for each story and for the title page.

[5] "Today the Corcoran biennial returned the three pictures I sent them, rejected by the Jury," PH wrote in his journal later that month. "I can't say honestly I am entirely indifferent but I believe most of my regret is for the ten dollars I squandered getting them there and back."

To Paul Horgan
Chadds Ford April 10, 1935

Dear Paul:

Early yesterday morning there was born to Henriette a splendid baby girl.[1] They are both fine . . .

. . . I'm in the midst of my pirate book — called Marauders of The Sea and amazed you'll be to hear — I'm enjoying it tremendously! The drawings are by far the most mature I have ever done for a book and I am really getting a fresh angle on pirate romance — It means a great deal to be able to pick one's own literary subject matter as well as pictorial.[2] The book is fairly bristling with pictures — each chapter (i.e. story) has its own heading — there are twenty odd of these as well as 10 full page illustrations colour jacket, cover imprint, lining, title page and sundry decorations. The book is a pot-pourri of fact and fiction with a preponderance I think on the side of chronicle some original some re-told. I'm pretty certain you are going to enjoy these drawings. I am making scrupulous use of the model and my drawing has improved a lot. Also the lithography has contributed directly to an advance in this medium.

. . . Well-a-day — I long to see New Mex and to be again in the light of the Sun. Such a tepid variation of sunlight we have here — with whole days and weeks when we see scarcely a glimmer! Sandstorms are to me much less awful than this continuous damp gray chill.[3]

Scribners have a book for me to illustrate.[4] I hope they aren't in such a hurry that I can't do it either in New Mexico (it is about Indians) or when I return. *Quien Sabe?*[5] but I'm glad to have the job . . .

[1] Ann Carol Hurd. Now Carol Hurd Rogers, she is a painter and lives in Santa Fe.

[2]N. C. Wyeth had asked PH to help him edit *Marauders of the Sea*.
[3]"You can talk about the dust but I have yet to see a dust storm which would not be more welcome than snow and ice" (PH to Mrs. Harold Hurd, February 19, 1922).
[4]For *Injuns Comin'* PH made drawings on gesso scratchboard with brush and ink.
[5]Who knows?

To Paul Horgan

May 10, [1935
Chadds Ford]

Dear Paul:

Marvelous news about the [possible] continuation of the frieze! I have gotten out the plans and again begun computing costs and materials. I think the plan of continuing the work panel by panel in the summer months is perfect.

. . . For this summer I would propose doing the corner panel on the East Wall and the larger panel directly to the north of it. These will balance the long panel on the West wall. Then if time remains before the opening of school we could begin in the alcove. The cartoon for the corner panel — "The building of the Mission" (or perhaps a better title would be "The Missionaries") is as you know completed there only remains to be made, studies from the model. This cartoon could be shipped down to be shown to the Regents in June with a written description of what I would like to do in the next panel — I would rather not crystallize any ideas into actual form until I am there and can again be in the spirit of the room and its purpose. You see how this is — particularly as I am much engrossed in finishing the illustrations for the two juveniles and once I turned my attention to the murals there would be a great flagging of interest in this other direction.

. . . Well Pablito write me what you think of this — It is certainly great to think of and I am so excited I can scarce think straight.

. . . So now I will roll up and send the cartoon for the corner panel and bend my attention to the next one — of the *"gentes de razón"*[1] . . .

[1]The leading families among eighteenth-century Spanish settlers in New Mexico

"called themselves *gentes de razón*, 'those who use reason,' 'the educated ones,' 'the right people'" (Paul Horgan, *Great River: The Rio Grande in North American History* [New York: Holt, Rinehart and Winston, 1960], p. 359).

To Paul Horgan
Chadds Ford, Saturday, May 11, 1935

Dear Paul:

My letter to you yesterday was a most garbled affair I'm afraid — due to the excitement of the news about the possible continuation. The purpose of that long meandering work was to lay before you the idea that I am eager to have at those East wall panels and that while my fee is really a minor item — to urge you to impress the Board (or rather Hi[1]) with the idea that I have got to make a small living from it. The fact that I live for nothing at my father's house hasn't really anything to do with it from their standpoint — Don't you agree? — It is a good deal like having my Father be an unnamed contributor of a large part of the cost of the job — Don't you think that eight dollars per sq. foot is a reasonable figure? — this at least. This runs the cost of the two end panels on the East wall up to around seven hundred twenty dollars with of course the small fee for an assistant and Allison's price on replastering. This if they have the entire room done at one time will be very inexpensive — something like fifty dollars I think — and how fine it would be to have white Kalsomined plaster where that dreadful egg custard is now. So, — Paul — as many times before I rely on you to do the work of entrepreneur extraordinary and deal both with the Board and myself. I will gladly abide by the result of your work if you will . . .

[1] Hiram M. Dow was chairman of the board of regents at NMMI.

To Paul Horgan
Chadds Ford May 24, 1935

. . . I am expressing today the Cartoon of the Mission. It is completely redrawn, this time from models and as you will see is much improved — details of hands, small figures around the

church, etc., etc. must be worked out later — Lithography has taught me definitely the tremendous value of a careful and thorough study of the model so that I find myself now *enjoying* referring to models rather than dreading it as I formerly did, when I would content myself with half-realized chic drawing. In the mailing tube is a small roll of gummed cellulose tape which will serve to affix the cartoon to whatever place it is to be shown. This adhesive is much stronger than masking tape which sometimes in warm temperature pulls loose with only a little weight.

. . . I am living in a trembling state — hoping and fearing alternately. Write me any news or any developments that occur — I'm most anxious to be on my way . . .

To Henriette Wyeth Hurd

Roswell, N.M. July 15, 1935

Dearest Henriette:

You of course know of the news of the mural frieze's continuance[1] and while I know you are somewhat lukewarm on the subject — I mean in so far as you think it will benefit me I am anything but so! It seems marvelous to me to be again given carte blanche on a great wall space in this country with pay which is at least something like maintenance wages — more, I mean, than I would be earning in the equivalent time working for Balch[2] or Scribner. This all in spite of the fact that probably 99% of the visiting public will be Elks from the Bovine Provinces — This doesn't matter — It is a grand laboratory and no opportunity could be better for experimentation — Instead of doing the *Ricos*[3] in the next panel (which would be disregarding entirely the 17th Century in New Mexico —) I am planning a sonorous and solemn passage in the Death of De Vargas — the Captain General of New Spain. Then the *Ricos* — later.

. . . I will tell you that my return to this place without you & Peter was the most difficult thing imaginable — That I love you as deeply as I possibly could and that only the ever-gnawing urge to transcend the mediocre — to win once I've started kept me from slipping into a pleasant life of laissez-faire at Chadds Ford. It is certainly that for nine months of the year . . .

[1]"The Colonel fought the continuation of the murals with all his might but the board of Regents — newly appointed by the Governor of New Mexico was unanimous in over-riding him" (PH to Henriette Wyeth Hurd, July 19, 1935).
[2]Earle Balch worked on the editorial staff of G. P. Putnam's Sons, publisher of *Marauders of the Sea*.
[3]The wealthy (a reference to the *gentes de razón*).

To Hiram M. Dow
[Carbon Copy]
Roswell, New Mexico
July 16, 1935

Dear Mr. Dow:

According to your verbal instructions of July 15, I am submitting here a brief proposal for schedule of payment for my work in completing mural decorations on all wall spaces in the lounge of J. Ross Thomas Memorial, as ordered by the Board of Regents at their last meeting, when the price of eight dollars ($8.00) per square foot was accepted.

Space remaining to be decorated, 1100 sq. ft.
 at $8.00 per sq ft. $8800.00

. . . We have discussed before a four-year plan for completion of the decorations; but I propose five years as the allowed time because I'd be afraid to limit my work to such a close schedule as four years. In the event of completion of the work before the elapse of five years, the remainder of the total sum will be paid on completion of the whole project.

For the sake of future contingencies, it should be noted here that all rights of reproducing the mural decorations belonging to N.M.M.I., and all drawings, sketches, etc. remain the property of the artist.

The expenses of preparing walls for my work are to be defrayed by N.M.M.I.

Yours respectfully,
Peter Hurd

To Henriette Wyeth Hurd
Roswell, N. Mex Friday July 19, 1935

. . . On Wednesday I drove to San Patricio — Everything in good shape at the Ranch — prospects (unless we have hail) of a very good fruit crop — picking began last week — A difficulty to be solved is the marketing of fruit — Last year Chester Lehn did this in his own truck but this year his wife is due to bear a child just at the height of the fruit season and he can't get away as before — But this won't be hard to solve. For the next six weeks we'll be living in Roswell then Chico and I will establish ourselves at the ranch to begin Paul's book[1] — this by the way has been deferred for Spring instead of fall Publication. This on account of the fact that actual work on the murals can only progress during the summer months when the Cadets are away . . .

[1] See journal, March 12, 1935, note 4.

To Henriette Wyeth Hurd
Sunday evening
July [21], 1935
[Roswell]

My Dearest,

The gestation period for the next panel has begun and I am of course in a state of great nervous excitement over it, wondering how to pour into it all the awesomeness and apocalyptic fever of the occasion: The Death of the Marquis de Vargas, Captain General of the Province of Nuevo Mexico. Little — *(fortunately)* is known of this — except that the Marquis sickened while on a military expedition into the Sandia Mountains (do you remember the mountains we went over with Paul on the way to Monté's[1] from Rody's?[2]) was brought to the town of Bernalillo and there died in April of 1704. A marvelous opportunity, you know — really worthy of the greatest of Giotto, Cimabue, Uccello. It must be sonorous, deep sounding with — by some magic I can only hope for, the *feeling of the moment.* Death coming to the Spanish nobleman in the wilderness of a new and unknown world.

I drive out alone on the plains every day and read the chronicles of the Conquerors. It is a perfect method for concentration. No possible interruption (which is always possible at the school) and so complete becomes my absorption that I feel myself actually likened to one of those old friars of Saint Francis of Assisi whose writings I am reading.

The weather has been simply gorgeous — magnificent skies sweeping across infinite distances shimmering mirages thunder storms that fly over the plains with the awful majesty of avenging angels in a renaissance painting. I had truly forgotten how marvelous it is — which is a loud argument for staying part-time away from here! . . .

[1] Robert Nichols Montague (Monté) Hunt, an architect, helped PH design and build a part of the residence at San Patricio.

[2] Rosemary Horgan, Paul Horgan's sister.

To Henriette Wyeth Hurd
Roswell, N.M. *July 24, 1935*

Dearest Bean,

My daily life has simplified itself down to a severe routine which I hope to keep unbroken until the present span of murals is completed. It consists of rising about seven getting to the school by eight and working there until noon; luncheon at twelve then 30 to 40 minutes sprawled on the grass in the Sun with shirt or breeks (or both) — off. Then to the school by 1:30 and there until five or five-thirty when Paul appears and we proceed to a café for beer and the resulting revival of energy. — We are compiling a Baedeker (Travelers' guide book) to the Cafés of Roswell pointing out in our synopsis the specific reasons for *avoiding* each particular one. Very amusing and always conducive to small adventures. Home at 6:30 to clean up for dinner at 7:00. Afterward we either sit on the grass or cruise around the town and its outskirts. There seems to be more than ever a wealth of marvelous light effects . . .

To Henriette Wyeth Hurd

[August 5, 1935
Roswell]

. . . I keep wishing for you — days and *nights*. The only way to make this tolerable at all is to work incessantly — This I do — I am up now every day at 5:30 out for a drive in the car to plan the day's work then to town for breakfast and right after that to the school . . .

To Henriette Wyeth Hurd

Roswell, *August 12, 1935*

. . . Come out here please. Damn debts, Damn everything — Come . . .

To Henriette Wyeth Hurd

Roswell, N. Mexico
August 25, 1935

Dearest Henriette:

Your postcard from Maine came telling of your safe arrival there after a good trip.

. . . Still no chance to go to San Patricio — I am behind my schedule in spite of most steady work at the new panel[1] — but I'm not hurrying it at all. I am still working on the cartoon — making studies on charcoal paper and transferring them to the cartoon by slides. So far there are fifteen studies completed — and four or five more to make. I am sparing no pains, taking no short cuts whatsoever.

I wish you were here with me — wish so many times a day,[2] but I'm sure you are much happier where you are so that's a consoling thought . . .

[1] PH regarded the panel on the death of de Vargas as "the largest expression I have ever attempted (I don't, of course, refer to space/size)" (PH to Henriette Wyeth Hurd, August 2, 1935).

[2] "I miss your critical eye Henriette — find myself trying to criticize my things as you would, imagining what faults you would find with them if you were here" (postcard, August 29, 1935).

To Henriette Wyeth Hurd

Roswell, Sept 2, [1935]

Dearest Henriette:

Sunday morning Chico and I drove sixty miles south to Hope, a little town in the foothills of the Sacramentos where a three-day Rodeo was being held. The drawing for the new panel had been projected upon the wall and drawn and I felt a need for a couple of days' respite. So we hooked up the trailer loaded in our bed rolls and struck out. The rodeo — its setting, its attendants and audience were all fine — no tourists whatever and all local contestants — which really makes a difference. Chico who has a rampant curiosity concerning humanity was completely, steadily absorbed in what was around him.[1] In the two nights we were there we joined with a Mexican string (guitar) quartet and played and sang Mexican *canciónes*. Chico was really delighted — He has lost his amateur standing now! for in the resultant collections we made all the expenses of the trip — The crowd was generous and enthusiastic and such stamping and yelling of that anyway boisterous *"Allá En El Rancho Grande"*[2] I've never heard. There were horse races, dances, a free barbecue and of course the usual rodeo events.[3]

We returned this morning, Tuesday when I found two letters from you — one the note with those *sweet pictures* of Ann Carol. The other the nice long letter from you written at Port Clyde. Isn't she marvelous? sturdy as she can be and what an expressive little face she has. It seems to me she has grown a great deal. She looks quite brown in the pictures — I wonder if she has the sort of blond complexion that will tan — like Nat's and Andy's. I'm very happy to have them — They seem a sort of tangible assurance that partly allays the forebodings and feelings of apprehensiveness that come over me without warning or apparent reason. An unhappiness like that horrible time when you and Peter took the train at Vaughn[4] — I think for acute suffering — concentrated — that was my low so far. I hate living with my mother & father[5] — awful associations are everywhere around me and I have the impossible problem of appearing not to think of them. Never again! — Once living there, there is no way to break without a scandal — (I have tried) and so I must stay on

the remaining few weeks before we go to San Patricio. Bean it is really awful. I know you think of me as having infinite imperviousness at times — and I'm realist enough to see that I have this (to a maddening degree). But this is really no fun. I have to keep up a pretence for Chico's sake and for my father's — He (my father) is really good at heart tho the most fanatical and obtuse person — having withal a certain child like credulity. O well — there's no use telling you about this — you know how I feel. Living with them I see my own shortcomings mirrored mockingly and I search for means to transcend my inheritance. But I do believe that such things help me shape myself.

I need you terribly — Really and seriously I long for you — When we have been separated in the past it hasn't been quite as bad as this has gotten to be . . .

[1] "He has a rare ability to make *himself* accepted without question among yokelry — which, since he shares my interest in them and their lives is a great asset. He has a good sense of humor and not much escapes his eye" (PH to Henriette Wyeth Hurd, August 21, 1935).

[2] "There At The Big Ranch," a well-known rodeo song.

[3] PH not only painted but frequently participated in them.

[4] February, 1934.

[5] But see PH to Henriette Wyeth Hurd, March 26, 1933, for a contrasting perspective on PH's relationship with his parents.

To Henriette Wyeth Hurd
San Patricio — Sept 22, '35

My Dearest:

I set this — "my dearest" down with a growing consciousness that this is true — You are my dearest and without you to complement me I am really only part of myself. Regardless of the divergence of our interests which you point out in your last letter, you are the only person woman I have ever loved — I still love you bitterly at times as now when these long miles separate us — and when to glance at your photograph which hangs on the wall before me is to loose a flood of the most tantalizing memories — of course — it is clear in your letters what you are thinking — *"Can I do without him?"* — My answer to this — is you can't — we can't —There is too much in the past too many bonds

which are too cunningly forged of memory and experience — If you renounce me they will return to torment you much more than the petty divergence of interests you point out ever could! I speak from your angle because the very thought of permanent separation from you means to me completest desolation — I really don't know what I would do! I know in my heart that no other woman could ever mean to me what you have. Neither in the matter of the spirit or of the actual — I know too that if you forsake me you will have in my place a living scar. You can't go through what we have together then will to change it and deny its reality. Believe me — I'm being as forthright as I'm able — This letter springs from my heart which has had an increasing ache for weeks — your letters becoming cooler and more remote — living in that dreadful house with its horrible memories — they (the bad ones) far outweigh the ones which might fill their place of certain gay times you and Paul and Chuki and I had there.

That is past now — those memories any way. I never want to live there again — I have taken your advice and Chico and I are living at the ranch. There is infinite peace here in this old house, made of the earth I love and near the river I love because it is so ~~interwoven~~ haunted with recollections of that rapturous time spent on its banks with you. As in the flight of a dream my mind returns to those days just six years ago. The smell of cedar trees and piñón smoke hanging in the air brings your vision, immediate and almost tangible. I am really tired. The Death of the Conqueror was the most intensive painting I have ever yet done. Here (since coming three days ago) I have done almost nothing but rest. All except my mind which won't rest. I keep wondering of you and Peter and the adorable Ann Carol whose pictures (all of yours) I cherish. But they — the photographs — are no better really than those eluding phantoms which hover on the river at Twilight when sometimes for a single trembling instant its song becomes your voice!

Come back to me — I implore you — with your warm heart which knows so well how to be tender and also candid. I long for you my dearest . . .

<div align="right">Peter</div>

My address now is San Patricio N.M.

To Henriette Wyeth Hurd

Oct 2, 1935 —
[San Patricio]

My Dearest:

You can't know how your last letter has made me feel because I don't think I can possibly tell you the depression and actually physical ache that would come over me twenty times or more a day during the past weeks. O, Bean — I do adore you — Your last letter has made of me a new person. I am entirely in your hands — you see — where heart emotion is concerned . . .

To Hiram M. Dow
[Carbon Copy]

Roswell,
2 October, 1935.

Dear Mr Dow,

This letter will request of the Board of Regents that I be given a contract at this time for the completion of the mural decoration scheme in the lounge room of the J. Ross Thomas Post Exchange, in accordance with the already expressed approval of the Board for such work to extend over the next four years.

I ask for a contract covering the whole project for these reasons:

1. To do the best work and still keep my activities on the walls within the summer vacation months, I must do my extensive and often complicated preparatory work in the winter months; and to refuse other work for this purpose, I feel I should be protected by this contract. My preparatory work really bulks much larger in point of time than the actual work on the walls. It includes detailed planning of the whole scheme, which for the sake of its eventual coherence and meaning must be done with "a long view," so to speak. Further, my preparation includes such things as historical research; much travel about the State; study from models; "trial and error" cartoons; and color drawings as rehearsal for the wall painting.

2. The scope of the whole job will take a lot of material, and to meet the price we have agreed upon, I must buy such mate-

rial in bulk or else lose money. A contract would enable me to buy in large quantity for the whole job at once, instead of wastefully buying a little material at a time for each panel.

If I could have an early decision on this matter, I really believe it would be to our mutual advantage. I enclose extra copies of this letter for the convenience of the gentlemen of the Board and the Superintendent.

Respectfully yours,
Peter Hurd.

To Henriette Wyeth Hurd

Oct 2, 1935 —
[San Patricio]

. . . Here then is a tentative plan for my return. If the board of Regents approves my contract . . . then I would like to return by train or Bus for Ann's wedding[1] staying there a couple of weeks then back to New Mexico to gather material for Paul's Book. —[2] This I haven't yet begun at all — various other jobs having intervened. Then back to Chadds Ford by Christmas. But I'm not at all sure Pearson will not block this thing with his blunt hatred for the whole conception and meaning of painting. If the contract is not given to me then I shall simply stay here through October and November returning early in December — the first week probably or maybe before. The board of regents individually seem greatly in favor of the decorations and I feel I will be called back from time to time to complete spans of work on them.

The Insurance Man's commission I wrote you of turns out to be an interesting one. I'm to do a lonely oasis-like ranch in the plains country quite large (36″ x 48″) on a gesso panel to be placed conspicuously in his "booth" at the fair & cotton carnival (which begins tomorrow) — on each side are simple signs lettered to read "Home is where you feel secure" — "Insurance *IS* Security." He tumbled for the idea and I am to receive $50.00 for the use of the picture for the idea etc. That is the picture afterward becomes my property — Then there's a jacket for Harpers. I have an amusing idea for this book — The one about rac-

ing in England in the early nineteenth Century — I must be at it
immediately — . . . Later

The Picture for the Insurance Tycoon is done and has come
out very well I believe. The Fair & Cotton Carnival is on and it
(the painting) is exciting quite a lot of favorable comment, as
anything even remotely resembling this land would, by its citi-
zens. The Gay lights of the Carnival, the throngs, so unmistaka-
bly stamped with this land & its sun and wind all recall the last
Cotton Carnival I saw here when you, my Darling, were with
me. The Rodeo is large and vivid and its riders roll and swagger
with a great bravado.

. . . It is you I love — You only and always you — I miss
you and dream of you repeatedly —

<div align="center">

ever your

Peter

</div>

[1] On October 26, 1935, Ann Wyeth married John W. McCoy (b. 1910), a painter,
who was then studying under N. C. Wyeth.

[2] *The Return of the Weed*, for which PH made lithographic illustrations.

<div align="center">

To N. C. Wyeth

San Patricio Friday Nov 1, 1935

</div>

Dear Mr. Wyeth:

Ever since finishing this year's span on the frescoes and
coming up here to the ranch I have found myself at odd times
during the day mentally projecting things to say to you in letters
— the letter — This has become a sort of daily habit and the
conclusion to be drawn is that in spite of ~~many~~ differences in our
natures you are still the most sympathetic and understanding of
anyone I can name. The projected letters haven't materialized
before, mainly for the reason that at the end of a day the de-
mands of creative and physical exhaustion make me throw my-
self in bed around eight o'clock or nine. At other times there
seems to be no way to summon my wits and will — although
there is a real desire. I suppose everyone has this feeling at times.

Tonight seems a good time to begin: Supper is just over and
I am sitting crosslegged in front of the corner fireplace in our

bedroom.[1] The only other bedroom in this four-room house is used to store the several hundred bushels of apples and pears that are always in storage between outgoing truckloads. The room is divided into separating bins and nearly the entire room — is waist-high with apples. All the house is pervaded now [with] their fragrance — Winesaps, Ganos, Grimes Golden Arkansas Blacks Northern Spys York Imperials winter Bananas — Constantly their smell carries me back to your Springhouse in Chadds Ford — for tho I have of course known apple fragrance all my life it all seems to date from Chadds Ford. It's strange now to think how many times I have handled apples of yours taking them from your house to ours without ever so much as wondering about what kind they were. In the last weeks I have absorbed a great deal of surface knowledge about Apples and their characteristics and so much does this have to come into play in dealing with truckers and in peddling the harvest that I can't believe I have [only] so recently learned it.

The orchards here are fed by an irrigation ditch which is an off-shoot of the river, like a millstream. We have around three hundred trees — two hundred-odd of them mature — They are mostly apples of the Varieties I named before — with a scattering of Pear and Peach trees. My share from these and from the grain and vegetable crops even in a lean season should easily cover the $70.00 taxes and $72.00 interest on [a] $1,200 loan . . . In other words [the ranch] should pay for itself entirely and include up-keep. As I grow to know the ranch more intimately it is comforting to know how completely it suits me — it is really much more charming than I had realized when, a year ago last May I hastily made a deal for it in the frantic ~~desire~~ need to have finally a New Mexico base.

. . . Chico is the cook here. With the sober deliberation of the scientist he has set about learning to cook — copying innumerable recipes in a slow, meticulous hand reminiscent of early Mss. As our fare is largely homegrown frijoles (Pinto Beans) with chile potatoes eggs corn meal and goat meat as what Mrs. Darlington used to call "si-dishes" we are the loudest, fart-roaringest household in Lincoln County. Verily by Saint Isidor (patron of

agriculture, hence of frijoles) I am becoming worthy of the clan of Wyeth! Such rump-thunder hasn't often been heard west of the Brandywine.

November 2,

It is now early in the morning a half hour or so until dawn. I won't begin to tell you what has been happening to the sky and mountains toward the East. The sort of thing that attracts me enormously to paint but which so far I haven't been able to infuse with the austerity the subject needs to save it from the scenic or the plainly sentimental. It Can be done tho!

. . . Great wonderment on the part of the Mexican population when last week they saw me with *El Largo* (The long one), as they call Taylor climb laboriously up the side of a mountain. From the plaza of San Patricio a mile or so from the ranch house, they could see us through a Sears Roebuck spy glass, see that one of us carried something which shone in the sun (my easel) while the other carried a large map (the canvas) and led a pony. Rumours spread quickly. Of course it could be only one thing we were after, Treasure and who hadn't heard the countless stories of buried treasure hereabouts of treasure trains from the mines of the rich chalices and vestments plundered from churches by godless *bandidos*. Of gold and jewels from the time of the Conquerors. They're still generally doubtful of the prosaic account I gave them of simply going to paint a landscape of the sierra and toiling up the mountainside to get a better view!

November 5. This sounds all very blissful and rosy and I believe it would be if only Henriette and the Children were here with me. But as time moves on it becomes more and more apparent that for H. the compromise of living part time here and part time in Pennsylvania is not worthwhile. For me it is a question of giving myself up to the easeful far from unpleasant life in Pennsylvania all the year around or living half the year here in New Mexico where I seem to be able to live during [illegible] half-year periods with an unflagging intensity — burning, — chancing that by so-doing I'll amount finally to something better than mediocre. In defense of my selfishness in this I believe I can say it is not a soft selfishness. I drive myself relentlessly and I think I know something about self discipline now. I wonder if you

see this as I do and can agree that I'm making sense. I realize that of course ironically I'll never know if it has been worthwhile never really know I suppose whether I will have amounted to a damn or not.

Any way three people in American painting that I really believe in and know in my own heart are on the right trail are yourself Henriette and Andy. This conviction remains and grows as I find your Canvases vivid and disturbingly vital in my memory after these months of being away from them. Does it interest you to know that I more and more am proud to be a scion of your teaching: to have I hope profited by the real robustness of your tradition. A truly American strength with no dilute European atelier crap which is the usual thing with the run of American artists & schools.

I think that if you could now by an enchantment be transported to Roswell to see the [mural] decorations you would feel that those nights nine ten and eleven years ago when I would leave the composition classes late to walk home my mind in a fever whirl of excitement yearning, — wonderment are now having their fruition. I am certain the last panel of The Death of the Conqueror is much the best painting I have ever done. The preparation and deliberateness necessary in the lithograph technique helped enormously. I planned and rehearsed in black & white every part of the panel so that when the time came to paint I knew the ground well and the impetuousness (which when controlled I look on as my asset) could come into a well-limited play. In the characters — all but one of them the Dying Conqueror himself I made actual portraits of the Mexican — Spanish — people living now in Roswell. For these I made black & white drawings just about like the lithograph head of Jimmie[2] so that there are now on the walls easily recognizable portraits of some of the Roswell Mexican peasantry clad in their own faded — patched stained garments altered as little as possible to become a costume similar to that of the 17th century. This seems justice since — ironically these very people are the descendants of these same conquistadors bearing still the unchanged names of the old rosters and archives. As I said, by completely rehearsing I was able to paint much more directly. For the first time I

painted as Henriette does in that I began at the cornice line and painted without the use of white paint. For this panel I used a different tempera formula — the Cennino Cennini one — yolk of egg, distilled water fig juice and pigment. It worked much more to my liking than the other which was an emulsion of egg and oil slower drying and with not nearly so agreeable surface or *feeling* in handling. An amusing coincidence in this came up when I found I liked the Cennino formula the problem of getting fresh juice of young fig sprouts came up — Then suddenly I remembered my Father had three fig trees right there on his farm. I had gotten him to put them out three years ago, long before I knew anything about their use in egg tempera!

November 7. What a letter this is getting to be in size! I think it might be well to bale it and load it into the trailer to deliver myself when I return next month. It keeps on because it is fun to be writing to you and there still seems to be lots unsaid. The Chicago Art Institute have two of my lithographs (selected by the jury from four) "Texas Nomads" & "The Old Homesteader" in an international Exhibition of lithographs and woodcuts. There are a hundred and thirteen Americans listed in the catalog — eighteen countries — including our own. I'm having a print show in Fort Worth, cultural and artistic mecca of the Southwest.[3] Good write-up in the Ft. Worth Star with a reproduction of one of the prints. The former seized by Roswell papers and copied for their "Home-boy makes good department" with some very funny (unintentionally) comments.

On the way home from Santa Fé Paul and I called at the Simms[4] Ranch near Albuquerque. Mrs Simms is building a large community art center and has three excellent panels which would be beautiful settings for frescoes. Paul who is their close friend insists that there is a good possibility that I will be allowed to paint them — as they are under a *portal* (a sort of pillared loggia) wherein one side is open to the weather they would have to be painted in wet fresco. I think I could do an interesting thing there, should I be allowed to try. The architecture is the simple, chaste — rather Georgian Mexican Colonial; whitewashed of course one-storied & with a flat roof.

. . . This letter seems inadequate to me as I scan back

through it. It is, I suppose, too late now to change it; you are one of the few intimates I have. Some way I'm able to make passing friendships easily and deep ones so rarely. As I grow to recognize this trait of mine I'm coming to know and cleave to those few I have.

<div style="text-align: center">

Yours ever

Pete
</div>

My love to Mrs Wyeth and to all the family. I'm returning as near the first part of December as I can make it. God how the days fly and how little at best is really accomplished in one. Little when one regards the total there is to do.

[1] Describing the bedroom in a letter to Henriette, PH wrote on September 24: "The adobe walls are coloured a shell pink which with white woodwork and white Viga ceiling is very nice. The floor is plain wide pine boards with Navajo rugs — some my own and some Paul gave us. On the walls are the Hoppé portrait of you and Paul's water-colour. The fireplace tiny as it is, throws a grand heat. For a light we use our old gasoline lantern . . ."

[2] A Chadds Ford handyman.

[3] Ironically intended.

[4] Albert Simms, a former congressman from New Mexico, was married to Ruth Hanna McCormick, daughter of Senator Mark Hanna, and herself a former congresswoman from Illinois. Mrs. Simms's first husband was Senator Joseph Medill McCormick of Chicago.

To Eric Knight[1]

<div style="text-align: center">

San Patricio N Mexico November 28, 1935
</div>

. . . I really long for a life absolutely ordered — a time for every one of the things that are to be done. This I don't suppose I'll ever make. But each year I think I do get on better at economizing on time. Getting every damn thing possible out of each minute of the time I'm awake. There's such a damned short time of it at most.

Well I've thot of you lots, wondering how it has been going with you, projecting letters, the letter so often that it's silly to tell of it since it never has materialized. You had been in my mind particularly during the past two weeks (your letter came here only last week) when I have been learning "*Adios Mi Chaparita*[2] which I first heard sung by you and Jere at Chadds Ford.

I have to head myself off from telling you of this rancho . . .

of all the ranches up and down this valley it really suits me much the most. There are no artists (God how I hate 'em!) No real estate promoters, no undertakers no idle rich. Just plain people & not one bit conscious of the ~~fact~~ possibility that in living as they do and deriving maintenance from the earth they are either singular or picturesque.

. . . What I've accomplished beside the new mural panels I don't know — particularly as the [lithograph] stones[3] have to be etched & printed before I can have any sort of opinion. I know I have never been so excited by the country — Never have there been so many ideas conceptions accumulated before. But what all this fermentation has produced — *Eso Todavía no sé*.[4]

There has been lots to do here at the ranch, furniture to assemble, a well and windmill to put in mud and cement plastering in the house — white-washing fences to patch, etc etc. It's all been grand fun particularly since young Taylor is such an able and enthusiastic kid . . . Consider yourselves invited to visit us here Sir and Madame. You will be entitled to full privileges of the Colony Club — including use of its elaborate and crested stationery! Spanish is spoken everywhere in this valley. There is dancing and music religious fiestas and rodeos which seem to go on without interruption thruout the year.

Hell! You must see it: It couldn't fail to appeal to you — and another year (if not this) you must plan to come over here. We have a gas plant and refrigerator but no bath now or running water as yet. Aside from this I can't think of any apologies.

It's fine to know you are both doing well that the adjustment to conditions has taken place[5] — to a certain extent at least. But when you speak of being homesick for Pennsylvania Lad, I ken what ye mean. Only for my part my nostalgia begins after being in Pennsylvania three months!

We've got almost no stock of our own on the ranch yet — someday I want to have a string of range mares and cross them with a Remount Stallion. But there's one good horse we have now, "Pecos," a little sorrel cow-pony: The wisest little devil I've ever seen. God does he love to run.

Would I love to see you come rolling in here tonight. We

have had some swell times together certainly, and I'm all for beginning a new sequence . . .

[1] Eric Knight (1897–1943), the English-American novelist and author of such popular books as *Lassic Come Home* and *The Flying Yorkshireman*, and his wife, Jere (b. 1907), a historian and writer, were very close friends of the Hurds. PH first met Eric Knight in Chadds Ford in the late 1920s.

[2] Don't Cry for Your Poncho.

[3] For *The Return of the Weed*.

[4] Who can say.

[5] The Knights had recently moved from Valley Forge, Pennsylvania, to Hollywood, where Eric had been hired as a screenwriter by Fox Studios.

To Henriette Wyeth Hurd

[December, 1935
San Patricio]

. . . Eric came to San Patricio a week ago completely fed up on Hollywood and quite tired. You should see his change after a couple of days. After working on the river and completely altering its course to match his own caprices (and the needs of better hydro-engineering) he turned his energy to clearing a piece of level mesa land of stones and cactus. Within this rectangle of land marked by whitewashed stones we play a sort of polo which we call Pasture Polo. Great fun. You should see Eric scamper away on Pecos whom he's taught some of the principles of riding-off. Eric and I assisted each by two Mexican cowboys comprise teams. It is really exciting all right but with certain unintentional drollery which good polo wouldn't have. These spectacular match games occurred on three successive days — in the hour before sundown when I was glad of a relief after spending the day on Paul's Lithos.

. . . O Bean — I do want to be with you. You may not believe this but I think a better warmer more adoring Peter is returning to you. I know your belief is that personalities are unchanging. No — I say according to the heat of the forge so is the metal changed. This has been such a long and cruel separation — all joys have been tempered by my wondering about you.

Nameless apprehensivenesses which have similarly gloomed and blackened the dark moments.

. . . I am coming to you just as fast as I safely can . . .

To Mr. and Mrs. Eric Knight

Chadds Ford Pa

January 8, 1936

. . . I left the ranch on the 18th and made 500 miles a day for the first three then getting into snow and Ice in Southwestern Virginia. I made slow progress from there on.

. . . Grand welcome met me in Chadds. Everyone very gay and a great round of parties. Horgan and his sister were here, also Marion Parsonnet[1] whom I hope you meet in Hollywood when he returns later this month. My small daughter is truly charming! I can't get used to being related to her — much less to being her father, there being no girls in our family it still seems strange — somehow I've been accustomed in general to looking up to women — as to a venerable Auntie or to another man's gal — Or in the other and more literal alternative of looking down at them.

I'm sure looking forward to seeing the movies.[2] I think I'll arrange a private pre-view so as perhaps to snip here and there where publicity for the ranch isn't accented enough. I'm not at all sure there will be any real need for this tho, — Henriette is really interested in the place . . .

[1] See PH to Paul Horgan, March 8, 1932, note 1.
[2] PH and Eric Knight had taken films of Sentinel Ranch.

To Paul Horgan

Chadds Ford

January 27, 1936

. . . A long letter from the excellent Chico came this morning. He is busy as the devil and evidently having a grand time doing the work we mapped out. The new tenants are installed[1] and work begun on the additional room of the tenant house. O, God the weather here! sub-zero temperature, snow and the

coldest winds I have ever known. I am sitting for a portrait for H. now ⅘ths finished and I think a fine Canvas. I am sitting on the model stand in my Studio a sheaf of drawings beside me on a portfolio and behind me one of the new New Mexico Gesso landscapes of the mountain country — A set-up which without any change whatever occurred when she happened to see me sitting just as I am in the portrait. I'm wearing blue corduroys and an earth red turtle neck sweater, I sit leaning forward resting my forearms on my knees which are apart.

 . . . Andy delivered the M.L.W. jacket[2] last week to Harpers . . . It came out well I think — figures — two of them (not necessarily ones of the story) are in and help it a lot in interest.

 . . . Yesterday the printer, Herr Cuno didn't have the Weed stones rolled-up (ready for me to make corrections) so instead I did work on the others which were ready. I made some extensive changes in several of these. I will try to send you first states as well as the finished — Aside from the Weed drawings which were not experimental technically I don't think this last group done in N. Mex holds up with the earlier ones. But I do know I am getting freer and the medium has many new channels for me I didn't know about before.

 . . . Yesterday after the interlude at the Printer's Henriette and I went to dinner and reception at the home of some people named Lewis. Henriette the honoree painted Mrs Lewis last summer and this portrait hung in the Academy[3] show. I hadn't seen it before and was delighted to agree with the Lewises that it is one of her most successful portraits, full of a sort of tremulousness which makes it live — exist in an aura of its own. Not in any sense related to the academic (or "modern") stupidities or the photographic vulgarities with which it was almost smothered in the Academy. God, what a lot of bunk that show is. I think, fortunately, I'm getting beyond being depressed by the experience of a show like this. This because I know now so definitely what I want to do — what goes on in the painting world — the rest of it matters little.

 . . . I recently wrote Mrs. Simms a note as the memory of those two panels has been brightened lately by Gardner Hale's book on fresco which Dorothy [Hergesheimer] sent me. In my

letter I asked her to see the new panels at the school in Roswell before selecting anyone to decorate the *Quinta*.[4] Here's hoping — You drove the opening wedge if anything does come of it — I suppose I'm shameless as far as modesty goes but hell, you know I'm desperate when the matter of paintable wall spaces in New Mexico comes up . . .

[1] A family named Wagner lived for a time at Sentinel Ranch, apart from PH's ranch house, and farmed the land on a sharecropping basis.

[2] PH had designed the full-color dust jacket for Paul Horgan's novel *Main Line West*.

[3] The National Academy of Art.

[4] The name for a section of the Simms's Albuquerque residence, known in its entirety as *Los Poblanos* Ranch. In Spanish *la quinta* means villa.

To Mrs. Albert Simms
[Draft]

[January, 1936
Chadds Ford]

Dear Mrs. Simms:

For the past few weeks recollections of the charming *Quinta* have been recurring, and more and more as visions return of those panels in the *portal* facing the pool I have been tempted to forget all modesty and tell you I am the person to decorate them with fresco when the time comes. I am not, naturally asking you to reply yes or no at this time, but this thing I do hope you will do — go to the Military Institute at Roswell and see there the frescoes in the lounge room of the Thomas Memorial Building before you make any definite decision.

The future of these — (only about a fifth of the projected frieze is completed) seems indefinite still the Board of Regents are all in favour of continuing but my nemesis in this is Mr. Pearson, the head of the school . . .

To Paul Horgan

[Winter? 1936
Chadds Ford]

. . . In a note replying to mine Mrs. Simms begins "It was nice to hear from you and to know that you feel so strongly you are the one to do these panels. Well, I don't know but what you are right — but first before deciding I should like to live with them for a time to etc etc." I quote from memory, but it sounds good doesn't it? In my letter to her I said that I of course did not look for a definite answer then — now, but that I hoped she would before awarding them see the panels at N.M.M.I. She says in her letter she hopes to get there before June. Do you suppose she will. Meanwhile I'm working away at wet lime fresco — now on the eve of beginning a 35″ x 37″ plaster panel for her of San Ysidro and the ploughing angel[1] which was of course your suggestion — I'm doing it in wet lime as you know because if I do get those panels at *La Quinta* I'll do them in this medium which is weather proof.

[John] Biggs,[2] magician, political conjuror extraordinary has I think wangled the W.P.A. job for me in Roswell (thru Vernon Hunter's[3] office) I meant to talk to you about these panels if I get them they are in the Chaves County Court house . . .

[1] According to twelfth-century Spanish legend, a laborer named Ysidro was kneeling one morning in a field that his wealthy patron Juan Vargas had instructed him to plough, when Vargas saw him and thought he was loafing. Ysidro's head was bowed and his hands were clasped as though in prayer. Juan Vargas was about to reprimand him when he noticed a yoke of milk-white oxen pulling the plough, held by a winged angel. After this, Ysidro came to be known as San Ysidro, the patron saint of farmers.

[2] See journal, November 13, 1932, note 1.

[3] R. Vernon Hunter, a painter, was director for New Mexico of the Works Progress Administration's visual arts and architecture program, which in 1934 made possible the extension of PH's mural scheme at NMMI.

To Eric Knight

Chadds Ford Pa
Feb 20, 1936

. . . I see Jere's (& Henriette's) point. Either of them *could* rough it and Pioneer it in New Mexico if they *had* to — and probably like it, — but they aren't really forced to — there is nothing heroic about it for them with things as they are —

But why couldn't you do as I hope to do — have a place where Jere is happy and a retreat in the hills of New Mexico. For me this is so necessary — not because I'm crazy about New Mexico — not only this, but because I tire of a country crowded with people. I need part time some such place as Roswell or San Patricio where ten minutes in a motor[car] or a half hour or so on a horse brings one into complete solitude. You know what I mean, I'm certain. Why couldn't you work out some such system whereby — part time you and Jere work where work is and the rest of the time either together or alone you are in New Mexico. Of course I know it isn't all so darn simple as I seem to be making it, but — if you need it enough I can't help believing you will find a way of realizing it — and with Jere's approval.

. . . Snow, Sleet, Slush, Sneezes, Sun-lowering Skies, Slop, Sh—! *¡Qué tan triste!*[1] There's no fun in the horses — with subzero weather and a landscape that belongs somewhere beyond Baffin Bay. I haven't once been fox hunting and I don't believe anyone else has here in over a month. Henriette is as fed up with it as I and were it not for Peter[2] we'd be off for Charleston or Florida.

As it is tho I'm working hard in the studio with only the duties of handy man (and stable boy) to interfere with the study of [the] technique of wet Fresco, in which I'm progressing I think. The lithographs for Paul's book are finished — These came out much better than the tentative ones you saw on their stones in Roswell. Constable & Co. are bringing out the book in England and Harpers in New York;[3] later a limited edition by the Golden Hind Press.[4]

O yes — how about the movie reels? we've never gotten them — wonder what happened to them. I'm afraid of what might happen to my morale if they turn out clearly on the screen here. I think I'm here probably until May tho I have been offered a PWA job in New Mexico for this winter[5] — Here's the rub — $62.50 a month. Peter's hospital bill is twice that in one week —

. . . Back to the main burden of this letter which is to urge you not to give up entirely the New Mexico idea . . .

[1] Oh so sad!

[2] Peter Wyeth Hurd had scarlet fever for the second time.

[3] "Along with the trade edition, Harpers published a second one limited to 350 copies in which my illustrations were the actual lithographs bound into the books . . . In the British version the title was changed [from *The Return of the Weed*] to 'Lingering Walls'; reason for this being that in Britain the word weed may be construed to mean either a cigarette or 'a rather useless old bloke'" (*Peter Hurd: The Lithographs* [Lubbock, Tex.: Baker Gallery Press, 1969], plate 15).

[4] Subsidized by Edward Nicholas, later referred to as Caesar, a friend from Roswell. PH painted his portrait in 1946.

[5] In the end, PH declined the Public Works Administration offer to decorate the Chavez County Courthouse.

To Eric Knight
⟨Chadds Ford, April 10, 1936⟩

Dear Eric:

It's swell news that you . . . have a place you're fond of in California. Of course I'm sorry it isn't as our neighbor in the Sierra Blanca, but what the hell, we're not so widely separated, (as you demonstrated in that celebrated non-stop run of yours last fall!) . . .

To Paul Horgan
Chadds Ford *Feb 23, 1936*

. . . All of Pennsylvania is a great grey glacier — it glimmers wanly at infrequent times when a weak sun struggles through heavy skies; a thoroughly bleak landscape.

. . . Henriette's Portrait of me — the one I wrote you of is certainly her best portrait of any yet.[1] It is really a grand work and having it come out well has helped her painting morale enormously. She is grand, in fine spirits and in spite of the dour weather which we both hate — and of Peter's troubles we are having a great time together . . .

[1] The following year Henriette's portrait of Peter was awarded the Mary Smith prize of one hundred dollars at the 132nd Annual Exhibition of the Pennsylvania Academy of the Fine Arts (see PH to Paul Horgan, January 27, 1936).

To Paul Horgan

[February, 1936
Chadds Ford]

. . . I believe if Peter weren't sick H. would drive out to N. Mex with me this spring — or sooner . . .

To Paul Horgan

[March, 1936
Chadds Ford]

. . . Henriette is being taken abroad by a friend this summer[1] sailing on the "Rex" July 12th. Peter goes to Maine, Ann Carol here with a nurse, I to New Mexico . . .

[1] Miss Beulah "Boo" Emmet took Henriette to Spain and France in return for having her portrait painted.

To Paul Horgan

Chadds Ford
June 4, 1936

. . . I have shipped the first cartoons for panels 3 and 4 on the East wall.[1] #5 is formulating itself in my mind and I don't anticipate trouble from this *as a composition* when the time comes to work it out.

Have I told you, I have got a book to illustrate. A juvenile by Cornelia Meigs called "Swift Rivers" published by Little Brown in 1932 with pen drawings and now being brought out with six full colour illustrations and an end-papers drawing in line. The first colour commission I have had for years! It is of Minnesota and the lumber industry down the rivers into the Mississippi River in the 1840's.

Work has begun on our addition to the studio.[2] I am very happy that it is being done for I am so tired of paying an exorbitant rent for this place. The burden of the rent robs it of all enjoyability for me. In the Studio there will be one telephone, one furnace fire and no 12-20 miles per day back and forth to and from work. Also an automatic pump which does away with the

need for a man when I'm not there. Henriette drives a car now and things should be simpler. Certainly I long for the simplest system of living possible — that is including reasonable comfort. I dread the strangling complexity living can assume if one doesn't constantly fight to prevent it.

I'm longing to see you again. I am already more than half packed, the trailer is having a general overhauling and I am trying to decide whether or not to trade in the Chevrolet for a later model. In any case I should be ready to set sail around the 12th to 14th as I had expected, exact date depending on my young charges.[3]

. . . as I survey the winter it looks pretty barren. Except for one portrait, lately finished (which I wrote you of) and the fact that I have learned a lot about the wet fresco technique it has been from the standpoint of work a dull five months with ebbing and flowing but always present a gnawing nostalgia! . . .

[1] Although he had not been given a contract, PH had continued his preparatory and experimental work on the succeeding panels of the NMMI frieze.

[2] To reduce their expenses, the Hurds had decided to convert their schoolhouse studios into living quarters and give up their house in Chadds Ford.

[3] PH returned to San Patricio with two Chadds Ford teenagers recruited by Chico Taylor to help him (PH) build up the ranch. They lived there through the summer as "paying guests."

To Henriette Wyeth Hurd

Wed. *June 24, 1936*
[Roswell]

O Bean I do hate this — I wish there wasn't this terrible conflict inside me of love for this land and love for *You* — The only possible comfort (and scant it is) is that perhaps the two feelings may engender something really worthwhile in my work.

Meanwhile I miss you dismally. — I am really desolated by regret and a sinking feeling every time I am visually reminded of you or Peter — a piece of material like something you have, a dark child near Peter's age — any number of similar things evoke this same horrible sinking vacant feeling. There is something so wanting — missing in not having you with me. O Dar-

ling I mean all this so much more than my actions in leaving you can indicate.

I can't explain and there's certainly no use denying my abnormal love for this land: Again the same feeling of exultation came over me as we sped across the plains entering New Mexico — Thru thunderstorms looking across infinite distances where the wind swept the prairie and Herefords fled before the storm — I was certainly in that two hours or so carried to heights — I don't know what it is this return of a native nor why — but it is tearing and uprooting and devastating to smugness and complacency — a sort of thing as primordial as birth or death . . .

[5]

Sentinel Ranch

Peter's chief concern now was to build up Sentinel Ranch. To do this, and still continue painting, he kept to an ascetic regime. He rose each morning before six o'clock. After breakfast, while his "young charges" would pave the patio with flagstones, setting them in puddled mud mixed with straw, Peter would put in the day's stint of landscape painting. Then in the afternoon, assisted by the boys and by some local ranch hands, he would work inside the hacienda at carpentering and painting woodwork, and later at farming the land or shaping up the polo field. Exercise was an important part of Peter's daily schedule—polo, riding, or fencing. And at night he often slept outside beneath the stars in some remote region of the foothills.

For Peter, the process of building the ranch at San Patricio represented the fulfillment of a desire that he had long held deep inside him. "I cannot say with what great anticipation I look forward to a permanent home," he once wrote Mrs. Wyeth, reiterating a frequent refrain. The "home" in this case was the house in Chester County, but the "permanent" home that Peter longed to build was in New Mexico. When he had sketched scenes of the Southwest on envelopes of letters sent home from West Point; and when in 1928 he left Chadds Ford for Roswell, his future with Henriette clouded, in order to "know this my homeland in its every mood and prismatic variation" so that he might someday realize his "dream of becoming one of the American Painters"; and when he came back to the Southwest the following year with Henriette on their honeymoon; and when he returned again in 1933 to paint the mural at NMMI; and finally when he purchased the ranch at San Patricio in May, 1934, Peter was responding to an implacable need of his nature to seek his fate in New Mexico.

He was doing this now—but without Henriette, for she was still attached to her own world in Chadds Ford.

To Henriette Wyeth Hurd

Aug 8, 1936
[San Patricio]

. . . You keep citing my discontent with Pennsylvania. I think you miss the point that my dissatisfaction was with the *place* where we were living which was so absurdly impractical from a financial angle.[1] O well we've been all thru this and I think you know how I feel — I don't see how any one could be more aware than I of the fugitive, fleeting quality of time: of the ultimate absurdity of thinking of *owning* any part of the earth. Our tiny span of life makes this absurd and ironical. This I know and ever I think of it — Yet I find the fact of "ownership" gives such an additional interest engenders such a real love that I can only leave it as a paradox.

Here at the ranch this summer I have made no large improvements.[2] I find I have everything I really need for complete comfort except running water and a bathroom. But an increasing flock of bills from the East puts this out of the question this year. Don't mistake the tone of this paragraph — I'm not being pathetic nor am I in the least disappointed for without the additional income from the [NMMI] murals I had never counted on being able to swing this or the studio this year. I now have an abundance of dishes, cooking utensils towels and bed linen — rugs and furniture enough for simple comfort. The ranch house is really very attractive . . .

[1] See PH to Paul Horgan, June 4, 1936, note 2.

[2] "As we both know all we can earn is needed in the Pennsylvania project. I am living as economically as possible and glad to do so in order that we can have the place finished in Pennsylvania. I am looking forward really to coming back there and being with you in November and December" (PH to Henriette Wyeth Hurd, July 1, 1936).

To Henriette Wyeth Hurd

October 15, 1936
[San Patricio]

Dearest Henriette:

Get started on a picture — Begin working so you will lose this obsession that has overtaken you about what we mean to

each other; *what people are saying.* Our names will be ringing when theirs have vanished even from their tombstones.

. . . I have plunged into an unceasing activity of work since sending off the paintings to Little, Brown.[1] I am working all day and after supper drawing until exhausted I tumble into bed and immediate sleep. This because I have so short a time left in order to be back with you all by Thanksgiving — This will mean leaving here in five weeks and I am working my hardest to get two or three first rank things harvested — also notes to work from later . . .

[1] For *Swift Rivers.*

To Henriette Wyeth Hurd

November 5, 36
[San Patricio]

Hello Bean:

It is a little after six and I have just a few minutes until breakfast to write you — (and keep up as best I can with the fair deluge of mail that rolls in from you!)[1]

. . . I'm working like the devil. You will see the harvest when I return and judge accordingly. One thing I know — I had rather be here from August or September through January or February than at any other season. For me any season is grand, but I believe then the activities of the people and the appearance of Nature combine best for me. At least for now.

. . . Now that the election is over I must see Mrs. Simms[2] — This I realize is a repetition, I told you the same in the last letter or the last but one. — But there's not much else [to say] unless I talk to you of the light that floods these mountains, of the people their antics sometimes humorous, sometimes pathetic, sometimes both — of how at fiestas and *bailes*[3] at political juntas (*mitíns*) (Mex from Amer. meetings) the dark-clad figures arrange themselves in a series of groupings of great beauty — so that watching them from a point away from them seeing the patterns of figures and lighting change is like watching a slow

ballet — I haven't any assurance this doesn't bore you, rather an increasing feeling that it does since I hear so little from you these days . . .

[1] Ironically intended.
[2] Mrs. Simms had been busy campaigning for Republican candidates.
[3] Dances.

To Henriette Wyeth Hurd

San Patricio

November 11, 1936

Dearest Bean:

This is a hasty scrawl to overtake (I hope) my last two letters written when I was feeling low as hell, to correct whatever bitter flavors they may have had; I am dying to be with you. The winter in Penna now has no terror [for me] at all. I want more than anything to be back with you in our house — and at work on whatever there is to do — Whatever, I know I have some usable notes — of actual accomplishments here during this two and a half months of incessant work I don't know — perhaps it wasn't worth the constant unhappiness of being away from you and the children. Darling Henriette I am truly yearning to be with you again — Now as soon as I can get things ready pack up close this house and leave. I have written Mrs Simms and dependent on her reply is my sailing date . . .

To Paul Horgan

[November, 1936
San Patricio]

Dear Pablo,

A most unfortunate letter from Henriette awaited me here. She would be greatly hurt if I didn't go to her by Thanksgiving. Ironically in the same mail came a telegram from Mrs. Simms saying tomorrow (Friday) is the only day I can see her till Monday. So off I go [to Albuquerque] tomorrow about 4:00 AM so as to arrive there by 10:00 AM to Lunch and talk the project over then post haste back here Fri Night. I am counting on you Pablo

to help me in this mad flight. If you can come up Saturday bring the paintings, the guitar and if you can swing it $100.00 in cash. I am mailing with this $200.00 to the Bank. Pathetically H. sent me the money (150.00 of it) herself. I must make it [back to Chadds Ford] by a week from today . . .

To Paul Horgan

Chadds Ford Dec 5, 1936

Dear Paul:

Once more here in Chadds Ford with the usual difficulty of becoming settled in this new *Ambiente* — this feeling rather exaggerated by the new surroundings and by the fact that I have no studio. However, after working out a number of pictures (paintings and drawings) from notes made in New Mexico I mean to settle down to a lot of reading. It seems so long since I have had time to read anything, not necessarily directly [related] to something I was at work on. Then of course there remains the cartoons for Mrs. Simms[1]. . .

. . . The weather is dreary and damply cold. Already it seems I have been here a month though today is the first day of the second week! I am continuously thankful to you that I have at least a possible return ticket in the San Ysidro frescoes.

Henriette, Peter and Ann Carol are marvelously well and were happy to have me return . . . The new house is very comfortable and very chic . . .

[1]The Simmses were still interested in having PH paint a mural panel in the *portal* outside their Albuquerque ranch and had asked him to make another preliminary drawing of San Ysidro (see PH to Paul Horgan, [Winter? 1936], note 1.

To Paul Horgan

Jan 28, 1937
[Chadds Ford]

. . . I have made some new lithographs which I'm anxious for you to see — those done in New Mexico last time were without exception failures. One — I have done over and it has come out much better — this is "The Sermon from Revelations"[1]

which you may remember my showing you the drawing for one evening at Duffields;[2] I had left the party to make it.

. . . Well the opening was marvelous.[3] Caterers, wine and sandwiches. Chico and I sang a few Mexican songs which was Mrs. Sullivan's idea and one I fought at first for all I could but as it turned out it went off very neatly with the people evidently enjoying the songs quite a bit . . . Three paintings were sold that night with the amusing interlude of two contenders for one painting matching for it! Word has come today that six paintings have been sold and that in the other show (Black & Whites at Assoc. Amer. Artists 420 Madison Ave) three drawings have been sold. Isn't this amazing! Dr. Harshe of the Art Institute of Chicago invited out to the spring show the portrait of "El Mocho"[4] . . . and the drawing of "The Baptism at Three Wells." Then later came another letter from him also inviting out the tempera painting of "The Valley in a Storm" which you helped us pack that dreary day at the ranch.

Other news is Henriette's portrait of me won another money prize — $100.00 at the Penna Acad. of the Fine Arts. I took Honorable Mention at a print show in Phila with the lithograph of "Baptism at Three Wells."[5] Andy has a 1-man show scheduled at Macbeth's next fall and they are keen about his work.

. . . I have no studio so am inconvenienced a great deal and forced to work entirely at lithography which however is progressing. A fine warm winter, — with marvelous foxhunts when the hounds fairly fly across the Chester County landscape and we the field follow in an exciting, headlong steeplechase over post-and-rail fences. One thing I'm hoping to do — set aside 300 dollars for a studio at the ranch.

[drawing of ranch plan, showing studio as new attachment to house, adjacent to bedroom] . . .

[1] PH liked to observe and draw revival meetings held on the outskirts of Roswell. After attending one in July, 1935, he wrote Henriette, "It was all mad — a wild combination of Goya and Daumier in the sharp focus of [its] super-reality" (PH to Henriette Wyeth Hurd, July 24, 1935).

[2] Colonel and Mrs. Barry Duffield, faculty friends at NMMI.

[3] From January 20 to Feburary 6 PH had his own show of sixteen paintings at the gallery of Mrs. Cornelius J. Sullivan in New York.

[4] A roguish-looking Mexican cowboy with only one hand. In Spanish *el mocho* means "the maimed one."
[5] In June PH sold this lithograph to the New York Public Library.

To Paul Horgan

[March, 1937
Chadds Ford]

Querido Pablito, Cuateson [1]

As my official and only Vollard [2] you will be delighted to hear that a unique fortune hath befallen me. This morning came word from Dr. Harshe of the Chicago Art Institute saying that in the current Sixteenth International Water Colour Exhibition my portrait of *El Mocho* has been awarded the Watson F. Blair Prize of $600.00 and because this prize is a purchase prize the painting automatically becomes the property of the Art Institute and part of its permanent collection. You remember *"El Mocho"* it was the egg-tempera portrait of the Mexican with a black hat tilted sideways on his head. Boy am I amazed!

So now it looks as tho I might be able to get a studio put up at the rancho this summer. You know without my telling you how much I need this — more than plumbing or more land for grazing or anything else. [3]

. . . I haven't a notion how good my chances are to win the El Paso Contest [4] but I have two designs ready — both gesso panels in egg tempera scaled as specified 1 inch to the foot. I missed not having you near at hand to discuss with me ideas!

If luck favours me in my plans for leaving I hope to be off not later than May 1st — perhaps before. Oddly finances control this more than anything else. Henriette still talks vaguely of visiting me this summer — perhaps with Peter and the Phelpses, [5] driving down sometime in August. But I haven't much confidence that she will altho she wants to — because of the trouble and expense of having the baby cared for here.

Separately — I'm sending you for the Horgan-Vollard portfolios impressions of some recent lithographs. One "The Sermon from Revelations" was bought by the Associated American Artists the entire edition for their $5.00 series.

. . . Well Pablito[1] I find myself looking forward with all kinds of eagerness to seeing you again soon. Catching up on all there is which has had to lapse since you put the Rembrandt portfolio into my hands that night in November and said goodbye. It has been a fine winter here all right — The kids healthy, the exhibitions safely negotiated and some successes returned from them; the weather was grand and I had some exciting chases with the hounds. But creatively, aside from the designs for the Federal Government[4], it has been bleak, due to my having no place to work here. And you can imagine how eager I am to return to whatever Fortune holds for me to do — whether decorations or easel paintings and again immerse myself in work . . .

[1] Old pal.

[2] Ambroise Vollard, a French art connoisseur, critic, dealer, collector, and biographer of artists.

[3] "Last fall when I painted 'El Mocho' I had to work in the kitchen where the cook, guests, peónes [workers] and the tenant family [the Wagners] were continually straggling in and out. They sang songs, swilled wine, and twanged guitars by the hour. The only thing that made it supportable in the least was that Mocho who had no love for sitting for his portrait was kept entertained" (PH to Dr. Joseph Harshe, draft, written during this period).

[4] The U.S. Treasury Department mural competition to decorate the lobby of the federal courthouse in El Paso, Texas. To supervise nationwide competitions among American artists for the purpose of decorating various government buildings, the Treasury Department had recently formed the Section of Painting and Sculpture. In October, 1938, it was made a permanent section of the department, rechristened Section of Fine Arts. By using 1 percent of the building costs of new federal buildings to finance decorations in painting and sculpture, the Treasury Department tried to stimulate the production of art throughout the country.

[5] William and Mary Phelps, neighbors from the Brandywine Valley.

Two months later Peter left for San Patricio. He had asked Henriette to come out to the ranch at the end of the summer, and Henriette had said she would try to make the trip.

To Henriette Wyeth Hurd

Saturday
May 14, 1937
[San Patricio]

Dearest Henriette:

Well — the main event of interest in the trip down here this time was my stop in Washington. I called the Treasury Dept. and there talked with Mr. Rowan[1] whom I've spoken to you of, (the man I met before when I was down there). He told me that while in the case of the El Paso competition the Washington jury had followed the recommendations of the local one in El Paso in appointing Lea[2] — himself an El Pasoan they were very favorably impressed with five or six of the sixty odd designs submitted. I suppose I sounded a little strange then in telling him I wanted to know the unvarnished truth about what they thought of mine and to have no reticence through fear of hurting my feelings on telling me. Well he sent for the files and produced a large photograph of the one of the burning ranch etc etc. and said they were much interested in this one and that most certainly tho perhaps not for a year yet I would be appointed to do some work for the Treasury Dept. He went on to say that he thought Lea's solution of the spaces better than mine and said that I might not have realized the extent of 52 feet by 11'. Of course he may have been very right (I didn't see Lea's design) but I am more and more agin' the overcrowded murals one sees so often these days when the decorator seems to be oblivious to the decorative possibilities of allowing certain spaces to be serene and uninterrupted.

At the Ranch all is fine. We[3] came back to find the house scrubbed, utensils freshly washed furniture dusted linen out and beds made. The Wagners are well and working hard at their crops. It gives me a stab sometimes to see Odell in an old shirt of Peter's and with his old corduroy shorts. They have done much repairing and building up. So far the fruit prospects are excellent — but there's always and continually the menace of hail . . .

[1] Edward B. Rowan was superintendent of the WPA Section of Painting and Sculpture.

[2]Tom Lea, El Paso painter and novelist. He and PH were good friends.
[3]PH had returned to San Patricio with Johnson Morgan, later referred to as Fritz.
Morgan worked as a hand on the ranch.

To Henriette Wyeth Hurd

San Patricio

June 3, [1937]

Dearest Bean:

Just a word to you to say we are all right in spite of pretty severe floods and storms. The Rio Ruidoso has been on a wild tear and we've suffered some damage tho less than some of our neighbors down the valley.

Roswell was under two to three feet of water and there was much excitement and some financial loss. I've been working all day with the Wagners and the farm team with a 10 inch turning plow and "fresno" [drawing of fresno, a kind of wooden plough] to make the ranch road passable. The rains had turned it into an *arroyo*[1] . . .

[1]A dry waterway subject to flash floods.

To Henriette Wyeth Hurd

[June 5, 1937

San Patricio]

. . . The Wagners are marvelous. Here they have lost all their crops (aside from fruit) the work of months and also damage to fences roads *acequias* etc. Yet they are quietly accepting it laying plans for catching up on what work has been lost and on the damage done; up at dawn with the team hitched soon afterward and down to the fields. It's for them that I'm really sorry, for our crops (the half mine) are their livelihood and a tough livelihood it certainly is! But they're a happy lot, grateful for the pleasant things however small, that fortune deals them.

. . . Coming back from Roswell Fritz and I met a party from the [Soil Conservation Service of the] Dept of Agriculture making a survey of erosion damage. It was a fortunate meeting be-

cause I want very much to enlist their help in controlling erosion here on this ranch . . .

To Henriette Wyeth Hurd
Sunday. [June 7, 1937
San Patricio]

. . . Well we got the fences up and the road rebuilt and now begins the Wagner's replanting. We find our feed crops, about 14 acres are relatively little damaged so Earl and Julius are in on them with a cultivator today.

I have made a few drawings but no painting yet. I want to get the memory of pictures out of my mind — everything of any ones I've seen and begin afresh. This may seem silly to you but it's really a profoundly important thing to me just now. I am nauseated at the thought of painting just "another picture." But now after three weeks here I'm getting the result I'd hoped for: That is, things to be done are occurring to me spontaneously. I'm not going out searching for something to do which I feel now with me would result in something very spurious and synthetic . . .

To Henriette Wyeth Hurd
Monday
June 21st [1937
San Patricio]

Dearest Bean

Again the *Acéquia Margarita* is running and from where I sit at my window I can see it gleaming out of the dark shadows of the Cottonwoods. The adobe makers will return to their task now; we think about eight or nine hundred adobes can be salvaged out of the 2700 which were made when the flood arrived, this leaves 2500 to be made.[1]

. . . A letter has come from Mrs. Force[2] inviting me as one of the 120 contributors to the Whitney biennial this next Fall. Isn't this fine?

. . . The Associated American Artists have written for an-

other subject to take the place of the ill-starred revival meeting which had no luck. Luckily for me the swaggering, poetical José[3] has just today returned from six months' work on a ranch twenty five miles south east of here breaking broncos. He came to see me of course as we are close friends and seeing him again makes me resolved to do his portrait as soon as I'm able.

Benito[4] is so jealous of his kitchen with its shining copper pots and polished linoleum that it's going to be hard on him [for me] to use part of it as a studio — For lithographs of course I can use any room. I suppose it will be two months before I can use the new studio — the floods set us back a month at least and the foundations are just being laid. *Qué carai* how I need a place in which to work — [with] bright light and plenty of room.

My mother was beaming about a letter she had got from you. Her ordeal[5] has given her a quality of character she didn't have before I think. We will never be very compatible or mutually understanding but on the other hand we get on perfectly easily. I offer her no confidences which seemed always to result in disastrous misunderstandings. There is nothing which we have built up in common which can be broken now; it simply doesn't exist —therefore there is much less tension.

Goodbye my Darling. I'm longing to see you and have you again really by me. I adore you, you know, deeply and completely and it is you who must fill (and you do) the double rôle.[6]

<div style="text-align:center">

Adiosito my Sweet

Your,

Peter

</div>

[1] The adobes cost PH twenty dollars per thousand.

[2] Juliana Force was the director of the Whitney Museum of American Art.

[3] José Herrera (not to be confused with the previously mentioned José, a gardener at the senior Hurds' farm) worked for PH as a ranch hand for twenty-three years. PH painted many portraits of José, one of which, *Portrait of a Cowhand*, was reproduced on the cover of Scribner's magazine in March, 1939. It now hangs in the permanent modern collection of the Nelson-Atkins Museum of Art in Kansas City.

[4] Benito Martínez was one of many briefly employed cooks at Sentinel Ranch.

[5] Mrs. Hurd had fractured her hip.

[6] Wife and mutually nourishing companion in art.

To Henriette Wyeth Hurd

July 6th, [1937
San Patricio]

. . . We spent a profitable 4th of July at Ft Stanton where there was a marvelous rodeo. I wished for you so! The light, colour, people, *what people*. We hauled a horse over and after he was unloaded I put my easel in the trailer and made drawings of the people — more studies for that litho & painting I keep telling you of.

. . . On Saturday I went to Roswell for supplies and then found [Clifford] McCarthy & Monté Hunt[1] who with another man had come to see me and talk about the addition to the house, window placing, roof pitch, etc. etc. They came up here with me that night and Monté as usual enthusiastic and excited about the possibilities . . .

[1] See PH to Henriette Wyeth Hurd, July [21], 1935, note 1.

To Henriette Wyeth Hurd

[July 11, 1937
San Patricio]

. . . work progresses pretty well on the house. Tomorrow should finish the cementing of the walls which I will allow to dry then whitewash with the special government formula cement whitewash. The gallery begins when lumber arrives and then the studio addition — for this the rock foundation has already been dug out of the mountainside above the windmill by Pablo, the mason and his *peón* whom I must paint and draw — a marvelous pair! I've been working half-days on the *acéquia* where avalanches of rock & earth filled it in some places nearly three feet deep. I am feeling very fit . . .

[I] heard from Eric — from him a long penitent, apologetic letter — no luck with the bratti,[1] no responses to letters, no interest generally and of his own disappointment at missing a summer in New Mexico.

. . . It has been a busy week and we're now in the full swing of life here but always there's the unhappy overtone of appre-

hension — "How is Henriette, Peter & Ann Carol?" and the sinking feeling I have at remembering how remote you are from this land and this life. I love you deeply, completely; there is no one here to arouse me inwardly and stir me as you always do. The more absorbing this life, the more frantic my need for you becomes. I long to touch you and kiss you as in past times. What times!

Your Peter

[1] PH and Eric Knight had planned to have roughly half a dozen teenage boys come to San Patricio during the summer as "paying guests" and help them build up the ranch in return for instruction in riding, fencing, and polo.

To Henriette Wyeth Hurd

San Patricio Thursday
[July 15, 1937]

. . . I've been painting the Lady Bronc Buster whom I wrote you of meeting at the Picacho rodeo.[1] I have a fine chance in it — a really fine one, if I can realize what is promised —, or what is possible.

We are having grand meals these days with our own fresh vegetables and fruit. The first fruit went to market last week at a very fair price considering that it was hailed on during the floods.

. . . The 4,000 adobes are finally all finished and you can hardly see the ranch house as you enter the house grounds for the long rows of adobes [are] piled four [feet] high edgeways (which makes a five-foot wall!) topped by sheets of corrugated roofing iron. The foundation is half finished and now remains a 2 week wait before we can begin laying adobes so as to allow the minimum of 3 weeks for them to mature in the sun. So far no more word from Monté but I rather expect him over this weekend.

. . . I have completed my first lithograph for this summer!

[1] "She was dressed in a flaming yellow print shirt a black sombrero with a low flat crown and chinstrap, beige coloured bolero vest and tight bell bottomed trousers over cowboy boots. Vest and breeks were trimmed with gold buttons" (PH to Henriette Wyeth Hurd, July 10, 1937).

To Henriette Wyeth Hurd

Roswell,
Sunday [August 1, 1937]

. . . [It is] due in New York by Aug 15th — It leaves by express on Monday — two sides of a stone one of an ancient shepherd named Pilar Morales, the other of the rodeo which I wrote you I had done. I like the rodeo better as it is free and in the idiom I like best viz quill and rubbing ink.

. . . I'm getting together as many notes and drawings as I can — to work from later in Chadds Ford. This is the sort of thing I felt the lack of last winter and I hope to remedy it now.

. . . Here is a picture I came across. It is sad as hell to me for it's the very thing I want so to do now. It couldn't then have seemed half so precious or desirable to hold you in my arms. The reaction (inevitable) from painting is, O Hell, where are you Henriette? Is this worthwhile being away from you days on days? Are these only mirages I'm following here? etc.

I keep having the feeling that you won't be able to come here finally. Then the thought that if you do, you'll think it's awful. All this tedious analysis of my feelings only to tell you I love you . . .

I have lived hard the past three months: More so than before and by playing the part of a good listener looked as with an X-Ray into certain lives: As if a Titan hand scooped at random a handful of humans for me to study and learn from them the qualities of the race of Man. From this I think I have matured and that now there is a weight of understanding to give me impetus to make drawings.

Please write me when you get this. I need to hear from you . . .

To Peter Hurd
From Henriette Wyeth Hurd

August 4, [1937
Chadds Ford]

. . . Lord, I do want to see you — It doesn't matter about whether or not I like the ranch or not we'll *all be together*! I'm living in an excitement of anticipation of our meeting.

. . . I thought if things seemed comfortable then, we would

stay as long as you'd like [us] to — but of course if I can't get some work done I'll simply *have* to get home within a month. — . . . I can't live without you *any longer*, & I *never* will again . . .

To Henriette Wyeth Hurd

Wednesday [August, 1937
San Patricio]

. . . I haven't any way of conveying to you with a few pencil scrawls how I feel knowing you and Peter and Ann Carol are coming here. I hope you won't mind my showing you off a lot; I have talked of you so much, often I'm afraid in spite of not wanting to — wistfully.

Goodbye for now My Sweet — I am, to translate literally from the Spanish, "Deliriating" in the news that you'll be here soon. . .

To Henriette Wyeth Hurd

[August, 1937
San Patricio]

. . . there certainly will be a place for you to work when you get here a big adobe room 20 X 30 feet with a 14 foot ceiling and a window just like ours in the big room 10 feet long and 8 feet high. I so wish you were here as we build it. I often need your help in planning doors, locating the chimney etc. a lot of things that I try to plan as though you were here at the time. The Walls are now ten feet high and the doors I mean the actual door, not doorway are being planned. I suppose that just about the time you get here it will be finished and certainly you are the one to use it if it will mean your staying with me. I can get on beautifully (with you here) working anywhere. I know it! So bring on your materials. You will be glad to know that I have built a sort of loft — or gallery at one end of the studio — a floor 7 feet wide and the width of the studio standing seven feet above the studio floor. This will allow us to store everything not in immediate use

off the floor. Closets were impractical because of the very high ceiling.

These two letters darling are the first from you asking about the studio and I am delighted at the prospect of your working there . . .

To Henriette Wyeth Hurd
Sunday [August 22, 1937
San Patricio]

. . . the building progresses and I find it odd to be an architect in fact — with walls raised of heavy adobes and doors set where I will and as I say. So different this than painting where with a scoop of a palette knife the work can all be undone and the ground ready to start anew. The house seems to grow with a curious combination of caprice and logic. One thing seems certain it will have a charm and a quality of hospitality which is important. I plan to take two days off this week with Julius and Earl [Wagner] to roof the *Zaguán* or connecting hall laying thick, puddled mud and straw over boards set on the Vigas and over that a pitched roof of galvanized Iron. This roof won't match the old roof's deep earth red nor can it be painted until another year.

I'm so pleased to hear the house will be well cared-for while we're here together. The Quaker couple sound fine and about the only sort one doesn't have qualms over leaving with the furniture books etc.

Probably it is best leaving Ann Carol behind this time with you at work here. It's silly to say here I'll miss her — I'd counted on a reunion here so much but in the face of the added cost and with your mother's good offer we'd better do as you say.

Last week I sent off eight drawings which I wished you might have seen — Pegeen Sullivan[1] had written once before for all I could spare and so when the second letter came speaking of a market for them I sent off all I didn't plan to use as studies for lithographs or paintings.

. . . Strange how as time grows shorter till your coming the days seem longer & longer. I'm in the curious place of wishing when I think of you that the time would fly and when I consider

the plodding *peónes* who are building the studio I hope for all the long days possible . . .

[1] See journal, March 12, 1935, note 1.

To Henriette Wyeth Hurd

Sunday [August 22, 1937
San Patricio]

. . . so much has happened . . .

First — the news I telegraphed you of — viz. the Treasury Dept.'s invitation to me to submit [mural] designs for a new Post Office at Big Spring [Texas] 250 or so miles east of Roswell. This is non-competitive which means that subject to their approval of my designs I have the job. There isn't a great deal of pay in it but plenty to make it worthwhile and besides the way I feel these days I almost will paint decorations gratis given interesting wall spaces and free rein in subject matter dealing with this land! For a panel 23 feet long by six feet high I am offered $1300.00. Since your new plan brings you here a week later than you thought I plan to go over there (Big Spring) the 1st week in September to meet the Post Master who will be advised of my coming by the Treasury Department. This so as not to conflict with meeting Paul at Albuquerque[1] on his return from Hollywood. No word from him since Santa Fé from whence he wrote me of the format he had discussed and decided on with The Rydal Press who are to do "Storm Toward Heaven" in limited edition with six quill drawings by me — backdrops of the New Mexico Landscape as I did for "The Return of the Weed" in lithography[2]. . .

[1] PH and Paul Horgan had planned to visit the Simmses at *Los Poblanos* Ranch to discuss the San Ysidro fresco.

[2] This latest collaborative project between PH and Paul Horgan, a historical narrative of the conquest of Acoma, New Mexico, in the seventeenth century by Governor Juan de Oñate, was published in 1938 under the title *The Habit of Empire*.

To Henriette Wyeth Hurd

[August, 1937
San Patricio]

. . . Since writing you last I have been to Albuquerque where I met Paul . . . We spent three days as guests of the Simmses and a grand time it was. If only you could have been there. I have grown to know Mrs Simms much better and to respect her great shrewdness of observation and appraisal of people. She told me some revealing and most interesting accounts of the Washington of her youth when her father, Mark Hanna was the President's[1] right hand man . . . One day Paul and I drove to Acoma[2] and tho I was prepared for something fine and exciting the actual sight of it was breath-taking. What a place!

. . . But most important — They the Simmses are crazy about the small colour panel of San Ysidro which really does look fine in its surrounding colour. I plan to do it in Egg instead of wet fresco[3] as they assure me rain never reaches this panel. So I am beginning almost immediately on figure studies and details for the cartoon.

. . . The studio made strides while I was away. Pablo Lara, my mason-carpenter outdid himself to make a showing of real progress. Roofing begins tomorrow and after that there's only the doors and windows to put in & another coat of plaster (mud & straw). Poor Pablo keeps good-humoured amid all sorts of storming from me. Sometimes it seems the work stands stock-still and I begin on the workmen with a combination of swearing & wheedling.

. . . Later . . . The men have put in two good days on the house and part of it is all roofed . . .

. . . The vigas are in place — they are beautiful tapering poles of yellow pine which were marked by the forest rangers for us to take out of the forest near here. I thought it would be very difficult to put these poles up on the wall fourteen feet above the ground but three of us had all eleven of them in place in short order this afternoon . . .

[1] Theodore Roosevelt.

[2] PH made drawings of the ancient Indian mesa-top pueblo for *The Habit of Empire.*

[3] In the end the work was done in wet fresco.

To Henriette Wyeth Hurd

September 9, 1937
Big Spring, Texas

Darling Henriette

Big Spring at last! What a place it is! I have been here two days cruising around drawing — making notes etc. The Post Office is a fine new building simple and attractive in design. The Post Master I had a tussle with at first as he proved to be a zealot of the first order with all sorts of ideas of his own about what is to be done. It took a lot of high powered diplomacy and the gift of a print of *Texas Nomads*[1] to get him around to pulling with me. As it is tho it goes very well and we are allied in the Cause of getting an epic decoration installed.

. . . I can hardly wait to get back to hear how you all are and what your plans are . . .

[1] A PH lithograph.

To Paul Horgan

[Postcard]
Friday [September 17, 1937
San Patricio]

Holá Pablo —

Word from Henriette she is due here Tuesday — or rather at Carrizozo where I'll meet her . . .

To Eric Knight

San Patricio
September 29, [1937]

. . . Henriette is crazy about the country and mirabile dictu is already planning landscapes.[1]

. . . miracles have been wrought — We have a new big studio and a cook's quarters running out east of the house and a grand gallery or *portál* ranch style running the entire length of two of the patio sides of the house. But the true wonder is running water and an elegant Montgomery Ward Bathroom where

the old saddle room was — that is — in the north half of it. There are also stone walls around the patio and garden and young *álamo*[2] trees sprouting under the new stimulus of running water —

The polo field is enlarged and every Sunday there are great matches among the local *Vaqueritos*.[3] We have a few new horses and lots of new polo equipment. [In] another year I'm going to begin really breeding for polo horses. We harvested 1100 bundles of feed this year which will feed three brood mares all year easily.

. . . The San Ysidro panel is due to be painted in November — Along early in December we plan to return to Pennsylvania. So for two weeks or three in November we'll be at the Albert Simms' in Albuquerque . . .

[1] "This place is excitingly and brilliantly beautiful," Henriette wrote her parents from San Patricio, "the air so curiously clear and sterescopic. (wrong spelling). White, very *Wyeth* clouds, float over the hills in a pulsating blue, and you feel that you can touch them, pull them down. And in half an hour, a complete & most temperamental change to stormy melodrama & a livid horizon. And the great foothills rise like sleeping tawny cats — they almost move . . . an intense stern beauty — which compared to the tenderness & mists of Chadds Ford is a little appalling . . . I want to paint it — I am surprised at myself for having this urge, which grows stronger each hour —" (Henriette Wyeth Hurd to Mr. and Mrs. N. C. Wyeth, September 22, 1937).

[2] Poplar.

[3] Cowboys.

To N. C. Wyeth
From Henriette Wyeth Hurd [1]

[November 17, 1937
San Patricio]

. . . Peter's done a tremendous lot and avoided a mess of future trouble & delay in the actual fresco painting by following my advice and making actual size charcoal drawings of the praying figure from life.[2] (You would be much impressed by this drawing; the first fine one he's done!) . . . Life has been so beautiful & simple here, and I hate to think of this chapter closing . . .

[1] None of PH's extant letters covers the ensuing period.

[2] For a description of the San Ysidro fresco, see PH to Paul Horgan, [Winter? 1936], note 1.

To Mrs. N. C. Wyeth
From Henriette Wyeth Hurd

[December 2, 1937
Los Poblanos Ranch]

. . . We left the ranch at San Patricio at noon last Tuesday (Nov. 23rd) . . . and the whole sunny beautiful morning [was made] overcast for me by a nostalgia & regret at leaving the place that somehow included Chadds Ford, Maine, and every other spot I've ever loved and been happy in.

. . . We all three are having a grand time here, the Simmses are marvelous to us in every possible way.

. . . Peter's doing his plastering himself . . . The sand has been a problem — along with a dozen others that he has struggled with & finally solved. — First, to find sand that contained no gypsum. Then to make sure it was *sharp* sand, & not eroded & worn with water. Then to wash — & finally to dry it. The plaster covered wall that's to have the fresco had to be chipped off to the tiles; that has taken 4 days, 2 peons working constantly. Then sheets of beaverboard nailed to large wooden frames were made (by Peter) to fit into the 3 open arches around the space, so that the wet plaster can be kept at an even temperature during the freezing nights . . . Of course Peter is in a feverish state to begin painting & tomorrow seems to be the starting day at last . . .

To N. C. Wyeth
From Henriette Wyeth Hurd

[December 4, 1937
Los Poblanos Ranch]

. . . Peter has prepared thoroughly and it is resulting in a smooth sure progress . . . I was positively weak-kneed yesterday when finally the beautiful white creamy plaster was all on the upper part of the space — and fled when Peter, on a scaffold in white overalls and very nervous & eyes looking quite green, started painting . . . [After lunch I returned] and by God, the top of the great dark mountain and most glowing sky was there, and thrilling to see even in its first broadly painted state . . . He

painted on for 2 hours (until the light went bad) — with directions from myself down below and 30 feet back, pointing out stains & introducing color shifts and merges — a brassy thing for me to do, but P. insisted . . . Peter asks for suggestions all the time. I ought to get a commission out of this thing! . . .

To N. C. Wyeth
From Henriette Wyeth Hurd
[December 18, 1937
Los Poblanos Ranch]
. . . Well, the fresco is finished and it's beautiful — and successful — the Simmses are crazy about it . . .

The Hurds departed for Chadds Ford the following day. They arrived in time for Christmas and stayed through the winter.

To Paul Horgan
Friday —
April 8th [1938
Chadds Ford]
. . . It seems to me I have done nothing but design all winter — all projected things and nothing carried through to completion — a thing which I find most exhausting for nothing seems to tax my energy like the conception & beginning of a work, particularly if I am working with my eye on the calendar. Henriette has told you what I am about so I won't repeat. I still have one more tempera colour design for the new Federal competition[1] to complete. It is for a long panel (25' X 12) and I have chosen for my subject the meeting of an emigrant train (covered wagons & livestock) with an East-bound Butterfield Mail Stage, the latter bowling along behind lathered horses and contrasting with the tortoise gait of the ox-drawn wagons. The other two depict "The Homebuilders," making a pioneer home on the Texas prairies, and the Air Mail —, a plane flying at twilight over a lonely Texas ranch with a mail box part of the foreground design, this is an upright panel, 5'5" X 8'.

Henriette's [New York] show has been on a week now and I am baffled and disappointed at the lukewarm press. I really have a notion that they (the critics) dislike her dealers personally and are inclined to discount any newcomer there whose name is not established. I have no other way of accounting for it for her work certainly looks superb in the spacious well-lighted rooms at the Rheinhardt . . .

[1] To decorate the post office terminal annex building in Dallas, Texas.

To William Wistar Comfort[1]

Chadds Ford, Penn.

May 15, 1938

Dear Dr. Comfort.

The exhibition [of my work] at Haverford College has been a pleasant and stimulating experience for me. The genuine enthusiasm which seemed to be voiced generally is a very encouraging thing to hear particularly in this day of "isms" in art. I, in so far as I know, belong to no cult and therefore get in on none of the organized hue and cry.[2]

In addition to this a number of sales were made which are the best proof I can think of of the genuineness of the enthusiasm.

To you and the college my thanks for arranging the show which I thought was extremely efficiently run and well presented.

With warm personal regards to you and Mrs. Comfort

I am

Sincerely

Peter Hurd

[1] See PH to Mrs. Harold Hurd, April 20, 1923, note 2.

[2] "They call me a Western painter, but it's true only in the sense that I live in this area. I don't think of myself in the tradition of Remington and Russell. I'm simply a painter of what occurs around me" (interview with the *Houston Chronicle*, August 21, 1966).

To Paul Horgan

Chadds Ford
May 16th 1938

. . . My delay here has been caused by the appearance of a few jobs — none large or important but the sort that since the barn burned[1]— I feel I can't afford to turn down. They were two Juveniles[2] — now finished and a horse portrait also about completed.

Henriette and the kids plan to come out the middle of July . . . Whether I will be finished with the fresco at Big Spring by then is questionable. The actual painting should be completed within two weeks but the preliminaries are what take the most time, washing and drying sand — building scaffolding and ripping off the present plaster. It is an exciting prospect!

My tentative departure date now is May 23rd — next Monday a week from today. It may be a day or two later depending on my progress in getting thru with things that have to be done. This year I have vowed to make no hectic over-tiring trip East for Christmas. I'm setting no date for my return as it seems to affect my work there so much . . .

[1]The old barn that was part of PH's original San Patricio purchase had burned that spring.

[2]*Deep Silver* and *Thomas Mason, Adventurer.*

To Henriette Wyeth Hurd

San Patricio Wednesday
[June, 1938]

. . . I arrived not at all worn out in fact there hasn't been any reaction at all except the awful and constant one of missing you. When I think of how you look all I can remember is how you looked weeping in the rain when I left. There's not much consolation about this — I almost wish I had waited so we could go out together and about all that makes this not unbearably acute is that the sight that greeted me of the ruined barn was so appalling I'm glad not to have had you share it.

. . . Aside from this everything looks fine.

. . . At Fort Riley [Kansas] I had a good relaxing time saw

lots of old friends some of whom I hadn't seen since West Point days. All in all it was very great.

. . . I send you my entire and complete devotion. I miss you really achingly — This house now has so much of you in it. I feel your presence here which is both saddening and reassuring — But it's great to know we'll be together again so soon.

ever your Peter

To Henriette Wyeth Hurd
San Patricio Tuesday
June 6, [1938]

. . . The newest development in the Big Spring affair is the arrival here of a note from Nat Shick[1] and a photograph of one of his creations — sent to help me "with our idea of the depicting of 80 years of postal Service in Texas." He evidently still thinks this idea of his is the theme of his mural. O God, what luck I got to have drawn such a one from the hundreds of run-of-the-mill P.M.'s. If ever I needed a Talent for diplomacy it is now. Stupidly I left without the other two sketches made for the Big Spring assignment and I think I know where they are. At least the one I need so as to show him of my bona fide living up to our agreement is the one of the windmill and stage coach air-mail plane etc. Will you please hunt up this charcoal drawing, rolled up and I think stored in the closet of the room I worked in upstairs. Send it to me Bean please as soon as you find it for I feel this is important to prove to Mr. Shick that I wasn't double crossing him that I did make an attempt to execute his idea. The photograph is of a pathetic and absurd layout he has got together made of stones and twigs with green leaves which quickly withered and a toy air-plane, stage coach and pony express rider — the latter so crude that I'm sure Nat whittled him out himself. Hanging by a hempen string like clothes on a line are big signs saying Shop now mail for Christmas. The 80 years progress of Postal Service U S Post Office Big Spring Texas. And down under a begonia that completely dwarfs everything a pasteboard sign supplied by the P.O. dept says "Save Time Use Air Mail." Also a toy train with a locomotive the size of the Pony express

rider's horse is beside him. A more dreary pedestrian stupid thing could hardly be imagined.

One thing accomplished and thankfully off my mind is the discovery of a container for carrying lime putty from Mrs. Simms' to Big Spring. It is the 100 bb drums used by Quaker State to send their grease around the country.

[drawing of container] . . .

[1] The postmaster at Big Spring.

To Henriette Wyeth Hurd

Friday P.M. [June 9, 1938
Santa Fe]

Dearest Henriette:

Paul is driving and we are bowling along over the road from Albuquerque to Santa Fé. A marvelous day and such country — as you remember. If only you and the kids were here with us how perfect it would be! The lime in the oil drums is setting behind us and there proved to be even more of it than I had thought left at the Simmses.[1]

. . . The fresco at [the] Simmses seemed to be in good shape all it needs is minor repairs at only a couple of places.

. . . We have just topped the divide in the Sandía Mountains and before us in the distance across the plain lies Santa Fé. Houses gleam white against the cloud shadowed Sierra Sangre de Cristo . . .

[1] "The lime putty has been slaking since October 1937," PH wrote Edward B. Rowan at the WPA Section of Painting and Sculpture, "and is made from Tiger Finish Lime Hydrate shipped to me by the Kelly Island Lime and Transp company of Cleveland. It is a Dolomitic lime from Ohio free from harmful water soluble salts and highly recommended to me by Mr. Fred Weber of the Weber Co. The Sand I shall try to find locally in the Big Spring area and shall examine it under a glass to be assured that it is sharp enough to bond well and shall have it tested by a chemist for the presence of dangerous quantities of Calcium Sulphate Magnesium Sulphate and Sodium Sulphate. It will be thoroughly washed then dried before mixing into mortar" (PH to Edward B. Rowan, draft, June 13, 1938).

To Henriette Wyeth Hurd

Early Monday Morning
— June 13 — [1938
San Patricio]

Dearest Bean:

Drama Continues with Alarums and Excursions! . . . on Fri Night, the day we arrived [in Santa Fe], Bynner[1] gave a party for me before another one at the Myers' old Santa Fé people. Paul dutifully dining with his Ma, wasn't there. The 'phone rang in this very special Chinese restaurant where Hal was giving the party and I was called to it to hear Paul shout, "Peter, Have you seen the papers?" It was first a wave of apprehension that swept over me as a distorted picture of catastrophe at Chadds Ford and San Patricio flashed into my mind. But an instant later I was hearing from him that an A.P. wire flash carried in the New Mexican the news of my *winning the Dallas P.O. Job!*[2] This of course you may have heard but I am assuming you haven't as it has more local than national interest. Anyhow I winned, I guess, Bean because arriving here last night I found a fine enthusiastic letter from Mr. Rowan saying my (*our!*) designs were the choice of both the local committee and the Section of Painting and Sculpture in Washington . . .

[1] The poet Witter Bynner, known to friends as Hal.

[2] PH was chosen for the job from among 149 competing artists, for a commission of $7,200. See PH to Paul Horgan, April 8, 1938.

To N. C. Wyeth

Sentinel Ranch
San Patricio
June 14, 1938

Dear Mr. Wyeth

Henriette has by now of course told you of my winning the Dallas Commission — the first really large one yet to come my way — so at this solemn time I think first of you to whom I truly believe I owe the greatest part of my success in getting this award. The very things that the Treasury Department singled out as liking are the things for which you stand so strongly; in his

letter telling me of my having been chosen the Superintendent says:

"In the estimation of the Section (Painting & Sculpture) all three designs were handsomely composed in a competent way — The figures were exceptionally well drawn and expressive and the work has an unaffected mural quality and is beautiful in color."

You will smile at the remarks about drawing knowing the struggle I sometimes have — However all of these things it seems to me are what we all in our family try to stand for — and I count this small success of mine primarily a tribute to you and the grand background of teaching you have given me.

The panels — two of them are large but fortunately my studio here is large enough for me to make the Cartoons in. — One panel is 25 X 10 feet the second 20 X 8' + inches and the third 5'8" X 8'.[1] I'm all for doing them in fresco if I have good luck with the Big Spring panel, the Cartoon for which is now progressing very well I think . . .

[1] About five hundred square feet in all.

To Edward B. Rowan[1]
[Draft]

[June, 1938
San Patricio]

. . . the sooner I get word from your office of your approval of the cartoon the quicker I can get started on the work on the wall.[2] My plans at present are to leave within the next two or three days for Big Spring, leave my assistant there to wash sand etc while I go over to Dallas to see the Terminal Annex building . . .

[1] See PH to Henriette Wyeth Hurd, May 14, 1937, note 1.
[2] PH's contract required him to provide the Section of Painting and Sculpture with an eight-by-ten-inch photograph of the finished cartoon.

To Henriette Wyeth Hurd

⟨Big Spring Tex
July 9th [1938]⟩

. . . Dallas contrary to expectation was fun. People at the Terminal Annex were both interested and very helpful. *The Spaces the lighting and surrounding colour are really magnificent.* It is a grand opportunity for a mural painter I should say one of the best in the country. My guide and friendly assistant in Dallas proved to be a young Painter named Dozier who had (not knowing me) written me a letter congratulating me on my being awarded the Dallas job. I called him on the 'phone and he took me to lunch and thru him I met several Dallas painters. Young men, very earnest not a bit arty or precious and a couple of them really gifted I thought. So that was fun. I went by train which to happen in Texas was a novel experience. In the Dallas Museum of Fine Arts I was recognized by the curator from your portrait, and again in the hotel lobby by a Dallas Painter! The Dallas Painters seem a very serious & hard working group no drinking whatever among them nor any reference to carousing either apologetic or prideful. They seemed to have about them a wholesome atmosphere and I felt immediately at ease with them. I drove through the countryside around Dallas and thus got an idea of how to treat the background in the Homebuilders panel.

The newspapers fanfared my arrival and even took my picture which I forgot to look for. But they all seemed so nice and friendly so different from my last visit here ten years ago when I fell into the terrible toils of about 30 stupid, sentimental clubwomen.

When I'm once finished here I want you with me. Whatever solution seems best about the kids but I want you at San Patricio while I do the three [Dallas] cartoons there. I become so depressed at the long weeks we are separated I want less of these long times![1] . . .

[1] To this Henriette replied, "The prospect of seeing you in New Mexico is so intoxicating that it actually stops my heartbeat when I think of it" (Henriette Wyeth Hurd to PH, [July, 1938]).

To Paul Horgan

Big Spring
July 8th [1938]

Dear Pablito —

Without doubt this is the bleakest dreariest little burg in Texas! It has a reputation for unfriendliness to Strangers coming from its oil-town personnel I suppose.

Pablo Lara my faithful henchman has already covered several laundry cardboards with the doleful lines he is composing of the Ballad of Big Spring. This incessantly he sings to a dirge tune. We are living in a squalid hut in a Tourist camp awaiting a green light from Washington to begin actual work on the fresco. I am rereading Don Quixote and Montaigne and keeping fairly cool with a fine drink called *Cuba Libre.*[1] I am new at this task of loafing in a strange land and find I like it not at all . . .

[1] Rum and coca cola.

To Peter Hurd
From Edward B. Rowan

[July, 1938
Washington, D.C.]

Dear Mr. Hurd:

Permit me to acknowledge your letter of June 29 with enclosure of photographs of the cartoon for the Big Spring, Texas, Post Office.

The photograph indicates that the cartoon has been satisfactorily completed and I want to congratulate you on the high quality of this work. It represents a distinguished performance and I trust that you will be able to retain this quality in the actual painting.

. . . The information in your letter shows how thoroughly you have entered into the study and research for this work and I think your cartoon bears this out.

The Post Office Department has been requested to permit you to start the actual work on the wall . . .

To Henriette Wyeth Hurd
— *Sunday* — [July 24, 1938]
Big Spring

Dearest Henriette

The fresco marches well I feel. I have now the largest part of it painted and the colours are of course only beginning to dry into their true relationship. I feel I have kept everything I had in the cartoon and carried it further in detail and design. The foreground still remains in part to be finished and the panel of lettering.[1] Today Sunday I went into the hills making watercolour studies of wildflowers and found some marvelous things.

The great surprise about this thing — is the terrific enthusiasm of the public: They are really crazy about it and while not one single person of them has any cultural knowledge by which he could gauge it — and no one has knowledge of the great traditions of painting — yet everyone (hundreds) come in every day stand below my scaffold which is 9 feet above the floor and talk. This experience of hearing my work constantly discussed by strangers as I worked at it was a new one to me. At first (and at times still) it was trying and I wished for quiet and solitude. But their complete enjoyment of what I am doing did much to mitigate this feeling and as time — days — went by I found my ability increasing of being able to tune out their voices completely.

Nat Shick is entirely enchanted by it and couldn't possibly be more proud of it if he himself painted it. Of course these people are all ignorant — terribly stupid and unlearned in all of Culture, but this doesn't mean that *anything* would command their interest. I am lucky in hitting on a theme and approach which they really understand and which insofar as possible is really stirring them.[2] You'd be amazed at the reaction really! Don't for heaven's sake think I'm in the least swelled up about this. I am merely grateful for myself and for the visionary people in Washington who began the Section of Painting and Sculpture. I feel very humble truly and regard this panel as a very valuable precursor — and study for the much larger — Dallas panels. Technically I know I have much to learn — but I'm improving and as I go on in this I find myself envisioning new colour com-

binations new arrangements and themes in this marvelous medium of earth colours — water — sand and lime. I feel I'm at the dawning of a period of new (to me) and broader subjectivity. It is so compelling a feeling, I keep thinking I can speak of it lucidly in words but like the echo of a dream it eludes me. But it is exciting and incessant these days, — bred I suppose of hard work and of the severely ascetic routine of living I have set upon myself. We are up long before dawn each morning in the dim cellar of the Post office mixing mortar. The smell of wet lime mortar is in the air and indelibly associated with the San Ysidro panel and with you being with me . . .

[1] "The mural depicts a family of plains settlers consisting of a father and a mother, and their three children: a son about fifteen, a daughter a little younger, and a child in arms. They are seen standing in front of their sod-house on the prairie, under a placid sky of vivid blue, streaked with long white clouds. The utensils of life are presented: a well, a plow, a covered wagon, the father's long rifle, his powder horn, the hand-scythe, buckets for water. Oxen, horses and fowl are shown as belonging to the family. A newly planted cottonwood tree stands by the house. Balancing it in symmetry is the yucca bloom, native of the plains. In the distance, the buttes and mesas of the plains rise in the white light, suggesting the wilderness of the past. And in the foreground, symbol of the human present, is a freshly turned furrow of earth.

"At the base of the painting appears this inscription selected by the artist from the poems of Walt Whitman: 'O pioneers, Democracy rests finally upon us and our visions sweep through eternity'" (autobiography).

[2] PH's theme, the fortitude of the pioneer family, had wide appeal for the townspeople, who were mostly plainsmen, ranchers, and farmers.

To Paul Horgan

[August, 1938
San Patricio]

Dear Pablo:

Your splendid letter did lots to cheer me and stimulate me creatively in that bleak and stupid town of Big Spring.[1] It was grand Pablito and should have been answered before (and would have been) had not news come the last few days I was in Texas of Henriette's decision to come on immediately with Ann Carol to New Mexico.[2] So after that I was in a great turmoil of excitement and returned to the ranch to get things in order here and go to Lamy where I was to meet them on the 5th at 7:30 A.M. This I

did and a marvelous reunion it was. Henriette looks very well again[3] and Ann Carol radiant and very cute in a straw bonnet and tiny print frock.

. . . Henriette is delighted with the ranchito and the new studio[4]. . .

[1] By this time PH had completed the fresco.

[2] Peter Wyeth Hurd was in Maine with the Wyeths on doctor's orders, having recently been ill with mumps.

[3] Henriette had been ill with bronchitis.

[4] "This place is twice as attractive as last summer," Henriette wrote her mother in early September, "beautiful weather — lots of fun and nice people — some thrilling trips that I've never had before . . . There is more charm in this little house, just as it is right this minute, than you could believe."

During the summer, Eric and Jere Knight visited the Hurds at San Patricio and considered buying their own ranch in the valley nearby. When Henriette returned to Chadds Ford in September, she wrote Peter: "A letter from Jere — says Eric has his heart set on the ranch & can't get to work for thinking about it. She's against the idea because she's afraid it will 'make a two-home family of us, too' — what the hell, I think we're a really successful couple, to be *emulated*, by God!"

To Eric Knight

San Patricio Sept. [19, 1938]

. . . Henriette is safely at Chadds Ford with the kids and the new regime has begun here with Aristótle Sanchez as cook.[1] Paul finding Aristotle either in English Greek or Spanish form intolerable as a name for a cook has dubbed the fellow Totl which he says is an Aztec variant somewhat more acceptable.

The Polo gets better — we have had three really swell fast games and we meet again this Wednesday.[2]

. . . All marches smoothly apparently and I confess to finding this life the most desirable the most exciting I have ever experienced — this all in spite of the enforced separation from my family for much of the time.

. . . I'm hard at work painting again and agree so fully with what you say about this stage of our lives being the productive one that we sink or swim, probably, by what we do now . . .

[1]"I found myself selecting my cook always with less interest in his cooking than in whether or not he could ride like hell and was willing to risk his neck on our polo field" (autobiography).

[2]PH recruited Mexican-American cowboys and ranch hands from the valley, taught them the game of polo, and made them into a team. *"Los Mendigos de San Patricio"* (The Beggars of San Patricio), as they were called, played against some fairly stiff competition, including civilian and military teams from Roswell, El Paso, Fort Bliss, and Juárez.

To Henriette Wyeth Hurd
Sentinel Ranch
— Thursday — [September 22, 1938]

. . . It is grand to know everything there is marching so well now. The kids well and happy with each other. Knowing this makes my solitary path here simpler. I'm again in the real swing of work and as I had hoped one project as it nears completion leads to the conception of others — The First cartoon for the [Dallas] Post office is begun the smallest of the three —, "Air Mail over Texas" and the background of José [Herrera's] portrait is coming well I feel.

After your departure things began inexplainably and miraculously to hum with the garage and shop.[1] There now remains only one door to hinge. All else is done — plastered with cement window trim and doors painted. It looks very neat and fits beautifully into the hillside. The greatest miracle of all is that the roof line is really approximately level. Chico[2] has contributed much effort to this *projecto*.

. . . please send me at once a glossy print of your portrait of me so that I can forward it to the Southwest Review who are doing an article on the Dallas Murals.

Kiss Ann Carol and Peter for their Papa who misses them both and you ever so much — I love you darling Bean

ever your — Peter

[1]A blacksmith and carpenter shop.
[2]Young Howard Taylor had recently returned to the ranch. While there he helped PH build a chicken-wire cage in which PH, astride a wooden horse, could practice hitting polo balls.

To Henriette Wyeth Hurd

Wednesday
October 12
1938
[San Patricio]

. . . The news of Andy's tempera show (proposed) is great[1] — and your father's new gesso panels, I would love to see them. Congratulate Carolyn for me on her sale!

My portrait of Maria[2] progresses slowly and with much spongeings-out. (This is not the mother and child subject) She is shown from waist up standing hand on hip in late evening half light with the great dark foothills (of Mrs Emmet's picture) below Picacho behind her and the Rio Hondo in the middle distance. I have no idea how good it is as it is not yet finished and seems so different to me from anything I have yet tackled. But it is exciting to do. I have taken her to the very spot where it is being painted from and made notes on colour, light, edges etc — *quién sabe*[3] —

Tell me when the Delaware show comes off I have a landscape I'd like you to see — better I think than the Lady Bronc Rider which is probably still in a museum show somewhere in the middle west.

I'm so anxious for you to see José's portrait done — the Whitney show opens on Nov 2nd I think.

. . . The cartoon of the Air Mail panel is now all but finished and I'm going to set up the beaver-board panels for the other soon. As I work on the cartoons I feel I am rehearsing for the technical treatment of the fresco and try (as in the figure of San Ysidro) to use the sharpened charcoal as I will use the long spiky fresco brushes later.

. . . I keep kicking myself that I didn't paint you while you were here. As I do this thing of Maria I keep thinking it would much better have been of you. But I will yet. Keep that hat you tell me of and I'll make some rich arrangement of you in clothing of the sort of colours I love to paint in Tempera earthy greens, reds, violets, golden ochers, blacks. It must be on gesso in tempera for now I feel I can handle this medium as I couldn't [before] with confidence . . .

[1] PH had started Andrew Wyeth in tempera painting.
[2] María Herrera, José's sister.
[3] Who knows.

To Henriette Wyeth Hurd
San Patricio
November 17th — [1938]

. . . with my tempera in muffin tins and my hospital tray palettes I worked away uninterruptedly [in the truck] all afternoon until the light changed and I scurried to Picacho to take notes on another landscape — again the river at dusk but very different as you will see. The wind made no difference working in the truck and I was reminded of Winslow Homer's portable painting house at Prouts Neck; the only disadvantage is in not being able to back away frequently and easily. However by opening the back doors it can be done when need be . . .

To Henriette Wyeth Hurd
[November, 1938
San Patricio]

. . . The best news I know of is the page proofs Paul brought for our new book together "The Habit of Empire." The reproductions[1] are wonderfully good! Really very faithful and as I again see the drawings after a year I feel they are much ahead of the lithographs in "The Weed." I had dreaded seeing these prints really — And it is a tremendous surprise (Paul admits feeling the same way) to find myself really enthusiastic. Publication is planned for Christmas — So far not a nickel has been forced on me in payment![2]

. . . We are still living out of our own garden — more so now than when you were here, as we are having fresh squash, beets, carrots, turnips and from our own harvest frijoles both the Mexican and the black for soup. Also yellow corn meal ground each day from our own corn and made into bread and *atole* meal. —

The Wagner exodus has begun[3] and is due to be terminated next Monday with the arrival of a truck from the oil fields.

. . . I've dreamed of you several times lately sometimes so vividly (always of being in Chadds Ford) that it seemed to me impossible that I shouldn't awake beneath the lace canopy of our bed there.

In a month we should be leaving . . .

[1] By the Meriden Gravure Company (see PH to Henriette Wyeth Hurd, August 22, 1937, note 2).

[2] "It certainly is a tiresome feeling to be so damned broke for so long," PH wrote Henriette on October 12. "— That is not really broke but there is a ludicrous lack of any cash-on-hand."

[3] Julius Wagner had taken a job working in the Texas oil fields.

To Peter Hurd
From Henriette Wyeth Hurd
[November ? 1938
Chadds Ford]

. . . Now look, there is something you must stop doing, because if you don't I won't write to you any more! In this last letter of yours you say — it's only a month now till I'll be migrating! Now in the last letter before this one, written a week or more ago, you said, 'a month!' Fine. But a month ago, in a generous spirit, you wrote you would arrive here in the middle of December. Now I know that if you get here by Xmas it will [be] a superb gesture from you, so you don't have [to] mention your changing plans again, unless you decide *not* to come . . .

To Henriette Wyeth Hurd
[December 3, 1938
San Patricio]

. . . Sorry; but I'm against the plan of setting a date to arrive and driving like hell to make it. My arrival there by about the 20th — perhaps the 19th is what I'm planning on — that means leaving here on the 15th which seems about the earliest I can make it . . .

To Paul Horgan
Tuesday January 10th [1939]
Chadds Ford

. . . I miss the light and air — the constant joy of the land-
scape in New Mexico but paradoxically I am happy here — as
you pointed out astutely, not long ago it is because I am sched-
uled to return soon. The dread exile feeling has gone. Henriette
is more and more fond of New Mexico and speaks with such
pride of the ranch. I think once the school problem is solved
we will spend more and more time in New Mexico together —
possibly only a few weeks a year here . . .

To Mr. and Mrs. Eric Knight
Chadds Ford
January 31, 1939

Dear Eric and Jere
We called you from N.Y.C. the other day on our way back
from a week in Boston[1] — to ask you here for the week-end of
the 17th, if that is convenient for you, as right after that I'm leav-
ing for N. Mex . . . On the 17th which is Friday the print club
of Philadelphia is throwing a tea to "meet" me —. This hokum
is a necessary adjunct to sales and honestly happens so rarely in
my case that I'm always enormously amused at it all. There are
inevitably moments of squawking (unconscious) comedy which
Henriette and I roar about later in private.

. . . Things rock along well here. This life seems certainly
and inevitably to build up in me such an enormous nostalgia for
the ranch that I can sometimes scarcely wait to return. One
thing is I'm bored by being surrounded by people — my friends
whose incomes are so far ahead of mine that willy-nilly I must
feel like a "little brother of the rich." You know how I mean.[2] In
New Mexico I never have the feeling that the other fellow is sit-
ting behind all the blue chips. Understand I'm not in the *least*
envious of them. I think with a lot of money I'd be of no account
at all. It has occasionally come to me that I'd rather be a *peón* a
sheepherder — ditch digger — anything in New Mexico than to

be one of these poor office-bound birds who have the money and live here in what to me is closer to slavery than the other — much!

. . . I'm having a show in April — just what dates I don't yet know. Late in February I'm returning to the ranch as I told you — but I'm scheduled to return for my show probably only for a couple of weeks. I'm anxious to hear your plans for the spring and summer.

The painting of José Herrera which you saw in the N.Y. Times is to be printed in colour on Scribner's Magazine (cover) for March. It looked pretty well in the early proofs I saw tho it wasn't finished then. They had to cut it down some which was better for their purposes, — a couple of inches on the original at the bottom and five or six at the side — then very cleverly they (the engravers) added sky to the top where the name is printed.

. . . I've been unable to paint anything worth a damn since returning — I've thrashed around in the little cubicle that is my work room spending hours on tempera panels which each time were doomed to practically instantaneous extinction with a wet sponge. A hell of a feeling this is! I dread so the long period of readjustment at least two or three weeks when nothing happens at all. The only encouragement is that — in N.M. at least — I get a lot of physical work done — all sorts of jobs that are yelling to be done and begin to get myself back into a state of physical hardness . . .

[1] Edward Hutchins had died in an automobile accident, and the Hurds had gone to visit Mrs. Hutchins.

[2] As for his friends in San Patricio, PH wrote, "They come in, drink wine, and tell stories & always accept my profession with the same friendly fellowship they would were I an adobe mason or a carpenter; I don't have to tell you how gratifying this is!" (PH to Eric Knight, May 25, 1937).

To Henriette Wyeth Hurd
[Postcard]

[February 27, 1939
Dallas]

Here we[1] are in Dallas — delayed for several hours by the fact that I must report to the P[ost] M[aster] here and unload the marble dust in the Terminal Annex building . . .

¹PH was traveling with Eric Knight. In the course of their trip a rooster ran across the road in front of their car. The event produced the following limerick, which Eric Knight composed in less than sixty seconds:

> There was an old lady of Brewster
> Who had an affair with a rooster.
> To him she was true
> Till one day there flew
> Through the window a gander and goosed her.

To Henriette Wyeth Hurd

Tuesday
Mar 1st [1939
San Patricio]

Dearest Bean:

In the dim light of our kerosene lamp I'm writing this — sitting in the studio in front of the fireplace — it being the evening of our first full day here and a full day it was in every sense getting the things unloaded from the truck etc. Well, the house was spotless — just as if we had just left it without a *trace* of the enforced occupancy of the Herreras.¹ José had done a fine job on what I had set out for him to do. Moreover the [new] tenants seem like pretty good people a step above the Wagners certainly on the scale of living. We have had a talk about messiness around their house and they are very amenable. I believe for one thing that the fact that they came to us for a place and that we didn't look them up changes the positions somewhat. They are put in the place of the petitioners right away.

. . . I miss you all so much you and the kids of course enormously for you have imbued this place with your separate qualities, first you and Peter together, then you and Ann Carol . . .

¹PH had hired the Herreras to look after the ranch in his absence. When he returned to San Patricio, he hired a new tenant family.

To Peter Hurd
From Henriette Wyeth Hurd

[March 1, 1939
Chadds Ford]

. . . I see no reason for not driving back to N.M. with you in May . . . I am crazy to see our rancho! . . .

To Henriette Wyeth Hurd

March 4th [1939
San Patricio]

Dearest Bini

All is moving well here. I am starting work today on the Scribner's book[1] with a "daily allowable," as the oil men say of a couple of hours work on the ranch — Cleaning up giving directions to the tenants and you'll be glad to hear putting out some trees. José had about a half dozen fine sturdy cottonwood saplings set out in the places I had indicated and I bought in Roswell yesterday nine Lombardy poplars; they are about ten feet tall now and are being set out along the *acequia* in a line at 3-foot intervals just east of the studio. Also I bought four pecans the paper-shell variety. I am having a lot of plums transplanted — some wild ones which have sprung up in thickets so they will bear better.

I am making plans to have work begun on your studio as soon as I can rake in the cash from somewhere.[2] I really feel I would do better here painting New Mexico than doing the lousy Rollins book, but I went after the job (hoping to do it in Pennsylvania before I left —) and now I certainly don't want to let them down. I will really enjoy making pictures of cows cow ponies prairies etc right from nature — the first time I've ever illustrated a juvenile where this could be possible . . .

[1] *Gone Haywire*, by Philip Rollins, for which PH made six drawings.
[2] Henriette sent PH a check to help defray the cost of her studio. It was built on the site where the old barn was located, across the way from the ranch house.

To Henriette Wyeth Hurd

Friday [March 25, 1939
San Patricio]

. . . A telegram to Paul from Dick Pollard movie editor of "Life" [magazine] says in effect: "Life using Peter Hurd's work need photos [of] his ranch. Plan sending photographer out within a week or ten days wire collect time of his departure for East." Amazing! and quite fantastic it seems to me. Pollard was much taken by the ranch when he came here with Paul to lunch on a Saturday two or three weeks ago . . .

To Henriette Wyeth Hurd

Wednesday Night
March 30th [1939
San Patricio]

. . . at 2:00 PM [yesterday] a call came from the Roswell Air Port and we drove out to meet the [*Life*] photographer, Mr. Peter Stackpole. He proved to be very pleasant, young and efficient. With the pilot, we all four drove out to San Patricio which place seemed to delight Stackpole. We arrived about 5:00 and by then the sky was clear. He seemed bent on taking polo pictures so we immediately fell to rounding up the players.

They all agreed to come and by 11:00 [this morning] were here and a practice game in progress. Stackpole had meanwhile taken many other random shots. The day was beautifully clear and we were all greatly relieved. Well, to summarize — Paul arrived at 10:30 playing hookey from school, as he put it, and everything went most smoothly and gaily. Eric pitched in and designed the meal (which was for ten) very simple but very good. By 3:30 Peter Stackpole & the Pilot, Mr. Cutter were all packed and ready to go Stackpole having taken (and now get ready:) *over one hundred and fifty shots!* . . . Of course it finally — ultimately — really doesn't amount to a damn and I know I'll be dropped next year just as I'm taken up this year but it is amusing and there is nothing dishonest in it. None of the shots were posed or self conscious as far as I could see and certainly our life here hasn't anything in it to be ashamed of — except that I ought to be doing more and better work!

I hope this all amuses you — reading of it I mean. I miss you like hell and keep saying inside myself, "why couldn't you have been here?" it would have been so much fun — only for ourselves this quite complete record of this place should be fun to have but so much more so had we all been here.

Life is using apparently, from the photostats Stackpole had, "The Dry Arroyo" (you know, the big one with the storm) "Landscape with Polo Players" and the portrait of Earl W[1]. . .

[1] These three paintings and *Lady Bronc Rider* were reproduced in the art section of the July 24, 1939, issue of *Life*, together with a short article on PH and several photographs of the ranch. PH's national reputation was heightened at this time by the sale of one of his finest tempera paintings, *Ranchería*, to the Metropolitan Museum of Art.

To Daniel Longwell[1]
[C]

⟨San Patricio, New Mexico
October 1st 1939⟩

. . . "Life" certainly did a fine turn for me in the write-up of my work last July. As I wrote Miss Varga,[2] it is the most important publicity I have ever had and because of Life's thoroughness in detail, the only entirely accurate account. I mean by this that all the facts — names of places, persons etc. etc. were absolutely correct. I have had a wide response from the article and even now get a letter or two a week. The letters have run a wide gamut: They have come from old friends & from complete strangers apparently sincerely appreciative of the paintings, others from autograph seekers — job seekers art students, school children but certainly the most amazing was a letter from the Casting Director of Columbia Pictures offering me a part in a western movie!

My close friend Paul Horgan speaks warmly of you and has asked that I send you greetings in this reply to your note about the painting.[3] I shall certainly let you know when I am in New York again and look forward to meeting you then. Again thanks for the loan of the painting.

Sincerely

Peter Hurd

[1] Daniel Longwell was executive editor of *Life*.

[2] Margaret Varga was one of *Life's* editorial associates.

[3] Longwell had loaned PH *The Dry Arroyo* for an international exhibition at the Carnegie Institute in Pittsburgh, which ran from October 19 to December 10. Also known as *Dry River*, the painting had been on exhibit on the twenty-sixth floor of the Time/Life Building. It is now in the Roswell Museum and Art Center.

To Henriette Wyeth Hurd

March 4th [1939
San Patricio]

. . . [Paul] is working on the foreword of the catalog.[1] He has written many pages which he is now boiling down to some few paragraphs. I feel and he agrees that the foreword should be merely to enlighten the people a little more, to state as a cor-

ollary certain things about my work, not to offer his comment
critically . . .

<hr>

[1] For PH's forthcoming show at the gallery of Mrs. Cornelius J. Sullivan in
New York.

To Paul Horgan

Chadds Ford.

April 22. [1939]

. . . The opening of the show went beautifully. Certainly
the response of the public was all I could have hoped for — the
publicity build-up moved smoothly. I was interviewed repeat-
edly and photographed too a dozen or more times — all a part of
the patently built-up effect. The only depressing thing is that
there have been no sales so far. Some pretty good strong yanks
at the hook but no catches as yet. It makes all the publicity and
fanfare a form of mawkishness. I can't help attributing it to the
fact that business is so uncertain now due to international poli-
tics. I'm really lucky I suppose to have had a favorable press.
Mrs. Sullivan is holding the show over an extra week. It is for
her as much as myself that I'm concerned about sales for the
show has cost her quite a lot.

I have been to Washington and am still awaiting the out-
come there.[1] This postponement is without precedent and no
one seems to know what the outcome will be — that is whether
I will be allowed additional funds. I'm asking for 800.00 more as
a result of the break —

Henriette and I went to see Life at their request and then
were photographed walking together on Fifth Ave. The Stack-
pole Photos are magnificent! Henriette is crazy about them and
we're going to try to get some prints of them. They are certainly
the best I have ever yet seen of the San Patricio Country . . .
The article in "Spur" is due to appear in the May issue.[2]

So far our plans are to drive out to New Mexico in the mid-
dle of May . . .

. . . Many fine comments about your foreword. Since the
original essay had to be cut it seems to me the result was a pretty
good unit. Don't you agree.

I'm [illegible (Spanish)] *ansioso*[3] — to return to New Mexico. The East is oppressive to me. The fault's all mine I'm sure but it boils down to the fact that all my real interests are in New Mexico. Perhaps this is an admission of a cowardly desire for escape but the fact is that there I feel the rumblings of war [in Europe] and the forebodings of sudden pillage from the air so remote as to be almost unheard. The concern there is with rain and sun and seeds and whether the *acéquia* runs properly. The world seen from here seems in such a colossal mess and our helplessness as individuals is so apparent. Of course on the other hand it's an enormously exciting time to be living. History in the making — big blobs of it every week. But my interests being what they are and so compelling, I can't help feeling this way.

Henriette and I speak so often of you. You must plan to be with us a lot this summer. We are putting off everyone else and there has been a fair-sized mob ready to appear at a moment's notice. I wish it to be a summer of work and reflection unbroken by the usual alarums — and excursions.

Love to you from us all,

Peter

[1] A proposal to push back one end of the lobby of the Dallas Post Office Terminal Annex Building made it necessary for PH to postpone his starting date on the frescoes until January, 1940, and to sign a new contract with the Treasury Department eliminating the largest panel, over half the entire commission.

[2] An article by PH about polo at San Patricio entitled "Beggars on Horseback" appeared with reproductions of several of PH's polo paintings in the June issue of *Spur*.

[3] Eager.

To Eric Knight

San Patricio

September 25th [1939]

. . . For us it has been a summer of hard work with quite a lot of new things resulting for both of us. Henriette's new studio is completed and she is very pleased about its appearance light etc.[1] She has painted both the kids portraits and is just now completing a portrait of Witter Bynner, who has been here with us for the past ten days.

. . . Henriette and both kids are here now but leaving [for Chadds Ford] I think in a couple of weeks.

. . . It was a strange feeling hearing the N.M.M.I. paintings were demolished by fire — I presumably have the job to do again tho just when I'll get to it is uncertain now[2]. . .

[1]"My studio is perfect," Henriette wrote her family in May from San Patricio, "one 8 X 10' North window in a room 20 X 22 ft — a thirteen foot ceiling, with old silvery vigas (or beams) in it — Kalsomined inside a pale warm gray — and the handsomest of fireplaces facing North, with a great stove lunette shaped hearth" (Henriette Wyeth Hurd to Mr. and Mrs. N. C. Wyeth, [May, 1939]).

[2]The lounge room of the post-exchange building was set afire one night by incendiaries, never identified. All the murals were destroyed, and PH never replaced them. The full-size charcoal cartoon for the panel of the death of de Vargas is on permanent exhibit in the Visitors Center of the Lincoln County Heritage Trust in Lincoln, New Mexico.

To Henriette Wyeth Hurd

Wednesday
Nov 22. [1939
San Patricio]

. . . The weather has been marvelous steadily since you left, tho I suppose a norther will roar in before many weeks pass.

I have in the past six weeks been enjoying music enormously — I have the Mozart B flat Concerto played by Schnabel —, The Pastorale of Beethoven both of which I'm crazy about, and I am getting to know them intimately. Music of this type seems more important to me than ever before — and I truly rely on it and need it. This machine[1] — your present from me — has been a great solace to me.

The news that you liked my foreword for Pa's Exhibition[2] was fine and gratifying. I wish it could have been longer — two hundred fifty words hardly gives a verbose glut [*sic*] like me a chance to unlimber his gums — but *you* know this! Bob Macbeth and I are launched[3] and I for my part feel much relieved . . .

[1]An electric phonograph.

[2]PH wrote the introduction to the catalogue for N. C. Wyeth's one-man show at the Macbeth Gallery that ran from December 5 to December 30.

[3]Mr. Wyeth had suggested that PH resume his association with the Macbeth Gallery, since Mrs. Sullivan had failed to sell his work.

To Peter Hurd
From N. C. Wyeth

[November, 1939
Chadds Ford]

. . . what a superb introduction you wrote and how impressed everyone is who has read it. Macbeth is delighted too, so it goes through unchanged.

My judgment is that it's an unusually splendid piece of writing and damned few painters have been so fortunate as I in this particular.

The major reaction I get from it is one of inspiration. You have made me feel more than ever the urge to get things done and do them better! . . .

To N. C. Wyeth

Sentinel Ranch
November 25th [1939]

Dear Pa —

Two fine letters have come from you, one (about Bill's death[1]) which has meant a great deal to me — The fact that he and I were never particularly close altho always congenial has, paradoxically contributed to the very poignancy of his going. The other letter about the introduction in the catalog came yesterday and brought me much pleasure with its message that you so liked this foreword.

My present plans are to go East by train from Dallas in time for Christmas, returning early in the new year to begin the frescoes. So I am hoping I can make New York while the paintings are still on view at Macbeths. I'm hoping like hell that the critics in New York give these works the praise I know they merit — and which I know well they would certainly have to give could they see them as anonymous works — or those of a younger unheard of man. They (the critics) are so encumbered by tabus — all of them — I do feel however that the last decade has done a great deal to kill the sneers cast toward illustration by the aesthetes. Not that illustrations or illustrators are necessarily *better*. I merely feel that the wave of interest in painting is

rising and that it is sweeping down all such petty, rancourous quarrels as this. The same is true of the tabu of the story telling picture. None of these old-time hidebound rules seem to need apply now. And so I feel that if not this generation of critics who are perhaps too schooled in the old beliefs — these tabus and others (we could both of us add to the list) then certainly the next, the coming ones, must partake of the new freedom and judge all painting more honestly — not for its relationship or lack thereof to the current vogues but for the timeless qualities that have always been sought since the time when painting began, on the walls of a cave in Spain . . .

[1] William Knight Hurd (PH's brother) was killed in a car crash.

To Peter Hurd
From N. C. Wyeth
⟨[November 15, 1939
Chadds Ford]⟩

. . . I note, more than ever before, how much Henriette yearns for you and needs you. I have watched those mutual bonds of affection strengthen and strengthen and the knowledge of it goes to the very bottom of my capacities for satisfaction and gratitude. The time is near, we all feel, that any lengthy separation from one another should be eliminated . . .

To Peter Hurd
From Henriette Wyeth Hurd
⟨[November, 1939
Chadds Ford]⟩

. . . I have come, finally, to a decision that I feel I've longed for, to move definitely to the West. I *can not* stay away any more. The ties here are just as strong, but those that have grown with you in San Patricio stronger.

This must seem a tardy decision to you. But I couldn't make a clean break until I felt I *wanted* to . . .

To N. C. Wyeth

Sentinel Ranch

November 25th [1939]

. . . I am of course enormously delighted at Henriette's decision to live out here. I have never consciously brought the least pressure on her to make this change (it possibly would not have worked) but now that she has made it I am overjoyed.

I look forward much to seeing you and talking with you when I return within a month . . .

[6]

Painter of the Southwest

Although Peter's return to Chadds Ford in December found him ill and discontented—"I damn loudly and openly the sort of life I seem to have to live when I'm here in the winter — overheated house — too much food and no exercise"[1]—knowing that his stay in the East would be short and that his family would soon be moving to the ranch was ample consolation. Now and then Peter begrudged the time he had lived away from New Mexico, but as he later wrote from San Patricio to J. Frank Dobie, noted author of the American Southwest, "I now feel that those years away from here probably were valuable since they taught me bitterly and painfully how necessary to me is my native land."[2] Peter was fully aware, of course, that his years in Chadds Ford had been valuable to him for other reasons too; and he never failed to express the gratitude and reverence he felt for N. C. Wyeth or his affection for experiences shared with all the Wyeths during his early youth in Chadds Ford.

When the Christmas holidays were over, Peter's immediate objective was to settle his contract with the Treasury Department for painting the frescoes in the Dallas Post Office Terminal Annex Building.[3] Toward the middle of January, he wrote Paul Horgan that he was "surfeited with cocktail parties, Deb. parties & dinner parties," and that he longed for "the intensive uninterrupted time in Dallas — accepting no invitations — merely working as hard as I am able on the decorations."[4] Portrait commissions kept Henriette in Pennsylvania, so Peter drove southwest by himself. He counted on Henriette joining him in Dallas in time to help with the mural. At Washington, D.C., Peter met with officials from the Treasury Department. To help assure a favorable contract for the frescoes, he pressed his case with New Mexico Congressman John J. Dempsey, later governor of New Mexico.

[1] PH to Paul Horgan, January 15, 1940.
[2] PH to J. Frank Dobie, March 3, 1941.
[3] See PH to Paul Horgan, April 22, 1939, note 1.
[4] PH to Paul Horgan, January 15, 1940.

To Henriette Wyeth Hurd

Saturday P.M.
[January 20, 1940
Dallas]

. . . The appointment with Dempsey was a WOW! Realizing that I know nothing of the usual machinations and evasions of lobbying and not wanting to take more time than necessary I immediately put the idea across that I wanted him to support this project in every way he could. I then perfectly frankly told him I would swing many a native vote his way next time he runs. At this juncture he glanced quickly around and called to his secretary (we were seated in his inner office) to close the door connecting! Isn't this wonderful? . . . He agreed entirely to my request and immediately called Carmody and the Assist Post Master in charge of building to get their ideas and state his own. Purdham the Asst P.M. said sure he liked the decorations in federal buildings all but the naked ladies — he was a little dubious about them. It was all a very funny encounter but of course entirely successful as he is definitely enlisted on our side. Before I left he requested photos of the Dallas cartoons with my autographs to be framed and hung in his office. Marvelous?

. . . I didn't arrive here until 11:30 last night then to find all hotel Space taken everywhere because of a convention — finally after trying with a cab driver a dozen places I landed the last room in a dirty little dump of a hotel called "The Texan" across from the T[erminal] A[nnex Building] where the murals are to be. Up early this morning interviewing plasterers — etc. and found the head custodian Mr. Beverley whom I'd met once before briefly to be most pleasant and accommodating. He has allowed me keys to the building and a fine large work room close by the panels; — in the basement directly below. Here he has established for me a large roll top desk (complete with key) and I feel like a terrific big shot in "the Department." All lots of fun and very exciting . . .

To Henriette Wyeth Hurd

Dallas. *Wednesday* —
[January 24, 1940]

Dearest Henriette. —

Never before has the preliminary work gone so smoothly or so swiftly as on this job. The rough coat is all in place for the Air Mail panel and it is possible to begin work tomorrow — The Scaffold we built last night after P.O. hours with the usual group of hangers-on watching the procedure with interest. I have prepared a synopsis — (3 short paragraphs) of the work to be placed with the photos of the cartoons on a special bulletin board so the Inquisitive Public can learn quickly and correctly what goes on.[1] Speaking of the Inquiring Public — They certainly got an eyeful with these news blurbs from the Times Herald which evidently had a terrific time locating me. I have been staying with the Howards — Richard Howard is the Museum Director and a nice person. So the Times Herald couldn't locate me at any hotel. I meant to enquire how far down the line toward flop houses they sent their sleuths.

. . . My enormous Tycoon's Desk is staring me in the face as I write this sitting on the conveyor truck (push) [drawing of truck] assigned to me to move sand lime water etc around this vast basement which I haven't yet learned to know entirely. I feel like Quasimodo living entirely within this building. A cafeteria on the mezzanine makes my leaving unnecessary for any purpose except sleeping[2] and during the norther I even did that on my old ranch bed roll here in my workroom.

The people here, P.O. employees, friends etc all continue perfectly so enthusiastic and accommodating . . .

[1] The synopsis read as follows: "This work is to consist of two mural paintings depicting Texas scenes. The larger panel to represent a family of East Texas Pioneers building their cabin at the edge of a prairie grove in the mid-period of the last century. The smaller one shows a lonely ranch in West Texas at dusk with the beam of the airplane beacon sweeping the sky as the mail plane roars overhead."

[2] By February 3, PH was both sleeping and working each day in the Terminal Annex Building.

To Henriette Wyeth Hurd
Friday [January 26, 1940
Dallas]

Dearest Henriette:

The art of fresco seems to have infinite ramifications and subtleties. Just as it appears to be well in hand, the painter finds an entire new host of problems and vexations. This time it is the metal lath wall which it seems is too springy and I should have used cement in the under coat — However I have always been reluctant to use this new material preferring to stick by the medieval materials which are so well tried by time. In spite of a slow drying wall at the start I got a lot done yesterday —

[diagram of first day's progress, showing completion of upper fifth of Air Mail panel]

. . . I am making an effort to keep a letter in the mail here for you — one a day but it is a little hard to do when you consider my work hours. 5:30 A.M. to 11:00 P.M. yesterday — I don't mean to sound pathetic I love it of course altho I'm depressed just now about the wall — However both the other walls are solid and this trouble won't occur with them . . .

To Henriette Wyeth Hurd
[January 28, 1940
Dallas]

Dearest Bini —

It goes well now the wall is working beautifully and the painting progresses well I feel.

What are your plans? Can you possibly leave earlier than you had planned? I have so much counted on your help on this job — As things progress now I should be ready to begin work on the large panel by the first of next week. I am ahead of my schedule because of the splendid Coöperation I have got from the contractors. The wall was cleaned and chipped practically at once and the sand had already been washed.

Ernesto too is a great help,[1] he is an interesting person I feel — And there's about him the same qualities that those Fran-

ciscan friars had — only his zeal and *goodness* have taken a course other than religion —

Give all the family my love — I'd like to have them — Andy in particular see the fresco as it progresses. He'd be fine at fresco painting.

I'm writing this in my work room in the T[erminal] A[nnex] basement at 8:00 P.M. Sunday. Above me in the lobby is the din of the workmen's hammers and chisels as the last of the Pioneer panel plaster is removed . . .

[1] Ernesto Burciaga of Santa Fe and Roswell, who had earlier helped PH at NMMI, assisted PH on the murals. His duties included plastering, grinding colors, and washing brushes. Ernesto was later drafted into the army and was lost in action in World War II.

To Henriette Wyeth Hurd
Dallas
February 1st [1940]

Dearest Henriette:

The Air Mail panel is all done except for whatever retouching becomes necessary and certainly couldn't want a better public reception than it is getting — (no index to real excellence I well know!)[1] I've got the cartoon of the pioneers on the wall and it looks marvelously well! It is certainly as good as I could hope for. The P[ost] M[aster] has decreed that I can change the lighting fixtures to allow for it which makes the location perfect. I plan to start the actual painting on Monday or Tuesday.

. . . I'm having a small rest between panels — Ernesto and I are busying ourselves with sifting marble dust screening lime and cleaning house in our work room.

. . . P.S. They missed the point in this clipping;[2] The artist I said is the historian of the present and it is only in linking the past with the present — viz with his own lived experience that he can make an enduring thing. Trite but true . . .

[1] A week later PH was offered the instructorship in mural painting at the Art Institute of Chicago, but he refused it.

[2] PH had recently been interviewed by the *Dallas Times Herald.*

To Henriette Wyeth Hurd

Dallas Feb 18.th, [1940]

. . . I am really tearing into it. There are certain places wherein one simply should not show any joins and that is what governs the day's stint.

Paul ran into a norther at Brownfield, Texas; left Roswell in his shirtsleeves and a couple of hours later encountered wild, roaring gales sweeping across the Llano Estacado out of the Panhandle. So he was marooned with no chance to move either way.[1]

. . . One thing I need — (I would have written you before but I kept thinking you were about to leave and that the letter would miss you) is my bone handled Colt Frontier revolver with its belt and holster. I expect to use it in the fresco and need it badly. Would you have Biddle ship it to me C.O.D. please?

I'm just delighted at Peter's progress at the Piano.[2] I remember the andante of the Surprise Symphony. I recall this symphony well and it is one of my favorites among all I know, as I wrote him . . .

[1] Paul Horgan was on his way to Dallas to make the annual address for the Texas State Historical Association dinner. When the blizzard finally subsided, he had to return to Roswell.

[2] Peter Wyeth Hurd was not quite ten years old (see PH to N. C. Wyeth, February 1, 1934, note 4).

To Paul Horgan

Dallas, Sunday
[February 18, 1940]

Dear Pablito:

Your adventure with the blizzard was certainly a disappointment here. — I had counted a lot on seeing you. The meeting of the T[exas] H[istorical] A[ssociation] I did attend after all since Mr. Carroll[1] arrived with a ticket to the banquet on Thursday complete with invitation to exhibit a group of prints. It was very pleasant — Dobie[2] was damned nice I thought, and made a very charming rambling talk. The other speeches were on the tedious side but I gave myself up to the food which was excellent

— (Home Economics Dept.) and a study of the faces turned toward us (I sat at the speakers' table). It all went off very well I thought considering the *pièce de resistance* was missing. Your telegram was read and received with understanding . . .

[1] H. Bailey Carroll, professor of history at the University of Texas at Austin, was director of the Texas State Historical Association and was also editor of the *Southwestern Historical Quarterly*.

[2] J. Frank Dobie was then professor of English at the University of Texas at Austin.

To Henriette Wyeth Hurd

Dallas
Feb 21, 1940

. . . The work today included the boy's head and sky beyond and is I feel sure one of the best pieces of painting I have yet done. Tomorrow I do his shirt and hands with the broad-axe then next day his trousers, feet and part of the foreground.

. . . Our only social life consists of supper nearly every night at El Fénix a good Mexican restaurant about ten blocks from here. We are well known there. — I find I'm recognized in lots of places in Dallas from my pictures in the paper.[1]

Here at the Annex there are daily delegations of school kids shepherded by their teachers who come to watch and the usual number of old beldames who pounce upon me to tell me "I have a daughter does art painting." I have developed a technique of giving a sweeping glance up and down the lobby to see if among any of the watchers I see a gleaming, predatory eye trying to catch mine. I only descend when the coast is clear of these bores . . .

[1] "I am in some demand by Dallas hostesses I find but so far I haven't succumbed to any dinner dates," PH wrote Henriette. "Living at the P.O. makes me more than ever a man of mystery to these gals which amuses me" (PH to Henriette Wyeth Hurd, February 3, 1940).

To J. Frank Dobie

Dallas

February 21. [1940]

Muy Estimado Don Pancho[1]:

Your letter reached me last night and I was delighted to hear from you. — Enormously stimulated to know that you who know our Southwest so well, should feel that I am hitting the nail.[2]

I'm delighted at the news of your idea for having a group of my prints in the permanent collection at the University — Should this patron you have in mind buy a substantial group — say twenty or more I will gladly give him a discount of 33⅓ per cent — on two or more 20% — I hope this seems fair and a tempting proposition to him. If not I greatly appreciate your gesture anyway and should they have to be returned unsold keep out the impression of the Windmill Crew[3] for yourself and I will duly sign it for you when I meet you in Austin early next month.

I talked to my wife by phone this morning and she says she will be in Dallas within a week then when the frescoes are completed we'll set sail for Mexico via Austin . . .

Original manuscript at the Humanities Research Center, University of Texas at Austin.

[1] Most esteemed Frank. "Don" is a Spanish courtesy title.

[2] Dobie had praised the prints that PH exhibited at the Texas State Historical Association dinner.

[3] See PH to J. Frank Dobie, [January ? 1943], note 1.

Henriette arrived in Dallas four days later, and shortly afterward Peter finished the frescoes. On March 6 the Hurds met Dobie in Austin; then headed south into Mexico.

"Definitely, Mexico very much depresses me," Henriette wrote her father on March 28. Nevertheless, she was "ecstatically happy with Peter, who is loving it all and in such top form — filled with plans for new paintings at San Patricio; stimulated toward his true house by this exoticism. — Hell, I do believe in him so firmly, & thank whatever the universe is that I do on this particular trip."

To Eric Knight
Gran Hotel Nido, Chapala Jalisco, Mexico
[March 22, 1940]

Dear Eric:

The frescoes went better (in time certainly) than I had hoped and so here we are in Mexico where I came eager to see the new works of the Mexican School and to rest up from the job. H. and I are terribly disappointed not to be seeing you at San Patricio but maybe before you and Jere return at the end of the Semester[1] you can swing back again. God, I do hope so! This seemed the golden and perhaps only opportunity of going to Mexico for a long time as the kids are both safely parked with the Wyeths in Chadds Ford. We are here with Witter Bynner and Monté Hunt[2] and having a grand time all right. Present plans are to return to Dallas on the 12th [of April] for a joint show opening there on the 14th then on to Chicago where I have a date with the Steuben Glass people on the 18th.[3] After this H. goes back to Chadds Ford to get ready to move and I back to San Patricio to start painting . . .

[1] Eric Knight was teaching creative writing at the University of Iowa.

[2] Bynner and Hunt shared a part-time residence in Chapala.

[3] PH was one of several American artists commissioned by Steuben to design a piece of glassware for a mid-April exhibit. His plains-windmill-ranch scene was etched on a limited edition of vases.

Before returning to San Patricio, Peter visited Eric Knight at the University of Iowa and then went to Dallas, where he met Daniel Longwell, executive editor of *Life*, and his wife, Mary, an editor at *Life*. The Longwells traveled with Peter to New Mexico, along with Reginald Bishop, who lived with his wife and daughter in a small outbuilding on the Hurd ranch.

To Henriette Wyeth Hurd
[Postcard]
Roswell ~~Apr. 30,~~ [1940] Tues.

Dearest Bini —

All goes well. The Longwell's couldn't have been more enthusiastic and really had a fine time with Reg and me. They are going to write you when they return to N.Y. inviting you to N.Y.

— Try to go if you can — not only because it will undoubtedly
do you good professionally but because they are grand people.
Longwell plans an article in Life debunking foreign portrait
racketeers like *La Vicaji* etc. I'm anxious to dig into new work —
All my love to you and the kids — Also Ma and Pa. — Carolyn
and Ann. ever yours.

Peter.

To Henriette Wyeth Hurd
San Patricio
Monday Morning [May 6, 1940]

Dearest Bini

I'm swinging in the hammock under the apple trees north
of the house and a gentle breeze is bringing me the odor of a
lovely Algerita bush in a mass of golden blooms which is just vis-
ible from where I am now. It is a marvelous morning — and I
have chosen this spot to work on Huck Finn for Winstons.[1] This
note must make this morning's mail when Reg goes in half an
hour, so I will hasten to tell you developments.

Yesterday I overheard Lionel telling Don Martín[2] of a "Te-
xano" who was wanting to buy his father's place East of us —
You know the little place with the orchard below and houses
above the hill? The view East which I have so often painted in-
cludes these houses. Well I went immediately to talk with him
and for something around five acres, the two houses and a half a
water right on the *acéquia* he wants $750.00. My plans for the
summer were to put in a metal tank and [a] new larger windmill
in order to irrigate the piece of arable land on the hillside. Now
it seems much wiser to me to get Miguel [Sedillos's] place with
five times as much land for a little more than tank and mill would
cost, and thus protect ourselves from a dangerous encroachment
in case of bad neighbors. What do you think? This land[3] is all
joining directly on ours and is a continuation down the river and
has nice orchards one young — one of large trees like our old
ones.

. . . The Fig Trees are coming[4] — all five of them and the
orchard alfalfa beyond where I am sitting is lovely and green and

knee high — Three Colts and Mama Inez (who is due to foal in a week) are grazing in it.

Paul came up Saturday spent the night and yesterday Sunday here and we read the plan (— outline for the Rio Grande — (Rivers of America Series) which is very fine[5] — It might be his best book I feel for it has in it a poetry of concept which he is so well equipped to handle. I'm anxious to have you read it . . .

[1] For *Huckleberry Finn* PH designed the jacket and frontispiece in color and a number of illustrations in black and white. He was paid $500. "They paid $1200.00 for Tom Sawyer with four colour paintings plus what they paid you for your jacket," he wrote N. C. Wyeth on May 27, 1940. "Although it is a perfectly grand book as you well know and I'd like to do it, damned if I think that isn't an awfully low fee."

[2] Lionel (pronounced Lee-o-nell), son of Miguel Sedillos, and Don Martín, an old Mexican-Apache, both worked as hands on the ranch.

[3] Later referred to as *La Mancha*, this land became the site of the Hurds' guest house, first occupied by the Bishops.

[4] "The fig trees . . . will soon be a factor in the tempera business," PH wrote Henriette on June 3. "Old recipes call for 'the juice of young fig shoots intimately mixed with yolk of egg' as a painting medium. The fig latex is a fine addition — it gives the medium a more fluid workable quality."

[5] Paul Horgan's *Great River: The Rio Grande in North American History*, originally commissioned for the Rivers of America Series (Rinehart and Company), was published in 1954 as a two-volume work outside the series. In 1955, the book was awarded the Pulitzer and Bancroft prizes for history.

To Henriette Wyeth Hurd
San Patricio May 11, 1940

Dearest Henriette:

I have decided to buy the Sedillos' place — and accordingly as it is a cash transaction (This and the fact that I have just paid back $500.00 of a loan — $100.00 insurance) I am broke at the moment.

I just got back here and found your letter explaining the same state of affairs with you. I had counted on the work which awaited you there to see you through this time as you had too and I suppose the fact that it hasn't materialized is simply one of the things that happens in our trade.

But I must insist that beginning with your coming to New Mexico you throw me the reins of finance. I'll see that you get all you need within reason but my mind is made up — and it is no

sudden decision. It dates from the shock of discovering that the General Motors stock had been dissipated. I may not be a very good administrator but I am a whole lot better at this business than you. In 16 years this stock would have brought in its own Value in income had it been left un-touched, Ten thousand two hundred and forty dollars! — $10,240.00. I'm perfectly willing to admit I am partly [to] blame for letting it go — the first part of it anyway, but believe me when I tell you I have changed and I am now resolved to handle our finances however much discomfort it may cause you.

I don't have to tell you how very much I believe in your great gift of painting and how I admire you constantly for sticking to it growing steadily better in it even while raising a family when so many other weaker ones have fallen by the way. *But* this has nothing to do with my governing our finances tho it is for this reason largely — fear of interfering with you and your painting that has kept me from taking over before this . . .

To Henriette Wyeth Hurd

San Patricio

May 17, 1940

. . . I have made two drawings of Juan Reyes[1] and now I mean to begin a serious portrait of him *Sans* Hat which though a marvelous design I want to avoid in this instance (He wears it in the drawings) as being too theatrical of the wrong sort of "theatrical" — At any rate that is my feeling altho it doubtless could be done with subtlety and conviction but I think the colour scheme will be good without it. We'll see.[2] I have also done a tiny self portrait in egg tempera on gesso.

Juanito by the way is a splendid guest. He weeds and irrigates all morning and at odd times when I'm not drawing him. While I draw him he is at work improvising songs — He has written — composed — I don't think it is actually set down yet — The ballad of the *Rancho Centinela* a very serious tribute to Meestair Peet who comes into the song and to Lionel among others whose *bisquitillos* (biscuits) are incomparable in their fla-

vor. This is a restricted compliment since before crossing the Río Grande he never knew they existed. I must close this now for a time at least as it is 7:30 P.M. and Juanito and I are appearing by special request on the local school graduation program with "Songs." We're howling four of the Chapalan songs which I have just learned. I wish you could be here! . . .

[1] Juan Reyes was one of three Mexican singers PH had met in Chapala during his recent trip to Mexico. Although PH had made arrangements to paint them all in San Patricio, only Juan, "the least interesting of all in appearance," had the heart to make the journey. "He is a quietly enthusiastic little man and not hard to have around at all" (PH to Henriette Wyeth Hurd, May 14, 1940). Juan Reyes stayed at the ranch until mid-June.

[2] "The portrait of Juanito turned out well!" PH wrote Henriette on May 31. "It is a head and shoulders — no hat with the brown *zarape* he wears thrown over both shoulders — against a brilliant blue sky background with a doorjamb to break this area with vertical lines." The portrait of Juan Reyes is in the Beachnut Collection, Conajahorie, New York.

To N. C. Wyeth

San Patricio
May 27, 1940

Dear Pa:

I have devised a small gift for you which left in Saturday's Mail: The *"Tierra Dorada"* you know of already but the green is, I think a new colour and one particularly hard to mix from others. I haven't tested it at all but I feel this is hardly necessary as it is from Le Franc in Paris who is one of the best colour makers. I hope you find it useful — as I have.[1]

What ghastly [world] happenings[2] since we were last together! In spite of the obvious peace and remoteness of this place — where for hours no sound is heard except the tinkle of a goat-bell on the mountain side or the cough of the windmill — I have a constantly heavy heart and a feeling of apprehensiveness. I do think the country is awaking to its dangers and the President's address on the radio last night was, I thought excellent. But I keep wondering what will happen to *us* economically with greater taxation for defense. Certainly anyone in a luxury profession such as ours can expect to take a tuck in his belt.

I'm lonely for Henriette and the children but I'm glad they are with you now, when I know you are missing Andy most.[3]

. . . *Later*:

I have just returned from a wedding in San Patricio which in the style of the Mexican people takes the form of an enormous feast in the patio of the bride's home. Sitting there under tall almond trees listening to the wedding guests discuss their flocks and crops and the coming rains — it seemed *impossible* that there could be the horrors the radio describes nightly — anywhere on this planet. It was a delightful party with songs and native wine — the whir of guitars and feet dancing on the packed adobe of the patio — something betwen Brueghel and Goya — the pale, serious children with enormous eyes looking like Goya portraits, in their party clothes. The bridegroom resplendent and ill at ease in a brand new Montgomery Ward suit, (his with the best man's were the only "suits"). The old ladies in black, fringed shawls smoking hand-rolled cigarettes as they sat on benches against the house wall. How marvelous these blacks become in the enveloping silver dust of twilight! I feel all this [is] so fleeting and yet challenging from the painting standpoint but as yet I haven't touched this phase of life here.

The days here — long as they are at this season — never seem long enough in which to do all I set out to do. Sometimes several days go by in which I don't leave the ranch — or even hear conversation in English. We are, between cultivating and irrigating crops — working on soil erosion control by plugging the *arroyos* with dams made of wire and stone against the coming of the rains. I think often of you and engage in the insidious practice of writing letters *mentally* which take the place of the actual execution — Do you know how this can be? I have had some interesting guests since returning from Mexico notably Mr. and Mrs. Longwell from Life's Editorial staff . . .

[1] "I'm so pleased that Pa liked the colour I sent him," PH wrote Henriette on June 6. "What a superb person he is! I reflect often what an influence he has been (and is) on my life. How his solid philosophy and steady guidance probably kept me off more shoals than I'll ever know of. I know we aren't much alike really as individuals — also that he hasn't imposed upon me any superficial characteristics of him — or insisted on bending me from whatever mould I was cast in originally. Yet deeply and fundamentally I feel we are entirely in accord."

[2] Chiefly the German invasion of Europe.
[3] Andrew Wyeth had married Betsy James on May 15 and was on his honeymoon.

To Mr. and Mrs. Daniel Longwell
[C]

San Patricio
May 28, 1940

Dear Mary and Dan:

How very nice of you both in the midst of all this shattering [world] news to take time out for notes and photographs — Now comes in today's mail a letter from Henriette saying she has some duplicates. You couldn't have pleased me more! and of course she too was delighted with these fine records of the ranch. I do want you two to know her —. And on your visit here next year you probably will, because early in July we are giving up the house in Pennsylvania to live here in this one permanently.

. . . Your enthusiasm and interest in the land was so stimulating — I look forward to your returning at the first opportunity you have — (I didn't have a chance to take you to half the interesting places) for as long a visit as you can make.

Peter

Paul is planning a trip East next month so you will no doubt see him then —

P.

To Henriette Wyeth Hurd

San Patricio Wednesday
[June 5, 1940]

My Darling Bini

Yesterday dawned with such a marvelous sky — the sort of cloud that hangs immobile for hours and the sort that I am very fond of painting, so I hopped right out and immediately recorded it on gesso in color — result that I missed writing the promised letter to you — I'm sorry but the results turned out well of the day's work — (I worked both inside and out) and I now again have a picture, temporarily entitled "sky in search of a landscape."

. . . The painting of Reggie has some good qualities I'm sure — in fact as far as I can tell now it is a successful thing.[1] Ernesto [Burciaga] meanwhile is here and he has been busy putting in the locks we bought in Mexico and doing a grand job of it.

I had a sweet and warming letter from you in yesterday's mail — the one with your cheque (which I hadn't meant that you return!) which I am going to send to the insurance Co. as a payment on the loans still outstanding. So thus you have a definite and helpful part in making us complete owners of the ranch — You see there is still something over a thousand dollars owed to the Insurance Co on loans and by cutting this down our outlay of interest will stop.

I'm delighted at your news of Mrs Wheelwright's enthusiasm for your portraits — It seems to me she has been a hell of a long time realizing how your works are so far superior to other modern portraits . . . I wonder why Macbeth doesn't see this. Is it because they are afraid your being a woman is a limitation? I'm not sure of this either way.

. . . The Cavalcade at Lincoln progresses and apparently I am unanimously chosen as Billy-the-Kid[2] — This I think I wrote you. Practice begins next week — wish you were to be here.

I continue to be harassed with anxiety about our future. And I keep coming back to the concept that if the worst comes to this country — that is we are embroiled in conflict — it will then be that I must do my best to make our living in food stuffs from this ranch — I mean it isn't in the least inconceivable that we would for a time have to live just about as simply as peasants while the economic pressure continued. It would then be up to us to hoard together beforehand as many materials as we could need for our painting and then continue as best we could with bartering and an occasional sale. And this concept of a possible future is far from the most ugly I can think of. I mean by this that we will be fortunate if we can work out our destiny in this way and be all together.

This is a sad note to end on but there is no need to hide from you my fears — and perhaps by having foresight enough we can lessen our troubles when they come — All love to

you three. I do adore you and miss you Bini — But above all know that I also *admire your achievements*! ever your Peter.

[1] PH painted Reginald Bishop "in profile — head and shoulders wearing the wide black felt hat and a deep dark — blue shirt against a silvery dusk background of the *Centinela* and the polo field" (PH to Henriette Wyeth Hurd, June 3, 1940).

[2] At the annual Lincoln fiesta in late June, PH appeared as Billy the Kid in a dramatic presentation of the history of Lincoln, New Mexico. Several weeks later he was asked to play the leading part of Coronado in an alfresco play at Roswell for the Coronado Cuartocentennial. "I'm bored as hell by it," PH wrote Henriette, "yet it seems my duty to throw in with them" (PH to Henriette Wyeth Hurd, [July, 1940]).

To Henriette Wyeth Hurd
Lincoln N.M.
Monday night [June 10, 1940]

What an ironical mockery this is — sitting here waiting between scenes of the rehearsal of a play about a forgotten and unimportant clan war while the radio brings hourly news of new horrors in Europe. I am conscious always of a dull aching apprehensiveness — As the actual imminence of war — our possible involvement in it increases I find my two years' of intensive study of its science becomes a haunting, disturbing memory. Even though the warfare of twenty years ago is now well outmoded that was complete enough. My philosophy (personal and not very applicable generally) is that I have a definite mission to carry out and I want at any cost to keep from being embroiled in this mess . . .

To Henriette Wyeth Hurd
San Patricio Friday [June 14, 1940]

. . . The war news is so appalling I am completely confounded. As I write this Paris is apparently surrendering without a defense certainly much better than being blown up by bombs. Did you hear the President speak from the University of Virginia the other day?

I'm at work now on a series of landscapes anxious to make some new strides but it is certainly doubly hard with the apoc-

alyptic news which the papers bring daily and the radio nearly hourly! . . .

To Henriette Wyeth Hurd
San Patricio Thursday
[June 20, 1940]

. . . as a preparedness move toward the day when sales of paintings will be nil, I have decided to regard the newly acquired land[1] as potentially rentable — Reg is anxious to be the first tenant and has accordingly started negotiations for the diversion of a part of his income to make a $1800.00 improvement on the house, this to go as rent until all used up then he to have priority over other tenants thereafter at a nominal rent.

The house has enormous possibilities and lying as it does in the lap of the hill doesn't affect our sky line at all. Not that a view of what I expect to build will matter because I think it will be extremely attractive.

. . . The future fills me with constant apprehension and consternation. This seems to me one way in which it can become more stable slightly . . .

[1] *La Mancha* (see PH to Henriette Wyeth Hurd, [May 6, 1940], note 3).

To Henriette Wyeth Hurd
St John's Day — [June 24, 1940]
(Monday Noon) [San Patricio]

. . . No darling, the new land isn't across the river — The river is our moat and all our far-flung empire lies south of it. The new farm called, *La Mancha* to distinguish it from this part lies directly down-river from us and is the background for the painting I made of you. The adobe house is the one I have painted so often from this view. It is occupied by Don Martín and his wife. Reg's house is a little hovel of 2 rooms set into the side of the hill — invisible from where we are. But in spite of its size it has enormous charm — You know the interesting sort of stonework set in adobe of those houses in San Patricio — One side of this

house is the solid rock of the hill-side, and it can be extended to be a charming and comfortable house.

. . . Just one rose remains on the big bush outside the window that gives onto the north patio (which place I hope another year will win for itself the name of "the rose garden") its fragrance is an enchantment that sends my mind reeling back to the remote weather of childhood. The de Bremond ranch[1] in its prime: the roar of the great artesian fountain as it cascaded over its pile of moss covered rocks — the deB[remond] girls in wide hair bows and starched white frocks . . . and a chain of successive tag end memories all instantaneously summoned up by a deep whiff of a rose . . .

[1] See introduction, pp. xxvii–xxviii.

To Henriette Wyeth Hurd

⟨Monday [June 17? 1940
San Patricio]⟩

. . . I have the constant feeling that I am part of a phase of a life about to pass — that these are "the good old days" that much of this kind of life is fairly bound to stop soon. This fine, utterly peaceful contemplative life will probably be found out and overthrown by those who demand universal change. I wonder then how vivid will be the memories of it which survive. This feeling is beginning to motivate me in painting . . .

To Henriette Wyeth Hurd

[June 27, 1940
San Patricio]

. . . I'm painting the White Comma Cat comma Bar[1] as you once said I should do. It hangs in balance — with one of the best skies I've ever done a good foreground including the Bar and a so far inept distance of the hills. But I have had only one go at the landscape apart from the sky and now in about a couple of hours I'll go perch myself again on the highway overlooking San Patricio . . .

[1] The San Patricio bar, long since demolished, had a sign that read: White, Cat, Bar; the commas were always spoken at *El Centinela*.

To Henriette Wyeth Hurd

San Patricio
Friday —
July 6 — [1940]

Dearest Bini —
Bulletins galore: — I'm making tracks in my work *I think* — really hard at it and I think the landscape came out among the best. A letter from Paul Gardner[1] asking to come here with Alan Robe for ten days while I paint Alan. I'm glad of course of the chance at another portrait and they'll probably be gone by the time you get here. I'm also beginning a portrait of Andronico Herrera a cute little youngster who lives at Don Martín's, quite a large gesso panel in a colour scheme I've never attempted before. Hope me luck, Bini! A note from Paul[2] says he'll see you Monday — Isn't that grand?

. . . I went to the Ft. Stanton Rodeo on the 4th and later to the Apache dance where I made a lot of drawings (at both places) . . .

[1] Paul Gardner was director of the William Rockhill Nelson Gallery of Art (now the Nelson-Atkins Museum) in Kansas City. He became a close friend of the Hurds, though they later had a falling-out. During the summer he purchased a large ranch near *El Centinela*, which was called *Las Milpas* (the Cornfields), and which he later sold to PH in its entirety.

[2] Paul Horgan was on his way east.

To Henriette Wyeth Hurd

San Patricio Monday morning
[July 16? 1940]

Dearest Bini
A great bustle of activity goes on here. The floor is more than half laid in the kitchen. The green room is ready for its new ceiling and for the rebuilding of the fireplace. We are taking the old one completely down and putting up a new larger one. Paul

Gardner and Alan Robe left this morning for Kansas City — The
portrait came out well I think — I have kept it for you to see
although there seems no doubt now that Gardner wants to own
it. He is writing me about it but his final words before leaving
were that they both are much pleased with it. He is a nice per-
son really I am very fond of them both. They fit in beautifully
here and were never the least trouble . . . Gardner — was
much impressed with your portrait of Ann Carol on the Rocking
Horse which he saw in Santa Fé. He is a good person to have
interested in our work, I'm sure.

 Your letter telling all about Paul's visit was marvelous and
reading and re-reading it was next best to being right there. I'm
so glad the party at Joe [Hergesheimer's] was a success! Paul is
certainly in marvelous form these days . . .

 . . . I'm about to begin a couple of new lithographs. 'Bout
time, isn't it?[1]

 . . . I'm hoping to have all the work done by the time you
get here — There are 6 men working on various projects now
and I must close this to run see how they are coming on.

 All my love to you Darling Henriette — I can hardly wait to
see you . . .

[1] "A letter from Pegeen [Sullivan] inviting me to do another $5.00 lithograph for
them [the Macbeth Gallery]. (They pay $200.00 I think) They want something compara-
ble to 'Texas Nomads' so I'm racking my brain — not wanting to repeat this motif abso-
lutely. I look forward to drawing on stone again" (PH to Henriette Wyeth Hurd, July 3,
1941).

To J. Frank Dobie

San Patricio
July 29, 1940

 . . . Henriette is out here now to stay — She and the kids
are full-fledged New Mexicanes now and apparently delighted
at being rancheros: being involved in the constantly changing
drama of this life — flooding rivers — new colts —, polo games
new cures for sick horses, roping contests fiestas weddings — a
rich and varied procession of events it always is here. So that I

honestly dread any business that takes me out of this vicinity — I sometimes go two months without going to town (Roswell) and days roll by — or used to, when my family was in Pennsylvania —, when I'd hear no language but Spanish spoken. Not that Spanish is *better* than English — I only cite this to show what a stay-at-home I've become! But one matter is to take me to Wyoming — and that at the very time you are due here. Henriette and I are mighty sorry that the middle of August is a date of over a year's standing with some people in Wyoming where I have a portrait to paint. We're to go to the J. S. Resor's ranch on the Snake River while I paint Mr. Resor. He returns to N.Y. early in September so this is the only time there is for me to do the portrait.

What I hope you'll do is come any way. Reg. Bishop who is associated with me in the horse business[1] will be here. He is building a house on a corner of the ranch and will be looking for you. There's plenty of room for you and whoever will be with you to stay — So come on anyway . . . I'm only sorry as the devil we can't be here . . .

Original manuscript at the Humanities Research Center, University of Texas at Austin.

[1]". . . perhaps I shouldn't say 'business' as we haven't any dollar profits from colts at all — but all the string of colts (about 9 or 10) have been traded off except one for older horses already 'made' that is not polo wise but broken to rope from and quick and handy. Beginning with next year we ought to have a fine string of half and three quarter breds" (PH to Eric Knight, September 16, 1940).

To J. Frank Dobie

⟨San Patricio
September 23
1940⟩

Dear Don Pancho:

If only I could have been here at the time of your visit! I do wish this could have been — you must have done a whale of a piece of work cutting down a ms. as you did. The piece on Don Martín is charming and recreated him immediately for me. (He has now gone to the Ojo Caliente to boil out his rheumatism)

With you, I am deeply preoccupied with the terrible destiny of Europe. How remote the enchanted atmosphere of those books of Kenneth Grahame's of Victorian England seem now! The thought of the places so indelibly associated with our blood, as Anglo-Americans, being destroyed ruthlessly and needlessly is desolating to me.

Paul [Horgan] was up this week-end and we spoke affectionately of you. I look forward to having another visit from you when I can be here, perhaps we can take the trailer and a couple of ponies then, and strike out for whatever adventures await us. Let's do this another summer if our existence is still compatible with such a project —

Henriette and Reg join in sending warm wishes to you.

Sincerely,

Peter.

Original manuscript at the Humanities Research Center, University of Texas at Austin.

To Mr. and Mrs. Eric Knight
Sentinel Ranch —
San Patricio — Sept. 16, 1940

Dear Eric and Jere:

This is the most disgraceful silence yet from the Hurd! After such fun together in Iowa[1] I should certainly have done something about letters — Truth is I began one to you — didn't like its sound began to reflect on my letters generally how they lack usually completely any *immediate quality* — of the sort that letters from you both have so and which makes the writer seem imminent as the letter is read. Well, here's hoping this is an exception:

H. and the kids, plus a van load of furniture are all installed here in San Patricio — Peter is in School; Henriette, temporarily the cook, is working daily in her own studio on a portrait of Ann Carol. The season has been dry this year — The rains came early then ceased altogether — But Knight Dam[2] withstood one test magnificently and has silted in to a point now nearly level

with the spillway. Dan Longwell of "Life" who, with his wife vis-
ited here after I returned from Iowa, expressed much admira-
tion for Knight Dam and made extensive plans for Longwell
Dam to be put in at another time on a location selected higher
up the *arroyo*. Which reminds me that since Knight Dam has
silted in so well, don't you think it would be a fine idea for its
engineer and designer and wife to come down here this fall or
winter to lay plans for the next step? We are here permanently
now and would certainly welcome a visit from you two. Fall or
winter — *no le hace*[3]— how about it?

 The rancho has expanded since I saw you: We now have the
school section (all the hills south of us for a mile) and eighteen
acres more of crop land. This is still in the form of a lease but
slowly we mean to buy it up from the State. I arranged the sale
of this, (the Clements Ranch) to a friend in Kansas City[4] who
sold me the land lying south of the Ruidoso. Isn't this fine? So
now we have a square mile ranging from the river land to the
foot hills 1200 — 1500 feet above where, because of this differ-
ence in altitude, there is actually a marked difference in flora.

 . . . Henriette is reading "Lassie Come Home" to the kids,
who love it. I hope this and "The Happy Land"[5] are having con-
tinued good sales. The latter is one of the most stirring and satis-
fying in its conviction of any book I have ever read! In which
Henriette agrees with me. Damn fine Eric! which brings me to
realize that dams or no dams — we have another cause to bring
you two here — viz our juvenile book together. I have never
been so busy as I am now — 2 portraits ahead of me another
Post Office (Alamogordo N.M.) fresco . . . These things together
with the fact that Macbeth's are howling for more paintings from
me — make me plenty busy. I don't want to have to stir or
budge out of this spot — a radius of 200 mi from where I sit now
in our house, is my domain. One of the portraits takes me to
Denton Tex. which is my only reason for leaving here that I
know of now — for a good long time. So how about you come
out and we get into it?

 We have a guest house now where you can be comfortable
when you come out — So put this on your schedule for when

winter piles up on you in Pennsylvania and roll down here to see
us . . .

[1] In April, when PH visited Eric Knight at the University of Iowa.
[2] An *arroyo* built by Eric Knight in 1935. See PH to Henriette Wyeth Hurd,
[December, 1935].
[3] Makes no difference.
[4] Paul Gardner.
[5] Books by Eric Knight.

To Mr. and Mrs. Daniel Longwell
[C]

Sentinel Ranch
San Patricio
Jan 24, 1941

. . . a show of mine is opening next week at Macbeth's
which I hope you both will see and one of its major results will
I hope be such an attack of nostalgia for San Patricio that you'll
both come swiftly back here for a long visit. The National Acad-
emy [of Design] has recently written me that they are consider-
ing making me a member[1] and in order to acquaint their mem-
bers more with my work they are requesting that I send them
two paintings — This is difficult with a show coming up and, tho
I hate to bother you, it has occurred to me that Dry River and a
recent portrait would do more to reduce the deluge of blackball-
ing than anything else I can think of. So — if you will allow me
again to borrow it[2] it would be a great favor and the best solution
to this predicament. So as not to bother you with having to an-
swer me I'll have the Macbeth Gallery get in touch with you.
Don't hesitate to refuse if you want to!

Our plans are to stay here all winter and Spring.

. . . I've heard from Paul [Horgan], of course, all about his
visits with you. He'll join me in a big welcome for you when you
come . . .

[1] PH was elected to the National Academy in 1942.
[2] See PH to Daniel Longwell, ⟨October 1, 1939⟩, note 3.

To Mr. and Mrs. Daniel Longwell
[C]

Sentinel Ranch
San Patricio
February 14*th* 1941

Dear Dan and Mary:

We are delighted that you can come again this spring —
And I'm hoping the ten days is an understatement of what's pos-
sible. I got a big kick out of your enthusiastic letter, Dan and
the news that the paintings appealed to you. I was so spang up
close to them when I shipped them off that I had no perspective
on them at all — and honestly didn't know whether they were
lousy or among my best. Of course I didn't once think they *were*
lousy or I wouldn't have sent them off — But rather I was in a
state of plain not knowing. Anyhow Macbeths liked them and
one or two others beside [those] you have written me about so I
feel much relieved. Also three have been sold — two definite
sales from this show one other possible sale, and another of last
year's harvest sold to Sweet Briar College (¡*que Viva el Colegio
Esuiet Braiar*!) So in this good fortune is the answer to your sug-
gestion that I might let you pay. I'm perfectly forthright about
such matters (not at all the perfect Spanish Gentleman) and if I
were strapped I'd simply say so and let you, if you wanted, help
with the grub. But I'm not and the item of two extra people is
practically nil so there's not the vaguest reason why you should.

The brothers Herrera, Manuel and José with a third He-
rrera, cousin to the first two, — Julian — are on hand for the
polo and we'll welcome your entrance in our game for whatever
degree of ambitiousness you want to, whether as a beginner
with stick and ball or on Pear or La Bamba or in full swing of play
— José is working for us steadily now. He's one of the most
paintogenic people I know and I'm frequently tempted to skip
even the most urgent projects of ranch work to set him on the
model stand — He posed for the little figure on the white horse
— ("*Caporal*")[1] in the large landscape called "The Rainy Sea-
son" which you saw at Macbeth's. This afternoon we played a
round of polo with Reg and Julian — a sort of practice game we
call "Knock-in."

Reg and family are all installed as I wrote you in the part of the ranch we call *"La Mancha"* this for the involved and literary reason that at the time I bought this land (with a very meager bank balance) it seemed another Quixotic venture almost worthy of the Knight of *La Mancha*. But I've changed my mind about this now and certainly the Bishops are glad I got it.

I'm returning the two prints on Monday, Dan, very glad to have added my signature to them! By the way I was much pleased to be included in Life's Survey of the Federal murals. This fresco at Big Spring was such a problem for the local photographers there that I haven't yet got a photograph of it worth any thing at *all*. The lobby is only 17 ft. wide and the painting is 6' by 23 long! so I was glad Life was able to get it at all . . .

[1] Foreman.

To N. C. Wyeth

March 16, 1941
[San Patricio]

Dear Pa:

Such a big boost your fine letter gave me that I hasten to reply to let you know how glad I am that you feel I am making progress. That was great news! I had no idea you would find a chance to go to New York but I'm mighty glad you did. I think "Anselmo's House" was the best one in the show all right,[1] and looking back on Rio Hondo I agree with you that the foreground needed some cutting down and the river probably some scrubbing in tonality.

Today we both got an enormous thrill with the photos of Andy's new tempera panels. These are to me really stunning and even in black and white they leave nothing to be desired! I mean, the photos being adequate, the design carries so well that one just accepts them as is the case with reproductions of past masters — one doesn't think of questioning them. They are complete and right! Do you know how I mean this? Andy is handling tempera uniquely and masterfully.

I'm at work on a Defense Subject for the cover of Collier's

Magazine. I ran over to Fort Bliss the other day and after riding around for a couple of days with division Staff Officers came home with an idea which I hope clicks with the editors. It is a picture of cavalry troops advancing at a gallop with drawn pistols working in unison with mechanized troops advancing in bantam cars. The picture is only in sketch form so far and is being considered now by the editors. The other is a large landscape for the Abbott Chemical Company's collection to be used (if accepted!) on the cover of the house organ called "What's New." I keep thinking how beautifully you could handle the Army subject. Needless to say I have put the scene in roughest desert terrain such as that outside of El Paso. I have a grand chance in it without any doubt, and now am hoping my sketch is eloquent enough to convince the art editors —

Later: We wished for you two nights ago when rain clouds swept over the *Centinela* and suddenly, magically, a lunar rainbow appeared, its arch a pale ghost that began at the foot of the *Centinela*; as the thunder rumbled and the clouds crossed the moon it faded, only to reappear a moment later as the successive showers marched down the valley. Today there is the steaming smell of inside a green house and the tender young green of new leaves is a miracle. A reassuring constantly comforting miracle to me — to both of us, I think Henriette feels it as much as I do — in these dread times. Nature at least stays sane and her rhythms are undisturbed — the sap starts to life, the myriad new cells build, the chlorophyll deepens; So that the ever-present apprehensiveness of impending disaster to the race of man lessens and in the vast pattern of nature the whole mess becomes only another fly speck on the page of Earth's history — finally inconsequential — unimportant. Thus I feel now but at times my very dreams are deep-dyed with dread — as last night when it seemed I was one of a great waiting army at El Paso — massed against Nazi invaders from the South, the result of reading and hearing of the coming showdown in Greece, I suppose (or maybe an extra shot at supper of Lucia's potent *chile piquante*). Anyway, disturbing and indelibly haunting and I suppose in a kindred way you are subject to the same thing.

Henriette is very well I think and together we are having

a great time planting and transplanting. Oleanders, iris, lilacs, roses (among the last, one called Mrs. Pierre S. du Pont!) fruit trees for the patio: Pomegranates, figs and almonds, Henriette selects the place I do most of the digging and together we set them out. She is working every day in the Studio — doing portraits of each of the kids and no day is long enough for either of us to get done all we'd like to.

I think I told you the Soil Conservation Service is doing some work for us on the lower farm land[2] — every day a gang of C[ivilian] C[onservation] C[orps] boys come over to man enormous tractors and trucks and make our work teams look very primitive. The C.C.C. boys are mostly from South Philadelphia which is a strange twist of destiny. But they are a healthy, hardworking lot: burned dark as Indians and stripped to the waist — they are getting the job done in short order . . .

[1] Having recently seen PH's show at the Macbeth Gallery, Mr. Wyeth wrote him that with *Anselmo's House* he had "produced something very rare in painting, that penetrating quality made of a splendidly balanced color pattern, and authentic mood. Moving beauty emanates from the work itself. The dramatic distinction of locality, merged and distilled into a transcendent appeal, that haunting appeal which music gives us; illusion, intangible yet pungent and critical . . . Unquestionably you are heading deep and fast into the real stuff—but you must expect a tedious time with the eastern critics" (N. C. Wyeth to PH, [March 11, 1941]). In 1945, *Anselmo's House* was bought for the Tate Gallery.

[2] PH later served on the regional Soil and Water Conservation District Board.

To Mr. and Mrs. Daniel Longwell
[C]

San Patricio Sunday
[May 4, 1941]

Dear Dan and Mary —

The Assignment to San Diego proved to be a grand adventure and thanks to your many friends there, Dan, I had a fine reception and much enjoyed doing the painting of the machine gun practice.[1] I have just written Margit Varga giving her some of the dope on the painting. There was some talk at [Camp] Elliott of doing the big .50 calibre machine gun firing but this wasn't the gun you had seen and it seemed to me better not to lose time with sending wires and waiting for answers. There is a

wealth of material for the painter in this defense program. I saw any number of things in my week at San Diego that would have been fine pictorial material.

. . . Now how about you two? When can we look for you here? I'm just finishing a portrait of Eric Knight who is here with his wife — (Henriette is painting her.) I hope you come before they leave as he is one of the most amusing as well as brilliant men I know — He is a charter member of our *poloistas* having been here the year we cleared the cholla Cactus off the field.

Don't worry about room there is lots of it and I'm hoping to see you soon . . .

[1] PH's first commission for *Life* magazine.

To Mr. and Mrs. Eric Knight

[June? 1941
San Patricio]

. . . My old room mate at West Point[1] has just been here for a visit — wish you could have talked with him. He had some new angles on the international set-up — based on many conferences (like the one we weren't allowed to attend at Camp Elliot, Von Nacht) [*sic*] and his conclusions were extremely interesting to me. In general he felt we are much more strongly equipped than most of us have felt — saying that the new army is falling to with a will and that only the labor question looks dark . . .

[1] Major General Robert Howze. See PH to Mrs. Harold Hurd, July 1, 1921, note 2.

To Eric Knight

June 25th [1941
San Patricio]

. . . Life here has settled into the old-time bachelor routine[1] a not too disagreeable life either — knowing that the family are well and happy and doing what they want to do cuts any pang out of my feeling at their not being here and I'm greatly

enjoying being alone. Horgan is in and out but mostly I am alone early up (it is not yet six A.M.) and ditto to bed. Polo twice a week Roswell as little as possible, long rides solitary or with Jose back into the sierra . . .

. . . You're damn nice to give me La Bamba she's a swell little pony and I love to ride her. I sure miss Cayman[2] like hell!

The rains continue as drearily daily showers rolling up over the *Centinela* in magnificent patterns of cloud and sun. I'm indoors a lot tho lately working on the Alamo[gordo] Cartoon which is coming well, I feel[3] . . .

[1] Henriette had returned to Chadds Ford with little Peter and Ann Carol in order to paint portraits.

[2] PH's polo horse. Cayman had broken his back falling from a high *arroyo* bank and had to be shot.

[3] PH designed two large panels for the Alamogordo Post Office fresco. The Sun Panel, to the left of the doorway in the entrance *portal*, shows a farm scene with a woman holding a hoe and gazing down protectively at her young daughter, who is kneeling beside an *acequia*. At the bottom is the following inscription: "Come Sunlight after Rain to bring Green Life out of the Earth." In the Rain Panel, to the right of the doorway, stands an old Mexican shepherd, his flock gathered around him, as he implores the heavens for rain. "*Ven Lluvia bendita, Ven a acariciar la Tierra Sedienta*" (Come blessed rainfall, come and caress the dry earth), is the legend at the bottom. The old Alamogordo Post Office is now the Federal Building, where the fresco still stands. See PH to Henriette Wyeth Hurd, August 4, [1941], note 1.

To Henriette Wyeth Hurd
Saturday [July 5? 1941]
San Patricio

Dearest Bini —

Back here from a painting trip into the Sierra Sacramento to find all well here and two nice long letters from you . . . no work now except the Alamogordo fresco and a $400.00 job for the Assoc Amer. Artists.[1]

. . . Gardner and Alan [Robe] came just before I left and are staying here, buying the food while I do the rest. They are fine and delighted with *Las Milpas*[2]; and Paul immediately "lit into" the work of carrying on construction — He plans to do the new wing anyway this year.

. . . Painting seems to be getting along well, with a lot of

projects brewing now — I have two landscapes planned, one
near Roswell the other South of there some miles . . .

[1] PH had been commissioned to paint "one of a series of 12 paintings by different
artists on harvest subjects, regionally distributed, to be used as a cover design for the
Country Gentleman" (PH to Henriette Wyeth Hurd, July 29, 1941). PH's assignment
soon sent him to a large sheep ranch near Magdalena.
 [2] See PH to Henriette Wyeth Hurd, July 6, [1940], note 1.

To Henriette Wyeth Hurd

Thursday
July 17, 1941
[San Patricio]
 . . . the wool buyer (who never appeared here by the way)
wired me to meet him at Magdalena on Monday at 10:00 A.M.
We went out to the Otero Ranch immediately getting there about
1:30. It is 45 miles from Magdalena in a beautiful location — of
piñon trees and mighty green (like West Chester houses) crags.
It was quite exciting to come suddenly, after 45 miles of wilder-
ness on the dust and din of the sheep shearing camp. Sixteen
shearers work at the same time with power fed by shafts from a
gasoline engine on a truck — the wool comes off in rich creamy
yellow masses and the shorn sheep look so bewildered and
funny, their colour now a bright creamy yellow. About forty peo-
ple throng the wool shearing camp all working steadily . . .
 . . . Everywhere was the *Patrón* — lashing about the cor-
rals in around the machinery over at the weighing platform yell-
ing, "*Mira, mira*[1] . . ." to his men. [His name] was don Manuel.
He interested me a lot — He had a fine strong aquiline face with
large piercing eyes of a turquoise-matrix, green blue — different
from any eyes I have ever seen. He is fair-skinned and large of
body — about 55 I'd say. He is one of the old Hidalgo families —
descendant of a colonial governor of this land — then New Spain
. . . In the evening we went among the shearers in the wide
camp in the glen — (It looks like the place where Saint Francis
of Assisi Received the Stigmata, by Bellini)[2] There was singing
and stories for a while then bed for the shearing begins at six in
the morning.

I had made my sketches and notes on Monday afternoon so by next morning I was ready to leave . . . I made three landscape drawings (notes for paintings) and am now launched in the first of these in colour — a 30 X 36. —

. . . Here everything was fine Paul and Alan had run things while I was away . . .

[1] Look alive.
[2] Bellini's painting (the Frick Collection) was one of PH's favorites.

To Henriette Wyeth Hurd
San Patricio Tuesday July 29, 1941

. . . Fruit is ripening everywhere now and we have been eating apricots for the past two weeks also rhubarb and all sorts of green vegetables from here and from *Las Milpas*. Paul's new windmill tower is in place and looks very handsome — just the right height and proportion with his house, I think. He is fine and spends each day at his house painting the walls and supervising the workmen. He has been made to know the worries and troubles of building in New Mexico and I think is truly understanding of and thankful for my efforts of last winter. They are here until the middle of August.

The C.C.C. work is finally completed but I haven't yet needed to irrigate the oats. They are now nearly ready to harvest and should yield about ten thousand pounds of threshed grain!

Clinton Anderson (Congressman from N. Mex) has written me to say he has suggested my name in a letter to Nelson Rockefeller[1] as being one capable of serving the Country in Latin America. A big half of me hopes nothing comes of this, for I dread leaving here for any time. Do you remember Mrs. Resor planned to do the same thing, being a friend of Mr. Rockefeller's but in so far as I know she never did.

My drawing for the sheep shearers . . . left by air mail last week and should have got to New York Sunday. Hope they like it. It is very complicated — not posteresque but a grand thing could be done of it and I plan to paint it anyway. I have finished three temperas since you left which I long to have you see.

I miss you and Peter and Ann Carol so much. Suddenly it seems an enormous age since you were here. Tell me about Peter's lessons: Is he making progress? — What does Pa think of his playing? — I will have our piano tuned and ready for him when he returns. What has Pa been doing beside the N.Y. murals?[2] Any new egg tempera panels? Write soon Bini — I love you so and *miss you*

ever your Peter.

[1] Rockefeller was then coordinator of inter-American affairs, appointed by FDR.

[2] N. C. Wyeth's last mural commission, for the Metropolitan Life Insurance Company, was a series of eight panels depicting scenes from New England Colonial life beginning with the coming of the Mayflower. The panels amounted to some three thousand square feet.

To Henriette Wyeth Hurd

San Patricio *Monday* Aug 4th [1941]

. . . You ask what I am painting: only the tiniest part of the Cartoon for Alamogordo remains then Rodden of Roswell will come up to photograph it to be sent to Washington for approval. They have already seen and approved photographs of the two supplementary end panels.[1] Then the two landscapes I told you of in recent letters — "The Shower on the Plains" — and Landscape with Sheepherder. Now I have all inked-in on a gesso panel 45″ high by 36 wide what is to be a tempera variation on the lithograph of the Windmill Crew. Something I have wanted to do for months. I don't suppose it will be very saleable (tho you never know) but it should be a striking and effective painting . . .

[1] Smaller than the two panels in the doorway, these both depict desert flora and are located at either end of the entrance *portal*.

To Henriette Wyeth Hurd

Friday — [August 22, 1941
San Patricio]

Dearest Bini

I'm sitting in the studio with Paul [Gardner] — We have just had lunch all from this rancho except potatoes — we had spinach, carrots, salad, milk, applesauce, corn bread and peaches and cream all home grown.

. . . *Well* at this point I get a summons to the phone — New York Calling — good old operator 42 and at the other end Reeves Lewenthal[1] saying he has a big commission of some sort for me[2] and can I meet him in his office on Wednesday (at 10:00 A.M.)? I falter out a "ye,e,es" and so am committed. My expenses are paid and I entrain Saturday (tomorrow) or Sunday which is certainly amazing to me. I know nothing about the commission except that it will pay well — I need not long be out of New Mexico (only this trip, I take it of several days including a run to North Carolina) So there we are! *I'll see you* anyhow which is the best thing I can think about the whole *projecto* at this point. Are you delighted?

All my love Bini darling —
ever your
Peter —

[1] An executive with Associated American Artists.
[2] Advertisements for Lucky Strike cigarettes.

To Mr. and Mrs. N. C. Wyeth

[September 11, 1941
Topeka, Kansas]

Dear Ma and Pa

The stay at Chadds Ford was fine and as always I leave stimulated and I think girded for work — I have gone into a philosophical huddle with myself and plan some revisions in my way of working which I'm now confident will have some noticeable results.

As planned, I stopped in Chicago where I went at once to the Art Institute and spent three hours. After wading through wall-acres of bright colored garbage it was such a relief and pleasure to come into Andy's room — and in the hour I spent there to hear many times others express the same feeling — Finally, hearing three most enthusiastic men talking loudly and intelligently about these watercolors I edged nearer and when one of them exclaimed — "He is like a swordsman with his brush" I couldn't help introducing myself. They proved to be three Chicago commercial artists and they said they have returned repeatedly to see Andy's show.

. . . I still have all today and all night on this train — reaching Roswell at 6:00 A.M. Mountain Time tomorrow.

Thank you for a fine rest at Chadds Ford. I was delighted to find you both looking so well.

<div align="center">

Love —

Pete.

</div>

"The Scout" — leaving Kansas City Thursday morning

<div align="center">

To Henriette Wyeth Hurd

Wednesday. [September, 1941

San Patricio]

</div>

Dearest Henriette:

In the worst flood the valley has ever known we have been marooned here since Saturday night. Every one on the river has suffered heavy losses but ours were relatively light. Crossing is impossible even on a horse and so this letter to you will be thrown across wrapped around a stone. No mail since Saturday makes me worried and apprehensive — I am alone with José & family — Don M[artín] and wife and one of Julian's kids on this side of the creek until the torrent relents — at least I'm working like the devil — and it's fine to know interruptions are virtually impossible —

I miss you so much awfully —

I'm going to try to have Julian throw the mail across the river tomorrow — piece by piece. It is a damn hard throw even at its narrowest point.

The L[ucky] S[trike] picture comes well but of course good models are impossible to find. I have also painted some landscapes —

All love to you and the children and to Ma and Pa —

<div align="center">

ever your

Peter —

</div>

To Henriette Wyeth Hurd

Sunday — [October 6, 1941
San Patricio]

Dearest Henriette:

Things have come back to normal again here — The last flood the one of a week ago today was a bitcheroo. Now, the weather brilliant and warm gives no hint of last week's chaos . . . For a complete week there was no mail; bridges highways were washed out everywhere in a flood absolutely unprecedented in size — a few houses went (none in San Patricio) but no drownings resulted hereabouts anywhere. It all began last Sunday with a crash of thunder and roar of rain. We have all suffered losses but Sentinel Ranch got off mighty lightly this time. Our crossing went out of course and a river, entirely unrecognizable resulted, now that things are back again.

. . . Whatever the cause it was a heller and we will be many weeks cleaning up patching *acéquias* fences etc. On the credit side of the ledger, I feel that the channel of the river has so widened and deepened that danger from another disastrous flood is practically nil. We are going to have a terrific time constructing dams now for diversion of water into the *acéquias* — moreover much of the *acéquia* (ours) must be relocated. But we may get more crop land by this resurvey.

. . . I have two new landscapes, and the Lucky S. picture leaves today. I've worked hard and honestly on it and hope it is a good one . . .

To Henriette Wyeth Hurd

Friday
October 10, 1941
[San Patricio]

. . . I've been working like the devil — Yesterday all day on a new painting last night by fluorescent lamp I cleaned up and repainted the old Whitman picture for the Wilmington man. I'll ship it off to Biddle as soon as it is dry enough to varnish.

After finishing what I have on hand I plan to go to El Paso and nearby places on a painting trip. Also I want to hunt up sand and lime for Alamogordo while there . . .

To Henriette Wyeth Hurd

San Patricio
Friday [October 31? 1941]

. . . I am about ready to go to Alamogordo but there is no hurry as I have asked for a delay in the contract until May 1st. I am going over to see Edna Imhoff to find out what chances there are of having her pose for a head, for the figure of the Sun Panel. She once said she would do this. I'd like to go to Alamo in January, it will be nice there then and I welcome the thought of getting at a fresco again . . .

To Henriette Wyeth Hurd

⟨*Lincoln N.M.*

Monday night [June 10, 1940]⟩

. . . I am conscious of a dull aching apprehensiveness — As the actual imminence of war — our possible involvement in it increases I find my two years' of intensive study of its science becomes a haunting, disturbing memory. Even though the warfare of twenty years ago is now well outmoded that was complete enough. My philosophy (personal and not very applicable generally) is that I have a definite mission to carry out and I want at any cost to keep from being embroiled in this mess . . .

To N. C. Wyeth

⟨March 16, 1941
[San Patricio]⟩

. . . at times my very dreams are deep-dyed with dread — as last night when it seemed I was one of a great waiting army at El Paso — massed against Nazi invaders from the South . . .

To Mr. and Mrs. Nathaniel Wyeth[1]

Sentinel Ranch
San Patricio
January 9,th [1942]

. . . The war is uppermost in my mind most of the time and I keep wondering how I can most efficiently contribute my services — The training I had at West Point — 1921 – 23 seems to

me might just as well have been under Genghis Khan for all the relating it might have to modern warfare methods. But I'd like to get a crack at "them squeench-eyed bastards" as I heard a cowboy here call the Japanese.

. . . Broadly, — from a moon's eye viewpoint — it is so futile and tragic that in this age of enlightenment man continues to be his own worst enemy! But our way of going is worth defending at any cost so what else is there to do but get in and hit hard.

Here we are out of the area of excitement that pervades the entire Pacific Coast but a 17 million dollar bomber base is going up at Roswell and over these sierras on the desert to the west of us is a bomber range as well as an A[nti] A[ircraft] range where the civilian population is strictly unwelcome as spectators. Troop trains go through constantly — ten fifteen twenty of them daily. A lot of boys have gone into the Army from San Patricio . . .

[1] Nathaniel Wyeth, a scientist and technological inventor, and his wife, Caroline.

To N. C. Wyeth

San Patricio Jan 15th. [1942]

. . . Air Corps officers have begun to come in and the old days are over in Roswell. For good or bad it is going to change. But I haven't much feeling about this: It is a tiny and sentimental issue in an apocalyptic cosmos.

. . . I'm now at the task of washing sand, packing it and lime putty for transportation to Alamogordo. I have made a small colour mill[1] as described by R[alph] Mayer in his book and it seems to work beautifully.

I had a disaster in varnishing a recently-completed self portrait (for the N[ational] A[cademy]) the colour began to [come] off and run in places and the features had to be cleaned with turpentine right down to the ink *imprimatura* in places and repainted. I have a theory (untried) that using a thin spray of Retouching varnish first then the heavier Damar whenever there is any doubt as to whether time enough has elapsed would be good. The R.T. Varnish has some cobaltic linoleate I think which is a dryer and might thus help to isolate the painting for further applications of varnish.

Your pal, Geo. Washington Hill (Hip & Tit series) sent me a gift box of Lucky Strikes at Christmas time. I'm about to begin a second picture for them.

. . . Rereading this letter I realize I may sound defeatist to you — *I don't mean to* at all. I think we're lucky as hell in most of our leaders and that the country really has a unity of purpose at last! . . . I'm certainly grieved about MacArthur who was Commanding Officer at West Point when I was there.[2] I can't foresee even the hope of any Dunkerque for those men many of them from right around here in New Mexico. I have had recurrent dreams of their fighting awaking each time tired and depressed by these vivid but I suppose incongruous dreams . . .

[1] A waterwheel made to rotate by the *acequia* that ran through the ranch. PH used it to grind raw pigments taken from minerals on his own land.

[2] See PH to Harold Hurd, July 28 and 29, 1921, note 2.

To Kenneth McIntosh[1]
[Carbon Copy]

Sentinel Ranch
San Patricio N Mex.
1/15/42

Dear Ken:

Thanks for your nice note and the enclosed blank which I have just filled out — I find however I need a second form just like this one as the forms must be filled out and signed in duplicate. Also — if available in your office I need a form for a report of physical examination (W.D. A.G.O. Form #63) to accompany these applications for Appointment.

Under "remarks" I quote what I figured out to say: being un-schooled in such things I send it to you to find out how it strikes you — pompous or brassy or otherwise wrong which I certainly don't want. Give me your reactions.

"I feel that I could be of technical service in the Foreign Liaison Section of G-2 as an intelligence officer in South America or Mexico or along the U.S. — Mexican border. I grew up with the Mexican people in this border region & speak their language without foreign accent. In offering myself I am prompted

by a sense of duty and the possibility that through my affinity for Latin Americans I might be of especial use to our Country. Leaving my family, my work and the ranch would be a hardship — This I mention only to let it be known that I am not a job-seeker." This is of course, as you know true but it may be so far out of the line of official language as to be incongruous & unnecessary.[2]

Henriette is in Chicago on a portrait commission[3] and I with the Mexican cook am holding the fort; So I haven't been able to discuss it with her. But she feels just as I do.[4]

I suggested rank of major arbitrarily in this application because it is the rank held now by my class at West Point — Also, I have to think of keeping Henriette and the kids going — Commissions for her will probably grow scarcer. But I don't care about this at all what rank is given me, I mean. What is important is how best can I do my utmost toward ending the war with victory for us.

My warm wishes to you and to Jessie

Sincerely

Pete

[1] Major Kenneth McIntosh, a friend of long standing, was the executive officer, Foreign Liaison Branch, Military Intelligence Division G-2. PH had written McIntosh earlier in the month, expressing an interest in obtaining a war commission and requesting the appropriate War Department forms.

[2] "The wording you proposed," Major McIntosh replied, "which is returned herewith in case you kept no copy, is fine; only suggestion is that in place of the restrictive expression 'Foreign Liaison Section' you use the broader expression 'War Department or other staff headquarters'" (Major Kenneth McIntosh to PH, February 21, 1942).

[3] Henriette was painting a portrait of J. E. Boudreau, a former classmate of PH's at West Point.

[4] PH wrote to Henriette the following day, and seven times more during the next three weeks, without discussing his desire to enter the war.

An Artist-Correspondent

Two months later, Major McIntosh wrote Peter that his proposed commission with military intelligence in Latin America had not yet come through, adding that "there is the chance that you might be sent to a routine and obscure assignment not at all to your liking.

"Comments or suggestions from you during the remaining days of March will be most welcome as whatever decision you and I do make in regard to your application will have far reaching effect for Sentinel Ranch and a nice family probably for years to come. You will doubtless agree that we cannot proceed too carefully."

Despite the lack of encouragement in Major McIntosh's response, Peter was still resolved to join the war effort. On March 20, an excellent opportunity for him to do this came his way unexpectedly, in the form of the following Western Union Day Letter:

DEAR PETE THE ARMY AIR FORCE IS DOING SPECTACULAR FIGHTING ARMY AIR FORCE IS LIKELY TO BE THE BIGGEST ADVENTUROUS EFFORT THIS COUNTRY HAS EVER SEEN HOW WOULD YOU LIKE TO PAINT AND SKETCH THEM . . . TERMS 2000 DOLLARS AND ALL EXPENSES FOR WHATEVER YOU GIVE US PAINTINGS SKETCHES DRAWINGS TO BE PUBLISHED IN LIFE AND PRESENTED TO WEST POINT RANDOLPH FIELD BY THE AIR FORCE WILL MEET YOU IN SAN ANTONIO TO GET PROPER INTRODUCTIONS AND START WEEK AFTER NEXT IF YOU ARE INTERESTED . . .
DAN LONGWELL

To Eric Knight

San Patricio,
April 21, 1942

Dear Eric:

Dan Longwell has just left here bound back to New York after a weekend with us. We had a grand visit with him — wishing like hell, all of us that you and Jere could have been here. We spoke together often of you and your work — particularly of T.A.A.[1] which of course we all agree is the top product of the war — And of Sam Small[2] Dan is a great Smallian and quotes at length what Sam said to the King and what the King said (in Yorkshire) to Sam.

. . . Yesterday we paid the first 10% payment down on the School Section buying it as is specified by law from the State at public auction — No other bidders appeared and acting mutually for Gardner (who takes all the land north of the Río Ruidoso) and myself I bid the minimum price of $3.00 per acre for the range land and $25.00 per acre for the 28 acres of Crop land.

. . . Polo is out for the duration; I miss the sport like hell but it doesn't seem to make the slightest sense to be playing polo with the world in flames.

. . . Dan's plans for me are Arizona and Texas first — then later possibly an assignment to a Combat Zone to be one of those he calls the "Visual historians." The present assignment is "The Air Forces — Spring on the Desert 1942." Tucson as well as March Field are I believe, now bases for patrol planes that range far out to sea. I suppose I'll be back here in July or late June. Is there not some chance of a visit from you and Jere then? How about it?

Henriette I think must have told you about the [Alamogordo] frescoes. They are now finally completed and I'm exhausted — for a week I mean to rest and then roll up my sleeves for Dan's Job . . .

[1] *This Above All*, Eric Knight's novel of Britain at World War II, was written chiefly at Sentinel Ranch in 1939.

[2] Sam Small was Eric Knight's fictional character of *The Flying Yorkshireman*.

Longwell soon changed his mind about Peter's assignment, and instead of sending him as planned to patrol plane bases in Arizona and Texas, summoned him to New York in early May.

To Henriette Wyeth Hurd

The Waldorf-Astoria
New York
[May, 1942]

Dearest Henriette

All goes well with my job and I have learned a great many details since going to Washington — There seems to be no precedent thus far for my assignment[1] which means that Life is putting a great deal of confidence in me as a correspondent. I saw all the editors from Luce down and sat in on some conferences which were enlightening and helpful.

I am everywhere urged to be extremely secretive about my destination — All that should be said now is that I have been attached to the Army Air forces for a four to six month period nothing more so as to be certain not to violate "Security" which is a word on everyone's lips here.

Washington is terrific with no hotel space and swarms of uniforms everywhere. New York shows a traffic decrease already. There is universal "dim-out" every night and much evidence that people are in general taking the war seriously.

I arrived in New York at 6:00 P.M. on Tuesday, ran to the 'phone to call Dan and was just emerging from the phone booth in the Penn Station after being told he had gone to Washington where I was to follow him — when I heard a familiar voice say loudly — "hey, you son of a bitch." Here was Knight as amazed and delighted as I. We went to Washington together where I saw much of him in my three days there. More on this when we meet which should be soon Darling — I am so crazy to be back with you and tell you all that has gone on . . . With luck I should get the train out Monday night arriving in Roswell Thursday morning at 6 . . .

[1] Longwell had commissioned PH to make a pictorial record for *Life* of the men and activities of the Eighth Air Force.

Peter had only a week in which to prepare himself for his impending assignment. He rested, packed, said his goodbyes, and then—as he had once dreamed of doing, though in quite a different role—he went off to war.

To Henriette Wyeth Hurd

Sun. May 24th [1942
The Carlton Hotel,
Washington, D.C.]

. . . I'm going to do my very damndest to see & feel and record the best I can, all that goes on from now on. Only by doing a bang-up fine job of this can I vindicate the ache of being separated from you . . .

[Journal]
—*Diario*

Washington Monday
May 25th [1942]

This strange, attenuated atmosphere of Washington in war time. Crowds everywhere in a hurrying rush — The signs indicating Air raid shelters in all the big buildings — soldiers everywhere guarding the estuary of the Potomac, the important buildings the bridges. All this against the background of new summer. The eternal cycle of nature is a constant source of reassurance to me now. For however great the upheaval by man — nature's procession of seasons continues —

Today I called on Maj Richardson of G_2[1] again received my correspondent's card — and authorization for the first of three Typhus shots — The inoculation over I went back to Maj McIntosh's in the foreign liaison section where I met through him, Colonel Heard — also of G_2 — a most enthusiastic and interesting man — one of the Army Heards whom I've known of since W.P. days. We talked of his work which is G_2 in Latin America — he is the father of all this work I learn from Ken McIntosh. We talked of many things of painting (he knew my work) of genealogy — which he says is all one family — the Hurds and the Heards. The Heards came he says from the Hyords of Norman

France and he has even traced the French side of the family from the 8th Century. The Hurd spelling, he says came later — in the 17th century here in America where the copying of records and illiterate people combined to have this result. Colonel Heard gave me his card and I was urged to write him from my destination with the 8th Air Force and to let him know my plans with [a] view to being commissioned as an officer in his department of Military Intelligence.

. . . At three I talked by 'phone with Col C. H. Welch [then] reported immediately to General Duncan who is to command the 8th Air Force. It was suggested that I receive a commission to facilitate my work with the Air Corps to allow me to [have] access to more experience with the Force. This I agreed to and the result was that I am to report to Col Welch tomorrow.

[1] The Military Intelligence Section, from which PH had to obtain accreditation and clearance to serve as a war correspondent for *Life*.

To Henriette Wyeth Hurd
Hotel Carlton Wash. D.C.
Thursday May 28, 1942

. . . We've been having a big time about whether I should be commissioned in the Air Forces or not — The general and his staff are all for it but Life frowns at the idea saying that by going into the Army I am sure to lose some autonomy even tho I gain in knowledge and entré with the Service. Meanwhile an entirely different branch of the service has been after me — and I am virtually promised a major's Commission with them. This outfit is the G_2 branch of General Headquarters — meaning they are the Military Intelligence service and would use me (*us!*) in Latin America. I'm much interested in this of course and plan to do something about it when I return. I met the head of this, Colonel Townshend Heard, and we clicked immediately.

The hotel is so crowded; I am living in first one room then another — Two days in Capra's[1] room while he was away now in Eric's[2] while he is away for the week-end. My own departure is so uncertain, so imminent that I must stay put here until I hear further . . .

[1] Frank Capra, the noted American film director.
[2] Eric Knight was then a captain in the Army Information Branch of the War Department.

To Henriette Wyeth Hurd

Sunday [May 31, 1942
Fort Dix, New Jersey[1]]

. . . Things are happening fast now and I am at Fort Dix — which is an embarkation center *for ENGLAND!* What the hell? I don't know just what to do; I have been assigned to the 8th Air Force and that's where we're headed now. My job is to get Life on the 'phone (today is Sunday therefore no chance now,) and see if they want me there — So secretive has everyone been that right up till yesterday I had no idea we weren't all bound for Australia.

So here I am in this big dreadful ugly camp full of the clamor and excitement of the thousands of men preparing to sail. Morale seems top and much esprit-de-corps manifest throughout the Air Corps. There is a sea of officers occasionally someone I know or someone who knows my name (which always surprises me). Among the men in one group the Hdqtrs. Squadron is Major Mellon who married Betty Woods' sister. Laurence Stallings[2] is in the outfit and I have got acquainted with him — seems like a fine person.

Dan is away on a trip[3] and I have no idea how to reach him to tell him what has befallen his ideas for sending me to Australia. I'll call Wilson Hicks at Life tomorrow and try to figure out what to do.

This is the most terrific melée of trucks and men I've ever seen! A long caravan has just gone by the barrack where I'm sitting writing this — the motors backfiring like cannon. Everywhere men are packing clothing guns pistols ammunition. What a job to move some 18000 men with all they'll need for a modern campaign.

Sometimes I feel I'm the wrong man for this job for instead of thinking "how brave how Splendid —" I simply have a sinking feeling of, "God what a vast waste of effort, materiel and men!"

. . . I have had to buy a trunk locker so Reg's bag may be

sent back. Thank him and explain will you Bini. I've been issued steel helmet [drawing of helmet] this type, gas mask, pistol, bed roll, musette bag (a sort of simplified knapsack) canteen ammunition clips & first aid pack so need more space for this — also much woolen underwear and a pair of heavy shoes.

By the way — someone said letters written to us abroad should be written on one side only so that in case the censor snips out a word on one side nothing will be lost on the other. Next morning — Monday.

It is a grey chilly morning and already 6:30 the jeeps and Scoutcars and big ten-wheel trucks are rolling in front of this B.O.Q. (bachelor officers' quarters). I feel in the officers and men neither a great elation nor a downcast feeling — a sort of solemn "we've got a job to get done" attitude. The soldier that delivered my luggage here replied to my thanks (he had been assigned to me all afternoon with a big truck to help me get the equipment I am to need) "O.K. sir, maybe I'll be seein' you in Tokyo." This is about the closest I've heard to a wisecracking attitude yet.

I still wonder what Life wants me to do — I must try to trace Longwell to find out. If you don't hear again for some time this will indicate they have told me to stay with the 8th . . .

[1] Fort Dix was headquarters for the 8th Air Force.
[2] American playwright and coauthor with Maxwell Anderson of *What Price Glory?*
[3] Longwell was inspecting military training camps throughout the country.

To Henriette Wyeth Hurd

Kent, Conn.

Sunday [June 7, 1942]

. . . on Wednesday evening [I] entrained with the troops bound for the troop-ship. We reached her at 4:00 A.M. after interminable waits long marches with full equipment plus hand luggage — (about 100 lbs in my case). Well, — we got to the Cunard docks and there a trap awaited me — The Cunard people refused to let me aboard because I am a civilian! I waited around till six and then headed out to call Dan. Everything at

the dock is done with terrific secrecy and hundreds of military police guard the docks. Dan's apartment didn't answer so I took a cab to the Penn Station where I checked my hundred lbs of luggage (& weapons) and ran around to Life's offices to await the arrival of the men I thought could help me. By nine thirty they arrived and such a scurrying around you never saw! We rushed to get a new Visa on my passport while an office boy got my luggage and another (one of the editors) called Washington — Things began to buzz as you can imagine — But the ship was sailing at 11:00 A.M. Seconds ticked away at the British Consulate where I was waiting while down stairs a taxi loaded with my equipment waited.

At last I was at the Dock side and there was the great Queen Elizabeth in her all over grey war paint casting off her cables! But I was met by a young Lt. of Military Police who saluting said — "Verbal orders from the Secretary of War have come authorizing you to board the ship." This was an ironical piece of news. But I spied a brigadier general standing watching the huge ship being nosed out by a tug — Introducing myself to the General I told him my problem asking if we couldn't somehow catch the boat — possibly when she dropped her pilot. The general was grand, immediately he ordered a couple of soldiers to grab my luggage and accompanied by a couple of M.P. soldiers we rushed down the long long dock to catch a Navy cutter. The plan formed on the spot was to grab the tug then hoist the luggage up by a rope while I would scramble after on a ladder. I got into the cutter with the General and his staff officer and we were about to shove off when a man intervened saying "You have no clearance from the British Embarkation Service and I refuse to allow you to board the ship." The general argued hotly a few minutes but meanwhile the boat slipped down the channel and our chance was gone!

Well, to boil down what happened later the war Dept. was furious that things had miscarried for us and one officer we called said he had spent the whole day working on a report of the affair to send to Washington — Meanwhile I am stuck here while 2 trunks and a bed roll are rolling over to England on the Q.E.!

The war Dept. has now promised me a priority on the Clipper[1] so that is how I am to go and I'll let you know as soon as I know when.

Now I am with Dan and Mary on their Connecticut Farm a hundred miles from N.Y. (They got back Friday morning). They are being extremely nice to me and I am glad to be here in this quiet and beautiful spot in the Berkshires to collect myself again after the interminable time at Fort Dix.

. . . I am naturally anxious to be at my job this early waiting stage is hard to endure. I am so anxious to do them a fine job something new in intimate documentary painting then to fly back to you. I think of you so much these days vividly and completely visualized sometimes I see you in your yellow dirndl sometimes (standing looking at me the way you do!) wearing the pink and black and white striped skirt (made over from the dress) and again the blue checked dress (gingham?) Anyhow my visualizing mechanism whatever it is has been good lately and I have remembered intimately so many things that have happened during the past few weeks when we were together. For one reason it may be better that I'm not going to Australia for from England the trip to and from should take much less time and consequently I should be finished and back sooner . . .

[1] A four-engine aircraft equipped to land only on water.

To Henriette Wyeth Hurd
Thursday —
June 11, 1942 [The River Club
New York]

. . . Washington is hopping mad about my being barred from the *Queen Elizabeth* which is a scant recompense for the discomfort of all this waiting around! Full reports have been demanded and the blame is being fixed — (on the right person too, I'm glad to know). Meanwhile — Col. Dupuy of Military Intelligence in Washington has a high priority for me on the Clipper for Foynes so in a matter of hours I expect to be off and away. I have boiled my luggage down to its essentials and expect to be

within the fifty-five pound limit in spite of my soldier's field equipment.

The high-up people here and at Dix whom I have talked with seem to think we are really delivering now — at least beginning and possibly the hump of our road toward Victory is in sight ahead — several months ahead of us — now. But I have a horrible sinking feeling at this inevitable destruction . . .

To Henriette Wyeth Hurd
Wednesday [June 17, 1942
New York]

Dearest Henriette —

Here I am still! Twice the Clipper has been postponed and now the time appears to be Thursday night at midnight — *Quién Sabe* I've never done so much waiting around before. If only you could be here, I keep saying. And when Dan returned, after my trouble over the Queen Elizabeth his first plan was to have you come up here to stay until I departed — then the people in Washington sent word that I must keep myself in complete readiness with no more than 24 hour notice for departure for Foynes. So we of course gave that plan up.

. . . I had dinner again last night with the Longwells who really are wonderfully kind to me — also present was Tom Lea[1] who is off to the Pacific to be with the Navy. Tom also is to become an accredited correspondent. Both "Life" & he got enormous response from his recently printed pictures of the North Atlantic Patrol —

. . . Since I'm to be here another day or so I have resolved to go and find out about the Butler painting of mine see what kind of shape it's in & c. and if possible retouch it and varnish it for them — I found Andy's[2] name in the 'phone book.

. . . No news from Eric — He of course thinks I have gone over long ago — I wish they'd do something about Paul.[3] If he could *go* there and camp on their doorstep they'd really take him on —

. . . I talked to Washington the other day and found that my Physical examination had come through O.K. . .

[1] See PH to Henriette Wyeth Hurd, May 14, 1937, note 2.
[2] Andrew Wyeth was living in New York City.
[3] Paul Horgan was still in New Mexico, awaiting word on a possible commission in the Army Information Branch.

To Henriette Wyeth Hurd
Friday,
June 19th — [1942
New York]

. . . By God — another delay. #5 now. *Asi es la vida.*[1]

I am so damned anxious to be on the job — get going so I can look forward actively to my return — thinking of returning before the job is even begun seems sort of silly.

. . . The prospect of another 24 hours here doesn't charm me at all but actually time passes surprisingly fast. I still haven't called any old friends except the Butlers (which was business,) but friends of friends of Dan's have asked me to go to Red Bank over this week-end — Nice of them but I haven't the least interest —

I am practicing drawing (quick notes) with pen and a marvelous little watercolor box with 18 colours about 3½ inches long made by Winsor Newton and called *le Bijou*. It is a fine addition and now with my pen and a little spit — I'm fully equipped . . .

[1] Such is life.

[Journal]
On the Clipper Sunday
June 21st [1942]

The excitement of leaving by Clipper is something to experience for the first time.[1] All the maze of detail: tickets — weighing-in as for a horse-race, baggage cheques immigration censorship inspectors, medical (I could qualify to run a pest house, I think for my Card states I have now been immunized for typhus, typhoid, paratyphoid, Yellow Fever, cholera, Smallpox and tetanus!) All these preparations take an hour and at last — at 1:00 A.M. we walk out of the rotunda at La Guardia Airport

and as we approach the long floating Gangplank I see the Clipper for the first time. It looks like an enormous grey sea gull resting on the water, with the Stars and stripes incongruously painted on its sides.

. . . We are twenty-six — we passengers of flight 101 and as I glance about I see that they are all men except for one American red cross nurse and a boy of fourteen — In the rotunda of the Airport someone apparently unknown to me recognized me and called me by name. I guess I looked blank enough until he told me he was Bill Stephenson a classmate at West Point. The passenger list is not published and I'm amazed at his memory for it is nineteen years since we have seen one another.

. . . I hope somehow by some means this journal will recreate for me again this amazing sensation of being aloft in a clipper bound for England in Wartime. If I succeed it will be by between-the-lines inferences and ~~understatement~~ a few broad charcoal lines for there is so much going through my mind at this time that I could never begin to set it down here . . .

[1]"Previous to this, my one experience in an aircraft was a short flight in a single engine plane when Henriette and I were invited by a neighbor in Chadds Ford to view our farmhouse from the air" (autobiography).

[Journal]
On the Pan American
Clipper
June 22nd. [1942]

. . . we are flying into the dawn and as we break from the clouds a clear lemon yellow sky is ahead and behind us the dim blue of that part of the sky still in the earth's shadow. As we fly on, the swirling clouds of our own level become more and more scattered until finally there are no more. But now a secondary level of clouds far below us becomes a crazy upside-down sky — a vast sheet of cirrus cloud with its regular, mackerel pattern seen from above. The drone of the four engines and this strange vista produce a curious state of mind. And though I am perfectly aware that it is not a dream I am experiencing, yet it is more like an ether dream than anything else I have ever known — and I

keep suddenly remembering details from the operating room in Wilmington where I was taken the time the two horses rolled on me in the hunting field . . .

[Journal]
[London]
June 23rd [1942]

. . . shortly before seven this morning we suddenly emerged [from the clouds] — and there below us lay Ireland — white surf breaking at her shore line and beyond the greenest Earth imaginable. All the clichés of the Emerald Isle occurred to me as I saw this land glide below us; the neat cottages of white-washed stone clear and sharp in the morning air against the dark green of the earth — There were clean fields, all flanked by hedgerows or stone walls, and suddenly coming into view the Estuary of the River Shannon. Here we dropped in altitude and after banking sharply came down to a graceful landing in the calm water. This was Foynes in County Limerick.[1]

My first impressions of Ireland were most exciting ones and I immediately got the feeling that this was *tierra simpática*. We came ashore in a launch run by 2 blue-eyed ruddy-cheeked men with the lilting accent of Southern Ireland. Ashore we were taken through the Customs quickly and escorted to the inn where breakfast awaited us —

. . . I recalled Mrs. [Cornelius] Sullivan's saying to me several times "You should go to Ireland, you could paint it." After breakfast we were put into a big bus and at a 20 m.p.h. pace we drove for 2 hours and a half along dirt roads through a lovely landscape: Square white Stone houses with blocked coining — (called cabins I'm told) often with thatched roofs and blooming gardens — But it isn't the pure picturesqueness that I find intriguing; Rather a feeling of complete simplicity of living — of a life keyed closely to the Earth; of clean farmland and shining white houses — There were everywhere horses — people going to town with big milk cans in two wheel carts drawn by Cobby ponies or Burros. The country looked like grand foxhunting — and in the entire trip I saw only two short stretches of wire

fence. Mostly the fences, such as were not of stone, were hedges. We went through Limerick, a clean town with neat cobbled streets, crossed the Shannon and on past many an ancient ruin to the Airport where we mounted a large camouflaged transport plane with painted-over windows. There for two hours it felt like being Jonah in the belly of a roaring aerial whale. We landed at Bristol airport were checked through immigration, health, customs, etc and where I, like a dope, gave up my diary together with all letters of introduction, letters from H. etc. merely because they the censors asked for them. I was then asked for my address in London, the censors saying "they'll be along in a few days." My baggage — field kit & c. was not even opened!

The Bristol *ambiente* was very different: gone was the lovely Irish landscape with its air of tranquility & easy going. In the Bus (glassed-in but completely without a top) we drove 20 minutes or so from the camouflaged airport which was a heavily guarded and sinister appearing place to the town of Bristol where I saw for the first time the gaps where houses had been bombed out of existence — But there was no rubble about and aside from these gutted houses and a couple of Barrage Balloons there were no other signs of the Blitz. The London train was a special one — and the ride was a smooth one, about two hours and a half without stop through a landscape that might have been Pennsylvania. The train was in London at 6:30 and meanwhile Major Lamond the Royal Marine officer — now on Intelligence duty and I had become very friendly and he called the war office (where he has an office) to get reservations for us overnight at some hotel naming a list beginning with Claridges — no rooms available so we climbed into a cab and were off to the Ford, a funny old Victorian hotel peopled entirely by living drawings by PONT, the artist in Punch. But the bed was good and I had a marvelous sound sleep after dinner and a walk with Lamond down through Piccadilly, Trafalgar Square past Whitehall past a lovely old Wren church which I recognized from photos and which had been badly bombed — on to Westminster which by a lingering northern twilight and British war daylight saving time we reached as Big Ben boomed out Eleven oclock. After a glimpse of the Thames we returned through the blackout down

silent streets past infinite rows of houses from which not a glim-
mer of light came. The few taxis were all taken and we made our
way slowly along the avenues of ghost houses, lighted by the
waning glimmer of twilight, back to the Ford where a lady-clerk
— a Victorian ghost she was admitted us and bade us good night.

[1] The entire flight, including stops in Newfoundland and the Azores, took twenty
hours and forty minutes.

[Journal]

London Wednesday June 26, [1942]

Today the Major and I moved out of our incredible hotel room
over to a flat he knew of, where we have separate rooms [1] — very
comfortable and a much more likely place to do some work — I
want to begin soon — doing first a painting from the window of
the clipper for which I made a pen & ink note on the spot.

First thing today was a visit to Time [magazine] offices [2]
where I met Bill Lang — I liked him immediately and we found
much to talk about. On to European Theater of Operations
Headquarters where I found Captain Brown awaiting me with a
Captain's commission in the Army [3] all complete even to serial
number and letter assigning me to active duty with the 8th Air
Force beginning on June 28! It was difficult to know what to do
for I want to be actually of the Army (since I wear its uniform —
I partially resent the anomaly of my position). But my first duty
is to get the best job possible done for Life — Then, after that
what I feel best inside myself. But to do properly and efficiently
this job I need complete autonomy and freedom to move about
as I want. This I'm afraid would be curtailed by a Captain's Com-
mission and I see clearly Dan's point in urging against it . . .

[1] The flat was located in the Mayfair District at 36 Clarges Street.
[2] The London offices of Time & Life were located at Dean House, not far from
PH's flat.
[3] Although PH was soon sworn in as an army captain, Longwell had the commis-
sion rescinded. "Dan (wisely) refused me the right to accept the captaincy offered me
. . . since to do so here would prevent my returning to finish the job" (PH to Paul
Horgan, November 10, 1942). As an accredited war correspondent for *Life*, PH was of-
ficially a civilian, yet held all the prerogatives of an army captain.

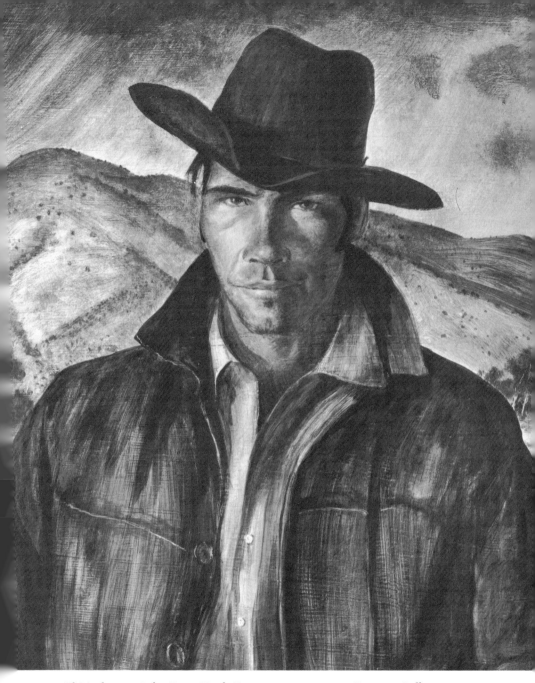

El Mocho, 1936, by Peter Hurd. Egg tempera on gesso. *Courtesy Collection of The Art Institute of Chicago*.

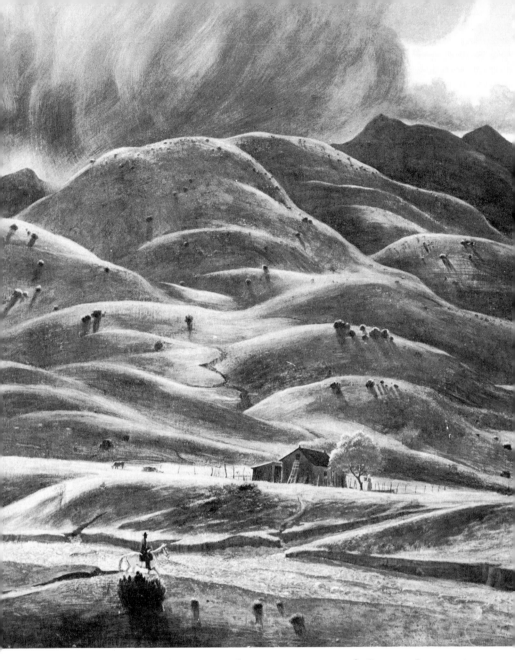

Dry River, 1938, by Peter Hurd. Egg tempera on panel. *Courtesy Permanent Collection, Roswell Museum and Art Center.*

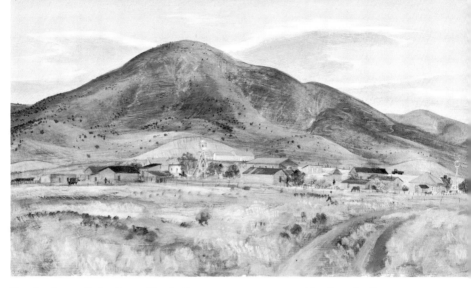

Rancheria, 1938, by Peter Hurd. Egg tempera on composition board. *Courtesy Metropolitan Museum of Art, George A. Hearn Fund, 1939.*

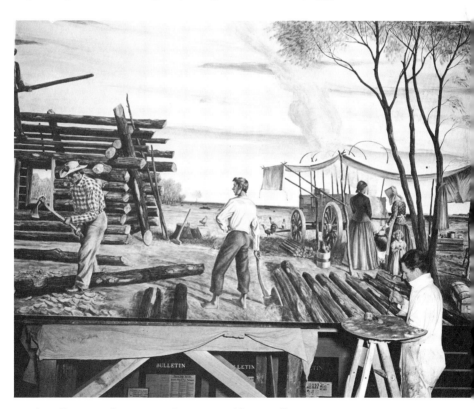

North wall, Post Office Terminal Annex Building, Dallas, Texas, 1940. *Courtesy Henriette Wyeth Hurd.*

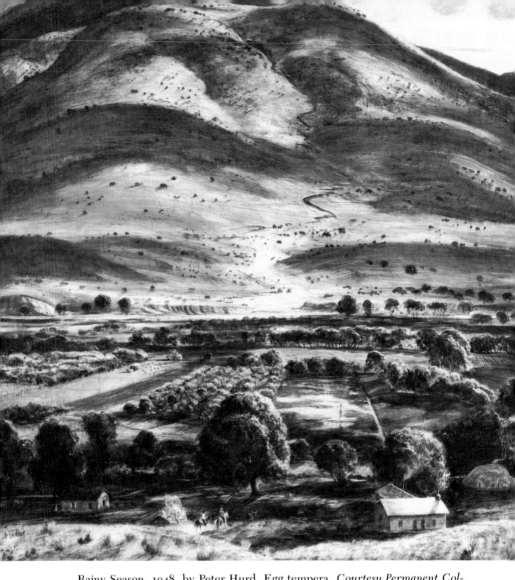

Rainy Season, 1948, by Peter Hurd. Egg tempera. *Courtesy Permanent Collection, Roswell Museum and Art Center.*

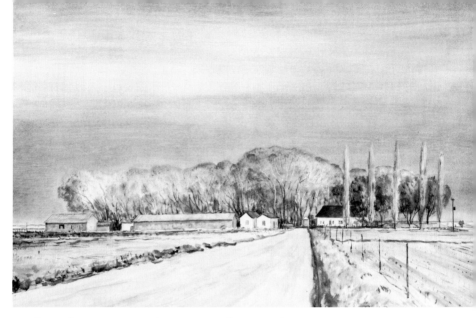

Ranch on the Pecos, 1949, by Peter Hurd. Watercolor on paper. *Courtesy Permanent Collection, Roswell Museum and Art Center.*

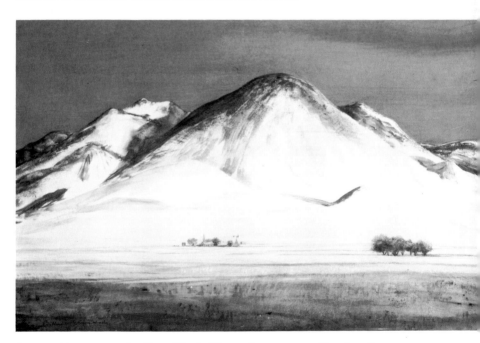

Primera Nieve, 1951, by Peter Hurd. Watercolor on paper. *Courtesy Permanent Collection, Roswell Museum and Art Center.*

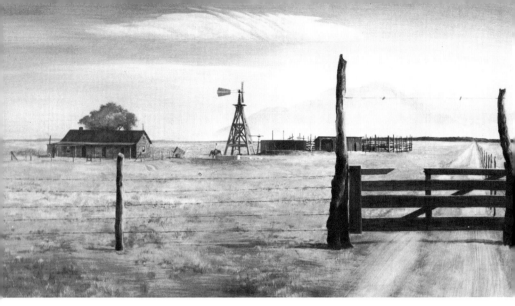

The Gate and Beyond, 1953, by Peter Hurd. Egg tempera. *Courtesy Permanent Collection, Roswell Museum and Art Center.*

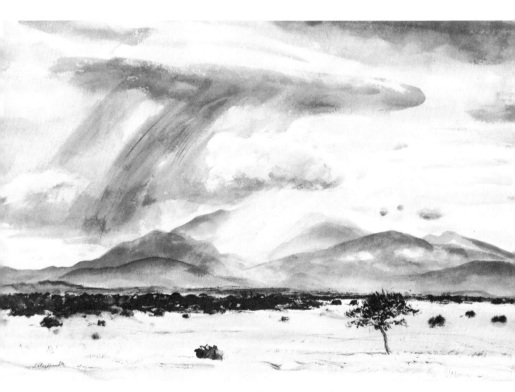

El Aguacero, 1959, by Peter Hurd. Pen and ink wash on paper. *Courtesy Permanent Collection, Roswell Museum and Art Center.*

Portrait of Felix Herrera, about 1957, by Peter Hurd. Egg tempera on masonite. *Private collection.*

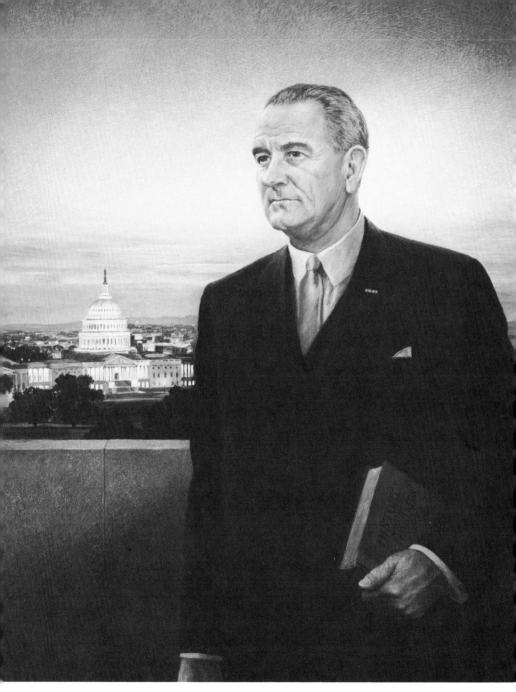

Portrait of Lyndon Johnson, 1967, by Peter Hurd. Egg tempera on panel. *Courtesy National Portrait Gallery, Smithsonian Institution, Washington, D.C.; gift of the artist.*

[Journal]
London, Thursday June 27, [1942]
. . . This afternoon at three I attended a press Conference
with Maj General Eisenhower newly arrived Commanding of-
ficer of American Troops in the European Theater of Opera-
tions. He was friendly, direct and without any pompousness or
woof, woof, qualities — aged I'd say 48–52 . . .

[Journal]
London June 28th [1942]
Today I began work in watercolour — developing the note I
made from the clipper window — and — so far the results are no
good. For one thing the gesso boards I got at Winsor Newtons
are a sort of chalk coated illustration board [with] none of the
properties of real gesso panel. But that isn't W.N.'s fault. Rather
when I think of London — of England it is amazing that they
have anything at all left to sell . . .

To Henriette Wyeth Hurd
July 1st — [1942
London]
. . . I'm working hard at watercolours now and they seem to
be getting better — So far no air force paintings mostly only pic-
tures of the London streets and its interesting skyline.
I've met some interesting people here and my reception
has certainly been a warm one with people all wanting to show
me the City the countryside the unchanging villages — Do you
know what I want to do when I return is to read a lot of Dickens
with you. Can't we do this this coming winter? You know how I
love to have you read to me — now amazingly in its vividness
the background of Dickens (I had supper last night in the pub in
Wapping called "The Prospect of Whitby," which under a dif-
ferent name he describes in "Our Mutual Friend)." But there is
Dickensian England everywhere! Also Turner (The Thames) —
and Constable in the mid-country landscape and Whistler at
Battersea Bridge — suddenly the enormous validity of Whistler

is apparent, walking on the Thames embankment in the long, long summer twilight of this country I see the sights that stirred him to paint Battersea Bridge and the nocturne series. And Keats — (I saw his house in Hampstead the other day) and Shakespeare & Chaucer.

I wish I could tell you my impressions of wartime London but for reasons of security I suppose I better wait until I return for this[1] — I am going to a Coastal Command (R.A.F.) station next week and hope to get some good drawings there — meanwhile I'm learning more about watercolour (how I've wished I'd watched Andy more!) and now feel less like an Old maid in swimming for the first time which is about the way it was when I began with it.

London is terribly expensive and as soon as I'm finished here I'd like to go to live with our A.F. troops somewhere either here or in Ireland. I think I'd get more done that way. I am to make a broadcast (part of an Amer-Brit prog[ram] called "Let's get acquainted") on B.B.C. on the 17th and this coming Sunday I go to the country with one of the directors to work out the program[2] . . .

[1] All mail was of course subject to censorship.

[2] PH had been asked to talk about differences in light and landscape between England and New Mexico. "The broadcast went smoothly and I found I had very little nervousness in front of the microphone," he wrote in his journal on July 17. "I talked five minutes . . . But it was all pretty unimportant, what I said — and makes me wish I could have said things more pertinent to our international equation."

[Journal]

July 3rd [1942
London]

More watercolouring today with somewhat better results. Encouragement is in the wind now and each attempt seems an improvement over its predecessor. In the afternoon late, I went down to Rathbone place (just around the corner from Dean House), to buy some more supplies from Winsor & Newton's. The atmosphere there is fantastic! completely Dickensian and as removed from the London of Blitzed buildings ack-ack batteries, barrage balloons as any place could be. The only apparent dif-

ference there is in where the war has cut down their supplies —
Watercolours are increasingly hard to get. Paper comes only in
small pads now and there was only one small drawing board in
the whole store, that for sale at 15 shillings! Later to Mary
Welsh's[1] where I met a statistician & economist named Abrams;
and a girl named Annette Millar whose life now consists of work-
ing nine to ten hours in a war factory. Her husband is a prisoner
of the Italians — her father a retired Maj or General. Also at
Mary's was Morrow Krum a major in the U.S. Public Relations
Dept. Krum was formerly on the N.Y. Times, I think. His job
among others is to write the history of the 8th Air Force.

 After dinner I made a drawing of the blitzed area in Belgra-
via —, a borough between Chelsea and Mayfair. In the wan twi-
light the gap between the buildings that remained appeared
even more awesome than ordinarily[2] . . .

[1] Mary Welsh, an American journalist, later married Ernest Hemingway.

[2] "New trick for keeping from attracting attention while drawing a bombed build-
ing," PH wrote in his journal on July 20. "(Some make terrific and strange patterns and
are wonderfully paintable). I stand in front of a large plate glass window and draw the
building in reflection — to the passerby I am copying prices or making notes on what is
being displayed in the window."

[Journal]
July 4th [1942
London]

 Today I went with Annette to Hampton Court — beginning
the journey by tube to Richmond Park a great green park over-
grown and dark with huge trees which of course made me think
of W. H. Hudson. From there by boat — one of those funny
little steamers I first saw on the way from Bristol, we went to
Hampton Court and with Annette as a guide — we went through
the grounds and into the great buildings which were so much a
part of Tudor England. Annette had an infected finger caused
from a piece of copper wire burning it in the factory so she could
not work. After tea in the garden of "The Mitre" we took the
return boat which was crowded with children — It was fun to
see kids again — and hear their voices, after nearly two weeks in
childless London! Annette and the lady with whom she lives had

invited me home for dinner — The latter is the Honorable Brenda Willert who also works in a War Factory — Her husband is a wing Commander in the R.A.F.

This proved to be a lively evening: also present was John Strachey,[1] a tall, very dark, sardonic young man in the Uniform of the R.A.F. In his high-pitched voice and veddy English-pedantic accents (which you felt he adopted to accent his sardonic humor) he was amusing and witty — We sat in the garden drinking and chattering together and I think I'd only talked with him ten minutes when he spoke of having a first wife in America — Oh yes I know her I said — whereupon followed an amusing discussion of Esther A.[2] and their friends — never really malicious it seemed to me, but damn funny often! Dinner was marvelously good — cooked by the gals themselves we had wine and steaks.

[1] British writer and editor of *Socialist Review*.
[2] Esther Murphy Arthur, President Chester A. Arthur's granddaughter-in-law.

To Henriette Wyeth Hurd

London, July 10th — '42

Dearest Bini —

At last I seem to be breaking through the entanglement of officialdom and I'm about to be sent to an Air Station where I hope to make some interesting records — write me c/o Time & Life Ltd., Dean House Dean St. London W 1. *Air Mail* — —
Better buy some light paper like this, Darling —

Having spent a lot of time getting accreditation from the British[1] and splashing around in Watercolor I'm now ready and anxious to take off — to leave London behind; Strange place this is — with its great gaping scars from the blitzes — its legions of soldiers on the streets in every sort of Uniform possible among all the united nations thousands of women in uniform too —

. . . Everything moves here on the assumption that it will be a long war. No one hopes for Victory under two years. For the most part the people are grim and damn resolute, they are determined to win — The Terrible attacks gave them a solidar-

ity and fire baptism that makes them know they can stand anything now.

This is a funny place I'm living in and though in the very heart of Mayfair it is a district patrolled by enormous squalling cats and terrific Tarts who lurk everywhere in shadowy buildings during the long twilight. But I am very well treated here and no one minds watercolour splashes all over the bathroom!

July 14th — Bastille day — the Free French threw a big parade reviewed by mon géneral de Gaulle. I walked out past where it was — pausing to watch the guard mounted at Buckingham palace which is right across the park from where I am living — Back home after lunch alone in a Pub — meat pie, ginger beer and dessert — called "a sweet." The food is completely adequate and no one is starving or so far as I can see, anywhere near it. Beer is diluted and not very tasty. I drink nothing here at all and have felt very well. One thing I do is take vitamin tablets regularly each morning — I've settled down to a pretty damn austere life now — after gadding about with the Time & Life crowd and with George Lamond and his friends the first ten days. I'm terribly conscious of the seriousness of my mission and of its *potential* importance as a valuable document. I really feel this. I want to collect data just as fast and completely as I can then return to evaluate and recreate it back in New Mexico. God how terrifically remote that seems now! I'm so grateful for the fine photos I brought along of you and the kids. They are more a solace now than I ever knew they could be. I keep wishing I had a locket made of that lovely snapshot of you, taken in Pennsylvania — bending over Ann Carol — the head from this in Silver would be about the one thing I'd most like to have now — the one thing *feasible. Later*: At last your letter of the 19th of June! I'm wondering how mine to you have got through — and the two cables one via Dan on my arrival here one direct to you on the 28th. It was marvelous Darling to hear from you I could hardly believe my ears when they told me at T[ime] & L[ife] this morning that a letter was there for me. I rushed down there grabbed the letter and a vacant office slammed the door and flung myself into the letter.

I'm so glad to have all the details Bini even tho they're now nearly a month old. I'm interested in hearing the progress of the garden. Sounds fine, the corn and chile and beans all coming on well. And about the Still Life. It sounds most exciting I know exactly the lilac coloured flower you painted — it has silvery foliage hasn't it? And the yellow quatre-foil too, I remember. I try to visualize the painting — It is large I assume — the colour sounds wonderful — the denim the straw — the book etc. I don't know anyone living that can outdo you at this!

Please Bini don't worry about me. I am safe and sound and longing to get back to you there. Nothing seems so important, I'm afraid, just now as getting my work finished and back to the tranquility of San Patricio, away from cities with sandbagged buildings, wire entanglements and pill boxes . . .

[1] In order to have the right to draw and paint in the United Kingdom, PH had to obtain the necessary credentials from the British Ministry of Information.

To Henriette Wyeth Hurd
July 20, 1942
[Remington Aerodrome][1]

. . . Military censorship prevents my telling you much about myself just now but I can say I am at last out of London, in a beautiful countryside and I hope about to begin work. Also I'm not in the least danger . . .

[1] "Henceforth for the sake of this diary, I shall call this station Remington which is not its name but for these purposes will serve and not violate security" (journal, July 21, 1942).

[Journal]
⟨July 27, 1942
Remington⟩

. . . This aerodrome consists of approximately 2500 acres and is all on the estate of the Duke of B[uccleuch]. The land has been requisitioned for the duration by the Air Ministry . . . On the south side of the intersection of the runways and bordering on the perimeter track is the square control tower, called watch

tower by the R.A.F. It is connected to a series of nissen huts where Intelligence — weather signals and operations have their offices . . . Just across the perimeter track to the south stands a series of buildings housing Squadron operations repair shops Armament shops etc; being a satellite Remington relies on her parent station Staffmere[1] for repair jobs requiring hangars.

. . . Bicycles are issued to all personnel by the R.A.F. Transport office and are indispensable on this big field . . . [Mine] is old and a little wobbly but has an interesting gadget on the horizontal bar a small gear shift — a big help in pulling up the steep hill that lies between the flying line — or airfield proper and my quarters.

To the north of the landing field lies a dense wood of oak and ash trees which mark the boundary of the requisitioned land. — Beyond this, out of sight, stands the Duke's big stone house. To the East is the bomb dump, a series of underground warehouses for the bombs, incendiaries, flares, and machine gun ammunition — This area is protected by pill boxes and a wide entanglement of barbed wire and is heavily guarded at all times.

. . . The open-topped brick-walled warehouses — are completely and adroitly hidden from above by camouflage nets. Seen from the sides — from the surrounding ground the area looks like only a pleasant grove of trees in pasture land. For this entire air station is a curious mixture of military and farming operations. The grass lands between the runways and within the perimeter track is all planted in meadow grass and here haymaking goes on while the big four engine bombers taxi about and roar up and down the runways sometimes only a few feet from sulky rakes or hay wains with their crews of farmers and Land Girls.

To the south of the flying line the land slopes upward and here, widely dispersed and hidden in densely wooded groves, are the quarters of the troops. The enlisted men's quarters are the pre-fabricated Nissen hut type — the officers having slightly more elaborate hutments with rooms for single or double occupancy. On this side of the field are also located the infirmary, the motor pool, the combined officers' club and mess and the en-

listed men's mess of the two squadrons — The motor pool is an open air park under enormous oaks and completely invisible, at least in summer, from even low-flying planes. All buildings are camouflaged in large, irregularly mottled masses in three variations of tan and drab green. Even the hay fields and runways themselves are camouflaged by crews of black overalled civilian workers who by means of a hand pump and crude sprayer mounted on a cart spread a heavy viscous paint, tarry black and having a foul smell. The paint is also spread on the concrete roads to make them merge with the trees when seen from above. The paint is laid on the grass & earth and runways in irregular strips which, viewed from an airplane become a continuation of the intricate pattern of hedge bounded fields thus belying the roads and runways they cross.

Finally — west of us lies the tiny village of Remington from which the field gets its name. It consists of a couple of rows of grey stone houses with stone or thatch roofs and abuts the main entrance of the field . . .

[1] PH's code name for the parent air station.

To Henriette Wyeth Hurd

July 20, 1942

[Remington Aerodrome]

. . . I wish I could tell you more of this place — but I'm sure it would be unwise to do so. It is a lovely landscape hereabouts much like John Constable's paintings — One impression I constantly get is how much Pennsylvania — parts of it — have imitated England — Around Moorestown for instance — might be a dozen places I've seen. The main difference is in the barns & houses — Here the barns are low & sprawling — a little like haciendas in Mexico and the houses are brick instead of whitewashed stone.

. . . Later: At last I am getting down to work drawing and painting aircraft. The practice period in London helped me much, technically, so I am relieved and really happy about the way things are going. I'm learning the types of aircraft and of

course can't help picking up the airmen's jargon. The recognition & classification of aircraft is a big study in which sight, hearing and every instinct all play an important part . . .

[Journal]
July 24th [1942
Remington Aerodrome]
. . . This morning a big Stirling Bomber circled the field and asked to land; I was in the control tower and watched the procedure of changing the reading on the ground — long colored boards that spelled out signals. The green beam from the Aldis lamp aimed thru a telescopic sight and the great ship came gliding in over the tree tops and down the long runway. I went out and made a drawing in water colours (my *first* of an aircraft) which took about 20 minutes and turned out quite well . . .

[Journal]
July 26th [1942
Remington Aerodrome]
This morning I spent drawing the new Fortresses — enormous crafts these B 17-E's with their twelve machine guns covering every possible angle of approach . . . I have been assigned a jeep, complete with driver[1] and am now free to move about at will in this widely dispersed station.
. . . *Later*: I am just back from the greatest experience I have had here so far! — At noon I was invited by one of the American Pilots, Lt. Doswell, to fly with his crew on a cross country reconnaissance mission. — I was ready on time with my dispatch bag kit of colours and was assigned a parachute by the copilot Lt. Snyder. With Capt Clark from Oregon, an intelligence officer, I sat up in the nose of the great Flying Fortress while she roared down the runway and became air-borne. We circled the field and picked up the other ships which were to fly in formation with us and set a southerly course.
The first thing consisted of gaining altitude — around 3,000

feet — and practicing evasive action which is something like swinging a polo pony around a field, turning and twisting him every way — except that this was done at 200 miles an hour and included up and down as well as right and left [maneuvers] — During this the Bombardier swiveled his gun — one of the .50 cal machine guns, from side to side getting one of our sister ships in the sights for practice. I made a drawing of the Navigator Lt. Dunn, plotting our course — poring over the maps with scale rulers & protractor. After about ten or fifteen minutes — (it seemed like more) the evasive action practice stopped and we flew in true "V" formation along the first leg of our projected 600 mile journey. The weather was sunny (strange as hell to see the sun!) and big cumuli were forming on one side of us, so the air was bumpy as hell. At this point the Bombardier gave me his seat up in the nose and during the trip I made five small, watercolour drawings of the landscape — as seen through the glassed-in nose. It was a great experience and fortunately neither the extreme roughness nor an occasional feeling of nausea kept me from working hard . . .

[1] Holding the assimilated rank of captain, PH, like all officers, was not permitted to drive a military vehicle. His driver, Private Jenkins, "a lean gangling solider," came from West Texas (journal, undated).

[Journal]
Remington Aerodrome
Thursday July 30th [1942]

. . . German raiders came over again last night and the Tannoy (a broadcasting system, named after the manufacturing Company, which communicates information & orders from the control tower to all points on the aerodrome) blared in a deep-Georgia drawl — "'Tintion to broadcast — 'tintion to broadcast eva'body proceed to shelters at once — air raid warning, red, repeat — . . ."

I hopped out of bed and scrambled into breeches and boots and throwing my trench coat around me clumped out with a sketch book — just in case there is light enough. The whole hut was astir then and sleepy-eyed men walked out in all degrees of

undress. The Sirens in K — began to howl, a horrible double-noted sound they make — the rain had stopped falling but the Grass and bushes outside were drenched with water — there was no sign of light anywhere and orders are strict against breaking out even a tiny black-out torch during an alert. We waited for a minute or so outside the door to let our eyes become accustomed to the dim light before going as ordered, to the bomb shelter a few feet away.

Suddenly there was the sound of Air Craft — flying fairly low and seeming to be coming from all directions — practically simultaneously the local anti Aircraft batteries went into action with a roar like a thunderclap. The heavens to the north were studded momentarily with the winking red flashes of shrapnel bursts. A moment later great clusters of searchlights came on three — nine, eleven — three more another — until at last I counted twenty-one, all on at once. They continued fingering the cloud ceiling nervously never pausing long on one place. The ack-ack kept up its pounding and I ran inside for my tin hat and a blanket for my legs — shivering, from excitement as much as cold, I found my way in the increasing light of the searchlight batteries over to a huge camouflaged water tower near our hut. I had previously spotted this as a good place from which to watch an air raid — and noted that there was a ladder. In a few minutes I was seated on a cross girder about forty feet above the ground.

Planes continued to roar overhead and once I saw a fighter plane dimly silhouetted against the clouds get on the tail of a bomber. I heard its machine guns fire in short bursts as they disappeared over the woods to the east. All this time I was scratching furiously with my drawing pen and a piece of charcoal — the light of the searchlights — a sort of dull universal glow made only the roughest kind of drawing possible. The planes passed over after an interval of six or eight minutes but still the searchlights kept flicking back and forth, criss crossing in constantly changing patterns.

At length my fingers became so stiff with cold that I couldn't draw and suddenly I thought — what a hell of a fix I'll be in if the searchlights go off completely and leave me to find my way down in the dark — So I clambered down, dragging my wet R.A.F.

blanket behind me reaching the ground just as, some singly and some in groups, the searchlights went off. I stumbled back to Hut Five holding my drawings under my trenchcoat and after falling over a bicycle that lay in the way I got inside. The "all-clear" had just sounded over the Tannoy and almost everyone from our hut had gathered in Oley Olsen's room — Someone pulled out a bottle of real Kentucky Bourbon — and poured me a drink . . .

To Henriette Wyeth Hurd

England, July [28?] 1942

. . . I think I am getting the job done for "Life." I can't give you the details that I'd like to now, but I am keeping a pretty complete diary. At last I am in a place where things are happening! The place and people are *simpatico* and as I said I think I'm getting on well — At least I'm off to a fair start!

. . . I am enclosing some lines — which I hope will attest to my thinking often and longingly of you — my Love! . . .

To Henriette

Now do you only come in fleeting dream
As when my worn spirit in sudden flight
Down the dim, starry corridor of night,
Rushes to meet you by our Crystal stream.
Pale as a yucca flower I see your face:
Beyond those thresholds of the wanton night
You sway, uncertain in that trembling light.
And I, fearful to speak or to embrace
You, lest somehow this magic be undone,
Walk slowly through the shadowed grove with you,
To the candle-lighted walls from whence we view
The revelers and see the dance begun.
 The voices fade, suddenly you have gone
 I wake with pain, knowing I am alone.[1]

[1] "I cannot tell you, my very dear, what the letter with the sonnet did for me, or to me," Henriette replied. "I was in such a hideous state of mind . . . and to get that utterly

tender & very dear avowal of your love for me was an extraordinarily poignant experi-
ence. I sat & *wept*; which no doubt you hate to hear of — tears I mean — but these were
of sheer happiness & [illegible] & comfort & devotion. How I love & long for you"
(Henriette Wyeth Hurd to PH, [August, 1942]).

[Journal]

Remington Aerodrome
Friday July 31st [1942]

At last the long expected men of the 2nd echelon of these
two squadrons' combat crews came in — Late this afternoon
with a golden light illuminating the field as the sun, clear and
brilliant streamed through big ragged openings in the clouds,
the flight of twelve B-17s was seen coming in from the north at
about 3500 feet. Slowly, in perfect formation they circled the
field then, one by one, they dropped down the long east-west
runway and glided to a stop. It was a wonderful effect — the sun
gleaming on the glass noses of the Fortresses with their pale
snake bellies — they seemed like some crazy anomaly of the ani-
mal world part reptile part insect. Pvt Jenkins and I sat in our
jeep while I made drawings of them as they taxied off the strip
and were led away by Engineering officers in jeeps to their
newly prepared dispersal points on the rim of the North woods.
Will Hadden and Carl Schultz came up just as I was finishing
and said "how about giving us a ride in your jeep over to the
dispersals" — So the three of us, with Pvt Jenkins driving, went
over to meet the newcomers —

. . . As we made the rounds of the dispersal points I jotted
down the names of the Bombers we passed: "War Eagle" —
"Hell's Kitchen," "Leapin' Lena" "Hanger Queen" "Birming-
ham Blitzkrieg," this Fortress is piloted by Lt. Borders a big vol-
uble Alabaman apparently enormously popular with the squad-
ron as I had heard yarns about him before he arrived. "You're a
Life Photographer, Hurd?" he said to me — I explained that I
was a painter — "Hey that's good — how's about doin' me and
the 'Chief'[1] here," indicating his co-pilot who with the other
crewmen I'd just been introduced to — "sittin' in the old Bir-
min'ham Blitzkrieg." "Sure," I said "if you'll sit for me." One of
my assignments from Longwell was to do a group of portraits

of combat crew members. Borders with his long, mobile face would be effective to do and I hope he meant what he said.

. . . One thing is obvious as I grow to know the men in these 2 squadrons here at Remington — there is no such thing as a typical man among them — they are of many sorts and from a variety of backgrounds . . .

[1] "Chief" and PH became roommates. His name is not mentioned in the journal. PH described him as "a good and tolerant roommate for my [painting] implements extend past the half way mark well into his domain in our narrow, longish room" (journal, August 20, 1942).

To Henriette Wyeth Hurd

England
July 31st, 1942

. . . The men here are an extraordinarily fine lot. The officers — there are about 100 I'd say are all young. I think only a couple older than I mostly all in their early twenties.

. . . Mostly they are from the South these youngsters, with I think a predominance from Texas. They are above all eager and enthusiastic but I feel they are also realists! Among the older officers is Fred Bryant a man whom I know we have both met somewhere. He was until lately a lawyer in New York. He knows dozens of people we know: Jack & Anna [Biggs], Mary Rupert, Bill R. Ran. Holliday — Libby Baker Clem & Marcia etc etc. I can't say where we met but we agree we *have* somewhere — Anyhow he is a good guy and we have lots of fun reminiscing at mess time. He is an intelligence officer which is a highly important and fairly difficult job — Also in military intelligence here and now a good pal of mine is Mike Phipps, the international Polo player. He is a damn nice person — You would like him! ~~Modest as hell.~~ Strangely he is a portrait painter. You'd be surprised at the things he can do — Really good! He studied under Bridgman and other well known painters. He has a farm in Middleberg, and knows Reg and Meg [Bishop].

I'm writing this at two in the afternoon. You are still in bed — or just getting up for it is now 7:00 in San Patricio — It is a relatively clear day and I'm sitting outside my barrack leaning

against the wall. Across in front of me lies the lush English fox
hunting country — The foreground and middle distance altered
somewhat by the ugly necessities of War. God, after five weeks
here — I find it hard to conceive of peace again. There is liter-
ally everywhere some reminder of war. A herd of Guernseys
grazes peacefully near me here. Ten, I count grazing the meadow
hay and switching their tails. But just beyond them is visible
the right wing of a mighty bomber — and beyond and in the
same vista other bombers. There is scarcely a single minute dur-
ing the day & night when at least one air craft is not audible in
the air.

. . . This Sun is marvelous — It's tempered by the constant
mists of England but still a great benison — Big sprawly cumu-
lus clouds hide it occasionally and the distance is blurred by the
milky haze of a July day in Chadds Ford. But unlike Chadds
Ford where a N.W. wind often brings a "Maine day" with com-
pact floating cumuli in a field of turquoise. England — at least
this part apparently never knows such a day.

. . . I'm anxious to hear what has become of Paul Horgan —
How the play was received and how he is — what he's in. Is he
commissioned?[1] How strange Roswell will seem without him
there.

Darling Bini — I adore you — You and *only* You. You know,
thinking on what I've seen — the past few weeks endears me
more and more to you and to the memories of our life together. I
feel completely welded to you —

<div align="right">ever your,
Peter.</div>

Kiss Ann Carol & Peter for me —

[1] After serving as a civilian consultant to the secretary of war, Paul Horgan was
commissioned a captain AUS in the Army Information Branch at the Pentagon. His play,
"Yours, A. Lincoln," was presented in two performances by the Experimental Theater in
New York in July, 1942.

[Journal]

Monday August 3rd [1942
Remington Aerodrome]

Today I spent drawing a Fortress and in the evening around five thirty I was attracted by the sound of machine gun firing from a plane. My blouse was being pressed by an R.A.F. orderly so I decided to wait for it before going to investigate — when I reached the road I found a gathering of soldiers near the officers' mess all gazing at a column of smoke rising from a point about a mile away. They soon told me excitedly that they'd seen two Spitfires get on a Jerry plane and shoot it down in flames — "It just now happened," a corporal said — "look there comes one of the Spits now" — Sure enough there came the Spitfire and as we watched he executed a slow roll only a few feet above the burning enemy plane. This I knew was an R.A.F. custom — Fighters of the Interceptor groups when time allowed always executed this evolution over their fallen enemies. It is called the Victory Roll.

Suddenly the wind bore us the sound of Air Raid sirens from the nearby town of W[ellingborough][1] and it became obvious that the low cloud cover had allowed the sneak raiders to get very close while still unobserved. I was just wishing for a means to get closer to the fallen ship when I spotted pvt. Jenkins in the crowd — I think he read my thoughts for before I could express them he ran off toward the motor pool saying "I'll be with you in a minute." I had my dispatch kit with me with pen and ink and paper and off we rolled to the potato field where the Dornier was still burning far too hotly to approach. Also there was the danger that all the bombs had not been jettisoned before the crash and might still be unexploded — Swiftly I drew — the great pall of black smoke the still erect tail of the plane the victorious Spitfire . . .

[1] The actual name of the small village to the west of the air station.

[Journal]

Remington Air Field

Tuesday Aug 4th 1942

Today — promptly at 10:30 A.M. Capt. Smith, (the adjutant,) and I drove up in a jeep to the police station at X. — and found our Inspector waiting to conduct us to the wreck.

[The Dornier] had buried itself eight feet or more into the ground and a crew of four soldiers were uncovering what was left of machine and men. To one side of the pit while they were digging was a horrible pile of remnants of the four humans who were in the Dornier. I was astonished to see what had so lately been a German flyer now a huge chunk of barbecue meat. But it was a sort of *intellectual* process to associate this cooked meat with a man's body until suddenly I saw a human foot, naked and cut from the rest of the man — Then came a stab of real horror and the *emotional* comprehension! Identification tags — Hauptman Fleischer — Luftwaffe number — etc had been found and an Iron Cross with wreath, which one of them wore. Bits of curling twisted metal blackened by camouflage paint strewed the ground — only a big metal casting and the vertical tail fin with its evil swastika emblem remained intact. I scratched at a drawing of this with the figures of R.A.F. soldiers and Intelligence officers disinterring the wreckage then went back to the Station, sad and disturbed . . .

[Journal]

Remington Wednesday — Aug 5th [1942]

Today Pvt Jenkins and I went in a jeep to the scene of the bombing of the Dornier — we went first to the Police superintendent's office where I showed my credentials and was given permission to make a drawing; then on to the town square, which was roped off while A.R.P. men in dusty grey coveralls and tin hats poked through the ruins and rubble, occasionally forming a line to pass along pieces of furniture and belongings they had come upon. — A line of tables and a chair stood forlornly on the side-walk in front of the ruined houses. A single

800 Kilo bomb from the Dornier had landed there and the entire block had been practically demolished — fortunately, the Casualties list was still low: seven killed were all that had been found and it wasn't expected that more than one or two others would be uncovered as the work of clearing the rubble away progressed. I sat in the jeep and made a wash drawing while two middle-aged English ladies looked on and chattered about horses & foxhunting a contrast certainly to the ~~mise-en-seène!~~ subject of my drawing. But conversation had veered to horses after they enquired from what part of the States I came. They were both enthusiastic fox Hunters and were soon talking the same horse gossip I have often heard in Chester County Pennsylvania.

The ladies departed after a time and as I drew the ruined houses with the pathetic reminders of their home-life piled up outside on the walk — the blasted walls and shattered glass everywhere the slow methodical A.R.P. crew digging and poking in the ruins I was engulfed by a wave of deep pity for our race — the entire Race — not just the English or the Allies but the entire human race who have inherited the earth and who are for all their progress and civilization still so barbarous. I thought of the horrible blackened unrecognizable bodies of the Germans who were the agents of this destruction and again the surge of pity for us humans. Like some of the lower animals — like the Lemmings or the salmon, we seem intent on some ritual of meaningless self-destruction. And I thought again of a talk I had with [Witter] Bynner in New Mexico last May and how his conception of war seems even truer now that I am more face to face with it: His idea being that War is a plague that sweeps our race [every] so often — a sort of spiritual disease with hideous physical expression. A tremendous racial purging perhaps finally linked to the mystic pattern of Life as is the Lemming's self-destruction.

. . . It is now nearly a month that I've been here and in many ways it seems like much longer: Under the stress of war time, friendships mature quickly there is no standoffishness and I find myself amazed to know that a month ago I hadn't even met Will Hadden or Tom Borders or Chief — or any of this gang that

I have suddenly become so deeply involved with. Fortunately they have accepted me completely as one of themselves and we all talk freely. They drop in on me while I am at work in my quarters — help me with their criticisms of technical details of the airplanes. Sometimes we go out together around the aerodrome; at such times as these they reveal a maturity and character which is far ahead of their years.

It is late at night as I write this, Chief and several others from this hut are on leave. I nurse the fire along in the little coal stove — a gusty west wind intrudes past the window frames and flaps the tightly battened black-out curtains. This has been a long, full emotionally disturbing day. I hope the drawing made at the bombing is worth a damn! I wonder how it will look to me when the impact of the tragedy is not so immediate in my mind.

[Journal]
Remington — Aug 7th [1942]
Work on the drawing of planes continues and now finally I am getting an idea of an interesting sequence for "Life" — beginning with a group of portraits. Already a number of the men have agreed to sit for me. I feel encouraged and stimulated — no longer appalled at the prospect of completing a journalistic assignment — it is resolving itself into a continuation of the sort of thing, in a broad sense that has interested me always — Trying to project and retain some certain moment in time — a concern with light and weather — landscape — the individual character of people — It is all here — I'm amused that I originally planned a 10 day stop here — Already I have been here twice that long — My original plan of going around from one station to another in the various commands Bomber, Fighter, Service-Air-Ground Support — of the 8th Air Force has begun to seem impractical. There are easily enough things, — things really interesting to me to draw and paint here on this field to keep me occupied a year. In fact there are so many subjects now occurring to me to be done that I must begin editing so as to weed out all but the most interesting.

Locally, here among the men my drawings such as are complete enough to be readable are enthusiastically received.

The men here are practically invariably interested in what I am working at or at least curious about it. I always have to make a routine explanation that there is no way to tell now what Life will choose to publish among my work — But they seem intrigued at the thought of a chance — however remote of being pictured in "the Life." Yesterday while sitting drawing a plane and its crew on its dispersal point I overheard Jenkins talking in his low slow voice to some of the mechanics who were looking over some brief drawings — quick notes in pen and wash.

"He don't even try to fix them up perfect here, he takes 'em back to his quarters and slicks 'em up to where they look all right." I hope he is right: In an attempt to cover all important details of things I may need later I use a system of words and sketches in the hope that the combination — with the help of this journal, will vividly recreate these fleeting incidents and their settings for me again when I need them . . .

To Eric Knight

August 11, 1942
[Remington Aerodrome]

. . . I keep thinking of you here — not only because this country makes me think of you or because I occasionally meet someone who reminds me of you but also because we were together on the California jaunt[1] which was a runner-up for this expedition — Here at an Air Station in England as you can imagine things are much more attenuated and at a hell of a different nervous pitch than Camp Elliot before the war! But there are similarities too —

I'm crazy about the country though — and the people who couldn't be more friendly and hospitable to me. I think my only complaint after nearly two months, aside of course from the very real one of missing H. the kids, the rancho is that I feel the lack of sun. But visually how marvelous England is! — So far I haven't seen Yorkshire although I have been over nearly all of the Island except the far northern portion. I'm wondering how

you are — How your gut is progressing and whether or not you made the Army physical exams. And whether Paul has joined the Special Services group[2] — And Jere how is she? has her job in Washington materialized?[3]

Henriette writes that all goes well at San Patricio and that she and the children are fine — but in spite of these reassuring letters I have never before felt so cut off from them! I wish I could tell you of the adventures I've been having here, but this will have to keep until we meet — which if all goes well and I get my work done should be in October or November. I'm really working and in the interest of getting the job done have been living in absolute austerity. (This, Knight, may be a large pill for thee to swallow, for in the past I have I admit been ever ready for a prowl!) So picture me in my lovely barrack cell, up with the sun and to bed with its setting, cycling or jeeping about the air field to make my notes and recordings seldom leaving except in the glass nose of a bomber! . . .

[1] A reference to PH's trip to San Diego in April, 1941, when he painted machine gun practice at Camp Elliot on assignment from *Life* magazine (see PH to Mr. and Mrs. Daniel Longwell, [May 4, 1941]).

[2] See PH to Henriette Wyeth Hurd, July 31, 1942, note 1.

[3] First a civilian consultant to the secretary of war in Washington, D.C., Jere Knight was later a major in the Women's Army Corps.

[Journal]

Remington Aerodrome
August 11th — [1942]

. . . At 2:00 P M today the [combat] crews were summoned twelve of them and as wearing various random pieces of heavy high altitude apparel they filed into the briefing room [and] the first phase of America's First heavy bombardment raid over Europe had begun.[1]

. . . The crews emerged from the briefing room, climbed into the waiting trucks and rode to the waiting Fortresses — Secretly working by dimmed flashlights and blackout torches the Armament section had spent most of the night hanging big yellow demolition bombs in the bellies of the bombers. I bi-

cycled over to the dispersal point of No 23 — Dowswell's ship, the "Yankee Doodle." It was with this crew that I have up to now made most of my flights[2] —

. . . We who have stayed behind begin what is to seem an interminable wait. Radio Telephone silence is maintained so as to give the enemy no inkling of our intentions. So no one on the field can get any news of their progress. We sit about near the control tower in little groups talking in a half-hearted way — "Sweating them out," as the army saying goes. By half an hour before E.T.A. (estimated time of arrival, in this case three hours after the take off) there are some forty of us gathered on top of the control tower anxiously watching for the returning planes.

. . . Now as they approach the field and lose altitude we see they are going to buzz the field for they come in in elements of three, landing gear retracted and sweep the length of the aerodrome only a few feet off the ground. Then circling the field again they begin to peel off and land one by one on the same runway where it seems to us so long a time ago that they took off.

Later: The above was rewritten from snatches of notes made in my sketchbook as the events were happening — now a few hours after the safe return of the twelve fortresses I have come back from supper and will continue

The weather has been perfect all day — from the pictorial point of view and now a little after five-thirty as the planes come in to land the low sun slants across the airfield making the turf a lovely mossy green. The men drift out slowly across the grass between the Control tower and the runway to cheer and wave at the returning bombers, from each figure stems a long splinter of cool shadow on the warm green. In the foreground are some of the visiting planes and the crash truck with its attendant in his ponderous man-from-Mars fire-fighting suit of asbestos — near this truck with its fire extinguishing chemicals are the ambulances — RAF Vans and petrol trucks and a half a dozen American canvas-topped trucks. I note all this down for it seems to me this is obviously an historic occasion and for this reason as well as because of its beauty sky landscape the intricate pattern of the foreground, something I must try to paint later . . .

[1] The planned target: the Nazi railway yards in Rouen, Occupied France.

[2] PH participated in a number of missions aboard Flying Fortresses, but never in combat.

To Henriette Wyeth Hurd

England.

August 23, 1942

. . . I want you to know that I have been involved (as spectator!) in a terrifically absorbing drama these past few weeks in which high courage and Death have played their parts. The tension and excitement in the air here has risen since my arrival a month ago until now it is at top pitch. The result is that I am rather out of focus on all else at the moment. I can tell you so little and yet I am so anxious to tell it all to you. To tell you what marvelous, cool courage I have seen shown by our men and to share with you the tumult of feelings that I have had — Somehow, someway I feel that I am a *better* much wiser person through having *merely seen* these events unfold. I make no pretense to having had any part in any of them. But (fortunately for my work) I am accepted as "one of them" here and consequently my feelings are more involved, and the events mount in tenseness proportionately. —

But all through this, always in the back of my mind, as the curtain goes up and the play opens and progresses, are you and the children and San Patricio and sunlight and orchards and flowers; all the components of our life there. And this is all part of the total picture. For me — (and I am not even one of the minor players) the tension, the suspense and the overtones of magnificent courage and skill and hazard are before me and through my intimate acquaintance with the men of these combat crews, their destiny becomes interwoven with mine. Everything is attenuated; I have known them only a short time but in that intense time, the prologue to battle, we have grown to know one another to the fullest. Barriers of reserve and inhibition drop when the game is played for keeps and Death is the referee.

But as I've said, always in the background of my thoughts

are you and Peter and Ann Carol — our experiences together — all the sweet components of our past life together. And as these thoughts are in my mind so are parallel ones in the minds of these youngsters who comprise the combat crews. Most of these men have young wives in America some have children — and in their minds too are similar memories and yearnings and hopes. Darling, it is really a most searing experience, being here at this time. My words must fall far short of the mark in saying what I would like to say; partly because I am not allowed to speak fully and probably partly because if this ban of security were not on I even then could not in words duplicate for you the tumult of emotions that I am having.

Saturday: — Since beginning this letter I have gone with Frank Wycherley (who is a civilian and the agent for the estate on which the Air Station is located) to his old home in another part of England — Here in a lovely country redolent of A. E. Housman — I am spending the week-end with Frank and his nice mother who is a widow living alone in her farmhouse. They have a sweet place here and but for the steady drone of planes overhead (on practice maneuvers) there is a wonderfully welcome air of peace. From a high headland behind the farm where I walked with F. today I looked out across a wide landscape flanked in the distance by the welsh mountains — This place is very near the welsh border and people talk with the sing-song speech of Wales. The deep woodlands are beech trees and ash and chestnuts — with mossy rocks and with bracken and fern, growing everywhere. The headlands are covered with gorse and heather — the latter in bloom at this season. It really is lovely stuff heather — this is the first I've ever seen — at least in such profusion — The colour reminds me of verbena.

Well as you see I am again in a peaceful place and more glad to be for a time out of the strain and tensity of the Aerodrome this part of the letter is a contrast to the first I know — By God I needed a change! Things have been so exciting that I have put off going to London repeatedly — Mike Phipps and I were to go last week but the expedition never came off. I must go now soon (I've been only once since coming to this Air Station over a month ago) principally to cable Dan and ask for a number of de-

cisions from him; also to pick up the supplies that I had shipped
— easel, gesso panels & C.

It is so good to be here for a little while: The wheat is in
sheaves everywhere and old farmers in smocks are gathering it
in to thresh it. I wish you could hear them talk: "Ay, — an' 'e told
oi 'twouldn't do." I keep thinking of a painting by Howard Pyle
of a farmer in front of his thatched cottage at dusk with the full
moon rising beyond. I can't remember what it was illustrating
now — something in an old Century or Harpers or Scribners —
Anyhow the *feeling*, the intuitive knowledge of this country was
so right. Funny how I should think of this picture so much here.
I hadn't thought of it for years. Of course when I am up here
away from the clamour of war, being in England is like a second
visit — I keep seeing it through the eyes of the writers through
Chaucer, Shakespeare, Dickens, Hardy, and Kenneth Grahame
and J. M. Barrie. These last two whom you've read aloud to me
from; Remember? God, how I remember now and with what in-
tensive yearnings!

Goodbye for now my Sweet Henriette I love you dearly and
constantly — Somehow in the past weeks I have grown to see a
little more clearly what a human being is and to what he may
aspire. Kiss *Güera*[1] and Peter for me — Tell Ann C. I'll write
her a letter — a special one soon. For now there is no more room
in this envelope if it is to go by Air Mail.

<div style="text-align:right">

ever your
Peter

</div>

[1] Blondie: PH's nickname for Ann Carol.

[Journal]
<div style="text-align:right">Remington, Aug 23rd [1942]</div>

Last Wednesday the Anti Aircraft regiment came in — one
battery apiece for Remington and the surrounding airfields with
a headquarters here. The C.O. is a colonel; a short stocky man
with a red face and about my own age who looked somehow fa-
miliar when I first saw him and when I learned at mess that his
name was Henn, time rolled back twenty-one years and I saw

him again as "Mr. Henn sir," a fellow plebe in my very goaty[1] math section at West Point. We have spent some pleasant times reminiscing about our scattered classmates and about things that happened in our cadet days. —

In the local battery are eleven Mexican boys from the border Country of Texas. None, so far as I can learn, from New Mexico — but I have met one Corporal Jesus Cortéz who is a whiz on the guitar — Elsewhere in this journal I may have mentioned that one of my orders from Dan Longwell when given this assignment to go with the 8th A.F. was to take along my guitar.

I have had lots of occasions to be glad I did so — particularly since meeting Cortéz — and Dallas' waist Gunner Sergeant Moreno from San Antonio whom I made a drawing of the other day. These boys frequently come into my quarters and play and sing in the evenings and tonight we had the biggest song fest of all — Mike and Orville Chatt and Art Clark — all the intelligence section and as many random flying officers as could fit into our room — Chief and Tom sat on the bed beating time with pokers. It is fun to hear Spanish again. Chief says — "Hurd what all are you, anyhow? A war correspondent an artist a farmer a guitar picker and now it turns out you're a damn Spick — I'll declare!"

This Sunday has been quiet up to the late howling of Mexican songs. A gentle rain most of the day and late in the afternoon a weather front is moving back revealing a low clear applegreen sky over the sparkling landscape — It occurs to me this will be a good background for [Captain W. W.] Foster's portrait — Foozy[2] is first on the list and sometimes it looks as though I might have to have the portrait customers queue up, there are so many of them applying!

[1] See PH to Mrs. Harold Hurd, June 27, 1922, note 6.
[2] Foster's nickname.

[Journal]

Remington Sept — 9th [1942]

Sudden orders have come that these squadrons are again to leave Remington and move to ~~Staffmere~~ the parent station.[1] Everyone I have talked to here, is depressed and at a loss to understand the move, for apparently Staffmere has not yet enough dispersal revetments ready to accommodate the entire Group of 4 squadrons. I plan to stay here a week then on there with them to keep up the portrait series painting these men whom I'm getting to know so well. The idea of going on to other commands now seems impractical. At each station there would be the ice to break all over again; a probational period of explaining my somewhat anomalous position as a painter–war correspondent. Moreover I have no urge to go to any other place or group just now. I could spend many months here painting the things that are fairly clamoring to be done. The trouble with writing about them is that I roll into bed by dusk.[2] I wish I were staying here too for the reason that I have already selected a lot of landscape subjects to do as background details in portraits or for the series of paintings for Life which will follow the portfolio of portraits.

Mike's plans for bicycle polo must be put aside now for at Staffmere there will be no place for it; all the runways over there are in almost constant use — moreover with a gymnasium and organized athletics on the post there isn't so much need. I'm a little sorry though, if for no other reason than that I had an amusing drawing cooked up of this sporting event.

[1] The two air stations were nine miles apart by air.
[2] At that time of year, around ten o'clock.

[Journal]

Remington Sept 11th [1942]

The squadrons have gone to Staffmere and except for the R.A.F. station force and the U.S.A.[nti] A.[ircraft] battery and possibly 20 air corps enlisted soldiers, the place is deserted — A strange peace has come over the station as if the war were over and as the field is closed to traffic the only aircraft here now are

three Fortresses which stand forlornly on their dispersals await-
ing spare parts to allow them to join the others at Staffmere. Left
behind to be in charge of them are the twenty enlisted men who
pass the time by blazing away with machine guns at all hours.
This is the only discordant note on the scene of peace that I see
through my window.[1]

 . . . It is cloudy and cold and I have spent the day preparing
the new panels. This work goes well now so far as I can tell but
the materials are completely different than any I have used be-
fore[2] so the result can't really be judged yet . . .

[1] PH had moved to a spare room in the R.A.F. officers' hut down near the flying
line. His new room was close to the kitchen, which gave him access to running water for
cleaning his palette, brushes, and paint dishes and to a stove for heating glue to make
coatings for his gesso panels.

[2] PH had to use for his tempera portraits dried egg powder from the officers' mess
rather than fresh eggs, which were not available.

[Journal]

Remington Sept 12th [1942]

 To Staffmere today with Col. Henn and the battery Com-
mander of Remington, Capt Dunstan — We Dunstan and I had
also met before, it turned out as we talked — back in Wilming-
ton Delaware when I was studying under Wyeth.

 Purpose of my going was a presentation of medals (called in
England an "investiture") to the men from our group. Capt Or-
ville Chatt had called me earlier in the week suggesting that I be
there in case I might find something to paint. This sort of formal
ceremony isn't the type of thing that appeals to me to paint[1] but
largely because Orville went to the trouble to ask me — telling
[me] where and when I could find him, I went. The ride over
was pleasant — we reminisced more — all three of us and some-
how it was reassuring and satisfying to find someone related to
that now remote curiously detached life at home . . .

[1] It belongs "more to the province of photography than painting" (journal, Sep-
tember 12, 1942).

[Journal]
8th Ground-Air Support Command Hq.
September 16th [1942]
To London yesterday with Foster's portrait to have it photographed. I also took along the two drawings invited by the United Artists' Exhibition and delivered these to Dorland Hall where they are to be shown. Out to the framers to choose a dozen watercolours from a hundred or so by Anthony Gross, British War office artist — this at the request of Fortune [magazine] who will reproduce them in an article on the Middle East. I liked many and found it hard on this account to keep my selection down to the required dozen. Later I met with officials of British Ministry of Information notably the Honorable Mr. Palmer who outlined for me the whole set-up whereby British War artists operate, their arrangements with the Government, disposition of their work, etc. on which I made notes to take back to the War Department in Washington . . .

[Journal]
Staffmere Sept. 19, 1942
Spent the morning looking for a place in which to work. No buildings of any size here have windows that give to the north so the problem was a difficult one. There is no question that the work on portraits will go much better in a room with a north light. At last decided to use a room down on the flight line in Squadrons' operations offices. It is O.K. except for its cubby hole size. A sergeant has loaned me an electric heater — my model stand consists of a large flat chest full of books. So now with Tom [Borders] my next subject I am ready to start work[1] —
. . . I am painting Tom (a head and shoulders view) in his officer's coveralls — and wearing a cloth of parachute silk around his neck. His bare head is tilted back as he looks skyward. His pale skin and contrasting black hair are shown against an early morning sky. So far I am only in the groping stage.
. . . There is no farming going on on this aerodrome as at Remington. The atmosphere is less anomalous and I suppose more official. It is plain to see that Staffmere has infinite pictorial

possibilities. Remington already seems remote and I'm glad to be back with the squadrons.

Mike has just come in — asks why I don't paint here — where there would be more quiet less interruptions — But weighing the advantages and disadvantages I figure I'd be better off with a good steady light than in a poor one no matter what advantages of privacy — After all I've had a pretty severe schooling in painting in public in the course of painting frescoes in three Post offices and Federal Buildings. I've been gawked at stared at pointed to yelled at and variously coached and advised on these jobs. I reached a high degree of concentration on these jobs — developed an ability to tune my audience in or out at will — only thing that used to get me going was when one of my ~~audience~~ public would climb uninvited up on the scaffold.

[1] "Tom is a colorful guy . . . a good-hearted kid spontaneous and gay on the surface but with an undercurrent of ~~philosophy~~ thoughtfulness that denies this gaiety. Sometimes as I paint him, I think he looks much older than he is — then at times there appears the fated look I see often on these boys' faces: — the same expression that is on many of the youthful faces of the soldiers in Brady's "Photographic History of the Civil War" (journal, September 25, 1942). Lieutenant Borders was later reported missing in action following an operational flight.

[Journal]

Staffmere, Sept. 21, [1942]

Saturday a big party in the club, given by our two squadrons of the Group —

. . . Around nine thirty the ladies arrive in large R.A.F. buses & Vans — They are girls from neighboring towns and cities and they seem to enjoy these American binges which whatever can be said pro or con are certainly different from English Parties. When the party really hits its pace, around midnight I have noticed more than one look of bewildered wonderment on an English face. The bar is open and Coca Cola, Scotch — American Grapefruit Juice, and British beer flow freely. A party one night is a pretty certain sign that there will be no mission next day — So the lid is off.

. . . Music is from an orchestra organized on the post and has four or five good professional musicians among its nine men.

They call themselves the "—th JIVE BOMBERS" and proudly display this name on the bass drum. The party's success depends much on them and they know it and enter into the spirit of the occasion with much enthusiasm. As the party moves along their pace increases and they sound more and more like some fancy name band back in the States.

The ladies are all young — except for the two or three hostesses who are of a matronly age. Some are in the uniforms of W.A.A.F.S. W.R.E.N.S A.T.S. & F.A.N.Y.S the women's services of Britain — but for the most part they are in civilian evening dress. ~~Never noted for chic they wear~~ They dance variously and some laughingly try to keep up with the disjointed jerkings of an occasional jitterbug partner. The girls come mostly from the homes of merchants farmers and professional men. There are usually one or two who are the daughters of landed gentry. At the conclusion of the party there is a mad scramble in the blackout to find their proper bus and the girls and their escorts grope their way from bus to bus inquiring if it is the one they seek. The dining room and bar is a shambles and a weary but undaunted kitchen staff set about getting it in shape for mess at seven.

. . . Borders' portrait moves along well but he is a hell of a sitter — fidgets constantly also talks and sings songs which I don't mind at all, but he has no idea of holding his head in a given position more than thirty seconds running. Result is a need for a lot more effort and sharp perception on my part. I keep thinking of H. at home painting small children. I have seen her, brushes in hand chase them around the studio to glimpse some wanted detail of construction. I pretty nearly have to do this with Tom . . .

[Journal]
Rodmere Sun Sept 27. [1942]
. . . Lately I have had that curious feeling I remember so well from twenty years ago in West Point — A feeling of the great protective unit that the Army is — How being part of one unit as I have become a part of the 97th Bomber group here one

is caught and held by the spell of it — The organization becomes a haven, a place of almost womb-like security. So that I find myself dreading any change (except of course for the final one which moves me back to America.) — But it is a difficult thing to write of yet I feel most people here experience it one way or another. Such a spirit must have held the great clerical orders together in the middle ages. I remember so well the tremendous psychological effect of the decision to leave West Point. How the complete security and haven quality weighed heavily against my decision to resign. That it was only the deep conviction that I could never find myself as a painter while in West Point — that invaluable time was slipping away. How great a decision this was — or rather how deeply impressing it was on me is attested to by the fact that I have so repeatedly dreamed I was back there again — always in some peculiar circumstance — such as appearing at a formation in improper uniform or forgetting the proper execution of an evolution of close order drill.[1]

[1] PH concluded another version of this entry to read, "I have occasional long, vivid and disturbing dreams in which I am back in Cadet gray again to finish those two remaining years!"

To N. C. Wyeth

London October 22
1942

. . . My work here is about to be concluded — then the return and all the fight I can put out to guard against any let-down until the paintings, eight or ten of them, are completed from my notes and studies made here.[1] My adventures have been so varied and touched such extremes that I couldn't begin to tell you of them or even part of them yet. I feel I have never worked any harder — never any more interested or excited by my task. Often, in fact nearly always heretofore I've worked under much less strain and in relatively serene and comfortable surroundings.

. . . I've been over most of England and some of Ireland and more than ever am I grateful for the knowledge I got of England's tradition, much of it via you through Thomas Hardy. I've thought of you so very often over here for in spite of War's scars,

much that is fine and old remains untouched. The British people have been splendid — generous, hospitable, anxious to co-operate in every way they can to help us and to get the war "fit and won" as my [new] jeep driver, pvt. Haldom of Texas says.

. . . All in all, in spite of the mental anxiety and apprehension I have experienced, these three months of life on an operational air station have been curiously stimulating ones and I feel my own horizons of human understanding have widened and that the deeply moving events that have transpired about me have changed me and made me somehow a better man — made me more — I search for a word perhaps "sapient" is as close as I can come to what I mean. At any rate this experience has been vastly stimulating and in the way a great poem or a symphony may it has opened new vistas heretofore unknown to me.

. . . So far I am uncertain about my own future after delivering the finished paintings to Life. To go back in the army as a captain or major which of course I can do immediately is an idea that is tolerable only if I can in so doing feel that I am really *contributing* by making this sacrifice, a sacrifice on both Henriette's part and mine and my decision will come only after I talk with her. The idea of going in for glamour or pursuit of excitement is utterly repulsive to me our life in N. Mex wants for neither of these elements. But more than anything else I dread being one more little man in an officer's uniform running around with his head in his ass! God, we're over the quota in this type! But I better not get started on this subject —

Love to you all — Ma, Carolyn, Ann and John and of course my old pals Andy and Betsy.

<div align="right">As ever,
Pete</div>

[1]"Dan was so right when he insisted on my returning to N. Mex to evaluate my experiences and *complete the paintings*," PH wrote to Henriette on October 12. "Thus I feel I can get into them some interpretive quality — something definitely beyond mere reportorial realism."

To Paul Horgan

London
November 10, 1942

. . . My commission? well I'm in a deep fog about where I really stand. Dan (wisely) refused me the right to accept the captaincy offered me until after I returned since to do so here would prevent my returning to finish the job — Meanwhile I have a fine letter to General Stratomeyer[1] (sp?) from our C.O. at the Bomber Station recommending my project to his attention — Briefly this is it — that I be given a commission in the Army Air Corps — allowing me complete autonomy for six months at the end of which time I'll return with paintings and drawings to Washington which should be an interesting record of certain phases of the Air Corps' endeavor. Maybe he'll say no, — and in that case I'll go on elsewhere — wherever I can be of service but naturally this is my first choice. Don't you think this is a fine plan?

Of finished work here, aside from a few drawings in black & white I have completed nine portraits in egg tempera — It has been extremely difficult — I mean the conditions under which I was working — and on one occasion my subject — a navigator, wearer of the Purple Heart awarded for gallantry in another action, — failed to return from a mission — shot down over enemy territory. I had one more sitting promised from him but the portrait is to all appearances finished — a hell of a good boy — In this curious attenuated life on a bomber station deep-seated friendships spring up quickly — and although the shadow of death is constantly palpable — the actual fact is a hideous shock.

I long to see you again — So far I have no certain idea of when I'll leave — affairs in North Africa govern my destiny with respect to returning — In any case I hope it won't be long . . .

[1] In an October, 1942, letter to Major General George E. Stratemeyer, chief of the Air Staff, Colonel J. H. Atkinson of the 97th Bomber Group wrote of PH, ". . . whatever he does will be done to the best of his ability and done exceedingly well."

An Artist-Correspondent II

On November 25, 1942, Peter flew back to America aboard a trans-Atlantic clipper. He had been away from San Patricio for half a year, and, as can be expected, the reunion with his family was a joyous one. But almost immediately Peter began "to evaluate my experiences" in England. *Life* was planning to publish a feature story on "Hurd's Airmen" in a mid-winter issue, and Peter had to meet a deadline.

In his studio each morning, trying "to guard against any letdown," he painted backgrounds for the portraits of the Eighth Air Force flying men. Within a month he had completed the pictures and had also written a set of terse biographical sketches to accompany them.

To Worthen Paxton[1]
[Fragment of Draft]

December 20, '42
[San Patricio]

Dear Pax:

Herewith is the data on the seven portraits. I'm fairly sure I have all the information accurately. One thing I am hoping — both as a tribute to the other boys whose portraits I couldn't paint and for the sake of people here in the U.S. who have friends or relatives in the group, I'd like to name the group and Squadrons in the article. I think it would be too bad not to do so. I hope you will check with censorship and see if this is possible. The entire group is now in Africa and *I* can't see what the difference would be if we spoke of them by name as being in England last Summer. The censors in England made me erase all numbers from the portraits before leaving there but I think it is

worth trying. The units were the 414th and the 342nd Bombard-
ment Squadrons of the 97th Bombardment Group.

Now — sitting here in the Sun of New Mexico my experi-
ences with these boys seem remote in time as well as in dis-
tance. Already in the retrospect of a few weeks, they seem like a
band of legendary heroes although I know well they themselves
would be the first to scoff at such an idea. I feel I have seen how
a great movement like the Crusades could begin, how in a unity
of purpose and a deep dedication to its fulfillment men have
banded together in the historic past just as these men are.

So it is that they have the look of veterans, these youngsters
in their late teens and early twenties . . .

[1] Then the art editor at *Life* magazine.

To J. Frank Dobie

[January? 1943
San Patricio]

. . . Over in England I met several boys Pilots, Bombar-
diers, Navigators who had been at the University [of Texas] and
who of course knew you. We often spoke together of you.

I know exactly how you feel when you say you look into the
faces of these boys and are ashamed you are not doing more.
God! I've had that feeling a thousand times. What really grand
youngsters they are. This observation I am about to make isn't
intended to seem at all as a "defense of war" but the fact is that
those men banded together in a dedication to a single high pur-
pose — faced repeatedly with extinction have attained to a cer-
tain indefinable sublimity of character. All pettiness has dropped
away from them. Their faces haunt me — these ones I painted
and many others whom *time didn't allow me to paint.*

I'm much pleased you used "The Windmill Crew" as a fron-
tispiece[1] and I'm looking forward to getting the book! I've al-
ways thought it was one of the most successful lithographs I have
done, and some months before going to England I made a paint-
ing of this subject[2] — It is a pretty large panel — about four feet

high I should say. I understand Life is printing it in a review of a current exhibition — I hope they do and that you see it.

Like ourselves I suppose you don't do much traveling these days but we'd sure welcome another visit from you —

<div style="text-align:center">Sincerely</div>

<div style="text-align:center">Peter</div>

Saw Tom Lea[3] in New York last May and had a big time with him before we set out in opposite directions.

Original manuscript at the Humanities Research Center, University of Texas at Austin.

[1] For Dobie's *Guide to Life and Literature of the Southwest*.

[2] The painting is now part of the permanent collection of the Roswell Museum and Art Center.

[3] Lea was a good friend of Dobie's and illustrated many of his books.

To Daniel Longwell
[Draft]

<div style="text-align:right">[March, 1943
San Patricio]</div>

Dear Dan:

I was so glad to get your letter of the 19th and if it weren't that I was working by day and trying like hell to keep abreast of a flow of letters[1] (like the enclosed — will you read it and send it back when you've finished?) you'd have heard from me before this. They tear your heart — and I feel I must answer them each one — it is one thing I can do for those boys and of course for the ones here, who worry so much, it is a crumb of comfort.

First — taking up in order the things you mention in your letter — now that Eric is gone[2] I haven't the least interest in Special Services — I am honestly in agreement with what you say, Dan and I've been all along afraid of being made an office boy by that outfit! I shan't of course mention your findings to Pablo[3] — He is Zealously devoted to his job and I feel he is doing the best he can. If I were to join the Army it is the Air Corps that attracts me and the only reason I'd consider surrendering the complete autonomy of a War Correspondent would be in the

interest of carrying on the work I began for you — *from the inside* — There is no questioning the fact that there is always a barrier between a civilian and a soldier.

But I am much interested in the proposition you make me[4] — This is the middle of March — I have three paintings to go for you which should be completed a month hence. However two things make me want to defer for a time going on any mission for you — first, I think I will be about "painted-out" at the time the present work for you is completed — I want a break in painting — to collect my forces, reevaluate and gather strength for my next job whatever it be. Second as you know this ranch is our savings account — we have no other — and now with an important program of work in progress we are facing serious labor shortage. I feel I must stay by this job until the crops are in — and our ranch & farm program for the growing season is complete — for example we are putting in a new orchard down on the lower farm land — and during the critical first months I am the only one here who can tend it. This orchard in a few years should be an enormous asset to us with its hundred and some trees of improved varieties of fruits.

"What are you sweating out?" says Henriette at this stage of the letter, and when I tell her I'm deep in a letter to you she answers — "O, I wish Dan & Mary could come out for another visit this spring —" And I guess I don't need to add my own wish for the same thing — How about it Dan — any chance? we'd sure love to have you!

The new series of paintings are coming well — I'm most anxious to have you see them these seven paintings now finished and ready. As you advised I haven't hurried them — on the other hand, I have done no painting except on them and I believe the group will prove a good complement to the portraits. I'm sparing no effort to make them as good [as] I can!

. . . Getting back to your proposition which I think is a fine one — If you can wait until the Fall — say September or October before beginning then I say let's go —

I hope you can get out here during the next few weeks —

You and Mary — How very nice it would be to have you
both here!
Henriette & I join in sending love to you and Mary.

<div style="text-align: right">

as ever

Pete
</div>

P.S.
Thanks [for] your enthusiasm about the portraits — I thought
their arrangement and the story was excellent.

<div style="text-align: right">

Interpolation Letter to D. L.
</div>

Following the pub[lication] of the portraits a telegram and
letter have come from Paul Brooks, manag[ing] ed[itor] of
H[oughton] M[ifflin] Co asking to publish a short account of my
experiences in England — using whatever sketches & paintings
you allow him, to augment the text. I wrote back that subject to
your approval I was interested — I don't think of myself as a
writer of course, but so many of the things that happened are
outside the province of painting that literally to get them out of
my system I'd like to have a try at this[5] . . .

[1] Following the publication of his portrait series in the February 15, 1943, issue of
Life, PH received more than one hundred letters of inquiry regarding Eighth Air Force
soldiers reported missing or killed in action.

[2] Eric Knight had been killed on January 14, 1943, when his war transport plane
was shot down off the coast of Dutch Guiana by a German submarine. Knight, then a
major, was bound for Cairo on a mission for the Army Information Branch. Acting on a
break in security, the Germans were lying in wait for President Roosevelt, who was to fly
this same route on his way to the Casablanca conference. They were one day early, how-
ever, and mistook Knight's flight for FDR's. In 1944 Knight was posthumously awarded a
Legion of Merit medal by command of General Eisenhower, "for exceptionally meri-
torious conduct in the performance of outstanding service as a member of the staff, Army
Information Branch, Morale Services Division, from June 1942 to January 1943."

[3] Lieutenant Colonel Paul Horgan became chief of the Army Information Branch
at the Pentagon.

[4] Longwell had offered to send PH around the world with the Air Transport Com-
mand as a *Life* war correspondent.

[5] There is no record of the proposed manuscript. A book of PH's war journal ex-
cerpts was later planned but never realized.

To Paul Horgan

[April 8, 1943
San Patricio]

. . . I want much to go nowhere for a time to stay on this ranch during a growing season — I missed last year's completely and you know how interested I am in the range conservation program. We are planting like fiends — but the year has been amazingly dry so far. Not a drop of moisture all year though as I write this there are great clouds about and a feeling of rain in the air. Following the harvest I have about promised Dan to go off again for them this time on a year basis — 6 months on assignment 6 months back at San Patricio but actually on their payroll all the time — This may be my best bet tho I don't enjoy being a war correspondent. This possibly stems from vanity or pride and is therefore an unimportant sentiment . . .

To Mrs. Eric Knight

July 6, 1943
[San Patricio]

Dear Jere:

It is so long since I've written you I am ashamed — There are so many things — actually long complete letters I have thought out and projected to you sometimes as I work or as I ride out alone in these hills. Then, when I return and the actual execution is to be done — the sitting down and writing of the letter — I am nonplussed — I have the feeling that it *has been* done. So vivid and complete has been the effort that I am exhausted of words or sense at the end. Silly procedure but it happens time and again with me and always with people closest to me; ones to whom I most want to write fully and completely like you and Paul. The written word being your own accustomed medium I suppose you don't have this disconcerting experience as I do.

This place breathes with vivid memories and reminders of Eric, from the masonry dam he built in the *arroyo* near the polofield to his own spurs and the polo mallet with E. K. on it

which he used on La Bamba. The spurs and the mallet and his hats hang over the door in my studio and somehow they are an actual comfort to me now (a few months ago I would not have understood how such a thing could be) as I am slowly beginning to realize I shall never see him again. For months it has seemed to me he was still living and in odd moments I would suddenly have the feeling — "It's time Eric was dropping in, dusty and tired from a long drive" — or a letter from him ought to be here any day now. Even when letters kept coming in through February & March from our friends and when people would stop me on the streets in Roswell to say "Wasn't that awful about Eric!" I still didn't fully realize. I don't need to tell you that his death is the first one that has ever so affected me. Last summer I lost an aged aunt in Boston[1] who was always far dearer to me than my own mother. In fact, in a sense, she was a sort of mother. But she was very old and although still strong and active I had long resigned myself to her going — and imagined ahead how it would be to be without her. Not so with Eric. I never much regarded those now so prophetic allusions to an early death in his letters.

Beside the tangible things — like the horses the little statuette of "Calamity Jane" done by a young sculptor in Iowa — the flagstones he laid enclosing the ꙮ brand in the *portal* — dozens of things like this — there are so damn many intangible things Eric has left me and one of the most vital of these is a completely easy and affectionately understanding relationship with Peter — Thanks to an illuminating talk by Eric I changed from an overbearing, too severe and unsympathetic attitude with immediate and such marked results! I tried to write Eric about this from England last summer.

I have never knowingly destroyed or lost a letter of Eric's to me and I find I have filed here thirty five letters including one to Paul (about the "Cherrystick" deal they made.[2] Of course Paul could have no objections so I'm sending it along,) and one to Henriette. These I am sending on by registered mail to you at the Farm.[3] It would be difficult to have them copied here and it is probably simpler to have you and Harpers choose what you want and have copies made of these and then send the batch of originals back to us. The Rotha correspondence[4] should be most

interesting. I have no idea how much of general interest there is in Eric's letters to me — They do contain many revealing flashes and of course all are vividly Eric as we knew him and therefore enormously precious to us.

The recordings amaze us.[5] They are absolutely superb and I am so proud and happy to have them. The most extra-special thing we can do is put them on the machine for certain guests. Henriette has written Lieut. Vincent and with this letter to you goes one to him from me. What a grand thing to have done. Desolated as we all of us are there is a real and living comfort in such things as this album of recordings and the things here that Eric wore and used or made with his hands. They are constant and nourishing reminders of the fact that his was one of the strongest influences on my life of the past ten years. You know how I mean this — His vitality — sincerity — loathing of sham and snobbery all these things and more.

I'm glad you're joining the W.A.A.C. for I know you'd be grand at this job and I echo your longing to be really useful at this time — For the most part I feel impotent and futile; — eddied and whirled by such a mixture of feelings. But at least the war is going well for us at last — and our enemies are bound to be crushed soon.

Let us know when you're on your new assignment Jere and write us how you like it and what you do.

Love from us all here —

Peter

[1] PH's Aunt Susan.

[2] Paul Horgan had given Eric Knight the name of a contact from whom Knight purchased, as a gift for PH, a trained, four-year-old filly. PH named her "Cherrystick."

[3] Springhouse Farm, Quakertown, Pennsylvania, Mrs. Knight's permanent residence.

[4] A book of letters from Eric Knight to British film critic Paul Rotha, entitled *Portrait of a Flying Yorkshireman*, was published in London by Chapman & Hall in 1952.

[5] Phonograph records of Eric Knight reading his Flying Yorkshireman stories.

To Paul Horgan

Aug 2, 1943
[San Patricio]

. . . I've at last got back to painting this landscape again[1] and am so anxious to have you see the new crop of drawings (and watercolours — amazing for me to be doing these?) and temperas. For a time I have found myself absent-mindedly wondering where to put the B-17s in each composition — gradually this fixation is growing less. Meanwhile while not working at this I work as a farm hand in the hay fields or gathering fruit amused at this reversal of the situation as it was last summer when sitting in the nose of a B-17 I often flew over crews of haymakers — now happily home again I look up from our hayfields at formations of B-17s on O.T.O. flights . . .

[1] PH had been occupied with a second series of wartime paintings, which were featured in the July 26 issue of *Life.*

In mid-November, the Hurds went to Chadds Ford for a family visit. Peter was soon to begin his assignment for *Life* as a correspondent with the Air Transport Command, and while awaiting word of his destination and departure date he managed to pick up a few small commissions.

To Harold Hurd[1]

Chadds Ford Pa.
December 14th, 1943

. . . The Boeing Aircraft Corporation want a series of paintings of Flying Fortresses for their offices and I am now at work on sketches for them. I know nothing yet of the time of my departure on my next assignment . . .

[1] The following two excerpts are taken from the first extant letters from PH to his parents since he was a cadet at West Point.

To Mr. and Mrs. Harold Hurd

Chadds Ford

Dec 22, 1943

. . . I am to paint the portrait of a young flier — a major in a fighter squadron in the South Pacific theater of Operations who lives in Wilmington and has to his credit 16 Jap planes destroyed. The portrait is an official one commissioned by the State of Delaware — "Commanded" by the Governor. No more word of the Boeing project. I am working on the sketches now in Andy Wyeth's studio . . .

While Peter was in Chadds Ford, he asked Andrew Wyeth, who at twenty-six was a master of watercolor painting, to teach him how to use the medium with more facility. He knew that on his assignment for *Life* he would need to record scenes of war directly and rapidly, and for this sort of painting his involved tempera technique was poorly suited.

"[Andy] replied, 'Why don't you go out landscape painting with me?' This offer I instantly accepted . . . For the next week or ten days while I was awaiting *Life*'s arrangements for my departure Andy and I tramped together across the wintry hills of the Brandywine valley . . . These daily lessons were absolutely invaluable to me in the ensuing [six] months." [1]

In January, 1944, Peter received his instructions from *Life*, together with "a wonderful set of letter orders from the Commanding General [of the Air Transport Command] [2] — a sheet of paper which was literally a magic carpet authorizing travel by air anywhere on the globe that an A.T.C. plane can land." [3]

[1] Autobiography.
[2] Major General C. R. Smith, who in civilian life was head of American Airlines (see PH to Daniel Longwell, February 4, 1946, note 1).
[3] PH to Andrew Wyeth, December 10, 1944.

To Henriette Wyeth Hurd

Jan 9th [1944

Jamaica?]

. . . I have made three watercolours since coming here — None I'm afraid good enough to stand up as it is now but I'm certain that they are valuable notes —

I'm being splendidly cared for by the Army here and have

been assigned a great hurricane proof house overlooking the sea and all to myself. One of the houses generally reserved for visiting Generals! The air is different here than any I have ever known. The men wear khaki all day and I have yet to see a blouse or jacket on anyone but a transient. Night and day inside or out it is perfectly comfortable with a minimum of clothing.

Writing is difficult because of the fact that I don't know what I'm allowed to say and what is forbidden — I plan to be here a few days more then on South stopping wherever it looks interesting. I find occasionally a man who knows my work and even see prints tacked up in offices (where pin-up ladies might seem too irrelevant).

It already seems ages since I left Washington but I am so damned glad to have this begun at last . . .

To Henriette Wyeth Hurd

Feb 12, 1944
[Puerto Rico][1]

Dearest Henriette.

Two weeks have flown and I now see that my greatest problem — (*almost*, anyway) is going to be to leave these stations once I arrive and establish myself — I mean leave to proceed on further so interesting does the immediate scene become. I suppose this is a good sign — certainly proves a wealth of material and plenty of interest.

Puerto Rico is a lovely spot really and now that I have begun to paint here all kinds of new ideas are evoked. I touched the island returning from Africa by clipper you know[2] so had a little conception of what it is like.

. . . I may lighten my load here by sending back some woolen clothing which I now feel is definitely un-needed and possibly all the finished sketches & drawings thus far done so I won't have to haul them around with me. I believe this will be possible all right — possibly I can send the latter by courier. I'd rather send the drawings to you not to Life because they would probably kick around Margit Varga's office there and some of the smaller ones conceivably could become lost. I've learned to save

every scratch of this pen until I'm sure I can't possibly use it to remind me of some detail needed in a painting — or the feeling of a place or a moment can be re-evoked sometimes by these inconsequential notes . . .

[1] In Puerto Rico PH spent five weeks with an Air Reconnaissance Squadron at Borínquen Field.

[2] PH had returned to San Patricio by way of Africa in November, 1942, at the end of his first wartime assignment for *Life*.

[Journal]

Feb 15th —
[Puerto Rico]

Worked last night from 10:00 to 2:00 on the Hangar painting — result is fair only it seems to me — I'm still far from sure of water colour. Wish there was an unlimited amount of paper to be had — I'd do several versions of it really work on it until I hit upon some technique that is expressive — but anyway it is a complete *note* perfectly O.K. for reference . . .

[Journal]

[February, 1944
Puerto Rico]

. . . Time has drifted — not fled as at the Bomber bases in England. I have been industrious and have a fair sheaf of work to show for the time but still the time has drifted along at an easy pace. My new friends are extremely kind and solicitous and this and the wealth of materials at hand make me slow to set the date for my departure. There is none of the constant tension of the bomber station the pace is a slower one but apparently extremely efficient in its results for this field is a model of neatness and functions like clockwork.

Saturday —

Impressions of the Base: the big concrete hangars at night with varying batteries of flood lights and the never ending repair and servicing of transient aircraft. There are Liberators B.25-s, B26-s & Flying Fortresses predominately and of course a lot

of Transport planes. The Puerto Rican sentinels, guarding the parked planes — their smart appearance and precise salutes. The coco palms, tossing their graceful tousled heads in the East wind — They grow upslanting in a variety of directions in spite of the constant East wind that prevails here —

The Athletic Club called popularly the "Alcoholic Club" where wonderful frosted Daiquirís cost 10¢ apiece — made with Ron Añejo — The island lilt of the Puerto Rican Spanish the repeated interjection, "Ave María" in their conversation — The *camareros*:[1] Santiago Frausquiri, De la Rosa — Ben — and Teo the smiling hat-check kid at the Officers' club — The sibilant rush of surf all night outside my window and always the rustle of coco palms. Their silhouetted patterns on these moon lit nights. Stevie (Capt. Stephens an AAF Pilot) from Georgia and his Alabaman roommates "Noche" Knight and Jim Sutliffe singing in harmony.

> "I'm not in your town to stay
> Said a lady old and gray
> I'm just here to get my baby out of Jail
> O-O-O-O-O-O-OOh Word — en
> I'm just here to get my baby out of Jail."

Ron Rico, Don "Q," Bacardí, always the tinkle of ice in glasses, la Rumba — danced in all its untrammeled hip writhings the orchestra at the officers' club playing slow boleros and the faster rumbas . . .

[1] Waiters.

[Journal]
Ponce de Leon P.R. Sunday
Feb 20. [1944]

Last night and wearily into the morning I took in the big Puerto Rican fiesta of the crowning of the Queen. What the queen is of I never got straight presumably she is the reigning beauty (determined by vote) of the current debutante set. Anyhow it

proved to be a huge affair monstrous and gaudy — with a tacki-ness and tastelessness I have always associated with Latin Ameri-can upper classes.

About 2000 people attended the party which began with a long line of señoritas *"las damitas de las naciones"* carrying all the flags of the United Nations and a few of the more acceptable neutrals thrown in for good measure and to take care of the su-pernumerary *damitas*. I was paired with a proud Spanish beauty named Lygia so named, she told me, after a character in a novel called Quo Vadis. I didn't examine her teeth but I think this al-most set her date of foaling. She might have arrived a few years after Q.V. but not many!

With this frail beauty on my arm (she was attired in a car-nival costume of red & green sequins on red & white flannel and wore a pale blue veil over her head and represented, she told me, La India.) With this frail beauty on my arm we minced down a long line of people that thronged the sidewalks from the forming point several blocks distant from the Club *Deportacion* where the function was held. We were in the first fifth of a line that included about 60 couples. And as we passed little groups of people that pressed to see I could hear expression of pleasure & enthusiasm from the people — elicited of course by the ladies most of whom were attractive and some really *monísimas* or as we might say if we used the latin suffix or superlative — cute-*issimo*. The procession had taken the hell of a time to form and twilight turned to evening while a pair of fat very perspiring ladies toiled over the arrangement and sequence of the pro-cession. The walk to the club was a matter of about four blocks and this part was done evidently to give a glimpse of upper class finery & splendor to the humble people who could not attain to the heights of this gay, giddy *haut monde*. The final portion of this procession was down the middle of the main ballroom — in the club — This was lined fairly jammed with spectators —

. . . [The dance] progressed after the arrival of the queen and her subsequent coronation from a desultory beginning to a greatly heightened pitch of tempo and enthusiasm — more than willingly I left this scene of rumba and Zamba — (and what Rs

and Z.s *they* dance here!) at 5:00 A.M. My fading nymph Lygia had departed.

In a letter to Andrew Wyeth written five months after his return to New Mexico, Peter described the next leg of his journey.

To Andrew Wyeth

⟨December 10, '44
[San Patricio]⟩

. . . To Hispaniola where the Squadron performed an Air Show for the President Sr. Trujillo. To Aruba and Curaçao through incredible cloudscapes cruising at three hundred miles an hour while the bomber crew kept an alert watch, scanning the water for Submarines. I guess the others as well as I wondered at one time or another what good to us the mae wests and parachutes we wore [would be] if we ever had to use them in that vast un-ending expanse of water.

To British Guiana for my first sight of real jungles — I'd flown over them when I was in Brazil before but this time I lived on an Air base hacked out of the jungle,[1] and it was all it is supposed to be; dark, damp, mysterious, unhealthy; a forest trackless and seemingly infinite consisting of trees whose height sometimes reached two hundred feet — whose thick branches often cut out all but a glimmer of daylight on the earth below . . .

[1] In British Guiana PH was stationed at Atkinson Field, on the Demerara River, thirty miles above Georgetown.

To N. C. Wyeth

An Army Air Base
British Guiana —S.A.
[March? 1944]

Dear Pa

Here I am sitting in a strangely built house which with its wide (8 feet) eaves and big stilt supports makes me think of a photograph I saw years ago of R. L. Stevenson in his Samoan

house. This must have been the first picture I ever saw of this sort of house for it made a deep, unforgettable impression on me —

This is the Commanding Officer's quarters and I am his guest while on this station. It is located in the jungle of British Guiana and the conception I formerly had of what jungle meant (Mexico) has altogether changed since living in this incredible tangle of plant life. I keep thinking of all the authors who have used this background — H. M. Tawlinson, Evelyn Waugh, W. H. Hudson etc. And their descriptions — the feeling of them — come back to me now with a new meaning.

It is seven A.M. as I write this and the steam of day has already begun altho it is perfectly comfortable to go about in a cotton shirt open at the throat — Towards noon if not mitigated by showers the Sun's heat will really be *plenty strong*. The light is soft and diffused and the jungle's color a greyish tawny green except when you come upon a tree in flaming red or yellow bloom, or see the flash of a bright-colored bird wing. There are hundreds of birds everywhere and particularly handsome are the white Cranes which are very common — there's another little bird with a loud raucous voice whose call seems to be an imperious *Get to wooork, Get to Work.*

His admonition isn't necessary though, for in spite of the fact that I feel like a man living in a dream my one governing thought is to get this job concluded and return safely to Henriette and the kids. Compared with the taut-wire tension of the bomber station in England this is so far quite mild — or better I should say the excitement is a very different sort. I'm working steadily collecting notes and I have already many more of these than I brought back from England. (I learned from that job that the least, most seemingly inconsequential note may later serve to evoke the feeling of a moment.) But I'm a little disappointed that none of the watercolors so far have enough quality per se to be used as they are — As notes tho, I feel they are complete and their lack of freshness is often a result of trying to make a *complete* record later to be translated and simplified. The theme is slowly resolving itself now and will probably be a pictorial revelation of the great job the Air Transport Command of the A.A.F.

has done in creating these remote bases out of rock — desert — jungle and against enormous prevailing handicaps — and how, having done this they are now maintaining a steady stream of passengers, aircraft, and supplies along these new air trails that circle the earth.

. . . I keep thinking of the Spring-house painting[1] — wondering how it has progressed. Henriette told me in Wash. of having seen it in an early stage — I want you to know that the stay at Chadds Ford, — being with you and Andy again and seeing what you are doing — was a big stimulation. I am convinced that you are doing your best work in these new things I saw in Chadds Ford. By the way Pa, you have some fans here — your Nat'l Geog[raphic] Discovery panels[2] are framed and hanging in the Officers' club here at the base . . .

[1]Considered N. C. Wyeth's finest easel painting, *The Springhouse* is now in the museum of the Wilmington Society of the Fine Arts.

[2]See PH to Mr. and Mrs. N. C. Wyeth, September 28, 1929, note 2.

To Henriette Wyeth Hurd

A South American Air Base

Mar 6, 1944

[Atkinson Field]

. . . I am having the best of care at this station and am the guest of the A.T.C. Commanding Officer, Lt. Colonel Paul Hinds who comes from Oklahoma and has been a pilot for twenty years. He is a charming guy — with a fine sense of humor and a voice that keeps reminding me of Wilbur Coe.[1] He is much interested in this project and has suggested a number of interesting pictorial themes.

. . . I'm getting at least a superficial knowledge of the equatorial jungle of South America — and what an incredible thing it is! Last week Col. Hinds, a crew chief and I went a hundred and fifty miles inland, in a small amphibian [and] set it down on the surface of [the Coyuni] river . . .

[1]An apple rancher from Glencoe, New Mexico, ten miles up the valley from San Patricio. PH wrote the introduction to Coe's book, *A Ranch on the Ruidoso*.

To Andrew Wyeth

⟨December 10, '44
[San Patricio]⟩

. . . We were looking for some signs of a lost B-24. The heat, the towering wall of deep green jungle the rusty-red river water made it all seem to belong on another planet. The bomber crew we were searching for had parachuted to safety we learned later — just fifteen minutes by air from the Base but just three weeks by trek through that wild jungle guided by French speaking natives from French Guiana.

. . . From there I went on to Brazil where I landed at Natal — Carnival time in South America — with the curious tacky decor of Latin American Society the dancing surging street crowds and the constant, unceasing rhythm of the Zamba. There were jeep trips back to remote fishing villages and daily bathing on the beach below the General's house. I made watercolours of this beach and thought often of you — for it was the sort of thing you could handle brilliantly. The contrasting masses of black basaltic rock and white coral sand — The surf and coco palms and of course the gay colors of the bathers — both their skins and their bathing suits ran a wide color gamut . . .

To Henriette Wyeth Hurd

[Natal] Brazil
March 12, 1944

. . . It is late summer here and I swim in the surf every day for the first time since with you years ago at Rehoboth. It is easy to talk with Brazilians in Portuguese after studying the records & the Army's little green book — but I find I'm not privy to their conversations among themselves as I would be were they in Spanish. In speaking to me — for me to understand them, they must speak deliberately and slowly.

. . . This trip is already much more difficult than the English assignment — There it was merely a question of going — and after completing the assignment returning — Here the return is still weeks ahead with much *going*, — much more distance to be covered in short laps before we return. This is an

involved way of saying — I wish I were *returning* by easy stages than still going farther and farther away. But it seems the most sensible way of handling the job.

I'm not sure really that I'll get all the places visited that I had planned to — more thoroughness at the expense of great variety seems best . . .

[Journal]
> Aboard an Army C-54
> 6:36 A.M., Thursday,
> March 16, 1944

As I write this we are approaching Ascension [Island][1] and through the window beside me I have my first glimpse of that island — a gray mass of cratered mountains appear in the faint pre-dawn light four thousand feet below and a few miles ahead of us. We are flying east and in front of us, its summit hidden by cloud is a large mountain. As we go in to land I can make out several large volcanic craters near the runway. Now, the long over-water flight from Natal ended, we passengers, twelve enlisted men, two officers, and I, remove our Mae Wests, adjust safety belts and prepare for a landing.

Later:

This place is wonderful — now, in full daylight, the color is amazing and ranges through rust, reds and rose pinks into sooty black and ash gray. It is all I had hoped for from descriptions.

. . . Ascension is a tiny island only 9 miles long and 6 miles wide. It contains 54 square miles of the roughest sort of terrain: Great masses of sharp-edged lava alternating with areas of cinder and pumice all thrown together in enormous irregular masses. There are over 40 large volcanic craters which geologists believe created the island in a cataclysmic upheaval some ten million years ago . . .

[1] The fifteen-hundred-mile flight from Natal to Ascension Island took a little over seven hours.

[Journal]
10:30 A M Friday, March 17th [1944]
Aboard the Colonel's Launch off Ascension

This has been a profitable and exciting experience. While the Colonel, his orderly, Sgt. Kennamer, and the crew members have been traveling I have been on the bowdeck of this 38-foot-cabin cruiser making watercolors of the big square rock called Bos'n Bird Island, separated by a narrow strait from the main island. There are literally thousands of sea birds in the air all mewing and crying as they wheel overhead . . . No seasickness at all but painting while sitting in the tossing, slapping bowdeck of this little boat is plenty hard to do. The picture turned out well, though, I think, and the Colonel stroking his waxed moustache, nods approval . . .

[Journal]
Saturday, March 18 [1944
Ascension Island]

I made good progress on the Air Strip painting today and while I was at work over one hundred transient planes, medium bombers, fighters and troop carriers landed — all east bound to the combat zones. The planes stay overnight to be serviced by maintenance crews while the plane crews are briefed for the next hop, the long trip to Africa.[1] These ferry and combat crews sleep in transient quarters near the Air Strip and are summoned for a dawn take-off. Last night I worked until 1:30 on a drawing of a wartime B-26 with the ground crew working by portable lights . . .

[1] Without the air strip at Ascension Island, supplies from America that helped drive the Germans out of Africa would have had to travel by boat.

[Journal]
Sunday, March 19th [1944
Ascension Island]

I have been installed in the most splendid quarters on the base, a big pyramidal tent with a real shower operated by a 55-gallon barrel of water overhead. Surrounding it is a tall hedge of

dried stalks bound together. The plant, I learn, is ginger which grows on the slopes of Green Mountain. The trade wind rustles through this and fills the tent with a spicy fragrance. I am the first to occupy these quarters which were built, so I hear, "for the wife of a very high U.S. Government official, a lady, herself in the lime-light, and much given to travel."[1] Speculation as to her identity quickly narrows down. However, although the lady in question never came to Ascension, the work on the quarters was certainly not in vain for this is a fine place for me to work: the ginger fence keeps my papers from blowing away.

[1] Eleanor Roosevelt.

To Henriette Wyeth Hurd

Ascension Island
Mar 23, 1944

Dearest Bini

Your Cable greeted me here on my arrival and was the most welcome thing I could have hoped for — next to a stack of your letters — but yesterday came your letter from Detroit and I was more relieved and happy than I can tell you here. This is the first letter I've got since your first one to me — the one telling of Nancy Heyser's wire to you. So all the news etc contained in any letters sent in between is unknown.

This island is the most incredible place, — no bigger than a fair-size ranch it has over thirty volcanic craters. It is itself a sort of terrestrial abscess with great black scabs of lava reaching to the sea in all directions — In between these lava areas are masses of packed cinders exactly like cinders on a railroad bed. This circumstance makes road and house building relatively simple for the cinders are of such uniformity of size they don't ever require sifting to be made into cinder blocks with cement & sea water — Except for its extreme barrenness the total effect is a lot like parts of the Southwest — The red hills of burnt rock, the clear air and light but with the constant incongruous proximity of the ocean. In every direction is the vast Atlantic with no sign of ship or land to break the rim of the bowl. Men live for the most part in canvas tents built over a lumber framework. The Equatorial sun is mitigated by a constant trade wind.

On this lower level — which comprises most of the island there are no trees — practically no grass or shrubs. The one exception to the above is a lone cocoa palm on the Southwest shore of the island. But near the middle of the island is a handsome tall mountain rising to something under three thousand feet above the sea level. This is Green Mountain capped by the most lush growth imaginable. For as in New Mexico the climate changes abruptly with altitude — Here are beautiful groves of eucalyptus banana — Norfolk Pines cocoa Palms guavas and to top it off one of the component knolls of the summit — (the highest, in fact), is crowned by a dense thicket of bamboo.[1] Of course as you can surmise this island is most paintable! In fact it is right out of Jules Verne and I'm constantly reminded of Pa's pictures in "The Mysterious Island"! But I'm frequently reminded of Pa's illustrations on this trip anyway and always marvel at the accuracy with which he hits the *feeling* of places where he's never been and things which he's never seen. He has "traveled much in Concord"[2] all right — Once a few weeks ago on the coast of South America we landed on a sand spit that separated the ocean from a still lagoon — There, as we lunched in the shade of the bomber's wing we watched a trembling haze of flame colour on the surface of the lagoon a half a mile away — In the noon sun it was like some strange fiery mirage until suddenly we realized that this effect was caused by hundreds of flamingoes feeding in the lagoon.

This trip has led me to meet several people I've known before — The first of these, looking exactly like an elongated gremlin by Artzybasheff[3] was Duncan Grover! We recognized each other at once and for all of my stay in Brazil Duncan (now a first lt. of Air Corps) couldn't have been nicer. He is not drinking and proved to be a charming and intelligent man far different from the erratic loop-legged Grover we knew in Wilmington. We went swimming together in the warm surf, and he did many favors in making me comfortable, guiding me around & c. He's a nice guy you'd like him, Bini. — Well — then arriving here whom should I find among the enlisted soldiers on the island but two boys from San Patricio — Remember our erstwhile cook, Domingo [Salas]? wittily rechristened by Peter "Dumb Ingo" —

He is now a very snappy, alert corporal pleased with his work and proud of his advanced station in life — The other is Tani's brother, Manuel Montoya who seems to be well liked by everyone and quite happy in his present assignment. They were perfectly delighted to see me and such a round of exclaimed greetings and *abrazos*[4] you never saw!

Later:

Yesterday I went on a hike with two officers and the Red Cross representative and I think it will amuse you that it took this clinker-littered island down near the equator to make me agree to go on a *hike*! But hike we did and quite a stroll it proved to be. We left at ten and walked until four thirty with an hour out for lunch, over terrain that would make you think of Mal País lava beds west of Carrizozo in New Mexico! It was the roughest country and the toughest walking I have ever done but well worth the effort in the interesting things we saw. Also I was relieved that these four months of relatively inactive living haven't softened me physically. I kept up with the three men, all younger than I, with no more effort than they were making. There are no snakes on the island which was a big advantage — occasionally an ugly land crab would scramble out of the rocks and away. From the top of Green Mountain the ocean was visible on all sides and we all stood in wonderment for a time gazing out on the vast South Atlantic. The water was singularly calm and in places the clouds were mirrored as in a calm lake. There was nowhere any sign of ship or plane or other land, only the boundless domain of sea and air and cloud.

Returning after my walk I wasn't in the least stiff and after a brief rest I went aboard a 38 foot cruiser owned by the Army. I slept aboard so as to be ready to make a drawing of the Island at dawn. You know — looking into the dawn sky from the sea. Later — after the drawing we cruised around to another side of the island where thousands of big birds have their habitat on a tall block of volcanic rock that stands apart from the main island separated by a narrow strait of bright blue water. The rock itself has lost all its original dark basaltic rock appearance by the encrustation of golden yellow bird guano. The birds are countless in numbers — and include Bo'sun birds (the little island is

called Bo'sn bird Is.) Frigate birds Booby birds and some species known only on this tiny island. I kept thinking of Andy as the big birds unaccustomed to Man and therefore quite fearless would hover only a couple of yards over my head — cocking their heads sideways to eye me. We fished for food for lunch and I pulled in the first catch a big Krevali — (I'm not sure of this spelling) [crevalle] anyway it is a type common in these waters and I know no better description than to say it looks like it belongs on a painted Chinese bowl. Quite fabulous and improbable. I returned late this afternoon weary from being tossed about in the little boat while trying to paint from its unsteady deck — My eyes are tired from the glaring sun on the white paper — but I'm not a bit stiff from the mountain climbing!

It is only eight thirty Darling — a wonderful evening. From Green Mountain the trade wind brings the curious & to me nostalgic smell of Southern lands a sort of spicy gingery sandalwood smell which you must remember from Chapala. The new moon is dipping into the Atlantic and over the hills beyond my tent flame the four radiant stars of the Southern Cross. From a nearby tent a polished British voice comes over BBC with an analytic synopsis of the day's news on the war fronts and elsewhere — It is hard to believe that north of us lies the bulge of Africa . . .

[1] When Charles Darwin visited Ascension Island in 1844, he did not report seeing any trees.

[2] Thoreau, *Walden*, Economy: "I have travelled a good deal in Concord."

[3] Boris Artzybasheff, twentieth-century Russian-American illustrator.

[4] Embraces.

To Henriette Wyeth Hurd

[Accra] West Africa
April 13, 1944

Dearest Bini:

Here I am again on the West Africa Coast[1] and this time with more time to know the place — It is amazing all right, this place. As soon as I get away only a few miles from this base I am really in a primitive untouched world! The base is an anomaly:

a curious island, in the figurative sense — where are heard the comforting sounds of voices from Iowa, Maine — Alabama Illinois — Texas with all their special allusions that are only American — Marvelous to think that by our national power — the summation of energy, resources and a great will-to-do our country has established hundreds of such "islands" — little Americas — all around the globe, where you can buy even Coca Cola — and fairly recent issues of American magazines.[2] This is only the barest hint of the extent of what has happened in establishing these bases — the rest must wait for me to tell you about when I return. I already have enough material for several stories — (I mean pictorial stories of the sort Life uses) and so I am going to move faster from now on out.

. . . Well Bini — this trip, exciting as it has been, has now begun to grow to such proportions that I feel it best to cut it some shorter (in geographical scope) than I'd planned — Better, obviously to do well a certain territory than to do a slip-shod job even though it include much more! It is hard to convey what I mean without being specific but you know what my original itinerary was. Anyhow — aside from all this I am really burning to see you again — Darling — As I survey this two month (*age long really*) absence I keep asking myself, what that I am doing or could do, could ever be worth even a day away from you much less these dragging weeks. Remember how very close we were in New Mexico how much we dreaded both of us — being apart at all? Remembrance of all this returns to gall me bitterly now, so that I wonder at times how I could *ever have left at all!*

Later

There is a little more time left so I'll continue this letter to try to give you an idea of the surrounding country: First glimpse of West Africa from the air is a low coast line with few inlets. The surf rushes across the sand in repeated patterns of escalloped lace. There are a few coco palms and mango trees — but in general the countryside consists of low grassy plains broken by occasional trees. Fishing villages dot the coastline and the palm-thatched adobe houses make me think of Mexico. The people (ASHANTI Tribe) are very clean and often wonderful looking. The other day I went in a jeep to one of the villages and called on

the chieftain a dignified black who spoke a few tentative English phrases. He brought out his drummers who proceeded to set up one of the loudest dins I've ever heard with some long barreled signal drums. They are all friendly, extremely respectful and as interested as children in everything that goes on. We were there during a fiesta — celebrating of all things (it was Easter Monday) the redemption of Christ! The women were dressed in wonderful vivid coloured silk dresses & bandanna Kerchiefs around their heads — the men in red tarbooshes, like the one I gave Betsy [Wyeth], and either a toga-like garment & shorts or just plain shorts. They were singing a hymn which our Ashanti boy, Chris, told us was sung in English and had been taught them by the missionaries, but which sounded to me like the time and words of "Kai-yai yippy-yippy-yai,"[3] sung in march tempo with an enormous European bass drum as an accompaniment. The marchers were 300 strong and in their bright clothing and rich black skins they outdid the best Hollywood extravaganza as they approached the jeep and swirled and eddied around us literally engulfing us and all the time singing and laughing and waving their bright silken handkerchiefs. It was at sunset and beyond them down at the end of the village street lay the ocean — and above that a jade green sky in which the round moon was rising. It was all like some very special musical movie done in the subtlest technicolor. What a contrast to my life during the past weeks on our remote volcanic Island!

It is difficult as hell to write of these things that are happening for I'm doing my best to keep them recorded in drawings and in journal notations altho the scene changes so fast and so completely it is at best only a smattering that I can record! . . .

[1] See PH to Henriette Wyeth Hurd, February 12, 1944, note 2.

[2] "One thing keeps recurring as I travel on — the thought that I'm enormously proud to be an American," PH wrote his father on April 13, "— whatever individual faults or national shortcomings we may have — we can really organize and manage and build in a superb fashion!"

[3] A cowboy song.

[Journal]

⟨[April 7, 1944
Accra]⟩

. . . Surprised to find [the Commanding Officer here is] Sewell — now Col. A.A.F. class of '24 — in "M" Co at the Academy — We talked briefly of our days at W[est] P[oint] and he turned me over to a P.R. officer.

The atmosphere here is hazy — a golden sort of haze at dusk that later becomes a marvelous exciting green background for the full moon-rise. Black African figures clad only in shorts moved about silently in their bare feet as I walked around the Freight loading stations — etc. Curious feeling here — one of sultry expectancy that I can't analyze, or catalog. The transient barracks are crude and rather cramped — I occupy the upper deck of one of two double deck beds. And a blaze of light pours in from the open doors of the shower room. The Eastwind brings the stifling smell of smoke from the mess-hall kitchens next door, but nothing can keep me awake tonight — I tuck in the mosquito netting carefully and toss this book down to the table below. —

[Journal]

⟨Accra. April 8th [1944]⟩

My two roommates came in after I had gone to sleep — but I failed to hear them — one is a lt. of Spec[ial] Services here with an Army show from the C[hina] B[urma] I[ndia] theatre of Operations called Hump Happy. The other is a young lt. Pilot from Lancaster Pa — en route to India and combat assignment.

Wandered around operations early this A.M. and my eye hit on a half dozen polo sticks standing near a desk marked Capt Glenn Rae. — I decided to hang around until the owner turned up. — In a half hour or so I met him — a youngster from South Dakota crazy about Polo which has recently been organized among the Americans here. Soon he was on the phone calling his polo amigos and before long we all got together. Capt John Martin of Ill. and Capt. Achy Achenbach of Lock Hannen Pa.

(who was in the 103rd Cav at the same time I). From then on all day I've had a grand time with these agreeable and amusing guys.

We went to the Accra market where I had a field day drawing the fantastically dressed Africans and later to the Accra polo stables where I saw the ponies — these are small wiry animals smaller if anything than ones [sic] but not so chunky a little inclined to be herring gutted and goose rumpled but these traits were so universal that I concluded they must be attributes of the breed. They look tough though — small hoofed rather common heads but fine legs. All are stallions — No obvious Arab characteristics could I see.

Later we went to Major Taylor's (R[oyal] A[rtillery] ret[ired]) house where we sat and chatted for an hour drinking beer. Back for lunch to the base then on to the most colourful races I have ever seen. The Accra Turf club's meet. The same sort of animals I'd seen in the polo stables even ridden by sweating black jockeys in silks that seemed by contrast to their skins more vivid than any I'd ever seen, the races varying from 8 furlongs to a mile and a half.

The crowd was wonderful! Europeans definitely in the minority and the ensemble looked like a coloured Shriner's Fish Fry and a Harlem Masquerade party. I drew continuously with what results I don't know but I scratched away with my drawing pen until the last! What a day! And tonight we take in a dance at the Accra Club and go as spectators to the St. George Club dance — the St Cecilias Ball Phila. Assembly Hall of African Society in Accra. More of this I hope tomorrow!

Easter Sun —

Last night was an amusing time. We went the four of us Achenbach, Martin, Rae and I to a formal — usual binge at the Accra Club when in an open air pavilion we sat and watched the dancers while a large African Moon climbed into the sky — jade-coloured with windborn dust. I was amused to find that our Nurses all wear mosquito boots and long sleeves against the night flying Malaria mosquitoes — not so the British ladies who wore décolleté gowns as freely as if they were in London far from the Malaria-infested Gold Coast . . .

To Andrew Wyeth

⟨December 10, '44
[San Patricio]⟩

. . . having been repeatedly warned that it [the Gold Coast] was a sink hole of malaria, I planned to get the hell right out of there, practically as soon as I could climb out of the converted Liberator that brought me there and into another plane. But it didn't work out that way at all. The Slave coast — including the Ivory Coast of West Africa was a marvelous place and I decided to stay a while. I used quantities of Insect repellent wore mosquito boots and fortunately got no malaria on the whole trip. The Africans (they aren't referred to as "Negroes") are wonderful and I had a great time there. They are paintable as hell, Andy, an amazing and wonderful people. If you were only here I'd tell you some tales about them that would make you squawk but I'd be forever, writing them out. So they'll have to wait until we do meet again. Incidentally I played polo twice a week while there — they play on chunky little Barb horses, all Stallions, that look like the horses Velásquez painted in his portraits of the *Infantes* of Spain. Remember them? Well, in West Africa I really got back into the bush. I flew with an Air-Sea Rescue crew and landed in a Catalina on a wide river called the Volta — marvelous experiences with the Africans there, who had never seen an airplane except high in the sky. They spoke no English and wore no clothes other than a Gee String. We gave them K-Rations out of the plane and I wish you could have seen their faces. I gave the chief a package of Doublemint which he very deliberately and seriously unwrapped stick by stick. And I thought, "here's a boy that's been around" until I watched him solemnly chew each stick up and then swallow it with a complacent and pleased look.

From there I went to [Kano] Nigeria in Central Africa . . .

. . . two lieutenants, a Major and I [took a bush trip into the heart of Central Africa] with a native driver in an army command car through a marvelous landscape in really god-awful heat. You know how I'm always bragging about liking hot weather, well, I got it plenty there and of a kind I never knew existed before. The trip was wonderful and took us through a spread of country that reminded me of nowhere I'd ever been before — the bush

country of Central Africa as it is called is a sparsely wooded flat landscape with the constant haze of the harmatan, the sand-laden wind from the Sahara always in the air. The earth was sandy with the curious orangey-clayey colour of Africa. We passed many camel caravans manned by ink-black men who bore crusader swords swung baldric-wise over a shoulder and carried bows and poisoned arrows. They spoke Arabic and wore a fantastic arrangement of cloths twisted around their heads & necks. The beginning of the orient, for these people were moslems tho of a negroid stock.

From Kano in Nigeria I went on to Khartoum in Anglo Egyptian Sudan — traveling across the Africa continent in a big C-46 loaded with rifle grenades and blood plasma. Cool for the first time in days, for we flew high to catch a tail wind. That is, until we came to Lake Chad in French Equatorial Africa where the pilot swung the ship low to give me a glimpse of that strange primordial swamp that comprises Lake Chad. We glimpsed hippopotami sloshing around in the water running clumsily from the roar of our engines.

Khartoum on the upper Nile reminded me of this part of our country — all but in its definitely oriental feeling. I met a Syrian there and had dinner in his home served by Sudanese arabs who could have been the servants of the Caliph Harun ar-Rashid in the Arabian Nights. Everyone said I cared little for the future of my gizzard — eating in an Arab-run household but I had no ill-effects and a wonderful meal; in as complete a contrast as anything could be to G.I. chow. But the orient in general, — all but India — was somewhat disappointing. So damned filthy and such appalling squalor! The air was murky with the haze of the Harmatan and the Sirocco, and the landscape un-lovely. Only the native costumes were interesting and of the natives of somewhere, I forget which oriental land it was now, — a jeep driver from Arkansas once said to me — "Say, if these guys dress like this now, what do you reckon they put on for halloween?"

Arabia next — the strange barren rock of Aden in the province of Yemen — The meeting of the middle and the Far East and interesting as one of the birthplaces of Islam. Strange to feel yourself shunned and hated as an infidel in these Arab lands. I

found myself thinking of the contrast this made with Africa with its friendly atmosphere, the scrubbed blacks in their spotless white clothing — From Sheik Othman in Arabia I flew to an island in the Arabian Sea over a wild landscape-on-the-moon desert of rock and sand. Cruising in the big Douglas four engine transport at nearly 300 miles an hour I kept my nose to the window looking in vain for trees, grass, trails, humans or any of their works. The island is not far from the coast, so much of this flight was over land. This island — Masirah is a refueling base and the most dismal spot I have ever seen anywhere. Before the Americans came, an Arab told me, it was well known as the abode of an evil Djinn, a spirit banished from the world of the living, centuries before by King Solomon.

From Masirah on to India: There I saw the real orient in those amazing three weeks — and found myself the guest of The Maharaja of Jodhpur this thru a chain of fortuitous circumstances beginning at a cocktail party in Karachi India where I met a Wing Commander who thought I should see "a bit of the Indian provinces" . . .

Although Peter had intended to join up with the U.S. Fifth Army in Italy, the wing commander persuaded him to go to Jodhpur instead and gave him a letter of introduction to the then-reigning Maharaja, Umaïd Singh. Peter was glad he changed his mind. In Jodhpur he lived among the Rajput princes and nobles in the Maharaja's 620-foot sandstone palace. In the cool early mornings they all played polo. When Peter traveled on to Jaipur, where the reigning Maharaja was "a polo player par excellence," he was given "a little guest palace all my own, with nineteen servants in green livery and a coach at my disposal with two grooms before and two foot-men behind."[1]

[1] Autobiography.

To Henriette Wyeth Hurd

May 12, 1944
[Egypt]

Dearest Bini —

Since India and the visit with the Maharaja I have written you only once — from Arabia early last week — but now I am in Egypt and the prospect of returning soon to you is the most exciting one I can think of — I must go to Italy for a short detour as I wrote you — and there I hope to see [Paul] Gardner and possibly — indirectly hear news of you.

. . . Military needs as well as a feeling of utter helplessness as to where to begin and how to boil down makes telling of any experiences in the last few days [impossible]. But after last week I still feel everything coloured by the lingering dream atmosphere of Jodhpur — Jaipur and Agra — particularly Jodhpur where the incredible maharaja and his court entertained me for a week, as I have related briefly in the other letters. The Hindoo wedding was something completely unforgettable and I find myself going over little details of it in my mind in odd moments. Do you remember Hindoo Holiday [1] which we read together in Chadds? You know Paul Horgan had the book — well — this Maharaja is of a different breed much wealthier much more powerful and cosmopolitan than the one described in H.H. but the background of India is identical. Through His Highness of Jodhpur I feel I have glimpsed the real Orient; and I seem to have been during the past week in a half-dream sitting in the gently swaying howdah while the gold-clad elephants bore me through a maze of extravagant settings — like superb backdrops for Burton's Arabian Nights, with never a jarring note to mar the complete effect no anachronistic if you will exclude the Maharaja's shining black Rolls Royce which appeared occasionally. The total effect of the parties and wedding was one of such sumptuousness and complete unreality that I can think of no way to carry you the emotional effect quickly and spontaneously — It was like the verse of Frederic Prokosch [2] which at heightened moments reaches a peak of metaphor and descriptive phrase. My other letters have been far too objective and this one is only the lamest effort to improve —

Well, I'll rely on telling you vis-a-vis later of this! O Bini how I long to see you, hold you feel you! This time seems to have fled in some ways but in other ways — when I think of you and the children and San Patricio it is years ago that I was with you. You'll see I have made a few good decisions while I have been away one is no longer "to suffer Fools gladly"[3] I've done far too much of this. And on this trip to counter balance gay generals and incredible maharajas I have met some dullards — dull*issimos*! ones who make me so glad I am not in the Army where I might be called on to serve with them, or worse, *under* them. I've made another decision too, which you'll like and which I'll tell you of when we meet. *When we meet*; marvelous phrase for it represents the one basic idea constant and unchanging I've had since leaving India — before that, before the U-turn at Agra I scarcely dared think of this, not concretely at least. But since then it has constantly been my governing thought. Now it's just a question of hitch-hiking home Bini . . .

[1] A book about India by J. R. Ackerley.

[2] An American poet and novelist. Prokosch was a classmate of PH's at Haverford College.

[3] "For ye suffer fools gladly, seeing ye yourselves are wise" (2 Cor. 11 : 19).

Readjustments

"PETER BACK AM HAPPY AGAIN," Henriette wired the Longwells on July 20 from San Patricio. After more than six months of travel around the world, and eight months away from Sentinel Ranch, Peter had come home to his family. Before reaching New Mexico, he had visited the Longwells on their farm in Kent, Connecticut, to discuss the series of pictures he was going to paint for *Life*—but not before taking a much-needed rest.

Peter was in "a disturbed and unproductive state" for weeks upon his return to New Mexico, and it was only toward the close of summer that he felt up to working again. He started by reviewing the rich supply of notes, sketches, and journal entries he had made overseas. Then, in the fall of 1944, he began once more to paint.

To Daniel Longwell
[C]

November 17, 1944
[San Patricio]

Dear Dan:

By the time this letter reaches you the first shipment of paintings should be on their way. One of the watercolours, the Aerial View of Ascension Is. I decided I could improve by redoing it in Egg Tempera. I think it came out well and I'm glad I did it. In general I find my tempera technique a difficult one for the engravers which is one reason why I have done so many water colours. However of those I have done in tempera these new ones are done with as little of the little-darts-of-colour technique as possible and I hope for better results.

. . . It seems inevitable that as far as work goes there is a let-down on returning from so exciting a thing as one of these trips. But once I got started on the job things rolled smoothly —

smoothly in all but one of the subjects of which I made *four versions* before finally abandoning the idea and substituting another. This was to have been a view of the encampment but the black & white drawing shows that adequately enough so I substituted the close-up of Green Mountain which with its rich tropic verdure is such an incongruous contrast to the rest of the island.

Sometimes it occurs to me that I have been off-hand and taking all for granted in these two big adventures you arranged for me. If so I sure want to correct that now. For I want you to know that I wouldn't have missed these experiences for anything — That I feel very definitely I have made some growth as a painter as a result. Also I'm not unmindful of the fact that were it not for you I'd have been commissioned in the army[1] and for all I know put to running a G.I. laundry in Ohio — Or still worse for me sent off to the Aleutians or Iceland. God how I hate cold damp weather! Incidentally I got plenty thawed out on this last trip but I still like heat.

Henriette went East early this month to paint some portrait commissions. I hope you all have got together by now. A letter from her today tells of delay due to weather — days too dark to paint.

. . . Six paintings remain on the next story and I'm looking forward to getting at them . . .

[1] See journal, June 26, [1942], note 3.

To Andrew Wyeth

<div align="right">December 10, '44
[San Patricio]</div>

. . . I have really been pouring the coal on in my work for the past few weeks [and] now with the first story delivered to Life I can breathe easily for a while. There still remain about ten paintings based on my last assignment . . .

. . . The curious dream-like aftermath of this Odyssey which took me between sixty and sixty-five thousand miles by air — traveling in Transports, Bombers and Sea Planes — still lin-

gers. It is easy to drift into a long meandering stream of memories of this trip which took me to five continents in all.

. . . I've told you of some of the high spots in this letter[1] not for any other reason than to amuse you — not certainly to point out what you may have missed — The fact is *you pay for it all*, and tho I'm glad I did go what a disturbed and unproductive state such adventures left me in for weeks! The only real issue is did I improve — was I benefitted as an artist? the answer is still obscure to me. So don't think I'm trying to give you a case of itching feet. One thing I do think you should do is know more of our own America — this of course you can do later when travel is easier.

Nor was the trip all high adventure and the glamour of story-book places as I may have inferred here. There were times of terrific horror: . . . one day in the middle of May, after a jeep trip to the front from Naples I found myself smack bang in the middle of a battle — a frontal assault by tanks and Infantry — my first (and I hope *last!*) battle. If we had an hour together now I think I could make you feel how it was to be there — to see it from my view: the view from the eye of a scared worm. I won't try here to tell you, but this much I'll say: I hadn't the least desire to paint or draw it. It was too vast, too horrible, too paradoxical to be paintable (by *me* at least) and seemed completely out of the province of painting. It was a phantasmagoria of shattered buildings, dust, smoke orange groves, teller mines, the smell of dead bodies the sight of abandoned German vehicles presumably elaborately mined with booby-traps, racing ambulances the unforgettable sight of a tired looking chaplain talking quietly to his men — who sat on a pile of rubble waiting to be called up to support our advance just a mile beyond us. He was whittling aimlessly on a stick talking inconsequentially apparently, but in that overwrought atmosphere every word, every gesture seemed full of the overtones of "who is to survive the coming ordeal who not?" Sometimes inside myself a feeling of flat banality mysteriously took the place of dread and I felt myself in those moments immortal, super human and that the battle was all a sham — a piece of poorly done playacting. Crazy? I agree, but that's honestly the way it seemed. I remember being careful not to

show any signs of fear or concern so that when a shell landed nearby I was the last one of the four of us to scramble out of the jeep and flatten out in the dusty road.

. . . I was with the Fifth less than a week. It is difficult to think of how it would be to be there day after day week after week — not as an outsider as I was. I could leave (and did) whenever I wanted to — I'll never be astonished at a man's character being altered or at least temporarily warped after that kind of experience. Boy, let's try to remember this when those poor bastards come back — those that do.

I haven't told you about Cairo, Iraq Suez Jerusalem, Tunisia, Algeria, Morocco. I spent over two weeks in Casablanca and would like to go back someday; or about the return flight over the North Atlantic via the Azores Newfoundland, Washington D.C., Harrisburg, Chicago, clear plumb out to Amarillo Texas by army planes — there, 300 miles from home, we were grounded by thunderstorms and I grabbed a bus for Roswell. I had traveled over 60,000 miles by air on the entire trip and do you know, pal that bus felt good!

Andy — I should have told you at once, at the opening of this installment of the letter how crazy about the book of drawings I am. I have already spent two or three hours poring over the reproductions and their descriptions. To you and Betsy, many thanks for this fine present! Best love to you all three — H. says Nicholas[2] is a wonderful child!

<div align="right">Peter</div>

[1] Several excerpts of this letter appear in chapter 8.
[2] Nicholas Wyeth was born on September 21, 1943.

To Ann Wyeth McCoy

<div align="right">

March 12, 1945
[San Patricio]

</div>

Dear Annie:

One of the editors of *Life* has wired me wanting to know when they can expect the next story (pictures) from me, so I hit the old salt mine in earnest today and what I had planned as a

long leisurely birthday letter to you must be cut somewhat short. I have been in no hurry on these paintings because I feel a long gestating period always helps the results — particularly in a painting which is purely of remembered, distant places and people. Also spring is such an exciting time here. For the past month we have been wrapped up in the minutiae of existence in the country. The birth of calves and colts: watching the young seedlings sprout and the orchards bloom. Being away last year I missed all this and so did Henriette but we're making up for it now! The war, at times, actually seems remote.

I am so glad to hear you are working at music again! I know how excited you must feel to be getting back to it again. Power to you and I hope nothing prevents your continuing with it . . .

To Margaret Varga[1]
[Draft]

[Spring, 1945
San Patricio]

Dear Margit:

At last I have finished boiling down and extracting the salient things in my journal — hoping to find sufficient pertinent facts to give you ample material for the stories on the paintings. I bemoan my miserable handwriting and am sorry to have to offer you the data in long hand but there is neither typist nor typewriter within miles of here.

As I see the story of my pictures — at least if they are used alone, not in connection with other aspects of the war — it is the story of the amazing aerial trail-blazing of the A.T.C. Their overcoming of innumerable & seemingly insurmountable obstacles in establishing their vast network of supply lines. A Service that includes such diverse things as complete hotel accommodations in most of the stations clear out to India — facilities for maintenance & repairs of all types of aircraft, equipment and personnel for the rescue of airmen forced down over sea or land —, elaborate and smoothly functioning air-evacuation of wounded from the front lines to dressing stations and convalescent hospitals behind the lines thence back to the States in big air ambulances.

Unless you feel that enough has already been done on the subject — (I don't, of course, for I feel their achievement has been a spectacular contribution to the progress of the war and one not understood at all by many) I hope you will conclude the present series merits a story in itself on the A.T.C. . . .

[1] See PH to Daniel Longwell, ⟨October 1, 1939⟩, note 2.

To Henriette Wyeth Hurd

[Spring, 1945
San Patricio]

. . . Telegram from Varga: — the most enthusiastic I have ever got yet: "Pictures are here and they are wonderful[1] . . ."

[1] The pictures appeared in *Life*'s April 30 issue.

To Henriette Wyeth Hurd

[Summer, 1945
San Patricio]

. . . A nice letter from Andy telling of liking my spread in Life. The others left him cold as they mostly did me too and I wonder how much he is reading into my things through knowing me so well — knowing what we're all *Aiming* for. I think the whole show was bad, mine included! . . .

To Paul Horgan

Oct 26, 1945
[San Patricio]

Dear Pablito —

You can imagine what a cruel blow to Henriette and me was the news of Pa's tragic end.[1] I don't mean to dwell on our own suffering or unhappiness in the light of those others like Nat & Caroline whose loss was an even heavier and more awful one. Henriette has been perfectly splendid through it all, pitching herself headlong into work in both the studio and household — Fortunately we have had a lot of diverting guests — Caesar[2] for

about a week and night before last — like a bolt from the blue — (a beneficent one this time!) into my studio walked Jack and Anna Biggs. They are with us for a few days before driving back to Wilmington. They both seem perfectly splendid and are a great lot of fun.

. . . In spite of letters — messages and newspaper accounts it still seems to us an unreal — impossible thing. As Henriette said he was a great lover of Thomas Hardy's books and his own end was so in the Hardy tradition an improbable implausible enormity coming suddenly and without forewarning of any sort . . .

[1] On October 19, 1945, N. C. Wyeth and his three-year-old grandson, Newell Convers II, first child of Nathaniel and Caroline Wyeth, were killed when a train hit Wyeth's car.

[2] Edward Nicholas (see PH to Eric Knight, February 20, 1936, note 4).

To John McCoy[1]

November 7, 1945
[San Patricio]

Dear John:

Thank you for your long and full letter. We know what a task writing this must have been — re-living that terrible time in order to let us know the events which led up to and followed the accident. Henriette read your letter and was most deeply affected by it and yet, as with the entire tragedy, she has shown enormous and amazing outward control. In one way the distance has been an aiding factor — By which I don't mean to infer that her grief has been any lighter — it has only been possibly a little less constant and un-remitting, due to the lack of objects and people here who might continually remind her of Pa's death. However as the pain has been probably less steady for this reason so the realization of what has happened has been strangely slow to reach us ultimately and fully. Realization comes in sudden chilling waves which seem to grow no less awful with time.

It still seems to us here a monstrous and impossible thing — Pa's end was so tragically out of keeping with his life. For ever since I can remember — twenty-two years ago — Pa was always

the one helping others out of predicaments — worrying incessantly about the security and welfare of the family. It was inevitably Pa who helped the other fellow to his feet never he who needed help. It is this together with the many miles that separate us from Chadds Ford that makes it all so unreal in a terrible and haunting way!

Last week Jack & Anna Biggs dropped in on us — and as a seeming paradox to what I have just written, their visit was an enormous comfort to Henriette and me. It was wonderfully warming and re-assuring to have with us two people who knew Pa intimately and loved him.

The only surcease that Henriette and I have found from these besetting thoughts has been to pitch headlong into work. This we have both done and it has been a blessing. I know that you have been unable to do this for on you must have fallen the brunt of the whole tragedy — I mean the heart-breaking duties of such a time. But I hope you can now begin to work again. From my own experience I believe you will have to force yourself at first to go to the studio — or into the field to paint, but, hard as this first part is, I feel certain it can bring you great relief and strength once you are well into it.

Moreover this is certainly what Pa would most have wanted all of us to do; and although we may be in many ways different from Pa we all of us know well, and with a surge of gratitude — that it was he who shaped the course we have been following. Now that he has gone I know that you must feel as I do — that the one real tribute to his memory and proof of our devotion to him is to work like the Devil! To vindicate those splendid lessons he gave us, — his constant belief in us.

Will you please give my especial love to Nat & Caroline; I have up to now felt completely unable to write anything coherent.

<div style="text-align:center">Yours,</div>

<div style="text-align:center">Peter</div>

[1] See PH to Henriette Wyeth Hurd, October 2, 1935, note 1.

To Paul Horgan

January 5, 1946
[San Patricio]

Dear Pablito

At last — a breathing spell to write you a long-due letter;
First of all let me tell you what a fine and wonderful, truly com-
forting thing, your letter was about Pa's funeral.[1] It was a reas-
suring and building sort of thing, Paul. We both felt immeasur-
ably nourished and sustained by it, at that awful time.

. . . Well Pablito *La Mancha*[2] is ready for you whenever
you want it but there are a number of conveniences you are pos-
sibly going to need later. Mainly a big butane tank, (now just be-
coming available) then a refrigerator and gas stove and later on a
well and pressure system. There is running water and a Butane
hot-water heater* now but only a couple of fire places for heat-
ing. It is ready aside from these needs, and is no strings attached
FREE, GRATIS, By *NO STRINGS*, Amigo I mean we won't
think of rent — It is your *casa* to have for as long or as short a
time as you like — to — entertain in, to hibernate in as you like,
with servant or without we don't care about how you run it but
suggest that whatever final plans you decide on you better have
meals with us at first any way. A small two-station field tele-
phone set could serve to keep you advised of developments on
our side of the big Cañon. The main thing is that *La Mancha* is
in an inhabitable condition now and that we are ready and anx-
ious to receive you there.

. . . I have been working with new zest and ardor ever
since I saw you and am longing to have you see such of the new
things as are here. The end of the war made the spiritual release
I had so hoped it would for me (at times, when sunk about my
non progress, I would wonder if this hope of mine was just a pre-
tense made to excuse my inability to get completely excited
about painting.) Thank heaven these fears were ungrounded for
I have never been more ardently engrossed or teeming with
new projects. It is a really grand atmosphere in which to work
and I feel I am so damned lucky to live thus remote from the
storms and hisses of little groups and cliques or rather cliques &
groups of little people . . .

*Present butane system is powered by a single small portable drum.

[1] A memorial exhibition was held for N. C. Wyeth from January 7 to January 27, 1946, at the Wilmington Society of the Fine Arts.

[2] See PH to Henriette Wyeth Hurd, [May 6, 1940], note 3.

To Daniel Longwell

Feb 4, '46
[San Patricio]

Dear Dan:

Following delivery of the sketch book to C. R. Smith[1] I got a fine note from him; He was evidently really delighted with the book and it seems to have been a very worth while project. I hope you all heard from him too. I haven't written him except a note in the book itself — I feel possibly I should have made it more clear that it was Life's project in the first place; that my contribution was negligible — But new examples of these laborious hentracks of mine seem to be getting scarcer and scarcer. I write damn few letters for they seem to require the same energy-fund as painting, and I am really pouring on the coal in painting these days.

There is another matter I feel I should tell you of Dan though with the Army's super-public relations system may be this is utterly needless.

A few days ago an old friend from the Air Forces dropped in on us and inquired as to whether Life had me on any assignments at the moment. When I told him I was in the middle of a story on my own home country — actually less a "story" than a series of paintings built around the theme of water in the Arid Southwest — he seemed disappointed. "Damn it I wish I could talk," he said, "but I can't." However, in the most guarded language — using only broad terms and vague hints he made it clear that a big project was brewing which my bosses should know about. "It is really going to be something!", he said and as he is a quiet guy (not the fighter-pilot type!) this restraint of his seemed to carry a lot of weighty conviction. Apparently military security *inside* the project is supreme. But as I have often seen

happen, higher-ups sometimes suddenly release data and seemingly secret information, to the complete indignation of the little fellows who have been so carefully briefed on secrecy. May be this is the case in this instance — For while he made no specific mention of it my mind immediately leapt to the new atomic bomb test — a couple of days later the El Paso Times carried a fairly complete outline of the plan to test-bomb a capital ship in the lagoon of an atoll . . .

[1] PH had had a group of field notes for his wartime paintings bound into a special volume and presented by *Life* to Major General C. R. Smith, wartime deputy commander of the Air Transport Command. Another group of field notes was sold in Philadelphia "for the benefit of the Air Force Society to help provide funds for orphans and widows of Air Force casualties" (autobiography).

To Mrs. Daniel Longwell

June 6, 1946
[San Patricio]

Dear Mary.

A note from our Dan says you are insisting on his taking off in the Fall and you're both coming down here. This is just to tell you how very delighted I am to hear of this decision and how wise I think you are to insist. He certainly needs a release from the high pressure — away off — far from a possible phone call — so I am *plumb* happy that you are coming out here. There are some lovely spots in this landscape that I am anxious to show you — if you feel like a few leisurely drives in the car. For the rest of it we can do just whatever you and he want to do — but one thing I'll *gawrn-tee* we'll all have a good time and we will also get Dan well rested!

Henriette is having a marvelous stay in Hollywood. She writes very entertainingly of her impressions of the place, the people, the customs. All very amusing to me — She has completed a portrait of Peggy Ann Garner, is now at work on one of Linda Darnell.[1]

Since you were here, so long ago, we have done a lot to the old ranch house — A new wing now comes out from my studio to enclose the patio on three sides (It is enclosed on four sides with

the stone wall). There is a *"portal"* as the Mexicans call the colonnaded porch on three sides now and the roof is laid with hand made clay tile from a nearby pottery. It is beginning to acquire charm.

Michael[2] is progressing well, in the care of an elderly nurse maid named Rosie. Peter and Ann Carol are both home and in another two weeks the entire clan should be united for the first time in Michael's life-time of 14 weeks . . .

[1] Linda Darnell, the movie actress, bought a house at Picacho, near San Patricio.
[2] Michael Hurd, San Patricio artist, was born on February 16, 1946.

To Andrew Wyeth

November 12, 1946
[San Patricio]

Dear Andy

Just got back from a trip down into the Guadalupe Mountains which are a continuation of these ones we live in — only a hundred miles South. I had a marvelous trip into that wild remote wilderness (one of the few truly remote areas in the U.S.) where I was taken by a wealthy rancher to paint a big landscape of his ranch headquarters. We took horses and packed back into the Sierras to a wonderful box cañon flanked by a primeval forest and a great fountain of clear water that gushed from the limestone walls in a miraculous torrent. Elk — Rocky Mountain sheep and even the *"Tigre"* the big spotted jaguar of old Mexico & South America exist there.

The great phalanx of Lombardy poplars shown in the little drawing on the next page is a wonderful golden yellow — or rather I should say *will be* for frost has not yet turned them — But what a spot it is!

Back here I found your letter and the Violet color — Thanks Andy for both — hope I'm not robbing you — let me know if and when you want the Native golden ochre. Referring to your note — I wish you could come here soon. It is really so simple now to get here. Just climb on an American Airlines flagship and in a matter of hours you are set down at El Paso where we'd meet

you only a hundred and forty miles from us. We really have a hell of a lot of fun, and I'd love to have you along on some adventures. We could whip out to Hollywood where I know a lot of people and where I have had *plenty* of fun on other trips! Or drive down to Mexico City where the same holds true. Or just stay here at this ranch where we certainly never lack for excitement. We have a procession of guests — (you know Henriette's particular brand of hospitality —) and most of 'em are great fun. Paul is living here — There are polo games and pack trips and Indian dances — Bull fights just across the border — and through it all blazing brilliant sunshine. You may wonder when I work — I've honestly never been busier or more excited about some projects that are brewing and in execution now.

Michael is fine — Peter you'll probably be seeing at Christmas — Ann Carol is cute as can be; we see her here every second week-end when she comes home from her school in El Paso. She chatters fluent Spanish, gallops a horse bare back like a small lady centaur!

So why'n hell don't you climb into a D.C.3 at La Guardia some morning early and wire us your flight number and I'll meet you at El Paso.

I wish I had a good copy of that reproduction of the Silversmith to send you but pal, they were all piss-poor, all I ever saw anyhow.

Give our love to Betsy — Adios for now Andy — Ann writes that your new son[1] is wonderfully cute—

Pete

[1] Jamie Wyeth was born on July 6, 1946.

To Mr. and Mrs. Daniel Longwell

December 20, 1946
[San Patricio]

Dear Dan & Mary:

Here's a brief line to you to wish you both a very Merry Christmas and to hold out some small but we hope fruitful inducements to visit San Patricio pronto. — First the great and

mighty *Manolete* appears in a bull ring in Ciu. Juárez, a scant three hours drive from this ranch, to kill six bulls, six noble bulls well tested for courage and ferocity, on Sunday December 29th! — Moreover at not infrequent intervals rockets —, mighty missiles of future eras, flame across the night sky to probe into the mysteries of inter planetary space at White Sands. This only a scant hour and a half's drive from our hacienda. And now tonight as though to cap all this with a climactic stroke I read in Time, a weekly news magazine with some circulation in these parts, that you are to lose the roof over your heads. That the U.N. is to take over your part of the Island. Doesn't this all add up to your coming out here now — at once? That it may is the wish and hope of

<div align="center">Your Ob't Serv't.</div>

<div align="center">P. Hurd</div>

P.S. I have written Capt. Weston asking him to visit us. Just finished portrait of Teresa Wright; She and Niven Busch[1] spent ten days with us last month. Henriette Ann Carol Michael and I are here this Christmas. Peter, now a special music student at Syracuse U. is to be at Chadds Ford.

<div align="center">P.</div>

[1] Novelist and screenwriter Niven Busch was then married to actress Teresa Wright.

<div align="center">**To Mr. and Mrs. John McCoy**</div>

<div align="right">January 2, 1947</div>

<div align="right">[San Patricio]</div>

. . . We're having our first taste of winter this week a norther rolled in on us and we're mighty glad of this snug adobe house. The new wing which José [Herrera] and his brothers built for us last winter (it was ready to be moved into on the very day (Feb 26) that H. & Michael returned from the hospital) is splendid — The walls are over two feet thick — like one of your Pennsylvania farm houses and for once we have windows that are wind tight — These new steel sash windows were a wonderfully lucky find. Most every thing else aside from plumbing came from these mountains — Lumber was cut in the high part

of the sierra. Roof tile of clay was handmade nearby. Adobe
bricks were made here on the ranch. Rocks for foundation and
flagstones we hauled in from one of our pastures on a sledge.
Now with the first test of winter weather we are really enjoying
this new part of the house . . .

To Oliver La Farge [1]

Oct 17, 1947
[San Patricio]

Dear Mr. La Farge:

Please forgive this belated reply to your most kind letter of
over a month ago. At the time of its arrival I was on an assign-
ment to paint "Task Force Furnace" for the Army Recruiting
Service. This Task Force was operating out of Yuma Arizona
testing men and materiel under conditions of extreme desert
heat and as there was a big and imminent publishers' deadline to
be met all correspondence had to go unanswered for a time.

I greatly appreciate your invitation to become an honorary
member of the Guitar Club of Santa Fe and hereby deliver my
enthusiastic acceptance. Though the humblest of aficionados,
limited in repertoire to the tinkling ditties of the Mariacheros of
Jalisco and the *huapangos* of the Huarteca region of Mexico
(This as you will discover for yourself is not false modesty) I
nonetheless greatly appreciate other and more classic playing
and I certainly hope I can hear Segovia when he comes to Santa
Fé in February.

In closing let me say I have much enjoyed your writing and
look forward to meeting and knowing you. Next time I am in
Santa Fé I will call you and hope we can get together.

Please greet the members of your Club for me and say I an-
ticipate with pleasure our meetings.

Sincerely
Peter Hurd

Original manuscript at the Humanities Research Center, University of Texas
at Austin.

[1] Best known for his Pulitzer-Prize-winning novel, *Laughing Boy*.

To Mr. and Mrs. Andrew Wyeth

Dec 27, 1947
[San Patricio]

Dear Andy & Betsy:

What a grand Christmas we have had here and I wish a magic carpet had allowed you at least to look in on us, Paul Horgan and the Nicholases — Mary & Caesar & their small daughter, Ann Carol's best friend, spent the day with us. The kids rode, after the usual early morning ritual Chadds Ford style, of opening gifts around a lighted *Piñon* tree. After cocktails in the warm sunshine of the patio we went inside for one of Henriette's best Christmas dinners, afterward Paul Caesar & I lay down on the rye grass in the patio and fell asleep — (P. & I had been up until midnight the night before & then at 5:30 A.M. up to jingle a set of rather incongruous sleigh bells). Today we played polo here on our field at the ranch an informal practice game among ourselves but great fun.

. . . The Radio is blaring something about a record snow storm in N.Y. so perhaps you had a white Christmas. It seems hard to think of any snow at this time in this warm balmy weather tho only 30 miles from here the high sierra peaks are piled with it, gleaming magic white in this lovely moonlight. I made a painting in tempera of this last year which I wish you could have seen but it was bought from its first showing by the Art department of a Texas State College. And speaking of painting nothing could have pleased me more than your book on Hieronymus Bosch. What a painter! And as Betsy wrote on the card what's new about Surrealism? This is the only work I have on this most interesting master and I am delighted to have it. Thank you both! . . .

To Mrs. N. C. Wyeth

January 12, 1948
[San Patricio]

Dear Ma:

I am but crazy about my pink kerchief and totally unable to find any out here around any of my old haunts. The Japanese who used to supply the rather flimsy silken ones I used to buy

have not resumed their exporting evidently for none of the stores either here or across the border stock them any more. Thank you for this most charming present; I popped it around my neck at once on Christmas morning and everyone who came here commented on it with enthusiastic approval.

It is Sunday afternoon, a marvelous lazy day with the temperature in the middle seventies in the shade. Henriette has gone to take Aurelia and Oliva[1] home and Michael is asleep on the grass beside me. We both fell asleep after lunch here in the patio and I wish you could see Mikey as he sleeps beside me now. He really is a strikingly handsome child. But then he would be an exception among all your grandchildren if he were not! They are certainly a handsome lot — those others in Chadds Ford judging from their photographs.

. . . This has been a marvelously quiet Sunday for us; we were due to go to Roswell to play polo this afternoon but the game was cancelled due to the military [NMMI] team's ponies being out of condition. At noon Ann Carol took the bus back to school in El Paso, and I worked in the garden a while wrote letters and went out and dug some fresh celery. Two weeks ago we played an officers team here on our field and gave the players and their wives luncheon before the game. There were twenty for Lunch, buffet in the patio, and Henriette and I were proud of the fact that every article of food came from our ranch except coffee and sugar! We had home-grown ham, fresh apple sauce, milk corn bread from home-grown, home-ground corn meal chile, water cress, onions, vinegar, fresh tomatoes and for dessert preserved pears from our orchard and fresh almonds from the trees in the patio! H. & I enjoyed the fact that this all came from the ranch — but don't think we do not have grocery bills. *Ay Diós*, we do!

We are so glad and grateful at the fine reports about Peter in Chadds Ford. I do wish so often that he and Pa could have known each other when Peter was at this stage of his development.

I am supposed to go back to Hawaii[2] in the Spring but if Andy & Betsy and maybe Ann & John too are coming out I am certainly going to postpone the trip — No hardship this for there

is no where I'd rather be than here, particularly with the prospect of their coming.

We have several projects brewing for the next months which will absorb a lot of attention. One is bringing water from our Spring which is situated a half a mile from this house to take the place of the well water (very hard) which we now have. Another is wiring the guest house which still relies on candles for illumination and a third enterprise is putting in another bathroom adjoining the guest room Paul occupies when he is with us . . . I hope some day you will visit the ranch Ma, I believe you'd like it!

Much love from me and thank you for the gay and charming present — Ma.

<div align="center">as ever
Pete</div>

[1] Aurelia, wife of José Herrera, frequently helped in the kitchen with Oliva, the Hurds' chief and still present cook.
[2] PH had first gone to Hawaii in 1947 on a commission from the N. W. Ayer Company to paint a series of historical works commemorating the centennial of the Hawaiian Islands' development and was returning to complete the assignment. The watercolor paintings were exhibited at the National Academy of Design in New York in 1949.

<div align="center">

To Henriette Wyeth Hurd
1861 Coldwater Cañon
[Hollywood]
Monday Morning [April? 1948]

</div>

Dearest Bini:

Here we are in the old whirl — only this time it's I who is doing the whirling as you were when you were out here — Peter is fine and having a great lot of fun and experience. He and Peggy Ann [Garner] have seen each other a lot and seem to get on O.K. Mrs. G. wants to own the portrait but I'd be careful of cheques — Let Time Inc. handle the deal, if possible. Lynian Peter & I had dinner with Linda [Darnell] the other night and she seemed so lonely — terrifically in love with H. whom she has not yet seen although they talk by phone twice a day. I think she'd like to hear from you a reply to that letter — She is as you thot an

essentially good person. I have glimpsed Tony & Grace[1] but find I don't seem to get anything from those two at all — A-Tall as my father would say. They are both smug fatuous and selfish! Maybe you disagree but that is how I have them figured. Saw Parsonnet[2] at Chasens and he is very busy — plans to finish his picture by October — late October and come to see us then.

My job[3] at the Studio & RKO Ranch is so involved — that is the getting of material is that. I am just about resigned to using my memory & imagination bolstered up by stills and strips of the film itself in order to get the detail I need.

Everyone has been wonderfully helpful and co-operative and I have an enormous black Cadillac limousine with a driver who looks like a body-guard assigned to me — *day or night* go anywhere anytime! — In my cowboy jeans & boots I melt neatly and anonymously into the landscape of a Western movie and have to take care that I'm not filmed in the background!

. . . I miss you awfully — Bini — it's all so damned complicated out here and I find myself thinking — resting myself by thinking — of the peace & quiet of *Centinela* . . .

[1] Hollywood screenwriters.
[2] See PH to Paul Horgan, March 8, 1932, note 1.
[3] PH was painting title backgrounds for the "bad men" western, *Cowboy*.

To Margaret Varga
[Carbon Copy]

May 15, 1948
[San Patricio]

Dear Margit,

A few days ago I received word from Dorothy Seiberling that LIFE has selected for its collection the painting RIVER-BANK FARM from my water series published in the August 18 issue. I am glad you all like the picture well enough to want it, but ironically enough, this selection has its hardships for me. I know you will welcome a discussion of the fix I'm in.

A former resident of New Mexico, now living in California, made a fortune out of oil in the Southwest, and being a generous and public-spirited man, he believes he should in some measure

return material thanks to the country which prospered him. He for years has been a patron of my work.[1] He owns five of my pictures now, including a portrait I did some years ago of his daughter. Last year he decided to present as complete a collection as could be made of my lithographs to the Roswell Museum. At his insistence, the gift was made anonymously on behalf of himself, his wife and their daughter. This year, still requiring complete anonymity, he has decided to found a collection in the Roswell Museum of such of my best work as could be obtained — this to the tune of two paintings a year, and by his own stipulation, at my top prices. This is of course a great opportunity for me to achieve relative freedom from the economic pressures which at times drive me to accept advertising jobs, and so forth; and for me to concentrate on painting for my very own interest and satisfaction. It is also, I must confess, a sort of lien upon posterity such as an artist would honestly have to admit would be reassuring and desirable. All in all, my patron who is also a good friend of mine deserves and has my complete respect and loyalty.

I am sure you have seen by now what is coming. After repeatedly requesting LIFE to choose the picture from my water series due to the LIFE collection under our agreement, and upon receiving no answer for many months, I felt free to let my patron examine for selection the RIVERBANK FARM, among others submitted to him. Sure enough, he chose it, and approved a price of $1200.00, and has asked to see THE OASIS (Swimming Boys) for the same purpose.

You now see what I must ask you and LIFE to consider, and that is, the choice of some other work from the series. If LIFE keeps this picture, I lose $1200.00, and the initial donation of this patron to a permanent public collection from my annual output suffers a serious blow.

. . . Can you let me know soon about this? Until arrangements are final, I won't feel really secure with regard to the first selection for the Roswell collection; and I won't feel on firm ground with the man who is so generously fostering my welfare and my reputation[2] . . .

[1] Donald Winston.

[2] *Life* obliged PH by choosing another painting for its collection.

To Mr. and Mrs. John McCoy

March 9, 1949
[San Patricio]

. . . thank you for your telegram which reached me at the exact moment of the opening of the [Roswell] museum. It was a grand occasion for me and your telegram was very heartening and it made me happy to know you were thinking of us. Of course you can see what a deal like this museum set-up means to us [illegible] anonymous donor buying a couple or three paintings each year it should make me able to turn down some of the more dreadful advertising commissions offered me. And that is just what I did not long ago when N. W. Ayer wanted me to do a series of portraits (from photos!) of big-shot executives for an advertising campaign (Webster cigars) a sort of gallery of lesser men of distinction if you can imagine anything less in any way than that crew. Anyway you can see how glad I was to turn down serenely and quickly, that deal.

A great thing, over 2000 people, appeared the first day February 13th and interest seemed to continue to such a degree that the loan show was held over another week. Of course I am delighted at all this and at the same time feel responsible and dedicated to the project — From now on out as the hour-glass sand seems to increase its rate of flow I feel I better dig in as never before! . . .

To Paul Horgan

April 1. [1949]
All fools' day with the weather
the chief *burlador*![1]
[San Patricio]

Pablito *Cuate*[2] —

Your welcome letter I have just read — bringing its picture of sunny landscape and endless wildflowers[3] ironically it was received just as I returned from Roswell in a near blizzard — not freezing — quite — but wet snow falling and this year's fruit crop hangs in balance tonight.

Not much to report — no further word from Niven [Busch] — H. is in Roswell painting Helen G[lover]. Miguelito the weezies and I here at garrison. Talked to Prof Todd today show big success in attendance most of any so far but no sales except a small drawing. Mr. McAnally looked and looked but finally evidently didn't acquire. But a nice lady turned up at the Studio door last week one day, (Mrs Griffin of Taos Wichita Falls & Brownsville) and left me a cheque for one of the polo paintings.

Winter's scheduled to leave tomorrow and I look forward to getting back to outdoor painting — I've done two watercolours which I think you'll like — H. and I rolled down to El Paso Sunday for overnight.

The Museum is in a complete uproar pending opening of the Crosby[4] show, they've moved in cactus Soap weed Grown weed a part of a corral and a stuffed horse! Thus the air with a mighty blast a Titanic horse fart has been cleared of all traces of Art or aesthetics — But it will bring a great response and attendance I'm sure! The photos are wonderful. We all miss you *cuate* — *Que Dios te bendiga*[5] —

<div align="center">

Hasta luego —

Peter

</div>

[1] Jester.

[2] Chum.

[3] Paul Horgan was in Corpus Christi, Texas, on a research trip for *Great River*.

[4] Bob Crosby, a world champion cowboy, had a show of his cowboy possessions at the Roswell Museum. PH painted his portrait in 1950.

[5] God bless you.

<div align="center">

To Paul Horgan

</div>

<div align="right">

April 19. [1949
San Patricio]

</div>

Dear Pablito:

Numerous interesting snippetti[1] from you and each time I have settled myself for a note to you something has popped up to interrupt. Tomorrow I meet Niven in El Paso[2] (I have already made one preliminary survey to some marvelous little towns on the Río Grande La Union Chamberino & San Miguel) now the

plan being to wangle someway permission to slip quietly & unobtrusively across the Río Grande into Chihuahua with a small company of actors & technicians to do a few scenes there. I feel dubious on only one score; that is the bad parts given to all Mexicans in the film. I wish Niven had found some other device less damaging to our Latin American neighbors. I plan to suggest timidly that he try to remedy this situation. Perhaps it could be done without too much difficulty.

Don Winston, here today with Betty and the Messers[3], just bought the watercolor of Elfego's House done last December for the museum and for himself and Betty "West-Bound Freight." My checking account is slowly recovering from its acute attack of anemia. Henriette and they seem to hit it off wonderfully for which I am grateful.

They have been so happy and comfortable at Fraction House[4] — they fairly purr and apparently the Black Rose[5] is doing wonderfully — Not much to report here *cuate* — Easter egg hunting in a wonderful survival of a pagan cult ceremony. A beautiful day here. Huera & Mikie fine and joyously dedicated to the tradition of Easter. Yesterday, Monday, Erna[6] arrived for over-night — full of charm enthusiasm & stimulating talk — She outlined the design of her new book "New Mexico" to Knopf. I thought the pattern a new and interesting approach for a subject on which she seems (as are we!) perennially refreshed.

Here's Bini to say the light is lousy so I'll wait a while and finish this when we turn on the lamps.

Later: Just in from planting some Violets and how we do miss you now. Your travail with the bulbs has yielded *such* results — tulips narcissi grape hyacinths daffodils — Plito, they are marvelous! I do hope you return in time to see the *acéquia* garden at its height! Adiós for now Plito — we all miss you and look forward to your safe return — Bless you —.

<div style="text-align:center">love
Peter</div>

[1] An invented word for clippings and snippets.

[2] For the filming of *Duel in the Sun*, written by Niven Busch.

[3] Thomas Messer was director of the Roswell Museum. He later became director of the Guggenheim Museum in New York City.

⁴Paul Horgan's Roswell house, so called because of its address, 1/2 Park Road, and which the Winstons were renting.

⁵Paul Horgan's cook.

⁶Erna Fergusson, author of many books about Mexico and New Mexico, and a good friend of the Hurds. She was the sister of Francis Fergusson, scholar of drama and literature, and Harvey Fergusson, novelist. For her book *Murder and Mystery in New Mexico*, PH did the frontispiece.

To Henriette Wyeth Hurd

July 30th [1949
The Drake Hotel
Chicago]

Dearest Bini:

The Cathedral[1] is just what everyone said — pretty awful both inside and out but I have data now sufficient for a good atmospheric painting of the interior I'm sure. On to N.Y. today then back by Thursday I hope. Plan to leave New York Tuesday night which may make it Friday — I'll let Paul know, anyhow.

It has been hot as the devil here but as you know this doesn't particularly bother me.

I'll sure be glad to be home again —

Much love to you and the kids — a kiss from

your
Petie

[1] PH was painting the Cathedral of the Holy Name for the cover of the January, 1950, issue of *Cosmopolitan*. His right arm was broken at the time, and with characteristic discipline he was painting with his left hand.

To Mr. and Mrs. Daniel Longwell

August 15th
1949
[San Patricio]

Dear Dan & Mary:

Home again after what certainly was a most stimulating trip. I'm all refreshed, refurbished mentally and full of the new projects ahead of me. Seeing the shows (paintings) in New York & Chicago was just what I needed, I feel.

I want to thank you both again for the stay at that wonderful River Club; and what a club that is! I think I told you I saw all my friends on the staff, all but Chico, the Puerto Riqueño house-boy who was away on vacation. Seeing them again, being again a guest of the club in the summer it was impossible not to relive the days I spent there seven years ago when I got thrown off the Queen Elizabeth. Though I didn't fully comprehend it at the time I was standing on the threshold of the biggest adventure I've ever had. As it turned out I feel it (this assignment) was pro-fessionally enormously valuable to me for it taught me to carry pen and brush constantly and use them at all sorts of odd times as a recording medium, much as one might use a candid camera — only with the advantage that in making even a little squiggle of a sketch or a fleeting note I had thus partially committed the moment to memory. This in a way I am sure never could happen (for me) with a camera. This procedure has been invaluable to me ever since.

As these schizophrenic hen tracks may have told you I am still plastered — I mean my right arm is, and the El Paso Vet whom I visited at once on my return says another month; three weeks now. However I'm in no particular discomfort as work goes on as usual. Next Monday I am beginning a portrait of the Chief Justice of the N.M. Supreme Court[1] a man whom I've known all my life. This will be an unlimbering project for the head I'm doing for you, Mary of you, Don Daniel.

The weather here is perfectly sublime — daily thunder showers that appear about noon, last from fifteen minutes to an hour after which the valley, freshly washed and fragrant with rain-moist earth, glistens in the clean air.

I am writing this in mid-morning sitting in the patio and over the *Cerro Centinela* thunder heads have begun to form and there is an occasional distant rumble. This is the most exciting of our seasons and I hope it won't be long before you will both be here to enjoy it with us.

Adiós for now and with love from us all here

I am as ever

Peter

P.S. Mary, I'm anxiously awaiting the letters column in Life concerning Maestro Pollock's opera reproduced last week.

<div align="center">P.</div>

[1] Charles R. Brice.

<div align="center">

To Helen Hayes
[Draft]

13 November, 1949
[San Patricio]

</div>

Dear Helen:

It is seven-thirty-three on Sunday evening and for the last half-hour your voice has been in this studio again bringing Henriette and me to a poignant realization of how much we miss you and Charlie! [1]

We are delighted you are on the air again and this is to tell you first of all that you were superb. Completely convincing and charming in this play "Still Life." I am glad you are back to work again for I know in work you can best find surcease from the suffering of these last weeks.

We loved your note from Hawaii and then a few days ago that magnificent shirt to remind us of you (It is now always referred to as my Helen Hayes shirt in the household and even Mikie knows it as such!) Thank you for this Helen. I am touched and delighted that you should have selected it for me. Incidentally it fits me perfectamente.

We all have the ardent hope that the coming year will find you and Charlie again with us — You Helen, seem to be such a practical trouper that the vagaries of our rustic menage apparently bothered you not at all. You will hear from Henriette soon — she is back to work again on an enormous canvas longer than she is tall: a great fantasía of tropical flowers the models for which she is having flown in from Honolulu in separate installments.

We think and speak of you so often; it was marvelous to hear your voice tonight, so like you and instantly recognizable.

With much love to you and that wonderful Charlie!

<div align="center">

As ever

Peter

</div>

[1] Writer Charles MacArthur and his wife, actress Helen Hayes, had recently spent ten days with the Hurds at Sentinel Ranch following the death of their daughter, Mary.

To Henriette Wyeth Hurd

Mazatlán, Sinaloa
Dec 12th [1949]

Dearest Bini —

What a trip! Rough & tough but such country as I've never yet seen in all the traveling I've done. We[1] are camped beside the Pacific near a grove of coco trees. To the Westward beyond the soft coral sand is a small island like the ones I've seen in Polynesia. The City of Mazatlán has 32,000 people and we have not seen a single foreign car in two days here. Today is Guadalupe Day and there is quite a fiesta in progress in the city six miles south of here.

There is so much to tell you I'll have to wait until I return — It is enough for now to say that Chihuahua is quite bleak and dull until Parral which has charm. Durango — high lovely and very paintable as is Zacatecas. Sinaloa where we now are is tropic and most engaging. So funny to find Mexicanos living by the sea — I mean I find it difficult to associate the two concepts.

The trip across the Sierra Madre was incredible and will have to be described in detail for you to have any idea of it. Over 100 Km. all above 8000 feet of twisting, looping extremely narrow road made of crushed tufa rock.

Our schedule is just as before. We've come much further than we planned but the effort of crossing the Sierra Madre was certainly worth it. We'll come here together sometime soon, I hope. Much love to you Bini — I do miss you so much. [Spanish] A little kiss for Michael and a big kiss for you.

ever your

Peter.

[1] PH and Daniel Longwell.

To John McCoy

May 7th 1950
[San Patricio]

. . . to get to the business at hand *leave* us know how many paintings you want for the family show next year and I'll see that you get a representation of my best. As you must know I am practically an un-known in New York (at the End for that matter) because of dissatisfaction with my dealers there (I've sent them nothing new in three years nothing, that is, which was not commissioned) The reason I haven't yet gone elsewhere to find a dealer is I've been kept busy with more or less local demand and seem unable to store up a stock-pile for a New York show. So it will be fun and I hope rewarding all around to send a group of whatever number you suggest to Wilmington.

Life with us seems to be a constantly involved swirl of events and whatever one may criticize of its content it certainly can never be said to lack variety and excitement! Henriette and I have just said goodbye to the last of our current batch of house guests which included a politician (our State Atty. Gen'l) a film star (Linda Darnell) and a young oil man whose portrait I'm just finishing. Tomorrow we're expecting Jack & Anna Biggs who are coming to see one of the big rockets fired at White Sands over on the desert west of here. One (a secret one probably since no announcement was made of it) was evidently fired this afternoon for we saw the great, nearly vertical, vapor trail in the western sky as we were riding in the hills this afternoon. Later this month we hope Bill Phelps will show up as we recently had a card from him telling of this possibility. I just hope it doesn't conflict with a trip I have to make to Chicago to correct proofs of a portfolio of colour prints the Lakeside Press is doing of my work . . .

To Kenneth Franzheim[1]
[Carbon Copy]

11 December 1950
[San Patricio]

Dear Mr. Franzheim,

Your very interesting second letter has just reached me — it came on Saturday and I have thought about the Prudential project[2] in the interim of a day and a half.

The principal thought that keeps recurring to me as I turn the matter over in my mind is that I wish the subject appealed to me more. I find on analysis of my feelings that where pictorial subject matter is concerned I am somewhat interested in the Past, altogether and wholly in the Present, and not much in the Future. This you must know refers only to my interest in subject matter of painting and of course not to any lack of concern as a citizen with our country's Future.

I could not predict the mechanical future of the country which I feel would look hopelessly inaccurate and dated in a very few years on any mural by me. To treat of the concept of the Future in terms of old age and the security gained by Life Insurance would I feel, in my hands at least, run the risk of being too sentimental.

In summation I feel that as the matter now stands — with the subject matter you have supplied in the proposed inscription[3] — my own limitations make it seem to me I am not the man for the project. However, its size and scope, its location (I am very fond of Houston) all appeal to me and I could arrange my schedule by some juggling of dead lines to include the execution of this work within the year . . . I believe that were the subject of your project a different one arising from my own experience and feeling I would attack it with all enthusiasm.

Consider for a moment that your thematic inscription were a somewhat different one, to carry this idea:

AS ALL LIFE GROWS FROM THE TENDED LAND
SO LET EACH MAN'S FUTURE GROW FROM HIS
OWN PRUDENCE.

Given such a theme as this, I could then interpret it in terms of sweeps of landscape, timeless in their forms, and yet alive with the activities of man at work improving and developing his natural resources for the present and the future.

Should this or a related conception appeal to you and your clients let us continue the discussion along these lines. I wish you to know that my suggestions are not made arbitrarily but only because they include within their frame the sort of thing I can do with conviction and feeling.

As to cost — I would execute the finished work in secco, i.e. casein tempera, painted directly on the plastered wall using the best and most permanent materials throughout, for the fee of $22,000.00 . . .

[1] An architect of a new Prudential Life Insurance Company building in Houston, Texas.

[2] A proposed mural panel, 14½ ft. high and 47 ft. wide, to be decorated in the entrance rotunda of the building.

[3] "The Future Belongs to Those that Prepare for It."

To Kenneth Franzheim
[Carbon Copy]

13 January 1951.
[San Patricio]

. . . I'll try to amplify my proposed scheme by saying that the mural, if I executed it, would represent many human activities upon our great southwestern background — activities such as types of farming, stockraising, habitation — and finally in overall picture it would stress in terms of decorative painting various aspects of the use, control and conservation of water and land. In all such themes, of course, there would necessarily be many depictions of people performing the various kinds of work suggested, so that the whole painting would not be, as you seem to fear, "landscapes alone," but would be, as I said in my letter of 11 December, "sweeps of landscape, timeless in their forms, and yet alive with the activities of man at work improving and developing his natural resources for the present and the future . . ."

I do hope this restatement of my general idea may lead to satisfaction, for otherwise, at this stage, I do not see how it is possible for me to be more concrete without actually proceeding with the detailed preliminary sketch, which, as I meant to suggest in my earlier letter, would be the first stage of work under the acceptance and launching of the commission. Thus, to your inquiry as to whether I am doing "any preliminary work on the same," I must reply, out of respect to my present commitments, that I am not, pending final agreements as to the terms of the commission as outlined in my previous letter . . .

To Mrs. N. C. Wyeth

Wednesday
Oct 24 [1951
San Patricio]

Dearest Ma:

As always, at this season of the year[1] my thoughts are particularly frequently with you and this evening being near a telephone I tried for some time to reach you. The operator reported you were expected to be home around ten but as I had to return to the ranch where Mikey was staying with the maids the call had to be cancelled. So here is a Substitute to say hello and tell you how often we think of you, only wish it could have been by voice!

Henriette is still in Canada but due to leave today I think and probably will reach the ranch around Saturday. I spoke with her by telephone on Sunday and at that time she said her heavy schedule (four portraits) had made her unable to write you all in Chadds Ford. I promised to let you know and perhaps she has already written too.

Mikey — now nearing the age Andy was when I first met him and the family sometimes reminds me of him — in spite of big brown eyes and coppery red hair. Quite a character Master Mikey, just as was his distinguished Uncle even at that age. His life is a wondrous pot pourri of jet planes, witches, box kites cowboys, apaches & military tanks. These things and beings real

& imaginary surround him and exist in the most serene harmony except when battles flare when the resulting chaos is appalling.

My work improves I hope; but I see new vistas ahead to be conquered and wonder if time can last to allow me to reach them. This may sound like a nose-to-grindstone life — but this is true only in part for [missing page] explorational trips on horses or in the truck back into remote mountain ranges — many of which I've known all my life as distant hyacinth blue masses at the edge of the plains. Always I've known them from a distance while travelling well worn roads — Now it is such fun to know their very nature to explore their forested cañons & rocky pinnacles. Then of course there is polo to keep me from getting fat tho Henriette finds this a devious and curiously frenetic way to keep skinny. —

The Biggses arrive Tuesday — then a few days later the architect from Houston[2] with whom I'm working on a mural project — Following that I think Linda Darnell will come to find some rest with us after a strenuous time with illness during her last picture in England. She is a marvelous gal — wonderful looking of course — but with intelligence wit & humor abundant.

Paul has written a very distinguished story which the Post published three weeks ago; it is called, "The Soldier Who Had No Rifle," and is a moving and haunting story which I hope you will read. Incidentally the spark for the story was touched off by an account I gave Paul of an experience I had when with the Fifth Army near Gaeta on the road to Rome. But this scant anecdote was enough to set Paul's imagination flowing and rushing with other experiences & ideas produced a wonderful short story.[3]

We all still hope for a visit here some day Ma.[4] Don't forget us — I certainly would love to see you — How often I remember your sweetness to me — your unremitting generosity in overseeing my well-being in those student days that now seem so long ago & Far away. But I shall never forget them nor the way you and Pa allowed me into the very heart of the family —

Love from

Peter

[1] Around the time of year of N. C. Wyeth's death and of many birthdays in the Wyeth family.

[2] Kenneth Franzheim.
[3] See chapter 9 letter excerpt, PH to Andrew Wyeth, December 10, 1944, refer-
ring to "a tired looking chaplain." Horgan's novelette appeared under the title "To the
Castle" in his book *Humble Powers.*
[4] The following summer Mrs. Wyeth made her first visit to San Patricio.

To Mr. and Mrs. Andrew Wyeth

10 January 1952.

[San Patricio]

Dear Andy & Betsy

It seems impossible that Christmas could already be so far behind — But I know you will know what I mean when I say I've been in a nightmare state of racing against deadlines on a commissioned job.[1] I think this one has been the most heated & intensive I've ever experienced but it all ended happily with architect & company Vice-president apparently pleased with my progress as they arrived here day before yesterday. The reason for the race incidentally was my three month stint at painting for myself — and now with a breathing space ahead I plan to go back this week to more of this personal painting. Wish you could see what I've been doing in Tempera. I think you would note progress! I certainly am delighted with each new work of yours Andy — always necessarily limited by reproduction but I applaud your direction and your steady march toward the wonderful supernal reaches of those painters in the book[2] you sent me for Christmas. I didn't know the existence of this book and couldn't think of any I'd rather own. It will be here in the studio within easy reach and next to the two beautiful Memling volumes which you both gave me in past years.

Wish you could be with me on a camping trip I'm about to take — I plan to take off with Johnny Meigs,[3] my assistant in the truck (which carries in addition to painting materials, a couple of weeks food & water supply, bedding, spare parts and a winch) We plan to explore a remote part of Chihuahua and Sonóra where these states join ours, a part of the country I've never seen.

We had a grand Christmas (for the rush toward the deadline hadn't begun then) with only Peter away — and I know he must have had a fine time with you all.

Henriette is about to begin a painting of the plant called *Copa de Oro* — or cup of Gold a long golden chalice of a flower with a 6-inch mouth supported on a rampant woody evergreen vine. They are in full bloom now and we counted twenty-six open this morning. Only trouble about painting them is that each bloom only lasts a couple of days either on or off the vine. But H. did a wonderful painting of them a couple of years ago and she is painting better than ever it seems to me.

Much love to you both — God, I hope we can get together somehow in the next year — It seems forever since I've seen you.

Peter

[1] Cartoons for the Houston Prudential Building mural.
[2] A book of animal drawings.
[3] San Patricio painter and writer.

Highlights: 1954–72

In March, 1952, Peter went to Houston to paint the mural in the rotunda of the new Prudential Building. It was his largest decoration to date, but eight months later he received a commission that surpassed it, both in size and scope. This was a series of sixteen mural panels to be painted in the true fresco technique in the rotunda of the museum of Texas Technological College in Lubbock. To Peter it was "the most exciting project I've had since Dan [Longwell] packed me off to the wars."[1]

Assisted by Henriette, John Meigs, and Manuel Acosta, another San Patricio artist, Peter executed the Lubbock murals over a period of two years. Viewed as a whole composition, the separate fresco panels form an epic vision of the history of the settlement of Lubbock. Each panel presents a different, generic pioneer of the newly settled territory—a schoolteacher, a stock farmer, an oilman, to cite only a few. All the various pioneers stand facing the viewer in the context of their particular locality in the region—in front of the village schoolhouse, for example, or amid freshly cultivated fields. These distinct settings all merge into a vast, common background, in which day is seen sweeping into night and on into another dawn, suggesting the great, inexorable march of human existence. Dedicated on November 18, 1954, Hurd's Lubbock murals are widely regarded as the height of his achievement in mural painting.

Recently the old museum at Texas Tech was converted into an administration building, and there the murals remain, with the following inscription at the bottom, joining two different sayings from the scripture: "Speak To the Earth and it shall Teach thee[2] So teach us to number our days that we may apply our hearts unto Wisdom."[3]

[1] PH to Mrs. Daniel Longwell, October 20, 1952.
[2] Job 12:8.
[3] Psalms 90:12.

To Andrew Wyeth

August 10*th*
1954
[San Patricio]

. . . I am at work on a variety of projects principally the last four cartoons for a large fresco mural I have been doing for the past two years for Texas Technological College. This is a fascinating project and involves making all sorts of studies and plans before hand trying to envisage and foresee all possibilities as well as exigencies before the exciting day when I am confronted with the blank wet plaster. I have tried to do something a little different in this fresco; how well I've succeeded, I can't say. When I say different I don't mean stylistically for I'm sure it is all my own so far as that is concerned. But rather I mean in the method of presentation and in certain treatments of the fundamental problems of design in wall decoration . . .

To John Biggs, Jr.

[August? 1955
San Patricio]

Dear Jack:

I was delighted to hear from you and in today's mail came the radiation detector — I'm much interested in this instrument and have already got flashes from Dan Brenton's ore samples (from the Sierra Capitan just north of us) Many thanks for this and for the warm invitation to stay with you when next I'm in the East. I will promise to do just that amigo and with much pleasure hereby accept. I'm hoping to make a run east this fall — sometime after we get our fruit sold.

We have had magnificent rains and the ranch looks like the hills of Killarney it's that green old San Patricio would feel at home could he visit his town.

By the way — the other Geiger Counter has turned up — You loaned it to John Davis who stopped in the other day and promises to return it — I'd plumb forgot but I knew we didn't have it —

Have a grand trip —
Peter

To Paul Horgan

June 5, 1956
[San Patricio]

. . . I hope you are enjoying your stay in N.Y. and look forward to hearing from Carol all about your ceremony.[1] I will be off to San Francisco to paint a portrait of Duke Ellington for Time Magazine[2] on Thursday . . .

[1] Horgan's induction as a member of the National Institute of Arts and Letters.
[2] The portrait appeared on the cover of *Time*, August 30, 1956.

To John Hersey[1]

November 21
1956
[San Patricio]

Dear John:

Here I am three weeks late in answering your fine letter — Actually I was away when it came, painting a young Olympic athlete[2] for Time's cover. This is due to come out on the issue of December 3rd and as usual I am sweating out the reproduction. There is something about the broken colour technique I use that causes engravers much grief. Perhaps I should say causes them trouble and me grief.

Your visit was certainly memorable for us, John and for me most stimulating. For some reason I seem to get much more from writers than from fellow painters. I except Andy in this but after all he is "family" and I've known him from the time when he was six. But with writers — if we have any common meeting ground at all I usually come away all set up and with new surge.

About your queries on the 8th Air Force[3] . . . One of my duties when Dan Longwell sent me to England in 1942 was to keep a journal. All their correspondents were so instructed I think and a book of excerpts was planned but never realized. Gathering dust in a loose leaf binder containing about a hundred and ten pages of typescript is my journal of this period — Until today I have scarcely thought of it since the time I had it typed after my return here from my first trip in December 1942. I flew no combat missions but of course was in constant and close con-

tact with the men who did — being a correspondent I could and did mingle freely with both enlisted men and officers. I have no certainty of course that the journal would be of the least value to you but if you think there is a possibility I could send it on to you to read . . .

[1] Distinguished American novelist, journalist, and author of many books, including *Hiroshima* and *The Wall*.

[2] Parry O'Brien, a shot-putter.

[3] During a recent trip to the Southwest with publisher Alfred Knopf, Hersey had met PH at the ranch of Wilbur Coe. Hersey was just then starting work on his novel *The War Lover* and talked with PH about PH's experiences with the Eighth Air Force.

To John Hersey

⟨April 21
1959
[San Patricio]⟩

Dear John:

How completely delighted I am to know my diary has helped you on your new novel! I couldn't be more pleased.

I received a picture last month of a recent re-union of the 97th Group held in Florida. I have been unable to make any of their bi-ennial get-togethers as they are always held far from here and I am usually involved in some project that keeps me here. So the photograph came as a shock — although my own mirrored face should have prepared me — I found I still thought of them as unchanged by time and this group of men now mostly in their forties seemed to have absolutely nothing in common with those dashing characters I knew so intimately in 1942. Aside from the dozen or so whom I have seen in the interim I don't believe I recognized with certainty, a single face in the forty or fifty who were included.

. . . I look forward eagerly to the galley proof [of *The War Lover*] which you mention planning to send . . .

To John Hersey

⟨September 3,
1959
[San Patricio]⟩

Dear John:

Just this minute I have finished reading "The War Lover" and without waiting for any further evaluation or for better phrases to occur to me I hasten to tell you at once I think it is a perfectly stunning book; to me so convincing, it seems impossible you were not there as Bo along with Marrow, that wonderful, very human Daphne and the crew members of "The Body." Your knowledge of the outward physical aspects of the subject constantly amazed me. As to the deeper verities those of the human spirit, I know well your ability to delve into these. Am not so amazed. I feel in this novel you are wonderfully clear in your intention and have completely sustained the feeling of impending doom right up to the superb description of the ditching. You of course already know how strongly I agree with you about that strange yet recurring type, the war lover. I think you have handled the matter of Marrow's disintegration with the greatest skill and understanding. He stands (for me at least) beside Ahab as a living and credible symbol of a tortured, violently possessed man. In Daphne you bring to vivid reality the woman we all seek: compassionate, tender, deeply understanding.

Naturally I was delighted to find snippets of my own experience subtly woven into the book; happy to have been of any value to you in the creation of this superb work. I know you will understand when I say that for me reading it was an experience both emotionally exhausting and richly stimulating. Thanks for this advance copy with its gracious inscription.

I greatly hope we meet again one of these days, John. Either here or in the east where I go to attend monthly meetings in Washington of the Nat'l Fine Arts Commission.[1] Should you and your wife ever want to escape the East for a few weeks or months we have an adobe house here on the ranch 1/8th mile from ours where you would be let completely alone when you wanted to be, (for this outfit greatly respects privacy!) and always, very welcome.

Sincerely
Pete —

¹PH had been appointed to the commission by President Eisenhower. He served on it from 1958 to 1963.

To Mr. and Mrs. Daniel Longwell
[C]

First day of Spring
Mar 21 [1957]
& it's raining ¡ole, ole!
[San Patricio]

Dear Dan & Mary:

This letter has been postponed due to the fact that I had up until now hoped to be able to say I'd be in Houston on the 4th. But here's the situation. I am painting a large landscape for the Albuquerque Natl Bank — not a mural but a large 16′ x 5′ masonite panel of a New Mexico landscape.¹ In spite of two phone calls to Chicago (Hqs of the masonite corporation) (and two special delivery letters) no panel has appeared yet. As this size — the 5 foot width and extra length is not regularly on sale but sold only on special orders I am on the spot until it arrives which I hope will be right away, but with an April 22nd deadline, even though the preliminary work is all completed I'm going to have to dig in hard to get the panel prepared and the painting completed by this date.

I'm sorry, for I had really counted on being there with you and I know well what a gay town Houston is. I was about to urge Henriette to go any way but she says she doesn't dare leave the painting she is at work on. This you would understand if you saw the painting: it is a wonderful project full of imagination and different from anything heretofore.

What fun it was being with you both in New York. I do wish we could meet more often. Our girl is fine and sends you her love as I do. Her present painting is really wonderful!

Pete

¹The egg tempera painting shows a wide plain flanked with mountain ranges on a clear October afternoon. In the foreground are two horsemen, framed by an open gateway.

To Mrs. N. C. Wyeth

Jan 14,
1958
[San Patricio]

. . . Wish you could see the ranch now: the grass on the mountains is like some lovely antique fabric, all interwoven with gold and muted silver. We now have forty head of beef cattle and eleven horses. If it weren't for the latter we'd make more profit but I love the nags as you know. All of the cattle are descended from foundation stock which were received in trade for paintings 5 bred heifers for a landscape, a registered bull as down payment on a portrait and again 3 heifers (bred) also a down payment on a portrait. We will now begin selling fairly soon unless I am lucky enough to get another square mile or two of grazing land. So far we've saved the heifers to replace later our mother cows and eaten up all the steer calves. It seems to take a lot of beef to keep this outfit in the saddle but that's one thing we seldom buy.

Tell Carolyn I'll write her a note soon — meanwhile love to you both and thanks for the delicious (and unique, yours are the BEST) Sand Tarts.

Peter

To Ann Wyeth McCoy

14 Mar.,
1958
[San Patricio]

. . . I've just returned from Palm Springs where I went to paint the portrait of an old friend, Sid Richardson,[1] a colorful and amusing old rogue who has collected millions of bux in the oil business. I had to, to pay for a ranch we have just bought joining us on the north. It consists of a square mile of wonderful remote country much of it out of sight and sound of any of man's works except an occasional aircraft. It is watered by a well and windmill in a meandering valley called, Cañon de las Chozas after some ancient dwellings — huts whose foundations and walls of crumbling adobe are still visible . . .

[1] The model for the "oilman" in PH's Lubbock murals.

To Paul Horgan

March 21
1959
[San Patricio]

Dear Plito,

The little flashlight is a notable success and has rendered obsolete the pen light I pack around my neck together with other implements of my trade, brush, pen &c. If only I would carry a spoon jauntily poked into my hat ribbon I'd be the very picture of a Breughel *paisano*. The little storage battery gives a remarkable amount of light and the shape is just right for one's pocket. I carry it in the despatch case Bini gave me ready for transfer to pocket as occasion demands.

We went to Guaymas for a week and it was wonderful. The brilliant water and mountains like those of El Paso tumbling down the beaches makes an exciting combination. We took the Goddards[1] along and everything went well . . . Guaymas is beautiful; wish we could see it together some time.

Weather here has been beautiful we've had no "marscher"[2] however and stockmen are beginning to worry. Two gritty, sandy-chill days early this week were about the only bad smell so far. But the elms are greening by the minute and for that reason alone I rejoice that you're not here being made miserable by their pollen.

Plito, I hope you're well situated at N[otre] D[ame] and getting all the research material you need.[3] We miss you and hope you will soon be with us again at San Patricio. Love from us all three.

Peter

[1] Mr. and Mrs. Robert Goddard, residents of Roswell. Robert Goddard was an inventor of the technology that made possible interplanetary space travel.

[2] Moisture, in Southwest lingo.

[3] For his biography *Lamy of Santa Fe*. The book won the Pulitzer Prize for history in 1976.

To Andrew Wyeth

Sept 4, 1959
[San Patricio]

Dear Andy:

A note to you at once to say how delighted I was to see your portrait of the President [Eisenhower] on Time [magazine]. Knowing well what such a commission entails I proudly salute you for an excellent effort. I hope it went easily although in my case they never do for I literally sweat blood and usually curse myself throughout the project, saying "why did I ever accept this job?" etc etc. You probably know what I mean.

I think your head is splendid even allowing for the inconsistencies and vagaries of the reproduction process on Time's Covers — and certainly a real honor to have been able to have painted him and had him pose for you. I wish I knew him for I admire him a great deal . . .

To Ann Wyeth McCoy

Jan 3, 1961
[San Patricio]

. . . I'm finishing up a portrait of General C. P. Cabell who is Deputy Director of C.I.A. and a W.P. classmate of mine. Always advantageous to paint some one you know well . . .

To John Biggs, Jr.

Feb 5, '61
[San Patricio]

Dear Jack:

Thank you for that fine letter to the State Dept.[1] Now I'm scared that I'll be called and am horrified at the thought. This country seems to grow more wonderful to paint as time goes on and I really do dread being away! But your letter was such a compelling one that I think I'll start hiding out.

Hey when are you coming back to San Patricio? How we'd love to see you.

Henriette is fine; painting better than ever and seems generally in fine shape. Mikey is in school at Middlesex in Concord

Mass. He is an honor student and stands Number 2 in his class of 34.

Well them bee-uz is fine Jedge an I never even got stinged whenever I robbed them last October.

Come see us, Pal!

abrazos[2]

Pete

LOVE TO ANNA!

[1] The State Department wanted to use PH in its Educational and Cultural Exchange Program and had asked Judge Biggs for a reference. PH never served in the program.

[2] Embraces.

To Mrs. N. C. Wyeth

Feb 16
1963
[San Patricio]

. . . Ma, you were a dear to send me the beautiful book of Andrea del Sarto's drawings. He is one of my favorite masters of the art of drawing — and I have a reproduction of one of his wonderful heads in charcoal framed on my studio wall. Never truly *never* do I begin a drawing in charcoal without a long contemplation of this head before-hand. Now, with an entire book of these wonderful and strong charcoal studies what a mine of inspiration and actual help you have given me. Bless you!

. . . My show in Phoenix, the opening of which I attended, was a great success and hordes of people turned up at a gala affair. Expecting to be bored I found myself greatly enjoying it all . . .

To Mr. and Mrs. Andrew Wyeth

March 13
1963
[San Patricio]

Dear Andy & Betsy:

Just got a notice of the opening of your Tucson show Andy and it looks as if the director has done a fine job of rounding up enough of your works to make a large show.

I certainly share your feelings about attending "Openings." Having made 3 of my own in 5 weeks I'm ready to go back to my old line — peddling enema bags and sex items: it's less exhausting.

Hey I hope to be seeing you next Wednesday — the 20th — right after my meeting I'll grab a train to Wilmington — this unless something unforeseen keeps me there till Thursday. At any rate I'll call.

Here is the promised publicity. I'm amused that both at Phoenix and Roswell the exhibition of my work brought record crowds — over 700 at Roswell Museum last Sunday and a similar number (also Record!) at Phoenix paid for a champagne supper at this (evening) opening. All this adds up to an indication of the public's hunger for a return to sanity in painting and I'm glad to share with you Andy in my own lesser way an attraction for the public. Also I like to think how much Pa would have been pleased at this even though we all deplore a certain type of "Popular painter" — but we will talk of this and more when next we meet.

love
Pete

To Mrs. N. C. Wyeth

December 16
1964
[Washington, D.C.]

Dear Ma:

Here we are just now Henriette & I finishing a portrait of President Johnson for Time's cover due to come out some time next month[1] . . .

[1] The *Time* Man of the Year portrait of LBJ, which PH and Henriette painted together, appeared on the January 1, 1965, issue. It was done "entirely from a photograph supplied by TIME, [and] was painted in our room at the Carlton Hotel in Washington" (autobiography).

To Paul Horgan

Taif
Saudi Arabia
July 7 1966

Dear Plito.

Well here I am again in the land of the rag heads: I'm sitting on a balcony overlooking part of Taif which is relatively cool and an attractive place. I'm awaiting my first meeting with H. M. King Faisal ibn Abdul Aziz al Saud. I write the name in full to help accustom me to the ring of it. I'm here to do his portrait for Time Mag[1] and an interesting but most arduous adventure it has been so far. I've always thought of myself as a Southwestern Salamander or *Rattus desertii, Var. Hurdius* until I found myself on the Arabian Gulf coast last week. The thermometer crawled up to 123° F. and seemed to stick there. I thought it was hotter than that and was beginning to turn into a piece of overcooked-bacon.

Purpose of this is mainly to say I hope you are O.K. again or at least nearly so and let you know I often think of you. My plans of course depend somewhat on how much time H.M. can give me . . .

[1] *Time* did not use the portrait.

To Henriette Wyeth Hurd

Riyadh S[audi] A[rabia]
Aug 11th [1966]

Dearest Henriette,

I can't say this is truly the first opportunity to write you a letter but I can pledge you it is the first one when I wasn't so exhausted I could think of nothing but sleep. I have been skipping around central Arabia at a great rate of speed on an inspection tour of the truly astonishing progress this ancient race is making. The heat is something you wouldn't believe and continues through the night with little change. There is a valiant air conditioner in my large hotel room here in Riyadh and the air that pours forth is icy but by the time it reaches the far wall it is warm!

The landscape such as I've seen so far is monotonous and gloomy under a flat grey light. The unbroken wastes around Riyadh are absolute desert yet there are Bedouin people living in low tents of black & white striped mohair fabric who "graze" their flocks of goats. But all of this I'll tell you later — all this and much more. I don't mean to paint a picture of complete dejection in my response to the landscape. You will see that the pieces fall together to make a strange and interesting whole. One quite the antithesis of my preconceived ideas in some respects. What one feels immediately is the excitement of a nation backward beyond belief suddenly coming alive under the stimulus of great leadership and new-found wealth.

My man Mohammed Minaonyi says the City of Taif where the King has his summer residence is in beautiful hill country. We go there on Thursday when I hope to meet His Majesty . . .

To Paul Horgan

⟨[August, 1966
Saudi Arabia]⟩

. . . The King is a magnificent individual. The keen features of the Arab aristocrat an erect and kingly carriage — he curiously manages to convey two usually unrelated traits: Majesty and humility — both real and unaffected. He was generous with sittings and I think for what it is — i.e. a cover portrait it is fairly successful . . .

To Henriette Wyeth Hurd

Kándara Palace Hotel
Jidda
Saudi Arabia
Aug 11, '66

Dearest H.

I will tell you my dream of a few nights ago for it remains vivid and clear in my mind — a rare thing for me for actually I so seldom nowadays recall any dream next morning.

In the dream I came upon Pa; it was spring or summer and

he was sitting on the ground beside a stream — whether ours or a run in Pennsylvania I can't recall. He seemed to be deep in thought as I stood looking at him and suddenly and impulsively I had a strong compelling desire to walk nearer to him and tell him how very, very much his teaching his philosophy of art and of life — have meant to me throughout the years — how grateful I am for his patience with me and his belief in my success. I don't think he replied to my words nor do I remember that he looked up. But the dream ended with my self in a euphoric state, a curious blissful feeling that I had actually communicated with him and that he was pleased. Strange, Strange!

So now with this strange and poignant dream still flickering vividly in my mind I send this same message to you, thankfully this time under different circumstances. To you My darling Henriette the same message but more too — much more and more than I could begin to say but which must be tacitly understood entwined yet unsaid in these lines. Beside loving you I greatly admire you — Your perceptiveness in critical help to me has been of the greatest importance in my progress. Your own gallantry and courage through the ordeal with the dentists and now with more threats to your health has set an example for all of us.

Henriette dear, I truly adore you . . . I miss you constantly and long for word of you but am glad you are not in this pitiless, sun-scalded country. All my love Bini —

> ever your
> Peter

P.S.
I'll try to write again. who *honest loves you*!

To Robert Ewers[1]

Nov. 25, 1966
[San Patricio]

Dear Mr. Ewers:
I am afraid after reading your letter and looking at the enclosed sample of your work that you are like many other people today who have been misled by modern art into thinking that it consists of random scattering of blobs and lines expressing the personality of the perpetrator.

You are not alone in thinking this is creative expression, for thousands of others have been lured into the all too easy formula and have been led to believe it is "art."

What all of you have missed is the fact that art is communication and great art is communication on two levels, an appeal to the intelligence and an appeal to the emotions. Consequently what is generally passed off as art fails miserably on both counts. I regret that many museums and most galleries have clouded the issue with exhibitions that too easily elicit the comment from the lay viewer "I can do that."

Do not take this to mean that I reject all modern art in toto, on the contrary I find much of the most significant of modern painting provocative and stimulating, but you will find that the practitioners who communicate are much more broadly based than their seemingly simple arrangements of color and line would indicate. Art is a profession and as a profession requires the background that any professional field demands of its practitioners. One does not take up surgery as a hobby and expect to perform operations on living people. Law or Science require years of study. You would not send your children to a school where the teachers just happened to decide to teach. The responsibility of the artist to the public is equally as great as that of any other profession. The self taught artist seldom rises above a quaint primitive style or a naive handling of his materials unless he is that rarest of people, a genius. You will never know what your potential may or may not be unless you are willing to sacrifice time, effort and money to attend an art school with a strong teaching staff and experience the heady atmosphere of real competitive artists working side by side in a creative atmosphere. From my own experience this alone is not even enough. Dozens of my fellow students at the Pennsylvania Academy of Art who showed great promise are unheard of today. Unlike other fields the obtaining of a diploma or degree is not the open sesame of success. In any creative act the inner spirit is the determining factor of success or failure.

Success in art cannot be judged wholly in the market place. Many financially successful hacks clutter the field with uninspired and gimmicky pictures of absolutely no value in terms of their contribution to creative art.

I again repeat that I place the blame on irresponsible exhibiting of amateur and hack work and the greedy promotion of anything that can be sold regardless of merit.

I think you will have to take a careful reevaluation of your own work and ask yourself innumerable questions before you can decide the best course of action for yourself but may I suggest that you be honest in your answers and from them chart your future course.
Sincerely,
Peter Hurd

[1]The original of this letter to an aspiring young painter was typed but never sent.

To Mr. and Mrs. Daniel Longwell
[C]

March 1, 1967
[San Patricio]

Dear Dan and Mary:
The long delay in answering two such old and dear friends can only be explained by the almost unbelievable bedlam here caused by the darn Presidential portrait business which, instead of diminishing, seems to get new wind from Lord knows where and presents more letters to answer, more phones to pick up, and more people to see.[1] . . . We have just started today our first venture in doing two portraits at the same time of members of the same Family. I am doing James Copley,[2] the publisher and Henriette is doing a portrait of his wife. They are delightful people and we look forward to a pleasant series of sittings . . .

[1]In 1965 PH had been commissioned by the White House Historical Association to paint the official White House portrait of LBJ. During the only sitting Johnson gave

him, the president fell asleep. After that PH had to work from photographs. When Johnson saw the finished portrait in 1966, he rejected it and publicly denounced it as "the ugliest thing I ever saw." PH then decided to return the $6,000 commission fee. In 1969 he donated the portrait to the Smithsonian's National Portrait Gallery in Washington, D.C., where it is on permanent view.

 [2] Publisher of *San Diego Union*.

To George P. Hunt [1]
[Carbon copy]

24 February 1969
[San Patricio]

Dear Mr. Hunt:

This is to express to you my thanks for setting right the record in the matter of my ill-fated portrait of President Johnson.

I was more than willing to let the whole matter drop into oblivion but when the Washington Bureau of [the] New York Times called me regarding it about a month ago I felt it better to state the facts myself rather than risk a distortion. The resulting article which appeared in the daily Times was an embarrassment to the Smithsonian Institution and, of less importance, also to me although it did make me out a great liar. Hugh Sidey's article certainly stated the facts correctly concerning the deal with the Smithsonian and, of course, was otherwise most generous in his praise of my effort. I have already spoken to him by telephone, and this is to reiterate my thanks to you.

　　With kind regards,

　　　　PETER HURD

 [1] Then managing editor of *Life* magazine.

To James E. Gibson [1]
[Carbon copy]

9 October 1969
[San Patricio]

Dear President Gibson:

I am greatly honored by the unanimous vote of your faculty to confer the degree of Doctor of Humane Letters upon me [2] and

I look forward to the Convocation on October 22 with much delight . . .

[1] President, the College of Artesia.

[2] Other honorary degrees awarded PH include a Doctor of Laws from New Mexico State University in 1968 and a Doctor of Fine Arts from Texas Technological College in 1966.

To Clinton P. Anderson[1]
[Carbon copy]

5 May 1970
[San Patricio]

Dear Clint:

A matter has come to my attention lately which seems to me to be of such grave importance that I am writing to you in the hope that you will see the need for some sort of corrective legislation. As you know, we live near the Mexican border and are frequently back and forth across the line. In the course of these trips we are more and more aware of the tremendous problems that have arisen through policy of the Immigration Service and the U.S. Department of Labor. I am very well aware of the fact that behind the scenes is the powerful labor lobby.

First of all, the Border Patrol in its present strength is enormously undermanned in terms of the job it has to do. My observation is that the Border Patrolmen are overworked, understaffed, and long hours are required to remain on duty, due largely to the enormous increase in the illegal entry of aliens. The morale of this elite group of Federal employees is at a low ebb. If we are to continue with the present laws then certainly a great beefing up in the number of personnel at such stations as Alamogordo, Carlsbad, and Lordsburg must take place. Personally, I feel that our country should go back to the system in use during the time of President Eisenhower wherein the *bracero* program was maintained with rigorous inspections of health and character before admission to our country. As the matter now stands, an estimate of hundreds of thousands of illegal aliens are now established in our country. Obviously this presents a great

problem in our country in terms of economy at a period when our economy is drastically faltering.

I would like to suggest to you, Clint, that an investigation in depth be made of this problem in the fervent hope that some equitable solution will result from Congress . . .

[1] Senator from New Mexico, and a friend.

To Mr. and Mrs. Andrew Wyeth
[Carbon copy]

10 June 1970
[San Patricio]

Dear Andy and Betsy:

The watercolor returned in good shape and I am truly glad to have it back because after an interim of a few days during which I had not seen it I find myself suddenly looking at it with clear and cool appraisal. I am happy that you were not able to buy it at this time. If in the future you do buy one I want it to be one of my very best efforts. Actually from the beginning I had certain doubts about it, feeling that it fell well short of my goal which was to create the envelopment of night in a lonely isolated ranch in the valley north of us. It was Henriette's enthusiasm for it that made me overcome my misgivings, at least temporarily.

Now I have a proposal to make and this is made with absolutely no idea of pressuring a sale to you for I know that this is out of the question at the present time. I would like to send you a few selected 35mm color slides of recent watercolors for the sole purpose of giving you both some knowledge of what I have been doing. Most of these, if not all, are ones which have not been exhibited or reproduced. The few that have been are ones which might have been exhibited at one of the two commercial galleries in Texas which handle our work. If this meets with your approval I'll send along a group of these and if you don't have a projector or one that you can borrow easily I have a tiny one which Bob Anderson[1] gave me some years ago. Like many articles in the field of optics this one was made in Japan and is a very simple operation and [has] excellent clarity. So, drop me a card if this idea appeals to you.

Henriette has done an absolutely stunning series of painting flowers this spring beginning with the first appearance of wild flowers here in late February and continuing on now with a magnificent arrangement of iris supplied by a doctor's wife who makes a specialty of growing these beautiful plants in their mountain home in Ruidoso.

My dearest love to you both in which I know Henriette would join if she knew I were writing to you.

<div style="text-align:center">

As ever,

[Pete]

</div>

[1] Robert O. Anderson, chairman of the board of ARCO, and a close friend of the Hurds. PH painted his portrait in 1965.

To Andrew Wyeth

<div style="text-align:right">

Feb 4,

1972

[San Patricio]

</div>

Dear Andy:

Just back from a trip to Sonora, one of the 2 Mexican states which join New Mexico where I participated in a series of stag hunts. The field consisted of ten people and it was all great fun. As in fox hunting in Penna. the quarry is not killed — invariably living on to be chased again and again. — The deer are the smaller white tail and run like the west wind.

I took writing paper along hoping to get some Christmas letters written but there was too much excitement and constant interruption — Hence this very belated letter to tell you I am enormously enjoying the two Volumes on Contemporary Mexican Art — The text is extremely well written and some of the reproductions seem to express the surge forward which is referred to in the text — a desire to leave behind the influence of the Mexican Mural Painters — men who worked in the period running from the early twenties up until World War II. Men like Rivera Orozco Charlot and Siqueiros — of these and others only the last two mentioned are still living.

They are beautiful and informative books — I enjoy studying the very interesting photographs of the artists — they make

me want to meet them on some future trip to Mexico City or Puebla, where many of them live.

I think of you so often Andy that [is] literally many times during a day — wishing it were possible to have you here — Spend a few weeks with us — How we would love this and believe me you would not be bored! We could go out water coloring together again, as we used to do in Chadds Ford so many years ago.

I've been working on a 3/4 length portrait of a lady — whom I've known for many years. She is owner of two huge ranches in Texas the Four Sixes — and the Triangle. A bountiful supply of petroleum and gas is brought forth from the subterranean depths of the ancient ocean beds that underlie these ranches. She is within a year or two of me in age and while time has treated her extremely well aided in this by annual trips to spas where fat and wrinkles are patiently and skillfully reduced!

She is standing on a hillside here in a tumult of New Mexico wild flowers — made from studies on our ranch — on beyond is the plains country of New Mexico as it merges with Texas.

Another project recently completed is a series of 12 tempera landscapes for the Leonard brothers — depicting the Months of the Year as seen by a countryman in New Mexico in our time —

My warmest love to you Andy. I hope you are well and working. Love to Betsy, please. Yours as ever,

Pete

P.S. Bob Anderson would gladly fly you out here on one of his frequent trips to N.Y.

After 1972 Peter's correspondence diminished, even as his fame grew and the number of his collectors increased. He painted with all his energetic devotion and added much to his large body of work. Favored friends continued to come to the ranch for visits, and Peter welcomed them with the old gusto and charm.

A serious fall during a polo game in the early 1970s seemed to have a lingering effect on Peter's general health. For a long time afterward he could work only occasionally, and he took his ease more readily than in earlier years. Eventually other episodes of ill health made further work impossible. Since 1980 Peter has lived quietly in retirement.

Chronology

1904	Born February 22 in Roswell, New Mexico.
1918	Enters New Mexico Military Institute.
1921	Enters West Point, Class of 1925.
1923	Transfers to Haverford College. Meets N. C. Wyeth.
1924	Begins apprenticeship in painting under Wyeth. Enrolls at Pennsylvania Academy of the Fine Arts.
1927	Engaged to Henriette Wyeth.
1928	First exhibition of paintings, New Mexico Military Institute, December.
1929	Marries Henriette Wyeth, June 28.
1930	Wins first prize in landscape painting, annual exhibition of the Wilmington Society of the Fine Arts. Peter Wyeth Hurd born, March 22.
1933	Begins mural scheme at New Mexico Military Institute.
1934	Purchases ranch at San Patricio, New Mexico, May.
1935	Ann Carol Hurd born, April 9.
1937	Wins first prize, Sixteenth International Watercolor Exhibition, Art Institute of Chicago.
1938	Paints mural in Post Office at Big Spring, Texas.
1939	Henriette decides to move to San Patricio. *Life* magazine publishes story on Sentinel Ranch.
1940	Paints mural in Post Office Terminal Annex Building, Dallas, Texas.
1942	Elected to National Academy of Design. War correspondent in England for *Life*.
1944	War correspondent with Air Transport Command; travels around world for *Life*.
1945	N. C. Wyeth dies, October 19.
1946	Michael Hurd born, February 13.
1947	Awarded European Theater Medal for Service Overseas.
1952–54	Paints mural at Texas Technological College, Lubbock.
1959	Appointed to Commission on Fine Arts by President Eisenhower.
1966	Paints portrait of LBJ for White House Historical Association.

Index